THE CAMBRIDGE COMPANION TO
Delacroix

The Cambridge Companion to Delacroix serves as an introduction to one of the most important and most complex artists of the nineteenth century. Providing an overview of his life and career, this volume offers essays by leading authorities on the artist's pictorial practice, the stylistic range over Classicism and Romanticism, his writings, both private diary notations and published articles, and his impact on modern aesthetics, among other topics. Designed to serve as an essential resource for students of French nineteenth-century art history, cultural history, and literature, *The Cambridge Companion to Delacroix* also provides a chronology of the artist's life, set into its political and cultural contexts, as well as a list of suggested further readings in the topic areas.

Beth S. Wright is Professor of Art History at the University of Texas at Arlington. The author of *Painting and History during the French Restoration: Abandoned by the Past* (Cambridge UP, 1997), which received the Dallas Museum of Art's Vasari Award, she has contributed articles on French Romantic art and history to *Art Bulletin, Arts Magazine, Word & Image, Oxford Art Journal, Bulletin de la Société de l'Art français,* and other journals.

THE CAMBRIDGE COMPANION TO

Delacroix

Edited by

Beth S. Wright

University of Texas at Arlington

CAMBRIDGE
UNIVERSITY PRESS

PUBLISHED BY THE PRESS SYNDICATE OF THE UNIVERSITY OF CAMBRIDGE
The Pitt Building, Trumpington Street, Cambridge, United Kingdom

CAMBRIDGE UNIVERSITY PRESS
The Edinburgh Building, Cambridge, CB2 2RU, UK http: //www.cup.cam.ac.uk
40 West 20th Street, New York, NY 10011–4211, USA http: //www.cup.org
10 Stamford Road, Oakleigh, Melbourne 3166, Australia
Ruiz de Alarcón 13, 28014 Madrid, Spain

First published 2001

Printed in the United States of America

Typeface Fairfield Medium 10.5/13.5 pt. *System* Quark XPress^R [GH]

A catalogue record for this book is available from the British Library.

Library of Congress Cataloguing-in-Publication Data

The Cambridge companion to Delacroix / edited by Beth S. Wright.
 p. cm. (Cambridge companions to the history of art)
 ISBN 0-521-65077-1
 1. Delacroix, Eugène, 1798 – 1863. 2. Delacroix, Eugène, 1798 – 1863 – Influence. 3. Art,
 Modern – 19th century – France. I. Wright, Beth Segal. II. Series.

N6853.D338 C36 2000
759.4 – dc 21
[B]
 00-028919

ISBN 0 521 65077 1 hardback
ISBN 0 521 65889 6 paperback

Contents

List of Illustrations

Acknowledgments

I would like to thank Beatrice Rehl, fine arts editor of Cambridge University Press, for inviting me to inaugurate the series of art historical Cambridge Companions with this volume on Delacroix. Her suggestions were insightful, her good cheer constant, and her support and encouragement throughout the entire project has truly been invaluable. Lee Johnson's preeminent knowledge of Delacroix was graciously made available to all the essayists, and we are all profoundly grateful for his support of our endeavors. Many of us were invited to participate in a symposium held at the Philadelphia Museum of Art in October 1998 in conjunction with the exhibition *Delacroix: The Late Work*. Special thanks are due to Nina Athanassoglou-Kallmyer and Joseph Rishel for this opportunity to exchange views with fellow Delacroix scholars, and to refine the thoughts expressed in these essays. My gratitude to Patricia Mainardi and the anonymous readers of the proposal; their advice was invariably pertinent and helpful, and they greatly facilitated my efforts in shaping and unifying this collection of essays. The authors of these essays displayed an exemplary commitment to scholarship not only in their insights here but in their patience with the process of bringing them to publication, including space constraints, deadlines, and my many requests and queries, and I have enjoyed their cooperation and benefited from their wisdom. As before, the loving encouragement of family has been essential to the successful completion of this project. My love and gratitude to my husband Woodring, and my sons Benjamin and Joshua.

Delacroix and His Age: A Chronology

1798 Birth of Ferdinand-Victor-Eugène Delacroix 26 April [7 Floréal year VI] in Charenton-Saint-Maurice, near Paris. Fourth child of Charles Delacroix (1741–1805), ambassador plenipotentiary to the Netherlands, and Victoire Oeben (1758–1814). Charles Delacroix served as prefect of Marseille (1800–3) and prefect of Bordeaux (1803–5), where he died. Their other children were Charles-Henry (1779–1845), a general, given the title baron de l'Empire; Henriette (1780–1827), who married Raymond de Verninac (1762–1822), at one time ambassador to the Republic to the Porte [Turkey]; and Henri (1784–1807), killed at the battle of Friedland.

1806–15 Eugène Delacroix attends the Lycée Impérial (formerly the Collège Louis-le-Grand).

1814–22 Political and satirical prints: etchings and lithographs, sold separately or by the *Miroir des spectacles.*

1815 Enters the studio of Pierre-Narcisse Guérin on the recommendation of his uncle the painter Henri Riesener. Friendship there with Ary Scheffer.

1816 Enters the Ecole des Beaux-Arts (Guérin appointed professor of painting at Ecole des Beaux-Arts, December 1816). Learns watercolor technique from Charles Soulier.

1818 Delacroix poses for Géricault's *Raft of the Medusa.*

1819 *The Virgin of the Harvest* for the church at Orcemont, near Rambouillet, is his first commission.

1820 Géricault asks him to take over a government commission for the cathedral of Nantes: *The Triumph of Religion;* completed 1821 (Ajaccio Cathedral).

1822 Salon debut: *Barque of Dante;* purchased by the government for Musée du Luxembourg.

1822 Death of brother-in-law Raymond de Verninac; litigation, leading to bankruptcy of family in 1823. Begins writing his *Journal,* which he maintains 1822 to 1824.

1824 Death of Géricault; death of Byron at Missolonghi. Salon: *Massacres*

	at Chios; purchased by the government and placed on exhibition in the Musée du Luxembourg.
1825	May–August trip to England; welcomed by Lawrence, Wilkie. Shares a studio with Bonington, winter 1825–6.
1826	Exhibition for Greeks at Galerie Lebrun: *Execution of Marino Faliero*, *Greece on the Ruins of Missolonghi.*
1827	Salon continues into 1828: *Death of Sardanapalus*; advised to restrain his style by minister of fine arts or cease to receive government commissions.
1828	Seventeen lithographs for French edition of Goethe's *Faust.* Government commission of *Battle of Nancy*, completed 1831. *Execution of Marino Faliero* withdrawn from Salon and exhibited in London at the British Institution.
1829	Publishes "Des Critiques en matière d'art" and article on Lawrence's *Portrait of Pius VII* in *Revue de Paris.*
1830	Publishes articles on Raphael and on Michelangelo in *Revue de Paris.* Exhibits *Murder of the Bishop of Liège* (from Scott's *Quentin Durward*) in London at the Royal Academy. July Revolution. Competes in two of the three competitions established by the new government for the Chambre des Députés (*Mirabeau Confronts the Marquis de Dreux-Brézé* and *Boissy d'Anglas* at the National Convention).
1831	Salon: *The 28th July: Liberty Leading the People*; purchased by the government. Delacroix receives the Légion d'honneur. He publishes a letter on competitions in *L'Artiste.*
1832	January–July he travels with the delegation of the comte de Mornay (special envoy to the sultan of Morocco) to Spain, Morocco, and Algeria.
1833–7	Mural decoration of the Salon du Roi, Palais Bourbon [now the Assemblée Nationale].
1834	Salon: *Women of Algiers.* Commission for *Battle of Taillebourg* for Musée de l'Histoire de France, Versailles (Galerie des Batailles).
1837	First candidacy for membership in Institut. Publishes article on Michelangelo's *Last Judgment* in *Revue des deux-mondes.*
1838	Commission for *Entry of Crusaders into Constantinople* for Musée de l'Histoire de France, Versailles (Salle des Croisades). Second candidacy for Institut.
1838–47	Mural decoration of the library, Chambre des Députés, Palais Bourbon.
1839	Third candidacy for Institut. Travels to Belgium and the Netherlands.
1840–6	Decoration of cupolas and half dome, library, Chambre des Pairs, Palais du Luxembourg.
1843	Publishes thirteen lithographs on Shakespeare's *Hamlet* and seven lithographs on Goethe's *Goetz von Berlichingen.*
1845	Salon: *The Death of Marcus Aurelius* and *The Sultan of Morocco and His Entourage.* Death of his brother Charles-Henry. Publishes article on Puget's *Andromeda* in *Plutarque français.*
1846	Salon: *Abduction of Rebecca.* Officer of the Légion d'Honneur. Publishes article on Prud'hon in *Revue des deux-mondes.*

1847	Resumes writing his *Journal,* which he maintains to the end of his life.
1848	Sends *Le Constitutionnel* a detailed description of the Palais Bourbon program, which he has just completed. Publishes article on Gros in *Revue des deux-mondes.*
1849	Fourth candidacy for Institut. Withdraws his fifth application.
1849–61	Decoration of Chapelle des Saints-Anges, Church of Saint-Sulpice. Lengthy periods of ill health make it impossible for him to work on this project during much of the 1850s.
1850	Travels to Belgium. Publishes article on teaching drawing, a review of Mme Cavé's *Le Dessin sans maître,* in *Revue des deux-mondes.*
1850–1	Decoration of Galerie d'Apollon, Musée du Louvre.
1851	Sixth candidacy for Institut. Appointed to Municipal Council; serves until his resignation in 1861.
1852–4	Salon de la Paix at the Hôtel de Ville, Paris (destroyed during the Commune in 1871).
1853	Seventh candidacy for Institut. Publishes article on Poussin in *Moniteur universel.* Awarded membership in Amsterdam's Royal Academy of Fine Arts.
1854	Publishes "Questions sur le Beau" in *Revue des deux-mondes.*
1855	Paris Exhibition: Delacroix a member of the commission; retrospective exhibition of 36 works; awarded Grande Médaille d'Honneur and named commander of the Légion d'Honneur.
1857	Eighth candidacy; elected to Institut. Publishes "Des Variations du Beau" in *Revue des deux-mondes.*
1857–61	Chapelle des Saints-Anges at Church of Saint-Sulpice completed.
1859	Last Salon: *Ovid Among the Scythians.* Elected *membre correspondant* of the Académie Royale des Beaux-Arts of Brussels.
February 1860–January 1862	Exhibition at the Galerie Martinet of twenty-three paintings from his career, including *Death of Sardanapalus.*
1862	Publishes article on Charlet in *Revue des deux-mondes.* Exhibits *Murder of the Bishop of Liège* in London at the International Exhibition.
1863	Dies in Paris 13 August.
1864	Auction of Delacroix's works and exhibition organized by the Société Nationale des Beaux-Arts.

POLITICS AND DIPLOMACY

1798	Napoleon's Egyptian campaign.
1799	Napoleon's coup d'état of 18–19 Brumaire (9–10 November) overthrows Directory; he becomes first consul.
1802	Napoleon elected consul for life. Concordat with Pope Pius VII.
1804	Coronation of Emperor Napoleon I.
1812	Napoleon invades Russia; forced to retreat.
1814	Allies (Britain, Russia, Prussia, Austria, Sweden) enter Paris 31 March. Napoleon abdicates 11 April; goes into exile at Elba. Restora-

	tion of Bourbon Louis XVIII (brother of Louis XVI, executed 1793) as king, with Constitutional Charter.
1815	Napoleon escapes from Elba and returns to Paris; Hundred Days 20 March–18 June. Napoleon defeated at Waterloo; exiled to Saint Helena. Return of Louis XVIII.
1820	Assassination of duc de Berry. Ultraroyalists come to power.
1821	Death of Napoleon at Saint Helena.
1823	France intervenes in Spain, supporting absolutist government (liberal constitutionalists to power in 1820).
1824	Death of Byron in Greece. Death of Louis XVIII; his brother Charles, comte d'Artois, begins reign.
1825	Coronation of Charles X.
1821–9	Greek War of Independence against the Turks.
1830	France invades Algiers. 27–9 July: Revolution of 1830; Louis-Philippe d'Orléans becomes King of the French.
1840	Return of Napoleon's ashes to France from Saint Helena.
1847	Defeat of Abd el-Kader.
1848	24 February: Revolution of 1848. 25 February: Second Republic proclaimed. 22–6 June: Parisian workers demonstrate against bourgeois Republic. 10 December Louis-Napoleon (nephew of Napoleon I) elected president.
1851	2 December: coup d'état by Louis-Napoleon Bonaparte; approved by plebiscite 21 December. He becomes president for life.
1852	After plebiscite 2 December, Louis-Napoleon proclaims himself Emperor Napoleon III; Second Empire 1852–70. Haussmann's Parisian development projects (broad avenues, sewage systems, train stations, parks).
1854–6	Crimean war: France and Great Britain invade Russia.
1857	Conquest of Senegal.
1859–60	Franco-Piedmontese war against Austria. France gains Lombardy. Italian unification. Construction of Suez Canal 1859–69.
1859–63	Colonial occupation of Indochina.

VISUAL ARTS

1804	Gros, *Napoleon in the Pest-House at Jaffa*.
1810	Girodet, *The Revolt of Cairo*.
1814	Ingres, *Grande Odalisque*.
1819	Salon: Géricault exhibits *Raft of the Medusa*.
1824	Salon: Constable exhibits *The Hay Wain*; Ingres, *The Vow of Louis XIII*. David (exiled in Brussels) exhibits *Andromache Mourning Hector, Mars Disarmed by Venus and the Graces*, and other works in Paris May 1824–March 1825.
1825	Death of David in Brussels.
1834	Daumier, *Rue Transnonain*.
1835	Death of Gros.

1839	Publication of daguerreotype process.
1845	Exhibition at the Boulevard Bonne-Nouvelle includes ten works by David (including *Socrates, Marat, Bonaparte at Mont St. Bernard*), eleven by Ingres (including *Oedipus* and *Grande Odalisque*).
1846	Baudelaire reviews 1846 Salon: Delacroix exemplifies Romanticism and color.
1850–1	Salon: Courbet exhibits *The Stonebreakers* and *A Burial at Ornans*.
1854	Manet asks Delacroix's permission to copy *Dante and Virgil*.
1855	Paris Universal Exposition; Courbet's *The Studio* exhibited at his Pavilion of Realism.
1863	Salon des Refusés: Manet exhibits *Déjeuner sur l'herbe*.
1864	Fantin-Latour's *Homage to Delacroix* places Manet and Whistler closest to the artist's self-portrait (1837); includes Baudelaire, Duranty, Champfleury.

LITERATURE AND MUSIC

1800	Pixérécourt's melodrama *Coelina ou l'enfant du mystère*.
1801	Chateaubriand, *Atala*.
1810	Mme de Staël, *De l'Allemagne*.
1812	Byron, *Childe Harold's Pilgrimage*.
1813	Byron, *The Giaour, The Bride of Abydos*.
1814	Byron, *The Corsair, Lara*; Scott, *Waverley*.
1816	Rossini, *Barber of Seville*.
1819–24	Byron, *Don Juan*.
1820	Scott, *Ivanhoe*.
1821	Byron, *Marino Faliero, Sardanapalus, The Two Foscari*.
1823	Stendhal, *Racine et Shakespeare*; Scott, *Quentin Durward*.
1824	Beethoven, Ninth ("Choral") Symphony.
1827	Hugo, *Cromwell*. Visit to Paris of English company of actors (including Kemble) performing Shakespeare.
1829	Rossini, *Guillaume Tell*; Hugo, *Les Orientales*.
1830	Hugo, *Hernani* ("Battle" between Classicists and Romantics); Stendhal, *Le Rouge et le Noir*; Berlioz, *Symphonie Fantastique*.
1831	Hugo, *Notre-Dame de Paris*; Meyerbeer, *Robert Le Diable*.
1835	Balzac, *Le Père Goriot*.
1836	Musset, *Confessions d'un enfant du siècle*; Chopin, "Grande Polonaise."
1844	Dumas père, *Les Trois Mousquetaires*.
1849	Chopin dies in Paris, his residence in exile from Poland since 1831.
1856	Flaubert, *Madame Bovary*.
1857	Baudelaire, *Fleurs du mal*.
1859	Gounod, *Faust*; Baudelaire's *Salon de 1859* centers on imagination, "queen of the faculties."
1861	Wagner's *Tannhauser* (1847) performed in Paris.
1862	Hugo, *Les Misérables*; Garnier begins to construct the new Paris Opéra.

Contributors

Nina Athanassoglou-Kallmyer (Professor of Art History, University of Delaware) is the author of *French Images from the Greek War of Independence, 1821–30. Art and Politics under the Restoration* (Yale UP, 1989) and *Eugène Delacroix: Prints, Politics, and Satire 1814–1833* (Yale UP, 1991). Her articles on art, politics, and culture during the French Restoration have appeared in *Art Bulletin, Arts Magazine,* and other journals.

Petra ten-Doesschate Chu (Professor of Art History and Chair of the Department of Art and Music at Seton Hall University) is the author of *French Realism and the Dutch Masters* (Utrecht: Haentjens, Dekker & Gumbert, 1974), *The Letters of Gustave Courbet* (U of Chicago P, 1992; Paris: Flammarion, 1996), and numerous publications on French artistic practice. She is completing a text on European art and visual culture 1750–1900 (Abrams/Prentice-Hall, forthcoming).

Darcy Grimaldo Grigsby (Assistant Professor of the History of Art at the University of California at Berkeley) is the author of "Rumor, Contagion, and Colonization in Gros's *Plague-Stricken of Jaffa* (1804)," *Representations* (Summer 1995); "*Nudité à la Grecque* in 1799," *Art Bulletin* (June 1998); and "*Whose colour was not black nor white nor grey,/But an extraneous mixture which no pen/Can trace, although perhaps the pencil may*": Aspasie and Delacroix's *Massacres of Chios," Art History* (December 1999). She is completing a book entitled *Extremities in Paint: Representing Empire in Post-Revolutionary France (1789–1830)*.

Michèle Hannoosh (Professor of French at Saint Catharine's College, Cambridge University) is the author of *Parody and Decadence: Laforgue's "Moralités légendaires"* (Ohio State UP, 1989), *Baudelaire and Caricature. From the Comic to an Art of Modernity* (Penn State UP, 1992), and *Painting and the 'Journal' of Eugène Delacroix* (Princeton UP, 1995). Her new edition of Delacroix's *Journal* based on recently discovered primary material is forthcoming in 3 vols. (Paris: Macula).

Paul Joannides (Fellow of Clare Hall and Lecturer in the History of Art at Cambridge University) has published numerous articles on the influence of Byron and Scott on French Romantic painting in *Burlington Magazine, Art History, Bulletin de la Société de l'Histoire de l'Art français,* and elsewhere. He is the author of *The Drawings of Raphael* (Oxford: Phaidon Press, 1983) and *Michelangelo and His Influence. Drawings from Windsor Castle* (Washington: National Gallery of Art; London: Lund Humphries, 1996).

Dorothy Johnson (Professor of Art History at the University of Iowa and Director of the School of Art and Art History) is the author of *Jacques-Louis David: Art in Metamorphosis* (Princeton UP, 1993) and *Jacques-Louis David: The Farewell of Telemachus and Eucharis* (Getty, 1997). Her articles on eighteenth- and nineteenth-century art have appeared in *Art Bulletin, Art History, Gazette des Beaux-Arts,* and *Eighteenth-Century Studies.* She is engaged in a book-length study entitled *Romantic Hellenism in French Art 1780–1840.*

James H. Rubin (Professor of Art History and Chair of the Art Department at the State University of New York at Stony Brook) is the author of *Realism and Social Vision in Courbet and Proudhon* (Princeton UP, 1981), *Manet's Silence and the Poetics of Bouquets* (Harvard UP and London: Reaktion Books, 1994), *Courbet* (London: Phaidon, 1997), and *Impressionism* (London: Phaidon, 1999). His publications on Delacroix and Romanticism include *Eugène Delacroix, die 'Dantebarke': Idealismus und Modernität* (Frankfurt: Fischer Verlag Kunststück, 1987).

David Scott (Professor of French [Textual and Visual Studies] at Trinity College, Dublin) is the author of *Pictorialist Poetics: poetry & the visual arts in 19th-century France* (Cambridge UP, 1988); *Paul Delvaux: Surrealizing the Nude* (London: Reaktion Books, 1992); *European Stamp Design: A Semiotic Approach* (London: Academy Editions, 1995); and, with Benoît Heilbrunn, *Figures de l'affiche* (Paris: Editions Somogy, 1998).

Alan B. Spitzer (Professor Emeritus of History at the University of Iowa) is the author of *Old Hatreds and Young Hopes. The French Carbonari against the Bourbon Restoration* (Cambridge UP, 1971) and *The French Generation of 1820* (Princeton UP, 1987). Recent work on the relationship between politics and the arts includes "La république souterraine" in *Le siècle de l'avènement républicain*, ed. François Furet and Mona Ozouf (Paris: Gallimard, 1993).

Beth S. Wright (Professor of Art History at the University of Texas at Arlington) is the author of *Painting and History during the French Restoration: Abandoned by the Past* (Cambridge UP, 1997). Her articles on art and its relationship to history and literature in nineteenth-century France have appeared in *Art Bulletin, Arts Magazine, Word & Image, Oxford Art Journal, Bulletin de la Société de l'Histoire de l'Art français,* and other journals.

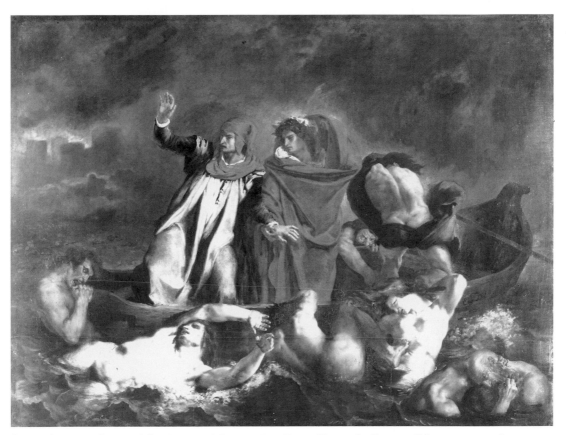

Plate 1. Delacroix, *The Barque of Dante*, 1822. Paris, Musée du Louvre. Oil on canvas, 189 × 246 cm. © Photo RMN (Service de la Réunion des Musées Nationaux, Paris).

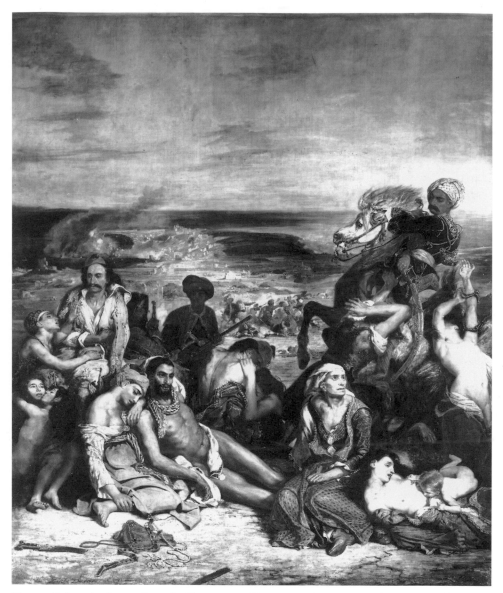

Plate 2. Delacroix, *Scenes from the Massacres at Chios,* 1824. Paris, Musée du Louvre. Oil on canvas, 4.19 × 3.54 m. © Photo RMN (Service de la Réunion des Musées Nationaux, Paris).

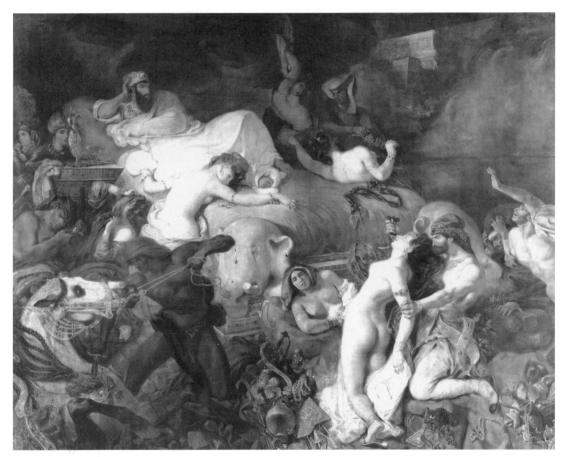

Plate 3. Delacroix, *The Death of Sardanapalus,* 1827. Paris, Musée du Louvre. Oil on canvas, 3.92 ×
4.96 m. © Photo RMN (Service de la Réunion des Musées Nationaux, Paris).

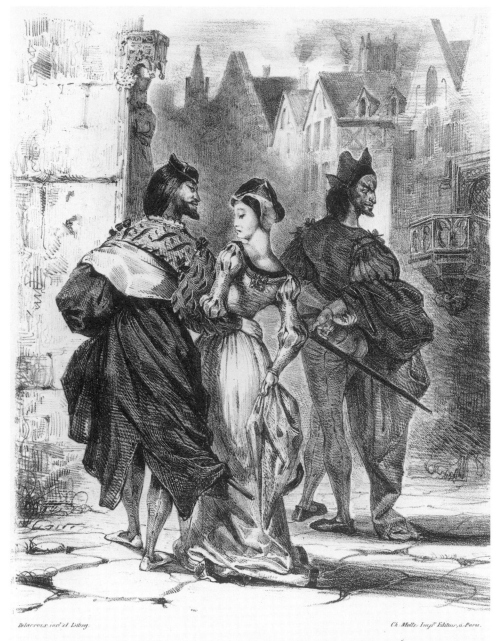

Delacroix inv. et Lithog.

Ch. Motte Imp.r Editeur, à Paris.

Faust — Ma belle Demoiselle, oserais-je vous offrir mon bras et vous reconduire chez vous?..

Plate 4. Delacroix, "Marguerite and Mephistopheles in the Street," Goethe's *Faust* series no. 9, 1827. Cambridge, MA, Harvard University, Dept. of Printing and Graphic Arts, The Houghton Library. Lithograph, 30.2 × 23.1 cm.

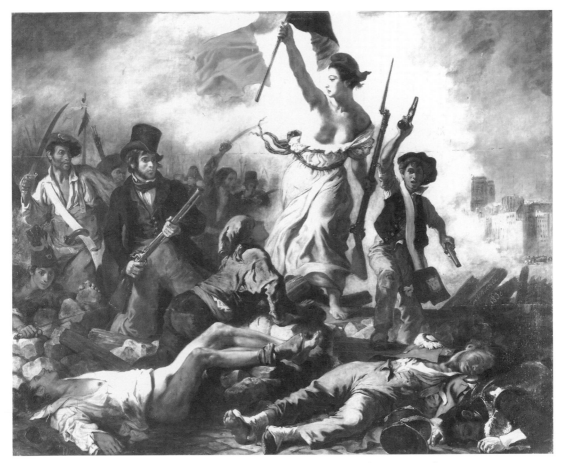

Plate 5. Delacroix, *Liberty Leading the People,* 1830. Paris, Musée du Louvre. Oil on canvas, 260 ×
325 cm. (Photo Giraudon/Art Resource, NY).

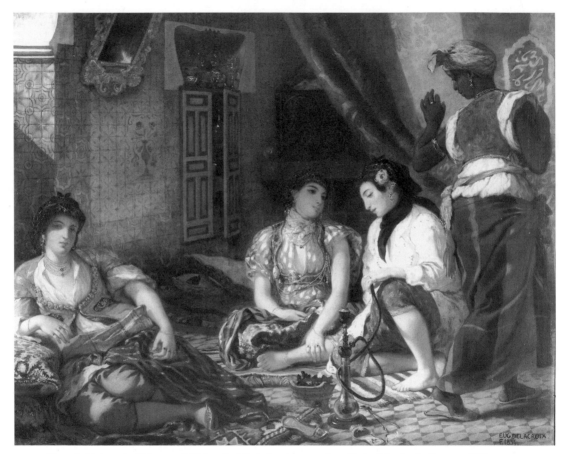

Plate 6. Delacroix, *Women of Algiers in Their Apartment,* 1834. Paris, Musée du Louvre. Oil on canvas, 1.80 × 2.29 m. © Photo RMN (Service de la Réunion des Musées Nationaux, Paris).

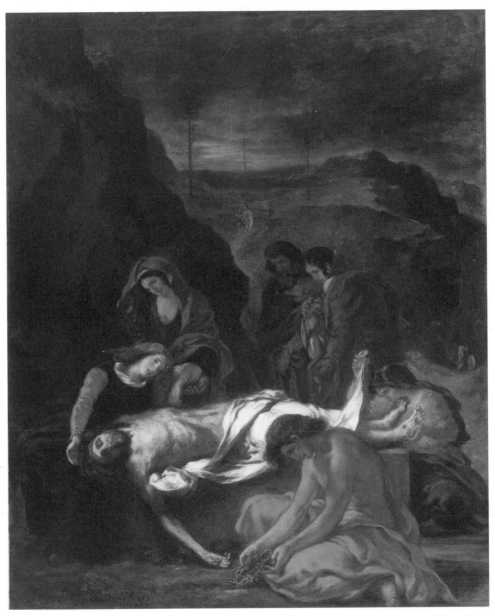

Plate 7. Delacroix, *Lamentation (The Entombment of Christ)*, 1847–8. Boston, Museum of Fine Arts. Oil on canvas, 162.6 × 132.1 cm. (64 × 52 in.). Gift by Contribution in Memory of Martin Brimmer.

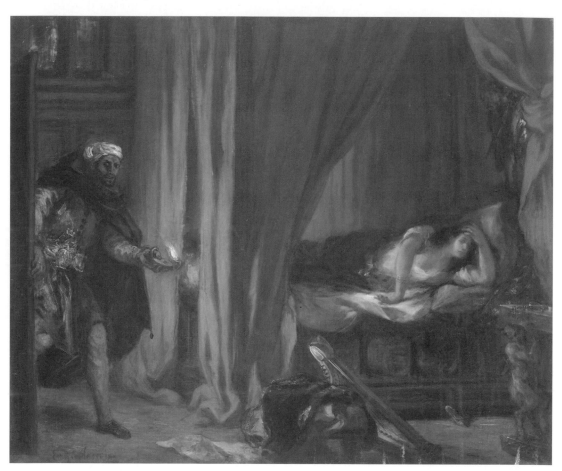

Plate 8. Delacroix, *Othello and Desdemona*, c. 1847–9. Ottawa, National Gallery of Canada. Oil on canvas, 50.3 × 60.7 cm.

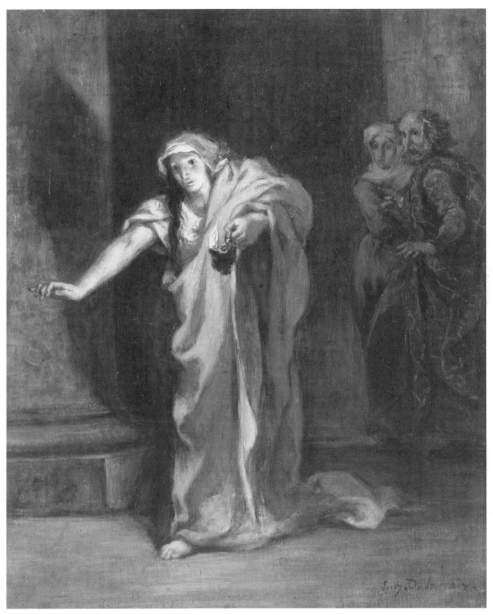

Plate 9. Delacroix, *Lady Macbeth Sleepwalking*, 1850. Fredericton, N.B., Canada; The Beaverbrook Art Gallery. Oil on canvas, 40.8 × 32.5 cm. Gift of Mr. and Mrs. John Flemer.

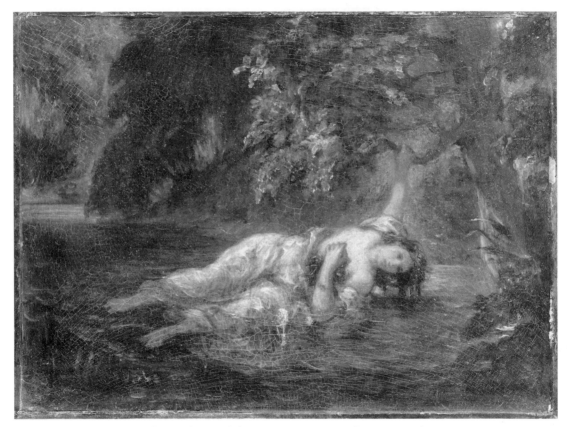

Plate 10. Delacroix, *The Death of Ophelia,* 1853. Paris, Musée du Louvre. Oil on canvas, 23 × 30.5 cm. © Photo RMN (Service de la Réunion des Musées Nationaux, Paris).

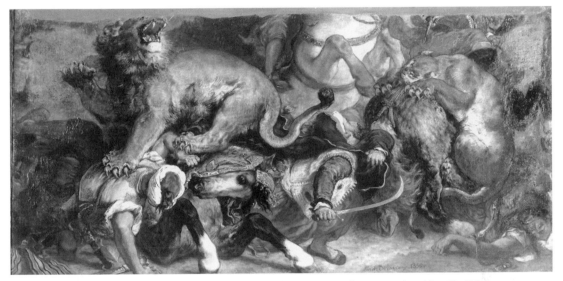

Plate 11. Delacroix, *The Lion Hunt,* 1854–5. Bordeaux, Musée des Beaux-Arts (detail). Oil on canvas, 175 × 359 cm. (originally 270 × 359 cm.). Cliché du M. B. A. de Bordeaux/photographe Lysiane Gauthier.

1 Painting Thoughts

An Introduction to Delacroix

Beth S. Wright

Ferdinand-Victor-Eugène Delacroix (1798–1863) could have included himself with Caesar, Napoleon, and Michelangelo when he wrote, "The greatest men have done something of everything when they wanted to."[1] He created passionate canvases, evocative lithographs, scabrous caricatures, philosophically enlightening murals. His stylistic range encompassed bravura and nuance, transparent glazes and densely wrought impasto. How are we to understand Delacroix's protean achievement, multifarious in genre, subject, media, and technique?

One key is his lifelong insistence that he was painting not objects but thoughts.[2] He wrote in his *Journal* in 1857, "[M]aterially speaking, painting is nothing but a bridge set up between the mind of the artist and that of the beholder."[3] Figures and objects were eloquent "hieroglyphs"; they were at once representations of concrete aspects that anyone could see and reflections of emotions, the painter's imaginative realizations.

Because Delacroix was inspired by a wide range of subjects and texts, because he insisted that "form is inseparable from conception" in painting and in poetry, it was only to be expected that he would consult varied visual sources and adjust his use of media.[4] In his opinion, a uniform style could easily become a manner. Completely opposed to this was the variance of a great artist like Titian; this was not vacillation but true taste, a "lucidity of mind" expressed as flexibly as possible, since it served as the "vital expression of thought."[5]

It should not surprise us, therefore, that Delacroix described himself as both "entirely classical" and "Romantic since my adolescence," as James Rubin points out.[6] His entire career (detailed in a biographical chronology set into its political and cultural context) was one of public honors and public rejections, for both aesthetic and political reasons. When he made his debut in the Salon of 1822 with *The Barque of Dante*, Thiers (historian, journalist, and later politician) hailed his genius. During the July Monarchy, as Louis-Philippe's ministre du commerce et travaux publics, Thiers would help Delacroix gain state commissions for murals in such significant Parisian sites as the Salon du Roi and the

libraries of the Chamber of Deputies at the Palais Bourbon (1838–47) and the Chamber of Peers at the Palais du Luxembourg (1840–6). Yet *The 28th July. Liberty Leading the People,* acquired by the government from the Salon of 1831, was soon taken down from the walls of the Musée du Luxembourg, and returned to the artist in 1839. In 1849, after the revolution, it returned to the government's art administration, but once again was taken down a few years later, and finally entered the Louvre under the Third Republic. In 1859, four years after he had been given the honor of a retrospective exhibition at the Exposition Universelle and two years after his election to the Institut (on his eighth attempt), his work was given such scathing reviews that he resolved never again to exhibit work in a Salon.

Delacroix was a particularly astute assessor of art journalism, for he himself was one of his century's most insightful and articulate commentators on art, whether his own or that of his colleagues in the present day or past centuries. His *Journal* is unparalleled in its insights, erudition, wit, and information about the cultural activity of his era. Leading periodicals published his articles on art and artists. He also wrote fiction (*Alfred* and *Les Dangers de la Cour*), drama (*Victoria*), and poetry.[7] This literary accomplishment is, in part, testament to his having taken his friend Stendhal's advice: "Neglect nothing that can make you great." In his youth, that had meant seeking information, even consulting a tutor so he could read Marcus Aurelius in Greek. In his maturity, he repudiated such "pedantic satisfactions," seeking wisdom.[8] Education (the cultivation of spirit as well as mind) should be lifelong, he wrote in 1853; it resulted, in part, from conversations and emotions experienced in the company of others.[9]

Delacroix's unerring recognition of genius led him to cultivate an acquaintance, if not a friendship, with virtually everyone of aesthetic and intellectual importance: Géricault, Stendhal, Baudelaire, George Sand. He could discuss flowers with the scientist Jussieu and philosophy with Victor Cousin, and ran with the sculptor Barye to see the dissection of a lion who had died in the Jardin des Plantes. He adored the music of Rossini, Mozart, and his friend Chopin.[10] In literature, an early friendship with Romantics (Hugo, Dumas, Mérimée) and admiration for moderns (Walter Scott, Thackeray, Pushkin) was balanced by a classical foundation from his days at the Lycée Louis-le-Grand that inspired a love of Racine and Homer.

His works challenged pictorial standards of compositional legibility because they were subjectively derived insights rather than embodiments of action. To provoke the spectator's recognition of his evocation of meaning, Delacroix dispersed compositional interest throughout the entire canvas rather than concentrating it in the center, sought coloristic brilliance through broken tones, and revealed formal energy by sculpting contours as they moved through space. These innovations often puzzled or infuriated his audience.

The art critics who championed Delacroix were often poets: Heinrich Heine, Théophile Gautier, Charles Baudelaire. This was not a matter of coincidence. As

David Scott demonstrates, these poets recognized the principle of expressive correspondences at work in his art; they could easily accept an art based on sensation rather than representational figuration, and their reviews were often prose poems, evoking rather than describing the images they reviewed. Baudelaire centered his review of the Salon of 1846 on Delacroix as the exemplar of Romanticism, which he defined as "intimacy, spirituality, color."[11] But the critics who admired Delacroix's union of form and content were reluctant to acknowledge its literary allegiance lest they tether it to a burden of illustration. They severed his paintings from the texts that had inspired them, so they could be differentiated from so-called literary paintings which repeated, re-presented the visual aspects of a text. These critics suppressed analysis of Delacroix's thematic conception and textual interpretation, stressing his ability to evoke emotions through pictorial elements without intermediaries such as recognizable objects or subject matter.

In expressing such support, they gained him a Pyrrhic victory. Delacroix, insisting that form and content were inseparable, was fully aware of the difficulty of creating art works which could succeed in the grand tradition of *ut pictura poesis*, while interpreting modern literary sources which were characterized by a subjectively driven narrative and detailed descriptions of local color. He succeeded magnificently; his creations were both completely successful expressions of the textual meaning and wholly self-sufficient. Goethe himself was overwhelmed by Delacroix's lithographs to *Faust,* admitting that the artist had surpassed the author, forcing him to discover new meanings in his own work.[12] When critics praised his visual works without acknowledging their intellectual merit, they misrepresented them to the very audience they hoped to engage.

Paradoxically, it was Delacroix's literary insight and agency that enabled him to create self-sufficient visual works inspired by literature. A fellow author, he was an extraordinarily sensitive reader who described reading as an active collaboration between author and audience.[13] His approach set him apart from his colleagues who were illustrating actions extracted from the same literary texts, for he was fascinated with the verbal aspects of a novel which would not be immediately obvious in a visual rendition: narrative structure, which the reader would construct through associative links between episodes, character development, temporal shifts.[14] Delacroix's consummate comprehension of literature involved far more than a knowledge of an encyclopedic array of literary themes. In "painting thoughts" he achieved a seamless interdisciplinarity, even transposing verbal and visual activity, as when he respectfully described the "masculine prose" of David's gesturally lucid *Leonidas at Thermopylae*.[15] Baudelaire acknowledged this when he wrote that Delacroix's approach to painting was so informed by his knowledge of the text that he "wrote the canvas."[16]

This aspect of his genius also placed him in a particularly vulnerable position. As he pointed out when he began drafting a dictionary of art (the day after he was voted into the Institut), an essential requirement for the creation of

great works of art is an enlightened audience.[17] In ancient Greece and Rome, breadth of culture made it possible for spectators to be, successively, lawyers, soldiers, scholars, senators. But now, he commented mordantly, spectators only receive a narrow technical training, enough for a cavalry officer to be able to comment on the horseflesh in an equestrian portrait. "I should like to contribute toward the teaching of a better way to read great books."[18] An audience trained to vocations rather than educated in mind and spirit would not be able to follow an artist whom Meier-Graefe deemed "the last great painter who was a man of profound culture."[19]

His art inspired every generation. Manet asked for permission to copy the *Barque of Dante,* the only contemporary work he ever copied. Cézanne not only copied and quoted Delacroix's works but portrayed him and planned to paint his apotheosis. Van Gogh described Delacroix's "portraits of the soul" as essential for his own stylistic formation, as Petra ten-Doesschate Chu points out, and Signac linked Neo-Impressionism's coloristic innovations to Delacroix's initiatives. Picasso began a series of fifteen variations on *Women of Algiers* in 1954. Why does the comment that Delacroix's name was "illustrious, but not well known" still ring true today, even after the bicentenary exhibitions and publications?[20]

One reason is that comprehending his visual achievement requires unifying technique with text and thought. Delacroix's association of word and image was exceptionally fluid, and evocative rather than illustrative, and this in an age in which photography and illustrated texts were becoming dominant influences on the Salon audience. He insisted that execution, touch, was not simple dexterity, but indispensable to conveying thought. And thoughts, and the texts inspiring them, were the result of both profoundly classical culture and an eager exploration of modern psychic address in literature and the visual arts. A second reason is our need to integrate all of his activities across his entire career, instead of oversimplifying him conceptually and chronologically. Until recently Delacroix's avowed classicism was slighted apart from his mural decorations, his Romanticism was considered a threat to the grand tradition rather than a renovation of it, his passionate fascination with color and pictorial address was discussed (taking Baudelaire's cue) as pure emotive expression, severed from thought and from theme. Although his life spanned France's Empire, Restoration, July Monarchy, Second Republic, and Second Empire, discussion of his work was often partitioned to one regime, most frequently the Restoration.[21] Thus, although his political sympathies with Carbonarists and Bonapartists were studied for the Restoration ("the life of Napoleon is the epic theme of our century for all the arts" he wrote in 1824), little attention was given to the sequel of this tie to Bonapartist circles. After Napoleon III's coup d'état in December 1851, Delacroix was made a member of the Municipal Council of Paris, where he served for ten years, during Haussmann's program of public works.[22] Similarly, modern scholarship tended to concentrate on Delacroix the challenger, controversial by nature of his political themes, his technical innovations, and his pas-

sionate exploration of a wider aesthetic range. His many attempts to be admitted into the Academy before he was successful in 1857 were often recalled. Less was heard of his efforts to support and renovate art institutions: his draft of a dictionary of fine arts or his articles for *Revue des deux-mondes, Revue de Paris,* or the *Moniteur universel* on Raphael, Poussin, and "The Beautiful" as well as Michelangelo, Gros, and Charlet.

Scholarly efforts to reverse the misconception of Delacroix as an artist who groped toward greatness began immediately after his death, when preparatory drawings and oil sketches sold for higher prices than anticipated, making it a matter of urgency to document the dimensions of his oeuvre. His friends (Piron) and contemporaries (Moreau, Robaut) hastened to provide biographies and descriptions of the extent of his pictorial and graphic activity. That documentation is still a vital part of scholarship at the end of the twentieth century, both of Delacroix's visual creations and of his verbal expression. Lee Johnson's eminence in the field has been crowned by a six-volume catalogue raisonné of Delacroix's pictorial works, which is now the definitive source; hence references in essay notes begin with their Johnson number.

Efforts are still being made to redress the inaccuracies that entered into the first edition of Delacroix's *Journal*. Its precious testimony is only available for the years 1822 to 1824, a travel diary of his trip to Morocco in 1832, and 1847 to 1863. Delacroix sent the diaries for safekeeping to his friend, the painter Dutilleux, whose son-in-law Alfred Robaut copied them by hand (sometimes inaccurately). The Robaut copy, the source for the first published version of the *Journal* (1893), excluded material of great interest to modern scholars, such as Delacroix's extracts from other published writers.[23] André Joubin corrected many errors and added newly recovered material when he published his edition in 1931–2; it has remained the basis for a revised edition (1981) and for the English selections, translated by Pach and Norton. Michèle Hannoosh is now completing a new edition that incorporates much new material from recently discovered archives and corrects many textual errors. Because of these variations in material as well as wording, references in these essays all include the original date of Delacroix's entry. Editions of his publications on art and aesthetics, his notes for a dictionary of fine arts, his correspondence, and his short story and novelette are listed in the selected bibliography, along with suggestions for further reading on essential aspects of Delacroix's art and French culture.

The essays, arranged in a roughly chronological sequence, intersect to form a three-dimensional portrait of the artist. Instead of singling out a chronological period, they establish a consistent point of view or direction. After Delacroix's life is considered in the context of his generation's experience, his Romanticism is discussed, particularly during the early part of his career under the impact of "Gothic" melodramas and his trip to Morocco in 1832. Then lifelong concerns are studied: his pictorial practice, his relationship to the classical tradition, his transformation of literature into art, and Delacroix's own writing about art, in

his *Journal* and his journalism. The concluding essay leads us from the artist to his assessment by art critics during his lifetime and his legacy for poetry as well as art.

Every aspect under discussion, whether biographical, technical, aesthetic, or conceptual, takes on richer meaning by intersecting with points raised in the other essays. For example, Alan Spitzer describes Delacroix as a member of the Empire generation: his political allegiances, patronage, and friendships. Michèle Hannoosh points out that in 1853 Archille Fould, minister of state for the Second Empire, solicited Delacroix's writing on aesthetics for the *Moniteur Universel* (this became his essay on Poussin), and supported his candidacy for Institut. Politics influenced one of his formative experiences: the visit to Morocco in 1832, which Darcy Grimaldo Grigsby describes and sets into multiple contexts: biographical, aesthetic, colonialist. Petra ten-Doesschate Chu, in her essay on Delacroix's technical practice and its rationale, points out the radical political associations of colorism, perceived by Saint-Simonian and Fourierist art critics and evident in Bertall's cartoon (Fig. 29), where Delacroix is deemed the "Proudhon of color." Rubin relates Romanticism to subversion, a viewpoint also taken by Grigsby, who draws a connection between homosocial and colonialist tensions. Nina Athanassoglou-Kallmyer links Romanticism to anticlericalism as well as antiacademicism. Her discovery of Delacroix's two essays for Pétrus Borel's periodical *La Liberté* in 1832–3 (see Appendix) allows us to see how Delacroix's determination to establish "liberty and equality in the arts" was more than an expression of his frustration at being excluded from Salon exhibitions.[24] Politics and aesthetics continually reverberated in Delacroix's life.

Yet the same man who denounced an academic jury's conservativism as intellectual constriction admired true classicism: great masters of the Renaissance and Baroque eras. Delacroix's homage to Rubens and Poussin is stressed by many essayists, and the influence of Raphael and Rembrandt also signaled. Both Rubin and Dorothy Johnson survey Delacroix's entire career, starting from the *Barque of Dante,* for that debut work proclaimed its dual allegiance. Delacroix constantly adapted his visual style to the literary text inspiring him, which could range from the monumental (Dante) to the poignant (Shakespeare) to the shocking (modern "Gothic" British novels by Lewis or French melodramas). Paul Joannides maps this extensive and complex field. Beyond this, he reveals how Delacroix's sensitivity to literary style as well as subject had an impact on works that could have been assessed as reportage, as when his paintings and lithographs of subjects from Byron's poetry affected descriptions of modern events from the Greek wars of independence. Both Joannides and Athanassoglou-Kallmyer demonstrate Delacroix's awareness of popular literature's commercial impact on a mass audience through graphic works. Athanassoglou-Kallmyer compares Delacroix's Romanticism to horror novels and melodramas earlier in the nineteenth century that rejected an eternal, universal classical tradition and combated official art institutions. The impact of book

illustration and operatic and theatrical spectacle influenced Delacroix's art during his entire career, for both expressive and commercial reasons, influencing not only his scenes from Mathurin but from Shakespeare.

This collection of essays serves as a companion to Delacroix by illuminating his life, his culture, his craft, his philosophy of art, and his triumphant achievement in transforming literary texts and intellectual truths into potent images, great paintings of his thoughts.

2 Delacroix in His Generation

Alan B. Spitzer

The emergence of an idea is always the emergence of a generation.
> Théophile Thoré. "Artistes contemporains. M. Eugène
> Delacroix." *Le Siècle,* 25 February 1837

But he [Delacroix] is above all the man of our time full of moral anxiety, betrayed hopes, suffering, sarcasm, anger, and tears.
> Théophile Silvestre. *Histoire des artistes vivants* (1856)

There are times when what demographers call a cohort, and historians, who are less austere, alternately cohort or generation, can be distinguished from its predecessors and successors by shared attitudes and historically significant behavior. This distinct identity has often been associated with the life stage of youth when a cohort is separated from its elders by something like a "generation gap." This was the case with the generation into which Eugène Delacroix was born in 1798.[1] Whether the stamp of early experience continued to distinguish Delacroix and his coevals from other cohorts as they matured is a more complex question, but as they aged together into the nineteenth century they continued to experience the same historical circumstances at the same life stage.

Although Delacroix's life was deeply implicated in his generation's collective experience, this is not to say that what mattered most about it, that is his art, can be reduced to an age-related phenomenon. As Walter Pach, a translator of Delacroix's *Journal,* observed, "had he [Delacroix] been merely a man of his time, his importance would be no more than historical, and would long since have declined beyond recovery."[2]

In 1826 Paul Dubois, editor of the *Globe,* organ of the young liberal intelligentsia, coupled Victor Hugo with Delacroix in a prescient evaluation of talents that would transcend the confines of their cohort. In a review of Hugo's *Odes and Ballads,* Dubois wrote,

> In rereading these verses, one dreams and is moved in the reading, while those cold versifiers, proud of their vulgar elegance, cannot even elicit a momentary pause before their pallid tableaux. Monsieur Hugo is in poetry

what Monsieur Delacroix is in painting; there is always a great idea, a pro-
found sentiment, beneath their harsh infelicities; and I must admit, I like
this youthful, abrasive vigor.[3]

This youthful vigor was channeled into a uniquely creative and powerful
response to circumstances shared by what, following historical precedent, I have
called the generation of 1820, bounded by the birth dates 1792 to 1803. Although
these, as all such boundaries, are arbitrary approximations, they are historically
plausible. Salient attributes of those who came of age between 1814 and 1825
distinguished them from their younger siblings who flamboyantly expressed
their alienation in the early 1830s, and from their elders already embarked on
the careers afforded by Napoleon's military imperium. Although this cohort has
been characterized as the first postrevolutionary generation, its collective
trauma was not the revolution but the collapse of the Empire. This was the
trauma of that "pale, ardent, and neurotic generation" evoked in Alfred de Mus-
set's *The Confession of a Child of the Century,* an "anxious youth" conceived
between battles and awakened from the dreams of the snows of Moscow and
the sun of the pyramids by the sound of church bells, its horizon illuminated
not by the brilliant sun of Austerlitz but by the pale reflection of the lilies.[4]

The fall of the Empire was certainly traumatic for the Delacroix family.
Eugène's father, who died in 1805, had been a Napoleonic prefect; one of his
brothers was killed in battle; another, an ex-general retired on half pay. The
young Delacroix entered the era of the Bourbon Restoration under the care of
an elder sister in a grim family environment of straitened circumstance.

I have situated Delacroix's generation with reference to historical circum-
stance, but its distinct identity should be understood as a symbiosis of circum-
stance and self-invention. That is why a male, educated, predominantly upper-
class minority was recognized and remembered as constituting the generation.
Their sisters, and their uneducated coevals (who comprised the majority of the
cohort), were excluded from the groups through which young men expressed
their solidarity, realized their career aspirations, and forced themselves on the
attention of their contemporaries. A few promising boys were culled out from
poor families to be inserted in the educational meritocracy; young women were
not even afforded that opportunity: None appeared on the boards of influential
journals dominated by editors in their late twenties and early thirties, and none
experienced the subversive fellowship of legal, or clandestine, political move-
ments. A few did establish public personae through the narrow opening of liter-
ature, and of the literary prize competition, because the ubiquitous principle of
the *concours,* in and out of the academy, constituted an important avenue of
public recognition and collective self-regard.

Membership in the various groups through which an educated *jeunesse*
established its public identity constituted a nexus of personal relationships that
social scientists call "a social network." This network was first woven at school,
notably in the four Paris lycées that, at the end of the Empire and beginning of
the Restoration, constituted the cradle of the meritocracy. Delacroix was worked

into that dense network when he matriculated in the Lycée impérial, retitled the royal Collège Louis-le-Grand when the monarchy was restored. There his name appears at ages 9 and 10 on the list of *palmarès* (prizewinners) for 1807 and 1808. The 1807 list includes the name of Théodore Géricault, then age 16, and probably not even aware of Delacroix, because at those ages a gap of seven years separates two universes. Delacroix's school years overlapped with those of Victor Hugo and his brothers, with Godefroy Cavaignac and future paladins of republicanism, with the generation's precocious poetic star Casimir Delavigne, and with other nascent luminaries.[5]

Delacroix left the lycée in 1815 to enter the atelier of Guérin, where he met Ary Scheffer and his brothers. The brothers Scheffer were tightly enmeshed in a network of political activists who constituted the junior branch of the aborted conspiracy of the *charbonnerie,* the French version of the Italian Carbonari.[6] They were also connected with the Saint-Simonian circle, the young liberals at the *Globe,* the coterie around the brilliant young philosopher Victor Cousin, and the participants in the salons of Lafayette and Etienne Delécluze frequented by the young.

The elements of these overlapping circles were scarcely homogeneous, but they shared certain assumptions, a way of looking at the world, and a reading of the past. What underlay that rather inchoate but discernible worldview was the conviction that the previous generation, which had carried out the indispensable task of clearing the ground of obsolete institutions and antique prejudices, had been unable to replace them with what the young Saint-Simonians would call a "New General Doctrine." The sense that the elders were inadequate to a world which they themselves had made was reinforced by the observation of the political flexibility of parents and teachers who practically and symbolically switched from tricolor to Bourbon-white cockade virtually overnight.

Although Delacroix and his coevals never erased the neoclassical stamp of their education, they repudiated its sterile application to the arts and despised a narrow nationalism that pictured Shakespeare as an aide-de-camp to the Duke of Wellington and celebrated Corneille and Racine in order to sneer at Goethe.[7] Delacroix's openness to the currents of foreign culture, to the works of Shakespeare, Byron, and Goethe, as well as to the great art of other nations, was to be realized in the visual representation of his generation's cultural cosmopolitanism.

The young intellectuals distanced themselves from the meretricious cleverness of the remnants of that pseudo-Voltaireian elite that still dominated the cultural commanding heights, replacing shallow wit and affected cynicism with moral *gravitas.* They were, according to Victor Hugo, then in his ultraroyalist phase, "a sweet and serious generation," committed, in the words of the liberal *Globe,* to "*méditation sérieuse.*"[8]

We find a certain amount of that in Delacroix's intense letters to his dear friends. To Felix Guillemardet he writes, "We live in stormy times where a thunderbolt has struck, and as we cross this tempestuous passage of our lives a constant philosophy provides a permanent rampart."[9] Like the grave young Saint-

Simonians and contributors to the *Globe,* he had some difficulty assimilating the sardonic wit of Stendhal and spent his life trying to come terms with Voltaire.[10]

Delacroix also attended the lectures of Victor Cousin,[11] the great athlete of the scholarly meritocracy and the incarnation of the higher seriousness. Cousin, who lectured on philosophy at the Sorbonne at age 23 to a large audience, established a cult similar to Henri Bergson's before the First World War. Years later (1855) Delacroix would recall, "When I left college, I too wanted to know everything; I went to lectures; I thought I was becoming a philosopher with Cousin, another poet who was forcing himself to be a learned man."[12]

Not that Delacroix's temperament was completely aligned with the acolytes of Victor Cousin, or the infinitely serious editors of the *Globe* whom Stendhal labeled the Roundheads of the literary civil wars. Delacroix's preoccupation (to put it mildly) with sex, or what he called *l'amour,* which scarcely distinguished him from young males of any generation, did distinguish him, he thought, from "the types uninterested in the question of *amour,* that is to say, the editors of the *Globe,* the fops who change women like garments, the studious types, mineralogists, lepidopterists, *Saint-Simonistes,* and others who understand nothing about it."[13]

However, from time to time Delacroix did lace his creative, and sexual, intensity with a melancholy streak, consonant with that notorious *mal du siècle,* entailing expressions of cosmic despair, inexplicable melancholia, *tedium vitae* scattered through Delacroix's journal and in letters to friends: "Try as one will, one always sees within oneself, an abyss that is never filled. One is always longing for something that never comes. There is always a sense of emptiness, never an abundance, a full draught of happiness."[14]

Still, the letters of Delacroix taken altogether certainly modify the image of an entire generation in the grip of a grand malaise. And here he is representative of his cohort, if on a titanic scale. As Milner, Barbéris, and other scholars have remarked, the French romantics convey a powerful impression of vitality, pugnacity, and creative power that their genuine misfortunes and pessimistic affectations could never repress.[15]

That dynamism was frustrated, or partially blocked, by the niggling, inconsistent, and intermittently paranoid policies of a regime that no longer enforced Napoleon's iron grip on the schools, the professions, journalism, and the theater, but perceived a youthful exuberance as a threat it could never completely contain.

Despite his phenomenal precocious success in the salons of 1822 and 1824, and the receipt of state commissions, Delacroix, like his coevals, reacted to the regime's inconsistent efforts to rein in unruly talents. After his submission of the *Death of Sardanapalus* to the 1827 salon, he was summoned by the director of fine arts to be told, "if I wanted to share in the government's largesse I would ultimately have to change my style." The consequences of this unacceptable caveat, Delacroix recalled, were, "no more pictures bought, no more commissions for more than five years, a revolution like that of 1830 was needed to pave the ways for other ideas."[16]

Before his breakthrough in the Salon of 1822, Delacroix would enlist his talent in the opposition to the Bourbon regime. His sixteen political cartoons (1814–22) caricaturing the British, the émigré nobility, and the Church more or less obliquely expressed his political views, plausibly characterized by Nina Athanassoglou-Kallmyer, as Liberal-Bonapartist.[17] Delacroix is usually reckoned a Bonapartist *tout court* in the light of his family antecedents and the oft-quoted entry in his *Journal* for 1824: "The life of Napoleon is the epic of our century for all the arts,"[18] but in the particular circumstances of the Restoration era, Liberal-Bonapartist is no more an oxymoron than is Republican-Bonapartist, or what Robert Alexander has called Revolutionary-Bonapartism.[19]

When public support for any of the alternatives to the monarchy was prosecuted as a crime, latent political differences could be obscured in an inchoate opposition coalition that assimilated the nostalgia for imperial glories to the promise of a libertarian future. "I was a Bonapartist and at the same time I was a republican," the artisan-author Agricol Perdiguier recalled. "I confounded Napoleon with liberty and all of my companions accepted the same logic." One of the veterans of the republican faction in the conspiracies of early 1820s remembered, "The flag covered everything and that flag was the tricolor, which suited the amalgam of the various parties, united at least in a common hatred for the kings of the Holy Alliance."[20]

And that flag, of course, is the banner that floats over *Liberty Leading the People,* Delacroix's apotheosis of the Revolution of 1830, which was, in a way, the apotheosis of his generation. That is the way it is seen by René Huyghe:

> From time to time a work of art contrives to bring together and express all the ideas that mean most to the spirit of a particular time and give it its meaning. This is certainly the case with Delacroix's *Liberty Leading the People,* in which the clamour of a generation on the march becomes a joyous and unanimous hymn.[21]

"Unanimity" characterized the Revolution of 1830 as conceived by Delacroix's exact coeval, Jules Michelet: "After the victory, one looked for heroes and found an entire people . . . the sudden display of the tri-color flag by the whole of France represented the unanimity of several million men."[22]

When, however, the search for unanimity is focused on the lists of killed and wounded on the revolutionary side of the barricade, it does not reveal an "entire people," but the worker-artisans who comprised, mutatis mutandis, the Paris insurrectionary crowds from 1789 to 1871. It is difficult to find that figure in the top hat, or the student from the Ecole polytechnique, or even the pistol-packing gamin, forerunner of Hugo's Gavroche, on the lists of those who actually did the fighting.[23] Even so, the painting was soon perceived as a disproportionate celebration of the unwashed masses by those who would reap the political fruits of the "three glorious days" of July. After attracting crowds of viewers at the Salon of 1831 it was purchased by the government and put in cold storage along with other overenthusiastic portrayals of the revolution.

Delacroix described his great painting as an allegorical picture of the July events,[24] but precisely how to read that allegory scarcely attained a consensus, then or ever since.[25] A standard interpretation has always found the evocation of the revolutionary tradition of 1789 in Delacroix's depiction of the Revolution of 1830. According to Maurice Agulhon, the representation of Liberty, "firmly linked with the Phrygian cap," remained as "the very essence of the Republic." Her bare-breasted, robust figure has often been interpreted as symbolizing the revolution of the people, the masses, *le menu peuple*. For Heinrich Heine she seemed a bizarre melange of "prostitute, fishwife, and goddess of liberty." A recent critic, Jörg Traeger, proceeds from analogies with many representations of Napoleon at the pont d'Arcole to the conclusion that the painting is an affirmation of Bonapartism. Michael Marrinan depoliticizes the painting by reading it primarily as a solution of artistic problems rather than as a political statement.[26]

The ambiguity of *Liberty Leading the People*, dated 28 July when the issue of the battle was still in doubt, might also be read as representing the political indeterminacy of the event. Delacroix portrays the last moment before the solidarity of his generation fractured along political lines. Those who contrived the invention of King Louis-Philippe – Adolph Thiers, François Mignet, and their associates – would find the fulfillment of their ambitions and their spiritual home in the July Monarchy, and their fortress in the Académie française. They confronted across a new barricade their coevals Godefroy Cavaignac, Paul Bastide, Ulysse Trélat, and the other republicans, *pur et dur*, determined, as Cavaignac put it, that things would be different later on.

There is no doubt as to where Delacroix did *not* stand. In a letter to his nephew, Charles de Verninac, dated 17 August 1830, he writes, "anyone with common sense hopes that the republic-mongers will be willing to keep silent."[27]

According to the reminiscences of Alexandre Dumas, not exactly a model of historical veracity, when Delacroix, *fanatique de l'Empire*, saw the tricolor floating over Notre-Dame, his enthusiasm overcame his fear of the aroused masses.[28] In 1830, however, Bonapartism could only have been a sentiment because there was no viable candidate for the imperial throne.

Delacroix informed his nephew that under the present circumstances, "What will preserve the commonweal aside from the universally recognized goodwill of Louis-Philippe is undoubtedly the truly admirable discipline and organization of the National Guard."[29] He enlisted in the Guard himself and served with a certain temporary enthusiasm, to the point of devoting considerable attention to the smartness of his uniform. After several months of service the enthusiasm rather waned as he summoned his friend Felix Guillemardet to come, "sample the pleasures of the National Guard into which, thanks to a brother-in-law, I have been crammed like an imbecile."[30]

In any case, Delacroix seemed to settle for the pragmatic political solution represented by the renovated monarchy. In the letter to his nephew, summing up the immediate results of the July Revolution, he expressed a certain sardonic sympathy for the new head of state:

I assure you that in spite of my penury I would not care for his [Louis-Philippe's] crown at the cost of the burden he is obliged to carry. The job appli-cants spring out of the earth like snails after the rain. This is a universal mania and as you can imagine he is bound to make a great many poor selections.[31]

The ubiquitous urge to feed at the public trough unleashed in the revolu-tionary/napoleonic era certainly characterized the members of the generation of 1820, who already featured themselves as the brightest and the best. Those ex-*normaliens* and *polytechniciens*, those precocious editors and youthful pleaders before the bar, did not locate their ambitions in the free market. At age 22 Delacroix had staked out the position occupied by his educated coevals. "We are not merchants," he wrote. "Our youthful heart will not bury itself at the age of twenty-five or thirty in the bottom of a strong box."[32]

To a considerable extent, the satisfaction of youthful ambitions remained in the hands of the state. The struggle to define the nature of the July regime was also a scramble for the seats at the table. The state was central to artistic ambi-tions, too. "The change from patronage to market"[33] could not support, or sat-isfy the artistic ego of, the young Delacroix. In 1824 he writes, "Glory is not an empty word to me."[34] He sold his paintings to wealthy patrons, displayed them in the major galleries, and enjoyed the semiofficial patronage of the duc d'Or-léans or the duchesse de Berry, but would long for the distinction that could only be won through great works commissioned by the state or selected through public competition.[35]

It seems surprising, then, to find, in a response to a request from the journal *L'Artiste* for his opinion on the artistic concours, Delacroix's trenchant critique of the system. The jury of a concours, he wrote, could never be disinterested given the inevitable artistic biases of the jurors. "Above all, since the great dis-covery of classic and romantic, the reasons for discord seemed to be even more irreconcilable."[36] A plausible argument, but rather odd coming from someone who had won his first honorable mention in a drawing competition as a 12-year-old schoolboy, and whose precocious reputation had been sealed at the age of 24 with the acceptance of the *Barque of Dante* and the award of a medal at the Salon of 1822.

One conjecture as to the motive for Delacroix's letter proceeds from its refer-ence to the unfortunate consequences of an *essai tout récent*, that is, to the competition for the selection of three paintings to decorate the Chamber of Deputies. Delacroix presented submissions for two of these, *Boissy d'Anglas at the National Convention* and *Mirabeau Replying to the Marquis de Dreux-Brezé*, to lose out to competitors whose place in art history owes a great deal to the fact that Delacroix came in second.[37]

Perhaps Delacroix's letter did reflect a temporary access of spleen, but I think it can also be situated in his generation's ambivalence regarding the prin-ciple of the concours in general as well as what he personally could expect from a jury of his peers in particular. The talented *jeunesse* of the Restoration era had staked their individual ambitions and collective amour propre on success in

meritocratic procedures whose violation was bitterly resented when a clerico-royalist litmus paper had been applied to various state-sponsored appointments and awards. On the other hand, they often opposed, or intended to undermine, the standards imposed by the sclerotic dignitaries who administered the concours. That sclerosis was the chronic condition of those outraged by Delacroix's flouting of neoclassical shibboleths.

One might be inclined to read Delacroix's letter as an anticipation of the *salons des refusés,* but that was not what he had in mind. Throughout his life he would back away from such proposals.[38] His alternative to peer review was simply to leave the decision to the appropriate public servant. In a letter to the minister of the interior subsequent to his contribution to *L'Artiste,* he would observe that only the government was exempt from the coterie spirit fed by the fanaticism of contesting schools of art.[39]

And, from his point of view, with good reason. His preference for the critical insights of bureaucrats over the preferences of juries of artists anticipates the disparate treatment he was to receive from the government of the July Monarchy and the *Académie des Beaux-Arts.* Albert Boime cites the case of Delacroix to warn against too close an identification of the labels "official" and "Academic" under the July Monarchy.[40] In the 1830s Delacroix would be awarded the great commissions for the decoration of the Chamber of Deputies and the Senate, while submitting the first of seven unsuccessful applications for the vacant chair in the Académie des Beaux-Arts before admission in 1857. His treatment by juries for the salons, composed of the academicians, was intermittently shabby, too. In a review of the Salon of 1839 Stendhal castigated the bias against Delacroix, "three of whose paintings have been rejected by those animals of the Institute; the dogs!"[41]

What seems to hindsight an uncanny preference for mediocrity did reflect artistic standards to which Delacroix's work was perceived to be in radical opposition.[42] And, as his friend Charles Rivet recalled, he was misperceived, especially in his youth, as a "frightful revolutionary . . . the Robespierre of art."[43]

Beyond any artistic or ideological bias lay that familiar resistance of talent to genius. Even the genius of Victor Hugo was less threatening as it took Hugo only four attempts to be taken in to the Académie française. Genius had eventually to be recognized, but not right away, not too easily, not without the candidate's solicitation of support from anyone who might be able to influence members of the Academy, and not without what reads to us as embarrassingly sycophantic appeals to individual members.

Delacroix managed to take his succession of humiliating rejections with a dose of good humor, predicting more or less correctly, "This [election to the Academy] will occur, I presume, at about my sixtieth year. While awaiting that distinguished age and that distinguished position, I remain your devoted and grateful servant."[44]

Although he could treat his ambition with a certain self-irony, he could never rise above it. On promotion to *officier* of the Legion of Honor he confessed,

"They have long dangled before my eyes this award which I have never pursued, but I am not sufficiently a Roman to refuse it. As for the *Institut,* that would surprise me even more. If ever that comes about it will be about the time I have lost all my teeth."[45]

Delacroix's desire for official recognition, his obsession with the academic *fauteuil,* is not simply an example of what Napoleon identified as the human weakness for "baubles," but a response to the deeply rooted French tradition of honorific membership in public institutions as the certification of status. That cohort of Delacroix's precocious coevals who stormed the heights of the July Monarchy – Cousin, Hugo, Vigny, Mignet, and almost thirty others born between 1792 and 1803 – planted their banners at the very pinnacle of the Institut, that is, the Académie française, which permanently sealed their status even after they had been pushed off the top of the political pyramid by Louis-Napoleon.

The equivalent institution for artists, the Académie des Beaux-Arts, had bolted its doors against Delacroix until, one might suppose, it was too late to really matter, although it certainly did matter to him, even then.[46] However, as early as the end of the Restoration era, he had forced the ramparts of the French elite, that triptych of birth, wealth, and talent – not exclusively an aristocracy or simply an haute bourgeoisie – constituting the *grands notables* who occupied the apex of the French social system.[47]

Birth, of course, was independent of accomplishment; wealth, if sufficiently great, carried its own authority; but talent required public recognition. Even without the sanction of the Academy, Delacroix enjoyed the status conferred by public awards and state commissions, and the ambivalent but profound esteem of the artistic community. This is not to suggest that one constituent of status guaranteed the others. In a letter to his brother, Delacroix wryly remarks, "I have a greater reputation than many other artists, and nevertheless, I am far from earning what that should decently afford me."[48]

There is another sort of social certification inscribed in the question that preoccupied *tout Paris* throughout Delacroix's century from Stendhal to Proust: "With whom did one dine?" While still in his twenties Delacroix is found in the company of Victor Hugo, Alfred de Musset, Ary Sheffer, Prosper Mérimée, Edgar Quinet, Victor Cousin, and other coming luminaries of high culture. He will be bored by the conversation at Adolph Thiers's dinners for the political movers and shakers of the July Monarchy.[49] He will be intimately involved with George Sand and her circle. He is seen with assorted counts, marquises, an occasional duke, and the Prince of Monaco at the salons of Madame Ancelot, whose guest lists are meticulously recorded in her memoirs.[50]

A glimpse into that stratified but unstable social system is afforded by the history of Delacroix's relations with the comte de Mornay, agent of his epochal trip to Morocco in 1832. Mornay, former gentleman-in-waiting to the last Bourbon monarch, Charles X, appointed as Louis-Philippe's envoy to the sultan of Morocco, wanted an artist in his entourage. With the support of various influen-

tial personages, including the count's mistress, the actress Mademoiselle de Mars, Delacroix received the appointment.

The artist did not accompany the emissary simply as an illustrator for the expedition. He and the count became close friends, and Delacroix had occasion to use his connections in the home government to make life easier for Mornay. To obtain for the count the authority to decide when to terminate the mission, he wrote to a friend in the ministry of foreign affairs, "use your good influence at the ministry to make sure that they do not let us rot here."[51]

The friendship continued after their return to France. Delacroix presented the count with an album of eighteen watercolors as a souvenir of their voyage and submitted to the Salon of 1833 a double portrait of those *deux lions de la mode*,[52] the comte de Mornay and his friend Prince Demidoff (the future, deplorable, spouse of Princess Mathilde Bonaparte). He kept up a friendly correspondence with the count – *cher Charles* – after the latter was posted to the embassy in Sweden.[53] In 1849 Mornay apparently lent his influence to obtaining the commission to decorate the chapel of Saint-Sulpice.[54]

Delacroix enjoyed a visit to the chateau of the count and his charming wife in the Seine-et-Oise where, as he confided to Madame de Forget, he was surrounded by *un luxe qui passe toute idée*. Affecting the posture of a simple *roturier,* he finds himself longing for "the simple roast and boeuf à la mode of my *ménage*. . . . I avow myself decidedly bourgeois, an *épicier,* even worse if possible, but simplicity of life's machinery is preferable to the splendor of twenty servants."[55] Delacroix was indeed "decidedly bourgeois" when it came to keeping a meticulous record of expenses and receipts, and tracking the expanding market for his paintings.[56]

The wheel of fortune turns, even for aristocrats. Apparently the count's cash flow was not adequate to his *luxe,* for in January 1850 Delacroix learns that Mornay is auctioning off several valuable paintings which the artist had given or sold to him. For one, at least, *Cleopatra and the Peasant,* no payment had been received. Given the *état de ruine* in which Mornay found himself, Delacroix writes to have the sale blocked and the painting returned. Too late; it is sold on 18 January, netting the count 1,305 francs.[57] There is no further reference to Mornay, who had slipped out of those circles where Delacroix would continue to occupy an established status.

Not the least important constituent of Delacroix's social status proceeded from the authority of his personal distinction. Throughout his life, his physical and moral presence conveyed an impression of controlled power that imposed respect. Baudelaire painted what was probably the most influential portrait: "Eugène Delacroix was an odd mixture of skepticism, courtesy, dandyism, a firm will, guile, despotism, and finally, a certain characteristic kindness and quiet tenderness that always accompanies genius."[58]

Delacroix's dandyism, thanks largely to Baudelaire, has been fixed in the historical imagination.[59] That phenomenon, the subject of considerable literary attention in the nineteenth century, proceeded from the outrageous arrogance

and sartorial ingenuity of a segment of the British aristocracy, and soi-disant aristocracy, personified in the meteoric rise and fall of Beau Brummell, sometime favorite of the Prince of Wales. Transported across the Channel, dandyism was the subject of dense, Gallic theorizing, notably by Barbey d'Aurevilly and Baudelaire, and in the novels of Balzac.[60]

Baudelaire maintained that the French version had less to do with an excessive taste for elegant dress than with the aristocratic superiority of the dandy's temperament characterized by a cold, unflappable surface demeanor concealing the fire within, or, in the case of Delacroix, "a crater of a volcano artistically concealed by bouquets of flowers."[61] This remains the twentieth-century version. According to René Huyghe, "Delacroix, combining a surface coldness and an inner fire, is a perfect model of the dandy."[62]

The public Delacroix fits this description to a certain extent. In those striking daguerreotypes and photographs he is impeccably if conventionally dressed, Legion of Honor in the lapel. This is scarcely equivalent to that studied foppishness which he viewed with mild contempt.[63] There certainly was fire beneath the ice, not only in his creative passion, but in the powerful emotions revealed in his letters to lovers and friends. Delacroix is least congruent with the standard characterization to the extent that the dandy was presumed to fabricate his life as a work of art,[64] a pose unnecessary to one whose life was defined by creation, not by affectation.

Baudelaire manages to assimilate into his protean conception of a dandy not only Delacroix's artisanal self-discipline, his intense concentration on the production of masterpieces, and his polished social persona, but even his political views. "Hating the masses, he saw them as little more than icon-smashers, and the wanton damage done to some of his works was likely to convert him to political sentimentalism." And anyone, Baudelaire recalls, who "abandoned themselves to childish utopian enthusiasms" would be the victim of Delacroix's sarcastic pity.[65] T. J. Clark begins his treatment of Delacroix's visceral counterrevolutionary reaction to the Revolution of 1848 with the artist's dry description of a conversation with Baudelaire in 1849[66]: "He [Baudelaire] then ran onto Proudhon whom he admires, and calls the idol of the People. His views appear to me thoroughly modern and in the line of progress."[67]

So much for utopias. Delacroix's contempt for talk of "equal rights and twenty chimeras," and the fear and hatred aroused by the frightful troubles of June,[68] should come as no surprise. Like so many of his coevals he became more conservative with age and is traumatized by the reincarnation of the Paris "mob" in 1848. By 1849 he reimagines the Revolution of 1789 as the iconoclastic destruction of cultural treasures, "the most evident result of all revolutions."[69]

Yet Victor Hugo was wrong to see Delacroix as simply betraying his youthful idealism to self-interest.[70] Perhaps, as he once informed Balzac, "I had a friend like Lambert [the hero of Balzac's novel *Louis Lambert*]; we established republics but I was less of an enthusiast than he."[71] During the Restoration, however, Delacroix did not join the enthusiasts who conspired against the

regime; nor, for that matter, did he reject any commissions offered by the monarchy. He certainly welcomed or, with his great painting, celebrated, its destruction in 1830, but as we have seen, the creator of *Liberty Leading the People* volunteered for the National Guard to preserve the social order against republican adventures.

While in quarantine upon his return from Morocco in 1832, he responded to the news that the barricades were up in Paris once more[72] in words that anticipated the anger of 1848: "Ah! Well, you fight, you conspire, ridiculous madmen that you are." What will become of the arts, he asked, "with your incorrigible revolutionaries?" And even fantasizes another turn in uniform: "One of these mornings it will be necessary to pick up the rifle again."[73]

Therefore, except for a certain tentative optimism on the morrow of the February Revolution,[74] he is scarcely an enthusiast for one more attempt to realize those abstractions in the Paris streets. His reaction to the insurrection of the June Days was simply that of his class. A great deal of historical ingenuity has been directed to the demonstration that what Tocqueville called a servile war was not class conflict, but that is certainly how Delacroix and his contemporaries perceived it. The combatants on either side of the barricades were not randomly distributed along the social spectrum, and virtually none of Delacroix's middle-aged, middle-class coevals had a shred of sympathy for the stonemasons, cabinetmakers, day laborers, and the like, who threatened their world and were shot down by its defenders.

In fact, Delacroix's generation, well into its fifth decade, had little sympathy for the vision of a *République sociale,* or even what might be called the Republican Left. Louis Blanc (born 1811) or Alexandre Ledru-Rollin (born 1807) belonged to the next cohort.[75] There were some exceptions, Pierre Leroux or F.V. Raspail, for example, but far more characteristic was Eugène Cavaignac,[76] heir to a republican dynasty and the general who crushed the June insurrection, or Ulysse Trélat, ex-Carbonarist, unreconstructed republican after the Revolution of 1830, in 1848 the minister whose liquidation of the National Workshops precipitated the insurrection.

In 1848, and on other occasions, Delacroix expressed deeply felt political convictions, but this is not to say his self-identity was essentially, or even significantly, political. His identity was in his art. Aside from that, Baudelaire was surely right to say, "Delacroix reserved his virile and profound sensibility for the austere sentiment of friendship."[77] Throughout his life, Delacroix's letters, especially to his oldest friends, are filled with references to the priceless virtue of deep long-lasting friendship.

The most striking example of the priority of friendship over politics is in the continuation of his correspondence with George Sand right through and beyond 1848, when their political views could not have been more opposed. She remains his *chère amie* in their continued warm correspondence. What temporarily cooled their relationship was Delacroix's disapproval of her treatment of Chopin.

In the narrow sense of a particular political affiliation the familiar label of

Bonapartist is appropriate, but throughout those long eighteen years of the July Monarchy this was a more or less passive loyalty. With Frenchmen all across the contemporary spectrum, he certainly did embrace the Napoleonic legend. In an essay praising the Baron Gros as the only artist who captured the emperor's greatness, Delacroix canonized Napoleon, "as poetic as Achilles, greater than all of the heroes sprung from the poetic imagination, who has yet to find his Homer, and Homer himself would have given up the attempt to portray him."[78]

This essay was published in September 1848 just when Louis-Napoleon Bonaparte, Napoleon's nephew and the only serious pretender to the imperial succession, had returned to France and a seat in the National Assembly. Delacroix notes this event in a letter to Madame de Forget, his sometime mistress and lifelong confidante: "I have learned . . . that Prince Napoleon [Louis-Napoleon] has been seated in the Chamber, and that his presence has occasioned no disturbance; to my delight, above all, for the interest that he has in you."[79]

Josephine de Forget was related to Louis-Napoleon through his mother's family, the Beauharnais, and was able to use her entrée into Louis-Napoleon's circle after he had been elected president in 1848, and into the court of Emperor Napoleon III after he disposed of the Republic, to advance Delacroix's career. She and Delacroix briefly considered the idea of the directorship of the Gobelins, or the dignity of the Senate, but settled for the Paris municipal council where he thought he could make a useful contribution to the selection of artistic works for the city, if only by warding off the worst choices.[80]

Although Delacroix permitted himself occasional acerbic remarks about the imperial court, and even more sour observations on courtiers, he would circulate comfortably through the upper reaches of imperial society. He was the object of friendly personal attention from the emperor, who was solicitous of his health and who invited him to Compiègne where, Delacroix writes ironically, "I'm going to undertake the apprenticeship of the métier of courtier."[81]

Far more important was the continuation of support for the great public commissions: the Louvre ceiling painting, *Apollo Conquering the Serpent Python,* the decoration of the *Salon de la Paix* at the Hôtel de Ville, and the *Chapel of the Holy Angels* at Saint-Sulpice. The most precious award in the gift of the emperor was the public recognition, and the official sanction, of Delacroix's distinction, in the great *Exposition universelle* of 1855.

Delacroix was appointed to the Imperial Commission to oversee the organization of the *Exposition,* the only artist on the commission who was not a member of the Academy. With Ingres, Horace Vernet, and A.G. Decamp he was assigned space for a retrospective exhibition of his life's work – including *Liberty Leading the People,* temporarily retrieved from artistic limbo thanks to the emperor.[82] The selection of Delacroix and those other superstars for the great retrospective exhibitions was one more application of that competitive principle which pervaded French culture from the schoolboy concours to the contest for the next *fauteuil* with one of the "Forty Immortals" at the Académie française.

Still closed out of the Academy, Delacroix had been distinguished as a worthy representative of French culture to the world. After this official affirmation that Delacroix was not a revolutionary but a national treasure, it would be impossible for the Académie des Beaux-Arts to reject his successful application in 1857.

Ingres, implacable opponent of Delacroix's admission to the Academy, was predictably outraged, as Delacroix put it, "at the insolence of the special jury on painting which had placed him on the same level as myself in the preliminary classing of the candidates."[83] In contrast to Ingres's lifelong animus, Delacroix's generosity of spirit in the realm of art even impelled him to grant a grudging respect to Ingres.[84] So too, despite his distaste for what had come to be called Realism, Delacroix could discern the genius of Courbet, brilliant representative and strident voice of the next artistic generation dedicated to elbowing Delacroix's cohort off the stage.[85]

Although open to the merits of artistic rivals, Delacroix could scarcely welcome innovations that implied his obsolescence. With all of those who survive past some indeterminate chronological boundary, there would come a point at which he no longer believed life's inexorable transformations constituted progress. At age 55 he writes, "I have no sympathy for the present. The ideas that arouse the passionate interest of my contemporaries leave me absolutely cold, all my memories and all my predilections are for the past, and all my studies turn toward the masterpieces of centuries long past."[86] And in his last lonely years he expresses his bitter repudiation of the modern world, of "this infernal charivari of our glories, our industry, our progress in every field, which will leave nothing more for our neighbors to do, and which I detest."[87]

Delacroix's distaste for what his contemporaries celebrated as progress was not simply that familiar crabbed response to the experience of getting old. Throughout most of his life he was dubious about the benefits of those developments – the march of science, urbanization, and industrialization – that transformed Western Europe in the course of the nineteenth century. Here he parts company with that segment of his generation represented by Auguste Comte and the Saint-Simonians, who celebrated the emerging stage of human history founded, they thought, on science rather than superstition or theology. The Saint-Simonians who had anticipated the coming industrial age in their youth would reemerge to realize their technological messianism as the railroad entrepreneurs, canal builders, and investment bankers of the Second Empire helping to construct a new order that Delacroix would damn as hostile to the human spirit.

In part, Delacroix's antimodernism reflects his sociopolitical conservatism. In 1854, proceeding from a complaint about inadequate techniques for preserving paintings, "while the chemists are boasting," he reaches for an extremely strained analogy: "It is like social progress which consists of starting a war among all classes by means of the silly ambitions excited in the lower classes," and goes on to ring the changes on the world is going-to-hell-in-a-handbasket that are still the staples of tory rhetoric:

We are supposed to make merry during our short journey through this life, and let the people who come afterward make the best of whatever state they are in; what used to be called the *family* is today a vain word . . . the welfare of humanity has become the passion of men who cannot live with their brothers, the men in whose veins their own blood runs; these professional philanthropists [read "liberal elite"] are all fat and well-fed; they live happily from the money they are entrusted to spend.[88]

In the nineteenth century such attitudes were often fused with a critique of life in the modern city. For Delacroix, of course, that city is Paris. To some extent Delacroix's alienation from the Paris of his later years simply reflects a nostalgia for the Paris of his youth. "After all of those changes which make us so like other European cities, I no longer recognize my Paris, which now displeases me as much as I loved it long ago."[89]

He regularly and for long stretches deserts Paris, "that anthill," for his beloved country place at Champrosay.[90] That providential quasi-rural retreat afforded the complete rest and restoration periodically required by the coura-geous struggle with his chronic disease – probably laryngeal tuberculosis. And Delacroix genuinely loved the out-of-doors; communing with nature was a vital source of his creative energy.

Except for a brief period in 1850 when he felt threatened by the spread of the Parisian political virus to the rural population,[91] Delacroix sentimentalized the peasantry, desiring a life "a little more like that of a peasant," and affecting a preference for a *réunion des paysans* to the company of rich parvenus.[92]

Eventually, even Champrosay in the Forest of Senancourt was spoiled by the encroachment of the capital. By 1862 it had become a "comic opera village" where all one saw were *élégants* and peasants who appear to have been cos-tumed backstage. He is offended by those cute little gardens and cottages (simi-lar, one imagines, to what he himself had occupied) laid out by Parisians. All of this in contrast to what he finds at his cousin's place in Champagne where he contemplates authentic "men, women, cows; all that gently affects me and affords me sensations unknown to the *petits bourgeois* and artists of the cities."[93]

Yet Paris was indispensable. It remained the locus for the displays of his great works, and of the public that could appreciate them. It afforded Delacroix the opportunity to pursue his communion with the beloved art of every era, and to attend treasured musical and theatrical performances that nowhere else could provide. It was the center of that rich social life which Delacroix deni-grated but continued to enjoy.

Delacroix's lifelong love/hate relationship with the City of Light expressed what Carl Schorske has described as an "archaistic" response of certain nine-teenth-century intellectuals to the industrialized city as it became a symbol of vice and disappointed hopes. The archaistic response seeking "a return to agrar-ian or small-town society" certainly characterized Delacroix in his sentimental moments. It distinguished him from the technocratic segment of his cohort who celebrated the industrial city as the harbinger of a glorious future, and from

members of the succeeding generation, Baudelaire above all, who embraced the city as a far more ambiguous, threatening, and challenging phenomenon.[94]

Delacroix's archaism was also expressed in outbursts of Luddite spleen. Scientists who "do no more after all, than find in nature what is there" are contrasted with the artist who "composes, invents a unity, in one word, creates." In 1857 he even descends to a kind of collective argument ad hominem:

> I have a horror of the common run of scientists . . . they elbow one another in the sanctuary where nature holds her secrets. . . . Besides, it is necessary to frequent drawing rooms and to get *crosses* and *pensions*; the science which can put you on the track to such things is worth all the other sciences together.[95]

Given this perception of science, Delacroix's querulous evaluation of the triumphs of modern technology comes as no surprise. The mechanization of agriculture, for one thing, threatened to displace his imaginary peasants from a place where products would be manufactured "exploited by the great arms of a machine, and yielding up the greater part of its production to the impure and godless hands of speculators."[96]

Transportation was another obvious target. The sight of English steamboats stimulates his contempt for those races "that know no more than a single thing: *to go fast*; let them go to the devil, and faster yet, with their machines and all of their inventions that make of man just another machine!"

Delacroix's generation was the last to reach maturity in an age when humans still traveled on land at a speed set by the domestication of the horse and the construction of good roads. The first common carrier railroad line in France was opened in 1837. By the 1850s "the horse has had his day. . . . Those little steam engines with their pistons, their balance wheel and their flaming throat are the horses of the future." Ordinary people are now "swept along at such speed that they can see nothing; they count the stages of their journey by the railroad stations – which all look alike."[97]

Like Luddite intellectuals in his day and ever since, Delacroix would exploit the technology he deplored. He will find a happy solution to the conflicting necessities of working in Paris and enjoying the peaceful life at Champrosay by catching an early train to the city to spend the day on his last great project at Saint-Sulpice and returning to his rural retreat by the late afternoon.[98]

Delacroix's negative attitude toward science and technology reinforced his skepticism regarding any overarching conceptions of history as progress. Unlike his coevals, the Saint-Simonians, he has no faith in any New General Doctrine or what nowadays might be called an optimistic metanarrative: "contrary to those baroque ideas of continuing progress which Saint-Simon and others have brought into fashion, humanity goes on haphazard, let them say what they will."[99]

As to old doctrine, that is to say religion, Delacroix's ambivalence elicits various readings.[100] I do not quite agree with André Joubin's characterization: "As far as matters of belief are concerned, Delacroix remained a man of the eigh-

teenth century, disciple of the *Encyclopédie* and Voltaire."[101] He undoubtedly venerated Voltaire but, with his cohort, came of age intellectually under the aegis of Victor Cousin.

The Cousinians repudiated the skepticism and materialism of the eighteenth century to fashion a "spiritualist" or "eclectic" philosophy presumed to arrive rationally at most of the great religious verities without deferring to the doctrinal authority of the established church. Delacroix was not much interested in the theoretical content of Cousin's philosophy, but its imprint is exposed as late as 1856 in his irritation at a sympathetic treatment of David Hume's reflections on immortality in an article by Jules Simon.[102] Cousin's "eclecticism," which continued to dominate university pedagogy well past midcentury, clung to the terrain bracketed by eighteenth-century skepticism and the truculent positivism of Jules Simon and the coming generation.

Like Alexis de Tocqueville, Delacroix endured the lifelong tension between an affirmation of the aesthetic and pragmatic virtues of the (Roman Catholic) faith and an inability to expunge doubt. He loved the venerable cathedrals and was enraptured by church music. With Adolphe Thiers and the upwardly mobile members of their cohort, he was sufficiently frightened by the "excesses" of 1848 to welcome a doctrine that made "gentleness, or resignation, or simple virtue the sole object of man on earth." But he could not resign himself to a theodicy which justified "the mass of ignorance and brutalization" that reigned on the surface of the earth, and he was unconvinced by any solution of the soul/body problem.

In 1862, a year before the end, he settled for a version of the inner light:

> God is within us. It is this interior presence that makes us admire beauty, which makes us glad when we have done well and consoles us for not sharing the satisfaction of the wicked. It is doubtless he who inspires men of genius and encourages them with the spectacle of their own creations.[103]

Whatever comfort such a faith might bring to a man of genius, it provided small consolation in the face of the inevitable. In a letter congratulating George Sand on her recovery from typhus, Delacroix writes, "Let's hang on, dear friend, there are many miserable things in this world, but after all, what awaits us? *La nuit, l'affreuse nuit.*"[104]

Eugène Delacroix's consolation was in his work: "One by one the illusions fade away; only one remains for me, or rather, it is not an illusion, it is a genuine pleasure, the only one free of bitterness or regret: that is, work."[105] If there is any scriptural text that conveys the substance of Delacroix's faith it might have been "I must work the works of him that sent me, while it is day: the night cometh when no man can work" (John 9:4).

∗ ∗ ∗

To return to the comment with which I opened this essay: Delacroix was deeply embedded in the collective life and historical location of his generation, but he

transcended these limits as an artist and, I believe, as a human being. That is why his work is in almost anyone's canon, whereas the congealed precocity of a coeval such as Ary Scheffer, who seemed best to express the sensibility of their youthful cohort, has been relegated to the category of the second rate.

Delacroix came of age when the nature of the postrevolutionary, post-Napoleonic political order and social system had yet to be established. The era promised immense, if indeterminate, opportunities for young men with sufficient family support or education – every future possible and none assured. With the ferocious ambition of his talented coevals, Delacroix made his way through the maze of the ubiquitous concours from the schoolboy competitions, to the selections in the grand salons, to the contest for public commissions, and finally (far too late) to the chair in the Académie des Beaux-Arts.

Despite a reputation, derived from his art, as a wild radical, Delacroix shared the latent conservatism of his cohort (many of whom had played at political conspiracy in the 1820s), especially after the trauma of 1848. Although he had been perfectly at home in the July Monarchy, the Bonapartism enshrined in his family antecedents led him to welcome the recreated empire of Napoleon III which would welcome him in turn, especially through the affirmation of his signal distinction in the *Exposition Universelle* of 1855.

Joubin observes that the lukewarm response to Delacroix's last magnificent mural at Saint-Sulpice revealed that he was felt to be passé, "no longer of interest to anyone but the survivors of the generation of 1830."[106] For succeeding generations, however, the last word rests with Baudelaire's affirmation of Delacroix's place in the great tradition, in the succession of the old masters. "Take away Delacroix and the great chain of history is broken."[107]

3 Delacroix and Romanticism

James H. Rubin

> I am a pure classicist. . . .
>> Delacroix, on being compared to the Romantic poet
>> Victor Hugo.[1]

No painter is so widely associated with Romantic art as Eugène Delacroix. Yet Delacroix himself was ambivalent about Romanticism, which even now means different things to different people. In its own time, *Romanticism* was understood as opposition to *Classicism;* at the time of Delacroix's formation in the 1810s and 1820s, these two terms, originally applied to literature, were interdependent and called forth one another almost automatically. Theorists and critics are often attracted to polarities, whereas artists who are the actual practitioners may find simplistic labels inadequate to define their aims. Further, when over time an oppositional position eventually wins favor, its revolutionary character necessarily wanes. At that point, either Romanticism died, or those who defended it had different interests from its founders. This evolution of Romanticism itself informs Delacroix's relationship to it as much as do his own ambitions and misgivings.

Early uses of the word *Romantic* described landscapes or literatures that evoked adventure or romance, as in wild places or medieval legends – worlds one could only imagine rather than experience everyday. In 1798, the year of Delacroix's birth, Friedrich Wilhelm Schlegel used the term *Romanticism* to designate modern and natural poetic forms as created by an artistic will free of rules and constantly changing in response to its times.[2] In both cases, *Romantic* suggested opposition to dominant norms. Other writers took up the comparison of opposites, including the ambitious Henri Beyle, better known as Stendhal – future author of *The Red and the Black* (1830) – whom Delacroix met in the early 1820s. Stendhal published his famous polemic *Racine et Shakespeare* in 1823, calling Romantic that which would please contemporary audiences and linking it to modernity through its realism and consequent democratic accessibility. Shakespeare was his model for modern artists, for he had mixed tragedy

and farce, nobility and vulgarity, widening his appeal across class lines.[3] Claiming links to nature and freedom from outworn traditions, the Romanticism of the 1820s acquired liberal political connotations as well. Indeed, in France, it was first understood as an artistic response to the reactionary regime of the Bourbon Restoration (1815–30), which had reestablished monarchy in the person of Louis XVIII following Napoleon's defeat at Waterloo.

* * *

These political circumstances and literary concepts framed Delacroix's first major artistic endeavor, *The Barque of Dante [Dante and Virgil Crossing the Styx]* (Pl. 1), which he exhibited at the Salon of 1822 in fervent hope that it would launch his career. Before examining it directly, we must survey artistic events of the preceding Salon, held three years earlier, to which Delacroix was directly responding. At that time the concepts of Classicism and Romanticism were first applied to visual art, as embodied by two important paintings. One was *The Raft of the Medusa* (Fig. 1) by Théodore Géricault, a slightly older friend and mentor to Delacroix. (Delacroix is said to have posed for the dead figure lying face down in the picture's right foreground.) The other was the now obscure *Pygmalion and Galatea* (Fig. 2) by an artist of the previous generation, Anne-Louis Girodet-Trioson. The Girodet was based on the legend of the ancient sculptor Pygmalion, who endowed his ideal with so much truth and genuine feeling that she came to life. His painting was hailed for embodying hallowed traditions that already seemed under siege. The astute conservative critic Etienne Delécluze, who like

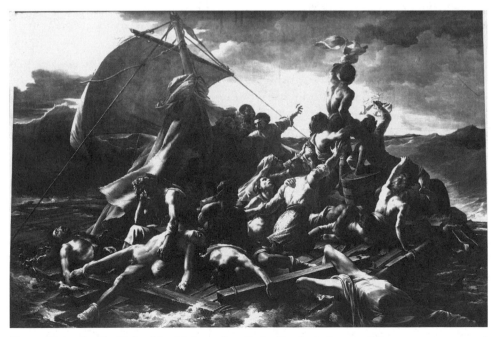

Fig. 1. Géricault, *The Raft of the Medusa*, 1819. Paris, Musée du Louvre. Oil on canvas, 491 × 716 cm. (Photo Alinari/Art Resource, NY).

Girodet had studied with the Neoclassical painter Jacques-Louis David, was aware of the new literary terminology and for the first time on record in discussions of French visual art used it to frame his arguments.[4] For him, the Classical style of *Pygmalion and Galatea* was metaphysical, for its idealized forms embodied human aspirations toward moral perfection.[5]

Contrasting with *Pygmalion and Galatea*'s mythological theme, Géricault's *Raft of the Medusa* was based on news accounts of the 1816 shipwreck of a French frigate named *La Méduse* that had been bound for the colony of Senegal.[6] The episode had political ramifications, for the *Medusa*'s captain was an incompetent appointee of the Bourbon government. He and his chief officers abandoned the sinking vessel and its many passengers to their fate on a makeshift raft. Any representation of the story implicitly condemned the corrupt practices of the royalist regime. However, Géricault cast his scene in the pictorial vocabulary of traditional narrative history painting, with figures evoking nudity and the grand art of Renaissance and Baroque masters, directly inspired by the sculptural anatomies of Michelangelo and the powerful realism of Caravaggio. From this contemporary event, he attempted to draw universal significance. His figures suggest human suffering changing to hope, as those to the right perceive a rescue ship far off in the distance. Humanity's struggle with nature is thus the painting's ultimate theme, even while Géricault introduced realism and modern subject matter as sources from which such ideas could be derived.

Recognizing Géricault's attempt to evoke grand art, Delécluze claimed that without a noble enough subject the result was merely a pictorial charade. He accused Géricault of *"manière académique,"* of knowing how to "speak well, without having anything to say."[7] However unjust history has shown this remark to be, for Classicists, the use of contemporary subject matter was demeaning. Rather than the noble quest for ideal truth, Romanticism, Delécluze argued, was directed toward material truths – with a small *t* – aimed at pleasing the public. He considered nature by itself to be imperfect, requiring idealization in order to be cast in worthy artistic form. Romanticism in other words catered to common taste rather than to higher principles; it encouraged an inferior genre – because it was naturalistic and popular.

Delacroix's *Barque of Dante* refers to this background in several ways. It directly evokes the *Raft* through its story of a boat on troubled waters and its similar structure combining forms that rise to a peak in the compositional center with a friezelike progression from left to right. Its muscular figures and tenebrism draw from many of the same old-master sources as Géricault's picture.[8] However, Delacroix's conception of his theme was actually closer to Girodet's, for Delacroix's art was inspired by literature, Géricault's by contemporary events. However different Delacroix's more realist aesthetic may have seemed from Girodet's, it did not reject the classical tradition entirely. Delacroix was inspired by the Italian epic poet Dante Alighieri, in whose *Inferno* the author is led by the classical Latin poet Virgil through hell. In the painting, Dante raises his arm

Fig. 2. Girodet, *Pygmalion and Galatea,* 1819. Château de Dampierre. Oil on canvas, 253 × 202 cm. Reprinted from *Girodet 1767–1824,* exhibition at the Musée des Beaux-Arts, Montargis, 1967, no. 44.

in defensive fright and leans back toward the rocklike Virgil, as he encounters condemned souls struggling in the murky waters, some of whom he recognized as his contemporaries. Delacroix's idea was that in the encounter with the modern, we must, like Dante, look to tradition for support.[9]

In Delacroix's time, Dante was a prototype for the modern artist, for he had dared to use the vernacular Italian rather than classical Latin and had included contemporaries in the *Inferno,* rather than mythological or religious characters. Yet Delacroix has represented this adventurous and innovative poet as cautious, relying on his companion Virgil. Like Géricault's *Raft of the Medusa,* Delacroix's *Dante and Virgil* incorporated modernity and naturalism into ambitious and large-scale art, but instead of directly representing a modern event, Delacroix proposed a literary and artistic meditation. He approached issues self-consciously and reflectively, guarding ties to tradition through legitimizing references to past art and a literary framework. For example, Delacroix's figures, especially the damned souls floating in the foreground, ostentatiously paraphrase Michelangelo. Delacroix thus addressed the issues Romanticism raised, but he did so at one remove, through rhetorical and aesthetic means rather than, like Géricault, through direct representation of a modern subject. Modernity was for him an object of both desire and trepidation.

* * *

At the Salon of 1824, Delacroix and Jean-Auguste-Dominique Ingres emerged as leaders of opposing schools that would take the names *Romantic* and *Classic.* Delacroix's most notable painting was called *Scenes from the Massacres at Chios* (Pl. 2); Ingres's was *The Vow of Louis XIII* (Fig. 3). A comparison between the

two provides an excellent if schematic idea of the principles underlying the opposing concepts at this time. Delacroix now used a contemporary theme – the Greek War of Independence from the Ottoman Turks. He chose the particularly tragic episode of the Turkish massacre of male inhabitants of the rebellious island of Chios and the abduction into slavery of their women and children.[10] Delacroix stressed his documentary intention by using the term *scenes* for his title, as if his image almost randomly represented a range of possibilities, and by substituting the phrase "See the newspapers of the times" for the detailed description that usually accompanied entries in the Salon catalogue. For his figures, Delacroix had posed live models, one of whom – the *Greek Orphan Girl in a Cemetery* – he redeployed for at least three of his protagonists, sometimes changing gender but preserving a resemblant pose, as if to trace the progression of despondency and death across his composition. The figures are organized on either side of an opening onto a landscape, upending the pyramidal arrangement of figures often found in monumental painting but preserving their concentration in the foreground and reading from left to right. The sketchlike handling of the landscape reflects Delacroix's experimentation in watercolor in collaboration with British artist friends, which he has here translated into supple handling in oils. In addition, at the very center of the foreground, with the bleeding dark-skinned figure embodying resignation and oppression, Delacroix has used impasto and reddened shadows that recall the Flemish Baroque master Peter Paul Rubens, seen through the techniques of Rubens's Napoleonic heir, Antoine-Jean Gros. There were already intimations of this style in the *Dante and Virgil,* where certain passages are loosely painted. But here, in the midst of Delacroix's most realistic representation of suffering, Rubensian overtones signaled an artistic pedigree to such effects.

In the context of Delacroix's time, these various elements – live models, references to British landscape art, and echoes of Rubens – were vehicles for naturalism, signaled by the open-air setting, attention to costumes, and allusions to the mixed racial composition of contemporary Greeks.[11] It was visibly an art historically self-conscious program as well. The name of Rubens in particular was associated with colorism – a conceptual process and associated technique in which the artist derives forms from masses of light and pigment in preference to defining them carefully through line prior to execution in carefully layered glazes. This was a conception to which the classically oriented Academy, having founded its ideals on the art of Nicolas Poussin – Rubens's traditional antithesis – was generally opposed. The new opposition between Delacroix and Ingres was to some extent, then, a revival of the old dispute between the ancients and the moderns and line versus color, for Ingres now embodied traditional authority.

Ingres's altarpiece, an official commission for the cathedral of his native Montauban, celebrated the traditional bond between the ancient monarchy and the Church, which the Restoration government was attempting to rehabilitate. In the painting, the French Renaissance king Louis XIII (ancestor of the recently enthroned Louis XVIII) places the symbols of his authority under the

Fig. 3. Ingres, *The Vow of Louis XIII,* 1824. Cathedral of Notre-Dame, Montauban. (Photo Giraudon/Art Resource, NY).

aegis of the Virgin and Christ. The composition is divided into lower and upper halves, maintaining decorous distinction between material and spiritual realms. The Madonna and Child are conceived as a miraculous apparition, staged by angels who dramatically open curtains onto a celestial realm, and the Virgin displays aristocratic coolness and the Infant a certain disdain for the mere secular ruler. Hierarchy and propriety are preserved. Contrasting with Delacroix's evocations of Rubens, Ingres's painting self-consciously echoes his artistic hero, Raphael. Although Raphael's *Sistine Madonna* is more approachably humane and warmly naturalistic than his, Ingres uses his predecessor's art historical authority to propound academic values of tight delineation and highly finished surfaces.

Line versus color, idealism versus naturalism, finish versus sketch – these stylistic oppositions add up to a confrontation of authority versus freedom. It is an opposition also manifest through the contrasting themes of the paintings –

historical versus contemporary and monarchist versus liberal in their politics. Yet as clear cut as Classicism versus Romanticism seemed to be in 1824, Delacroix's position was actually rather subtle. For one thing, his theme of frustrated Greek aspirations for freedom could appeal to all political parties. Even many conservatives would defend the rights of the heirs to ancient Greece in their struggle against what West European Christians considered barbarous and violent infidel Muslim Turks.[12] For another, even liberals were confounded by the painted Greeks' lack of glorious resistance, the most active figure being their Turkish abductor, whose rearing horse makes an ironic reversal of the heroic equestrian figure. Finally, despite his journalistic pose, Delacroix's knowledge of the events he depicted was at best indirect. Stendhal had personally experienced war during the Napoleonic campaign and, despite his admiration for the artist, complained that Delacroix simply reused conventions derived from pictures of plagues.[13] In fact, Delacroix's interest in the Greek wars was linked to his fascination for England, in particular his admiration for Lord Byron, who not only wrote of the Middle East but traveled there and fought to his own death alongside the Greeks at Missolonghi. At the same time as he painted the *Massacres at Chios,* Delacroix did smaller works based on Byronic tales like *The Giaour* (1813), which he was reading as early as 1824. And in 1826 he produced an allegory of *Greece Expiring on the Ruins of Missolonghi.*[14] So in the end, Delacroix's transposed an imagined reality into an overtly aesthetic construct, ostentatiously signaling its links to Rubens and Gros. His practice confirmed the theory of his *Dante and Virgil,* in which encounters with the modern are mediated by past art.

 This persistent art historical subtext in Delacroix's work cuts two ways. It maintains the distinction between outright realism and art – a distinction dear to traditionalists. Yet the particular literary sources Delacroix used were generally more modern (although not necessarily contemporary) than the classical repertory, and, as exemplified by his interest in British or German sources, frequently lay outside canonical schools. Delacroix's Romanticism was therefore defined by "otherness." Perceived as anticlassical, it was misconstrued as antitraditional. Etienne Delécluze again turned out to be a sharp observer, despite his conservatism. In 1824 he confessed that the French school of painting was "in a state of crisis and about to undergo a marked change," an "important event . . . tied to changes being fomented in literary doctrines." Alluding to Stendhal's *Racine et Shakespeare* of the previous year, Delécluze adopted the term *Shakespearian* to describe Romantic art in general and Delacroix's *Massacres at Chios* in particular. Although he may have agreed with those who dismissed it as "the massacre of painting," Delécluze recognized Delacroix's potential impact.[15]

<p style="text-align:center">✳ ✳ ✳</p>

Not until Realism and Impressionism did contemporary life itself really become the basis for modern art. The ethos of Romanticism was that artistic will must be at the origins of art, rather than observation or traditional formulas, both of which stifled imagination, despite being opposed to one another. Creativity was

displayed through a refusal of whatever seemed facile or readily available. The old repertory of classical historical subjects seemed exhausted; new times demanded novelty. So Delacroix's life was a constant and self-conscious search for viable material. The inspiration that had always been found in history and literature had to be sought in histories and literatures as yet unexplored.

The second half of the 1820s was Delacroix's most experimental period, when he sought stimulus in the supernatural, such as *Macbeth and the Witches* and an early version of *Tam o'Shanter Pursued by Witches* (both c. 1825), and the erotic, such as *Woman with Parrot* of 1827 and *Odalisque Reclining on a Divan*, c. 1827–8. Such works were generally made in smaller formats for private commissions or acquaintances. A small painting of *Mephistopheles Appearing Before Faust* (c. 1826–7), at first rejected, then accepted by the jury of the Salon of 1827, is related to Delacroix's famous series of illustrations to *Faust* done in the relatively new medium of lithography (Pl. 4). There, the painter felt perhaps more free than in paint to pursue the grotesque and the bizarre. Combining compact and angular figures with sneering expressions and mannered postures, picturesque details and claustrophobic settings, Delacroix produced a tough and sinewy version of the gothic drama whose effect on opening French culture to new literary horizons was almost as great as Shakespeare's.[16] Goethe himself proclaimed that Delacroix's prints, which the artist had sent him, were better than anything he himself could have imagined.

At the Salon of 1827, Delacroix exhibited the *Death of Sardanapalus* (Pl. 3), which is generally regarded as the most extreme manifestation of Romanticism in his career. Its brilliant colors, broad brushwork, and dynamic composition gave its theme of suicide and conflagration a powerful impact, corresponding to the most violent political and extreme sexual fantasies of his times. The composition shows an ancient Assyrian king, his palace at Nineveh besieged by rebels, taking his harem mistresses and possessions within him as he goes down in self-inflicted flame and slaughter. Delacroix's initial inspiration was no doubt literary – Byron's play of 1821 – but he enriched it with details garnered from historical sources.[17] The theme of suicide appealed broadly to Romantics for its expression of both defiance and frustration, and it had entered Romantic literature (J. W. Goethe's *The Sorrows of Young Werther*, 1774) and the visual arts (A. J. Gros's *Sappho at Leucadia*, 1801) early on.[18] Delacroix's painting was perhaps, then, most original for its exotic setting and prolific detail, observed from costumes and other paraphernalia brought back by visitors to the Ottoman East. Its contorted movement and overtly Rubensian coloristic sensuality contrasted markedly to Ingres's *Apotheosis of Homer* (Fig. 4), a commission for a Louvre ceiling exhibited the same year. Delacroix's frankly narrative composition was filled with dramatic incident, whereas Ingres's static arrangement allegorically represents a hierarchical pantheon of authors and artists dominated by ancient Greece. Both painters seemed to harden their positions following the opposition between them that first emerged in 1824. Delacroix's use of oil sketches and pastel studies for the *Sardanapalus* approximated methods and techniques associ-

ated not with the Academy but with Rubens and the Rococo painters who were
its antithesis. And his melancholy, antiheroic protagonist seemed the very oppo-
site of the noble simplicity and sedate grandeur admired in classical art.

Such efforts were certainly encouraged by a new sense of solidarity among
the younger generation. In the same year as the *Death of Sardanapalus,* the poet
and dramatist Victor Hugo published the combative preface to his play
Cromwell, an essay that quickly became a touchstone for the young French
Romantics in literature. Hugo seized on the example of Shakespeare to justify
"the liberation of art from despotic systems, codes, and rules." Modern *drame*
opposed the principles of classical tragedy (i.e., the French rule of three unities:
time, place, and action) because it was inspired by reality. Thus it could not
obey artificial divisions between genres, such as tragedy and comedy, for it must
encompass the full range of life itself between the sublime and the grotesque.
The echoes of northern Renaissance we find in the quasi-caricatural illustration
and genre anecdote of works like Delacroix's *Faust* lithographs can be explained
by this concept. Identification between the embattled heroes of Romantic litera-
ture like Faust and their struggling author-creators was also commonplace. For
his heroes, Hugo often sought those who overreached or were somehow
doomed by defiance of traditional authority. His play *Hernani* featured a Span-
ish nobleman persecuted by King Don Carlos, who loved the same woman. It
premiered on 25 February 1830 at the Comédie-Française to a furious public
controversy, now known as the "bataille d'*Hernani*" – a battle in which the
Romantics ultimately prevailed.[19] Delacroix's earlier *Torquato Tasso in the Mad-
house* (Fig. 5) relates to this phenomenon. Showing the author of the crusader
epic *Jerusalem Liberated* (1580) confined on grounds of insanity, it is a paradig-

Fig. 4. Ingres, *The Apotheosis of Homer,* 1827. Paris, Musée du Louvre. Oil
on canvas, mounted on ceiling, 386 × 512 cm. (Photo Giraudon/Art
Resource, NY).

Fig. 5. Delacroix, *Torquato Tasso in the Hospital of Saint Anna, Ferrara*, 1824. Zürich, Foundation Emil G. Bührle Collection. Oil on canvas, 50 × 61 cm.

matic image of the solitary and tormented artist – a cherished romantic notion. No less significant is the association between such suffering and arbitrary political power, as exemplified in Tasso's story by Alphonso d'Este, duke of Ferrara, who had him condemned for his passion for the duke's sister Leonora.[20]

＊　＊　＊

The three-day Revolution of July 1830 marked an important watershed both in Delacroix's career and the history of Romanticism. With the abdication of the Bourbon king Charles X and the installation of Louis-Philippe from the collateral Orléans line as monarch, Delacroix saw his family of Napoleonic soldiers and diplomats reenter the sphere of privilege from which they had been excluded since Napoleon's defeat. In 1831 Delacroix was awarded the Legion of Honor. His *Liberty Leading the People* (Pl. 5), exhibited that year, commemorates the uprising that temporarily united disparate factions to overthrow the reactionary Bourbon regime.[21] In its combination of pyramidal and horizontal frieze structure, its deep shadows and contemporary realism, including foreground images of the dead, the *Liberty* overtly recalled Géricault's *Raft of the Medusa* as the model for politically liberal historical painting.[22] Although Delacroix did not participate in the insurrection, he was enthusiastic over its outcome and planned to paint in support of the new government. Even if

headed by a king, it was ostensibly founded on more democratic principles, with its expansion of the franchise and legislative liberalization. Louis-Philippe was the son of "Philippe Egalité," who had supported the Revolution of 1789. He had spent most of his life in England and was associated with British parliamentarianism. He was often depicted wearing a bowler hat and carrying an umbrella, sure signs of his adoption of utilitarian principles appealing to the bourgeoisie. Delacroix's painting was purchased by Louis-Philippe's government but was exhibited only briefly. Its idealistic combination of different interests and classes of society – workers, students, Napoleonic soldiers, and bourgeois national guardsmen – quickly disintegrated in the bitter struggle for power that ensued. It was too much a reminder of principles ultimately betrayed by the oligarchy that underwrote Louis-Philippe's power. Not even Delacroix really supported his painting's inclusive politics.

Indeed, Delacroix so enjoyed the favor of the new regime that he was invited to accompany comte Charles de Mornay on an official delegation to the sultan of Morocco in 1832. Thanks to the influence of the parliamentary leader Adolphe Thiers, who was interested in art and had lauded Delacroix as early as 1822, he was commissioned to decorate important public buildings during the 1830s and 1840s. Prodded by the success of Romantic painting among prominent private collectors, the previous regime had bought Delacroix's *Dante and Virgil* and the *Massacres at Chios* for the Musée du Luxembourg, where contemporary French art was hung. He had received some public commissions as well, and had begun working for powerful patrons across the political spectrum, including Louis-Philippe d'Orléans himself.[23] Thus Delacroix's relationship with the new regime was a sign of continuity as well as of propitious relations. And because his art had only been political insofar as he sought to position himself moderately under an unsympathetic predecessor regime, with the achievement of recognition Delacroix's vested interest now lay with the established order.

The trip to North Africa provided Delacroix with a storehouse of new imagery, which he mined for the rest of his career. He admired what he believed was the simple life and dignity of Arab culture, its traditions and the noble bearing of its men, whom he regarded as living heirs to antiquity.[24] He was fascinated by their fabled horsemanship, their hunting of wild animals, and their violent games, such as jousting with rifles. He was correspondingly skeptical of France's colonialist destruction of the indigenous culture.[25] Indeed, here was a colorful and heroic alternative to the strictures and conventions of European society. Delacroix was especially curious about Arab women's submissive acceptance of sexual domination, and he arranged for a local official to introduce him secretly into his household. The women of the harem, who were forewarned, donned their most beautiful clothing; Delacroix was apparently ecstatic. His *Women of Algiers in Their Apartment* (Pl. 6), based on sketches he worked up into a painting on his return to Paris, recorded many details of the costumes and interior, but created the possibility of an emotional atmosphere as well. For the admiring poet and critic Charles Baudelaire, who befriended the artist in the 1840s, the painting expressed "not merely suffering, but above all *moral* suffer-

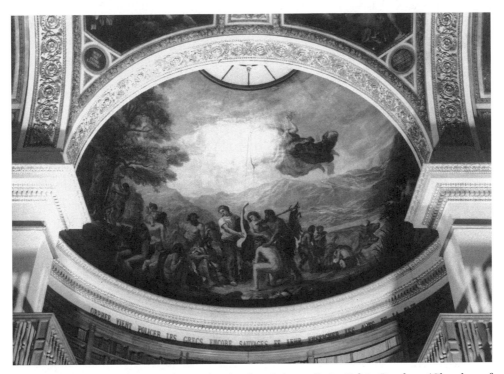

Fig. 6. Delacroix, *Orpheus Civilizing the Greeks,* 1838–47. Paris, Palais Bourbon (Chamber of Deputies). Oil and wax on wall, diameter 735 × 1,098 cm. (Photo Witt Library, Courtauld Institute, London).

ing. . . . This lofty and serious melancholy shines forth with a gloomy brilliance, even in his color, which is broad, simple and abundant in harmonious masses . . .; and yet it is as plaintive and profound as a melody by Weber."[26] Delacroix, Baudelaire believed, had fathomed the limbo in which these women lived, secluded and indolent but for the whim of their male keeper, whether he be the local potentate or the colonial conqueror.[27] Yet however sympathetic Delacroix may have felt toward their confinement, they nonetheless embody a construction of exotic heroism fantasized by the Western male. The Romantic protagonist here is thus as much an imaginary victim as a figure from life, whose gendered vulnerability makes her an available vehicle for vicarious sympathy. It is modern life still at a significant remove – aestheticized, if we follow Baudelaire, into a musically stirring art performance.

Delacroix's most important works under the July Monarchy were his decorative programs for the Library of the Chamber of Deputies in the Palais Bourbon (1838–47) and the Library of the Peers in the Luxembourg Palace (1841–6). In the principal scenes of the Chamber of Deputies, which were half domes facing each other across the long and narrow library, he depicted *Attila and His Hordes Overrunning Italy and the Arts* and *Orpheus Civilizing the Greeks* (Fig. 6) accompanied by numerous intermediary scenes in pendentives. In the Library of the Peers, the principal scenes were *Alexander Preserving the Works of Homer* in a half dome and *Dante Meeting with the Great Poets* in the central cupola.[28] These

works were executed in parallel to paintings like the *Women of Algiers* and private commissions. Here, Delacroix was acting as spokesman for lofty ideals that he probably felt transcended both political and aesthetic partisanship and freed him from the taste of private collectors. His overall program promoted the arts as originating and defining elements of civilization. He provided a rationale for nurturing and protecting the arts in the present, which he addressed to the politicians who would use the chambers where the works were visible. In adopting the language of classical history and allegory, Delacroix cast his work in time-honored rhetorical forms, which he deemed necessary and appropriate for public discourse. Yet he infused them with important aspects of the aesthetic with which he had become identified. Placing his figures in ostensibly natural settings, and representing them in the bright colors and the direct brushwork for which he was renowned, Delacroix tried to reinvigorate the tradition of monumental painting. In order to convey brilliance and immediacy, he mixed his pigments with wax. In order to preserve spontaneity and vigor, he painted in the studio on canvases later attached to the ceilings, rather than working directly at the site in restrictive positions on scaffolding. By the 1830s and 1840s, then, Romanticism's oppositional character was either dissipating, compromised, or increasingly confined to the aesthetic and literary realm. Delacroix felt sufficiently mainstream and sure enough of his accomplishments to apply for appointment to the Academy. Despite repeated attempts to win election, he was disappointed to discover that the members of that institution were not yet ready for his presence. He was not admitted until 1857.

* * *

Whatever controversy Delacroix still provoked was now primarily over aesthetics.[29] He showed regularly at the official Salon, but he also had individual works regularly refused. Academic jurors objected to the ugliness of modern subjects or to what they believed was imprecise drawing and lack of professional finish in his often freely painted works, especially smaller ones that approached the size of sketches and were made for private patrons. For his part, Delacroix claimed that such handling was a springboard to imagination and a "material bridge" between the emotions of the painter and the soul of the viewer. He first summarized this theory in an entry of the *Journal* for 8 October 1822:

> A writer has to say almost everything in order to make himself understood, but in painting it is as if some mysterious bridge were set up between the spirit of the persons in the picture and the beholder. The beholder sees figures, the external appearance of nature, but inwardly he meditates; the true thinking that is common to all men.

On 20 October 1853, he restated this concept, calling the outward forms represented by art a "hieroglyph" that "supports the imagination as it probes the deep, mysterious emotions." An overly detailed and finished execution impeded such processes.[30]

These two citations more than thirty years apart affirm that fundamental to Delacroix's conception of art was its ability to communicate on a primal level, through expressive forms that could be understood by all regardless of language or politics. In this ambition, Delacroix both embodies and transcends ordinary definitions of Romanticism. The aim of universality was age-old and traditional, but in visual art it was conventionally tied to classical ideals associated with Greek antiquity (in contrast to the broader definition of classicism).[31] In defying those ties, Delacroix appeared to side with those who advocated modern subjects as the basis for serious art. However, Delacroix claimed rhetorically that subject matter was not necessary for painting, whose impact was the result of its relationships between pictorial elements.[32] That is not to say he was unconcerned with themes and literary sources, for all the evidence is quite to the contrary. Rather, he was moving away from narrative – from compositions that tell stories through figures whose sequences of gestures and facial expressions have the look of a stage play. Following the painter's lead, the critic Baudelaire even argued that one should step away from a painting lest its narrative details obscure more general effects of tonality and rhythm. Both Delacroix and Baudelaire admired the stirring emotional power of music, whose means could be described with similar terminology. Yet painting had the advantage over music (and writing) of representing the thing itself. Delacroix began to integrate his figures and settings and to use novel technical means and subtle expressive devices to communicate in what might be called a more metaphorical than narrative mode.

A fine example of this approach can be found in the relatively simple composition of *The Death of Ophelia* (Pl. 10), inspired by the famous drowning scene from Shakespeare's *Hamlet* and painted in several versions. Although the lovelorn Ophelia is usually portrayed as gaunt and frail over the indecisive Hamlet's failure to return her passion, Delacroix here endows her with enough bulk that her attempt to stay above water seems tenuous. Her bare feet and ankles are refracted through water in an illusion that appears optically true and yet expressive, as the stream which is the physical cause of her death seems to flatten them weightless. The painting is dominated by the colors of surrounding vegetation, occasionally punctuated by red flowers – the complementary hue that intensifies the background of green. Highlighting with white suggests glints and reflections, and it animates the surface where it is not already displaying the painter's vibrant and openly gestural brushwork. On Ophelia's gown, this delicate, flickering tactility suggests shakiness, fragility, and uncertainty as aspects of the expiring maid's febrile psychology. The foliage of the tree to which she desperately clings seems to participate in the movement, although in the background the scene is tranquil and the waters virtually still. Female mad scenes were a stock in trade of nineteenth-century theater and opera (e.g., Gaetano Donizetti's *Lucia di Lammermoor*, 1835, inspired by Walter Scott). They are a complement to the male artist-genius theme we found in Delacroix's *Tasso in the Madhouse* of 1824, whose pose and the relative claustrophobia of its setting

anticipates the *Faust* series. By comparison to this earlier work, Delacroix's *Paganini* (Fig. 7) shows the movement away from narrative detail, for its formal characteristics more physically convey direct expression. Ostensibly crude and unfinished brushwork enact the inspired violinist's violent contortions as he thrashes in the feverish throes of virtuosity.[33] One recalls Goethe's phrase: "Classicism is health; Romanticism is sickness."[34]

<p style="text-align:center">✳ ✳ ✳</p>

Since 1847, Delacroix had returned to the writing of his almost daily *Journal*, which he had kept from 1822 to 1824. With his public commissions he was an established figure, even if continually rejected in his quest for appointment to the Academy. A cursory comparison of the later *Journal* to the early one reveals a more confident writer dispensing opinions and thoughtfully articulating ideas on art, with posterity or publication in mind. Although his accounts of daily activities naturally allude to intrigues of the moment, they also reveal a self-conscious artist-thinker seeking justification. Additionally, beginning around 1830, Delacroix began publishing occasional articles in contemporary reviews. In the 1840s history was certainly on his mind.

At this time the air was filled with notions of artists as secular priests whose visions would lead the way toward a harmonious future. Therein lay the origins of the concept of avant-garde.[35] Moreover, the Romantic literary circle led by Victor Hugo was deeply involved with *Le Globe*, a journal edited by Pierre Leroux, whose social theories influenced distinguished intellectual figures such as George Sand, the latter Delacroix's intimate friend.[36] Nonetheless, Delacroix was highly skeptical of the utopian socialist theories of Leroux's mentor, Henri de Saint-Simon, as well as of Charles Fourier and his followers, all of whom professed the inevitability of human progress. He read Montesquieu and had frequent discussions with the philosophically inclined painter Paul Chenavard. He concluded that chance and struggle played more of a role in human affairs than utopian theory would admit.[37] Yet, in his *Journal* for 1849, Delacroix did approvingly mention his friend Baudelaire's enthusiasm for the views of one particular social theorist, the anarchist philosopher Pierre-Joseph Proudhon. Baudelaire's interest in Proudhon at the time focused on the role Proudhon attributed to art as the ultimate expression of human worth. Art was the most ideal form of labor, according to Proudhon; grounded in the conflict between humanity's material limitations and its moral aspirations, art represented the ideal resolution of the central conflict in human existence.[38]

So Delacroix's skepticism about history and politics may have deepened his belief in art. The year before the artist returned to the writing of his *Journal*, Baudelaire had given Romanticism its most compelling redefinition. In the *Salon of 1846*, the critic called it "the most recent, the latest expression of the beautiful," and held its characteristics to be "intimacy, spirituality, color, [and] aspiration towards the infinite."[39] This definition must be understood in conjunction with the social function Baudelaire ascribed to art in the famous pref-

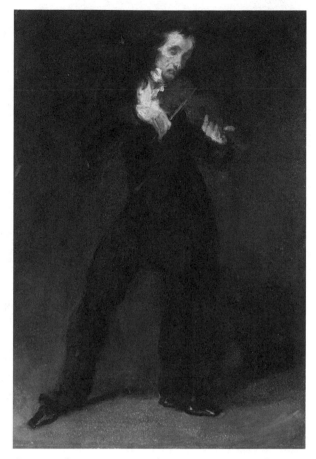

Fig. 7. Delacroix, *Portrait of Paganini*, 1831. Washington, D.C., The Phillips Collection. Oil on cardboard, 45 × 30.4 cm.

ace to the same *Salon.* For him, art was the necessary means to restore equilibrium in an otherwise tedious and disharmonious modern life. The "beautiful," born of collective fantasy and desire, which vary according to time and place, serves despite its origins therein as a beneficent escape from time and place. Hence Romanticism is spawned by the modern condition, but it is only through imagination, rather than positive reality, that human aspirations can be fulfilled.[40] Baudelaire thus recast the role of modernity for art. Rather than simply a required subject matter demanding naturalistic representation, modern life was the inevitable underlying condition to which the aesthetic became a necessary response. Romantic oppositionalism was redefined as all that alleviated Baudelaire's existential ennui. Convention and Realism, as in his attacks on academicism and photography – however opposed to one another – were the enemies of imagination, which he considered "the queen of the faculties."[41] Effects of color and other autonomous pictorial elements, which he and Delacroix had been discussing, were the means to attaining imagination's ends.

Yet in its very concentration on the individual's inner life, Romanticism

reveals a contradiction. Although it adulated originality and the visionary free-
doms associated with it, even gravitating toward political liberalism in its early
years, its withdrawal to the self and gratification ultimately formed a utopian
refuge in which political and social engagements were at best vicarious. A
romanticism born of alienation from a politics it associated with regression and
with a culture dominated by religion and academic conservatism led to an artis-
tic ideology positing the superiority of art and its worthiness for its own sake. It
was increasingly interpreted as the expression of personal temperament, and,
with time, it began to waver between its genuine search for new challenges and
self-indulgence. The growth of the art market reveals its dominance by collec-
tors of modest paintings, including many landscapes by artists of the Barbizon
school.[42] The lakeside idylls of Jean-Baptiste Camille Corot, the mournful sun-
sets of Théodore Rousseau, and the virtuous peasants of Jean-François Millet
catered to midcentury nostalgia for a simpler, ostensibly more natural life than
that associated with the emerging urban commercial and industrial economy.
Delacroix made many small paintings for the same collectors, their free han-
dling producing brilliantly colored visions of literary or North African adven-
tures. They were sufficiently generalized to avoid the illustration-like literalism
of so much contemporary subject painting while providing the sensuous plea-
sures of technical connoisseurship. Their opulence suggests a world of immedi-
ate material availability and leads toward the sensory saturation sought by Wag-
nerian *Gesamtkunstwerke* and Symbolist synaesthesia. So in addition to exotic
or nostalgic visions, advocacy of a universal idiom of communication through
direct sensation was a Romantic means to transcend the social world signified
by conventional narratives and literal, sometimes quasi-photographic, descrip-
tion. Although it disparaged the materialism of ordinary life, Romanticism's
rhetoric of aesthetic universalism clothed what was more a displacement of its
proponents' yearnings for sensual fulfillment than a true negation or transcen-
dence of them.

✳ ✳ ✳

We can assess the position of the later Delacroix through what in his own time
was surely his most public work – the famous Louvre ceiling, *Apollo Conquering
the Serpent Python* (Fig. 8), executed at precisely midcentury. Generally received
as a grand personal triumph for the artist, who used the victory of Apollo to
embody that of light and reason over darkness and evil, the ceiling was widely
understood as a definitive demonstration of Delacroix's coloristic dramaturgy.[43]
In addition to its aesthetic significance, the painting was conceived in a political
context, for it was commissioned by the fledgling Second Republic, which came
to power following the left-wing uprisings of 1848. The restoration of this presti-
gious, although never finished and by then dilapidated, part of the Louvre was a
central element of art patronage by a government anxious to reassure a wary
nation of its respectability.[44] The decorations were originally designed but left
unfinished two centuries earlier by Charles Le Brun, official painter to King

Fig. 8. Delacroix, *Apollo Conquering the Serpent Python*, 1848–51. Paris, Musée du Louvre, Galerie d'Apollon. Oil on canvas, mounted on ceiling, 800 × 750 cm. © Photo RMN (Service de la Réunion des Musées Nationaux, Paris).

Louis XIV and President of the Royal Academy of Art. In the 1830s Louis-Philippe, the ruler overthrown in 1848, had intended to display battle paintings in the gallery. By restoring and completing the work of a more ancient monarch, the Second Republic embarked on a less overtly partisan if no less nationalistic course. The role of Louis XIV, the so-called Sun King often cast as Apollo, was a model for any government seeking glory for the nation through support of art. Thanks to friends in high places and to his successful decorations in the Bourbon and Luxembourg palaces, Delacroix was chosen to fill the gallery's empty central ceiling panel. He immediately recognized the commission's importance, confiding to a friend that this work would be placed "in the most beautiful spot in the world."[45]

The story of Apollo's combat with the serpent Python came from Ovid's

Metamorphoses. Jupiter, dismayed by the human tendency toward criminality, had launched a purifying flood upon the earth. As the waters receded and land dried, novel and monstrous beings were born, especially the serpent Python. Apollo came to the rescue by attacking Python with a thousand arrows, aided by Diana, who hands him her quiver, as well as Minerva and Hermes, while Juno and others watch. A wonderful aspect of this story is its availability to endless interpretation. Intimations of the creation myth coexist with its seemingly opposite theme of transience. The gallery not only evokes Michelangelo's Sistine Ceiling through its shape and decorations within architectural motifs, it puts into play the encounter between matter and spirit under divine power. At the same time, however, mortality is signified by the passage of time in the allegory of the sun's daily course and through the hellish fire-breathing monster. Indeed, in Apollo's victory of light over darkness and the divine over the terrestrial we can read almost any version of good vanquishing evil – whether religious, political, or artistic. With the gradual taming of the Left following the February Revolutions of 1848, there is a possible (although retroactive) allusion to the restoration of political order by Louis-Napoléon Bonaparte, who was elected President in 1848 and became Emperor Napoléon III by the coup d'état of 1851.[46] Such a reading is not excluded by the tendency of Delacroix's contemporaries to trumpet the ceiling as the painter's own heroic victory, probably taking cues from the artist's known remarks. To George Sand, Delacroix wrote that "Pythons of every rank" would see the ceiling; and Delacroix's assistant Pierre Andrieux reported that the master grumbled, "Come on, courage, we must crush these serpents," after losing his sixth candidacy for election to the Academy.[47] In any case, the coloristic glories of the Apollo ceiling facilitate associations of the energies of life and creativity first and foremost with the powers of art.

Delacroix's self-consciousness was certainly intensified by the emergence of the Realism of Gustave Courbet, of whom Delacroix was well aware as he worked on the *Apollo* between 1849 and 1851. Courbet's *Stonebreakers* and *A Burial at Ornans* were earning him a reputation as a socialist painter.[48] Delacroix had at first been impressed by Courbet's vigor and stunned by what seemed an independence that either ignored or changed the terms of current artistic debate. But while admiring Courbet's robust technique, Delacroix had serious questions about how such talents were employed. He found "useless" the *Bathers* of 1853 (Fig. 9), asking, "What do these figures mean? A fat bourgeoise . . . makes a meaningless gesture. . . . No one can comprehend the exchange of thought between these figures."[49] Delacroix could not conceive of naturalism as its own end, for technique could never be more than a means for heightening poetic effects. Nature is a dictionary, not a story; one must use its elements for works of imagination, not copy them mindlessly, as Realism seemed to do.[50] By 1859 Baudelaire saw art divided into two camps, "imaginatives" and "positivists" – the latter his name for Realists. He identified Delacroix with opposition to the latter.[51]

Of course, we easily surmise through Delacroix's origins in Napoleonic aris-

Fig. 9. Courbet, *The Bathers*, 1853. Montpellier, Musée Fabre. Oil on canvas, 227 × 193 cm. (Photo Giraudon/Art Resource, NY).

tocracy, his social relations and official commissions, that he would have been out of sympathy with the upheavals of 1848. Many are the remarks of disdain for politics in his correspondence and diary.[52] Not only did Realism, as a persuasively material and temporal art, embody those qualities Delacroix was anxious to transcend through color and other aesthetic stimuli, but, particularly with Courbet, it politicized artistic languages. By 1848 the representation of modernity – with which Delacroix had been associated in the 1820s – had developed into the politically radical Realism, whose very language, seeming to come from nowhere, he felt, broke decisively with traditions to which he had always maintained links. With his reputation for modernity and opposition at stake, then, Delacroix used the *Apollo* commission to sidestep the now tainted style of naturalism for a combination of allegory with color. The former echoed the past, whereas color, as Baudelaire stated persuasively in his "Salon of 1846," was central to modern art, which he still named Romanticism. In the *Apollo*, then, was Delacroix's opportunity to demonstrate his theory of art's immediacy and directness as vehicles for transcendence of the mundane.

Even while Baudelaire claimed that art criticism must be partisan and political – which implies a corresponding dimension to the art from which such writing issues – he used art as the antidote to politics. Whether through the harmonies it could provide the bourgeois's dreary workaday life or in the dandy's heroic assertions of taste and identity against the leveling tide of democracy, aesthetic experience restored the integrity that politics always betrayed. The abstract language of color harmonics lifted the human spirit out of time to a universal and immaterial plane. However occasioned by modernity, this escape from time and place – meaning escape from the present – is in the end utopian.

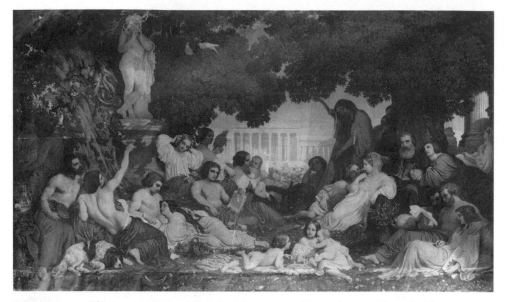

Fig. 10. Papety, *The Dream of Happiness*, 1843. Compiègne, Musée Antoine Vivenel. Oil on canvas.

Although Delacroix's conception of art is certainly neither a carbon copy of Baudelaire's nor inspired by utopian socialism, together these points of view, including Delacroix's, comprise a discourse of alienation from contemporary society. Underlying its rhetoric is nostalgia, which pervades not only Barbizon landscape painting, mentioned earlier, but the imagery of certain declared political artists of the 1840s. Compare, for example, Dominique Papety's *Dream of Happiness* (Fig. 10) to Delacroix's *Orpheus Civilizing the Greeks* (Fig. 6). Papety was a follower of Fourier, whose ideas Delacroix dismissed, yet he and Delacroix shared the vocabulary of classicism for descriptions of their ideals. The *Apollo* is not so far from these efforts, although it substitutes action for their fatuous Neo-Grec idyll of eternal peace and eschews smooth Ingresque finishing. The *Apollo*'s space, of course, evokes Baroque ceilings, an old-fashioned structure quite opposed to the hieratic planarity of Ingres's Louvre ceiling. Its learned display of allusions to the heroes of past art – Raphael, Michelangelo, Veronese, Rubens, and Le Brun – mixes different historical periods to signify a generalized golden age of pictorial authority. It was on such a basis that Delacroix could justify his claim to be "a pure classicist." But its fictive realm is one that sweeps the viewer up in brilliant colors and charged rhythms to make its world seem compelling and sensuously alive rather than remote and chastely unattainable.

✳ ✳ ✳

The core of Delacroix's Romanticism lies in his conception of art as a vehicle for the creation of and access to alternative worlds. Whether victims or heros, modern or medieval, Delacroix's figures display emotions that he himself could only fantasize or covet, located as they were always in imaginary geographic and/or

literary sources. Even in the painting of *Liberty*, which at first seems the exception to Delacroix's diffident approach to modernity, the ideal of Republican unity was an allegorical fantasy. When Baudelaire took the black frock coat, which he called the uniform of his age, as a "symbol of a perpetual mourning" – as if "we are each of us celebrating some funeral"[53] – he expressed both the need to find consolation in imaginary worlds and their dependence on a deadening material present incapable of fulfilling nostalgic yearnings. Romantic art was for him the tonic antidote to human temporality, to the reversals and trivialities of everyday life, which must be resisted at all cost.[54] In this sense, Delacroix's Romanticism, even in its late conservative form, is oppositional. Indeed, Delacroix consistently believed that art at its most rewarding could only be wrought through constant struggle. His engagement, down to its practical details, is what energized his work throughout his long career and provides the sensuous pleasures we still admire in Romanticism a century later.

4 Eugène Delacroix and Popular Culture

Nina Athanassoglou-Kallmyer

> My soul is a tomb, in which, unworthy monk,
> I live and wander through eternity;
> nothing adorns the walls of this loathsome cloister.
> Baudelaire, "Le Mauvais Moine"[1]

Some of the most virulent attacks against Eugene Delacroix were phrased in terms that may sound obscure today. The critic of the *Diable boiteux*, deploring the gory realism of his *Massacres of Chios* (Pl. 2) at the Salon of 1824, called Delacroix "the Darlincourt or the Pixérécourt of painting," and his painting "this truly demonic composition."[2] Three years later, at the Salon of 1827–8, in front of Delacroix's *Execution of Marino Faliero* (Fig. 40) with its grim display of the executed doge's headless body in the foreground, Louis Vitet urged visitors to behold Delacroix's "second coup d'audace, and . . . listen to what your neighbors say, you will think yourself, in the very least, transported to the performance of a tragedy by M. d'Arlincourt. How bad this is, you will hear them say, what a daub! what ignorance! some will even utter with a sigh the words of vandalism and of the loss of good taste."[3]

Victor d'Arlincourt and Guilbert de Pixérécourt were widely acclaimed if ephemeral literary stars in early nineteenth-century France. They created works in popular literary genres, "Gothic" novels and melodramas, which appealed to the larger public through their lavish use of suspense, passion, violence, and terror, features that opposed them sharply to the noble ethos of "high" artistic creation. The critics' comments on Delacroix's paintings, however, suggest that by the 1820s the lowly, popular aesthetic had infiltrated the spaces of high culture, including the exclusive realm of Salon exhibitions and the aesthetic imagination (and vocabulary) of Salon audiences. At the Salon of 1827, for example, the critic Jal pointed out that morbid Gothicism imported from England was a common feature of the new school of painting in its search for vigorous expression and freedom from academic decorum.[4] This was evident in the works of many Romantic artists, not only Delacroix but Sigalon, Boulanger, Champmartin, and

Horace Vernet. High literature was not immune to it either, as evident in Baudelaire's verses cited in the epigraph, with their gloomy evocation of tombs, cloisters, and monks.

Although unquestionably widespread, however, sensational Gothicism did not meet with everyone's approval. Thus while the critic of *Le Diable boiteux,* a traditionalist, clearly intended to sully Delacroix's Salon exhibits by means of a disparaging parallel with popular productions, Vitet, a Romantic progressive, concluded (albeit with some reservations) that Delacroix's *Marino Faliero* "must be seen as one of the most remarkable works presented in the new exhibition."

Delacroix's fascination with Gothic horror can be traced back to his teenage years and his infatuation with English literature and English manners. Although steeped in "high" literature by Shakespeare, Byron, and Scott, he also read Gothic novels such as Lewis's *The Monk,* Radcliffe's *A Sicilian Romance,* and Maturin's *Melmoth the Wanderer.* In 1824 he and his friends discussed *St. Leon,* William Godwin's novel of alchemical fantasy.[5] He even tried his hand at Gothic fiction himself with two early novellas, *Alfred* and *Les Dangers de la Cour,* whose plots teemed with the quintessential Gothic staples of clerical and aristocratic abuse of youth, goodness, and innocence.[6] In *Alfred,* for instance, a scheming priest named Harold persuades the evil nobleman Burtmann to force his son Alfred to take monastic vows in order to appropriate the boy's inheritance. Delacroix continued to admire the Gothic. As late as the 1850s, he cited Lewis's *The Monk* as a masterpiece on a par with Cervantes's *Don Quixote.*[7]

In the early Restoration, his Gothic fantasies were given free rein during his vacations at Valmont, the secularized Benedictine abbey in the vicinity of Fécamp, in Normandy, converted into a country house by his Bornot relatives.[8] In an 1814 letter to his friend Felix Louvet, Delacroix described the manor in a witty parody of a Gothic tale:

> The house is a former Benedictine abbey, which, as you may well imagine, was in no small degree romantic. Great passages, so long that you could scarcely see to the end of them; narrow staircases where two could not go abreast, and above all, the ancient church, half in ruins, in which were tombs, great Gothic windows with dim glass, and vaults in which stood the foundations of the abbey, all these things aroused in me a host of highly romantic ideas. At night the wind whistled through the ill-fitting casements and we were woken by owls which had found their way in through the church. But all these things, which many people might find disagreeable, were full of delight for me. I loved to walk by myself, day-dreaming, through the ruins of this silent church, whose walls echoed the very sounds of my footsteps.[9]

In another letter to Felix Guillemardet, he cast himself as the hero of a Gothic plot, mischievously warning his friend to "beware this is becoming like a novel":

> But I must tell you about Valmont . . . I am sleeping in a room which is close to the old abbey church . . . there are huge interminable passages. At the end of one of them, *right at the very end,* there is my room. Beside my door there is a little winding stair . . . (beware, this is becoming like a novel) you go

down that winding stair . . . (I can see you trembling) and you find a little,
very low door. You open the little door and you find yourself . . . inside the
church, which is partly ruined. In the middle of the church there is a crypt!
In the crypt there is a staircase and all about there are . . . monks buried in
coffins of new lead. . . . I'll tell you that there is . . . a lady who comes back at
midnight and rushes wildly about the place. . . . I must admit that she hasn't
yet come to tweak my feet but I am expecting her any minute. That's not all:
there's a certain wood. . . . Goodbye my friend, that is enough for today.[10]

Such taste for the lowly Gothic on the part of someone affiliated with the intel-
lectual elites, such as Delacroix, exemplifies a larger cultural phenomenon, the
surge of a popular aesthetic within the hallowed precincts of high culture that
eventually resulted in a fusion of elite and popular traditions in nineteenth-century
France. The swift rise of bourgeois industrial capitalism and the explosive growth
of urban populations in the first decades of the century gave birth to large con-
suming audiences for the arts, literary, performing, or visual. This new public for
culture was essentially urban, located in the capital or in important provincial cen-
ters. It was socially diverse, bringing together members of all classes, nobility,
bourgeoisie, and working class, thereby signaling the onset of an urban mass cul-
ture whose chief characteristics were as much the elision of aesthetic distinctions
between "high" and "low" as the gradual breakdown of "the cultural cleavages
between the bourgeoisie and the *menu peuple*," according to the literary historian
James Smith Allen.[11] In the sphere of artistic creation, as in that of audience for-
mation, the process was one of mutual interpenetration. As the conventions of
elite Romanticism filtered down into the lower genres, sophisticated authors, in
turn, steeped themselves into the world of lowbrow spectacle and literature. Char-
acteristic of this fusion of elite and plebeian were the many adaptations of high lit-
erature, such as works by Shakespeare, Byron, and Scott, into abbreviated or sim-
plified *"éditions populaires"* or popular plays intended for the boulevard theaters.
Leading authors as well as undistinguished hack writers contributed to such trans-
formations, from the well-respected Alfred de Vigny (who adapted Shakespeare's
Othello as *Le More de Venise* for the Comédie-Française in 1829), and the cele-
brated Hugo (who drew on Walter Scott for his *Amy Robsart* for the Odéon in
1829), to the mediocre Frédéric Soulié (who wrote a version of *Romeo et Juliette*
for the Odéon, in 1829), the forgotten Aloin (whose *Sardanapalus* derived from
Byron was performed in 1834), and the ephemeral Pixérécourt (whose *"Le Château
de Loch Leven, ou l'Evasion de Marie Stuart,* mélodrame historique imité de Walter
Scott" was a great hit at the Gaîté theater in 1822).[12] "High" and "low" painters
alike lent a hand to such vernacular productions, be it in the form of book illus-
trations and vignettes, or stage decors and costumes. In 1832 the brothers Alfred
and Tony Johannot, illustrators by trade, collaborated with the painters Camille
Roqueplan, Louis Boulanger, and Célestin Nanteuil in the settings of the Grand
Opéra's *La Tentation,* a melodrama on the story of Saint-Anthony.[13] And Delacroix
designed the costumes for the Odeon's production of Hugo's *Amy Robsart.*

Although by no means the only draw, economic speculation was a key factor
in such collaboration of the intellectual elites with the world of popular enter-

tainment, leading many a contemporary to deplore what they regarded as the capitulation of the fine arts to base vernacular taste and crass interests. Thus in 1832, the erudite "Bibliophile Jacob" (Paul Lacroix) complained,

> The weed of bankers has smothered the good seed of artists. Ever since they learned how to read in huts, no one reads anymore in gilded drawing rooms . . . grocers have become publishers, and vice-versa . . . they sing vaudevilles in the ancient chapel of Saint-Bacchus . . . Nodier writes masterpieces in order to make a living; Chateaubriand creates brochures, and Scribe writes for the ballet . . . How can we not despair of the arts?[14]

The purpose of this essay is to show that Delacroix, an artist usually associated with high-minded intellectual and aesthetic pursuits, did not shy away from the wiles of popular culture. On the contrary, like his coevals Nodier and Chateaubriand cited by Jacob, not only did he read trendy popular novels and attend performances of fashionable melodramas, he painted works inspired by them and meant for their audiences. His motives for doing so were complex. He undoubtedly regarded such developments as part of the modern sensibility he was eager to address. He also viewed the introduction of popular aesthetic resources as beneficial and rejuvenating, a valuable ally in his lifelong struggle against stultified art forms and official art institutions. In the early 1830s, such concerns became – as we shall see – interwoven with an antibourgeois radicalism that Delacroix professed despite his close ties, personal and professional, to Louis-Philippe and his "bourgeois" constitutional monarchy. In his latter years, however, all passions abated, for he himself was now well ensconced within the bourgeois public sphere. Delacroix profited from the commercial appeal exerted by such works on amateur collectors and turned them out commercially and serially, as the market demanded.

I will examine these multiple aspects of Delacroix's relation to popular production with reference to his lifelong fascination with the tale of terror, one of the genres that best epitomized the all-pervasiveness of popular taste in the artist's time. My goal is not so much to relate specific literary sources to their pictorial counterparts, as to suggest that, guided by the tenets of a widespread popular aesthetic, Delacroix deliberately selected certain subjects for his paintings that he interpreted according to their strategies and structures, thereby infusing them with the particular mood of Gothic narratives. In so doing, while largely responding to commercial impulses, he gradually brought about a significant transformation within the pictorial genre in which he operated. He popularized literary painting, that one time privileged category of the academic hierarchy. Like the mass-produced Gothic novels, themselves directed to a large public, Delacroix's literary works dealt with themes accessible to many, and were sized and priced accordingly.

In the making of a popular aesthetic under the Restoration and the July Monarchy, indeed, the Gothic novel or *"roman noir et terrifiant,"* as it was commonly called, and its theatrical counterpart, the Gothic melodrama, held pride of place. No other literary genre could rival their huge popularity. From the late

eighteenth century on, translations, adaptations, and imitations of English Gothic novels – the "classics" of their kind – by Horace Walpole, Ann Radcliffe, M. G. Lewis, C. R. Maturin, and Mary Shelley, as well as scores of like-minded French originals, flooded the Parisian book market.[15] In 1819 the publisher Pigoreau's *Dictionnaire des romans* listed a huge number of "Gothic" or "frenetic" novels: "novels and stories of convents of monks, nuns etc; . . . novels of magic; novels of phantoms, ghosts, shadows; mysterious, secret and impenetrable novels; black novels, catastrophes, assassinations, poisonings . . . novels of bandits, forgers, thieves, criminals, brigands and crooks."[16] Crime, murder, death, and conspiracy pervaded the plots of such stories. Stock characters, neatly partitioned into villains and victims, aristocrats and plebeians, monastic and secular figures, real and fantastic beings, wandered through an invariable decor of abbeys, castles, dungeons, graveyards, and ruins steeped in impenetrable gloom. Mass produced in inexpensive, pocket-size editions, the books were often illustrated with crude but highly suggestive illustrations highlighting the supernatural, terrifying, or lewd aspects of the narratives.[17] Gothic plays thrived in spectacular effects and settings. Thus in the Porte Saint-Martin's 1835 melodrama *La Nonne sanglante*, Anicet Bourgeois's melodrama based on an episode from M. G. Lewis's Gothic classic *The Monk* (1796), the public was treated to the ghost of a blood-dripping nun, a dagger plunged in her breast, emerging from a Gothic archway into a stormy night.[18]

With its passionate and violent content and free-flowing formal structure, the Gothic tale appeared as the antithesis to classical literature that prized order, balance, and decorum. While the academician Louis-Simon Auger, a staunch defender of the classical tradition, inveighed against "this literature of cannibals which feeds on pieces of human flesh and drinks the blood of women and children,"[19] members of the Romantic avant-garde, such as Hugo, Nodier, Gautier, Dumas, and the young Balzac, embraced it and emulated it. Like Anicet Bourgeois's *La Nonne sanglante*, Hugo's poem *La Légende de la nonne* (1828) was derived from Lewis's novel.[20] The infatuation with the Gothic dovetailed with the taste for Walter Scott and Byron, whose works often incorporated Gothic strategies and a Gothic tenor. Even Shakespeare's plays were seen as part of the fashionable Gothic aesthetic.[21]

The Gothic genre's groundbreaking aesthetic was matched by its radical antagonism to the ruling orders.[22] Two stock characters embodied such ideals: an evil aristocrat and an evil priest, the latter memorably epitomized by M. G. Lewis's villainous monk Ambrosio, a lecher, rapist, and murderer.[23] Given such subversive contents, it is little wonder that Gothic plays and novels would be in demand during the French Revolution. Gothic plays – especially anticlerical dramas – proliferated on the revolutionary stage, particularly after 1791 when censorship of the theater was lifted. They included Boutet de Monvel's extremely successful *Les Victimes cloîtrées* (1791), about a Dominican convent terrorized by its corrupt father superior, Père Laurent,[24] and Olympe de Gouges's *Le Couvent ou Les voeux forcés* (1790),[25] which dealt with the theme of forced religious vows, a Gothic topos symbolizing religious oppression. In

Fiévée's *Les Rigueurs du cloître* (1790), one victim of monastic abuse warned, "Do not fool yourselves. . . . Hatred dwells in these retreats and it often erupts with greater violence than in the outside world."[26] Clearly, religion as seen in the microcosm of the convent was far from peaceful and idyllic.

Delacroix's Gothic Imagination

As was always the case with Delacroix, literary enthusiasm served to fuel his pictorial inspiration. In 1824, the year Maturin died, he wrote about his intention to do drawings from *Melmoth* and *The Monk*, as well as from Chateaubriand's autobiographical novel *René*, a story with overtones of an illicit incestuous passion that climaxed in a convent and in suicide.[27] Still in the same "Gothic" frame of mind, he considered painting a subject from the Spanish Inquisition under Philip II.[28] Goya too was on his mind that year, and he did a number of caricatures of priests and monks after Goya's *Caprichos*.[29]

His plans for a Gothic painting found an appropriate setting in the republican atmosphere of the early July Monarchy. Joint antiroyalist and anticlerical sentiment erupted again with unprecedented violence in the aftermath of the July Revolution. Subversive cartoons portrayed the deposed king Charles X, a bigot controlled by the Jesuits, wearing a priest's garb. Churches were vandalized and crosses torn down by a revolutionary mob. During the next five years, a generally hostile attitude toward the Church prevailed in keeping with the spirit of Voltairean scepticism embraced by King Louis-Philippe and his ministers, among them Adolphe Thiers – one of Delacroix's earliest supporters. The new regime viewed monastic orders with suspicion, Jesuits, Trappists, and above all Dominicans, whose past history associated them with the horrors of the Inquisition. Predictably, the Catholic Church itself sided with the proponents of the deposed Charles X known as "Legitimists" or "Carlists." In February 1831 religious tensions came to a head. During a memorial service held at Saint-Germain l'Auxerrois for the duc de Berry, Charles X's son slain by a Bonapartist radical in 1820, a fierce mob ravaged the church and the adjacent archbishop's palace at the cry of "*A bas les jésuites! A bas la Congrégation!*"[30]

In this climate, the Gothic tale, whether revolutionary play or mere irreverent novel, knew a second efflorescence. Diderot's *La Religieuse*, put on the index under Charles X as blasphemous, was reprinted by Firmin-Didot.[31] A new edition of Monvel's *Les Victimes cloîtrées* was issued, and the play was revived at the Porte-Saint-Martin.[32] In the theaters of the boulevard du Temple, monastic plays were the rule, the Gaité alone offering as many as three claustral productions: *Le Jésuite, Te deum,* and *Le Couvent.* The Théâtre Français mounted *Les Intrigants ou La Congrégation,* a five-act comedy by Alex de la Ville.[33] Posters announced new editions of Lewis's *The Monk.* Fontan's theatrical adaptation entitled "*Le Moine . . . drame fantastique en cinq actes*" opened at the Odéon in 1831.[34] The Ambigu-Comique staged *Jeronimo ou Le Dominicain,* a melodrama also based on *The Monk,* featuring a "*détestable moine*" who commits murder and incest.[35] The

story of the rebel seventeenth-century priest Urbain Grandier, who was accused
of sorcery by the Inquisition and condemned to be burned at the stake, provided
the subject of both a play at the royally subsidized Odéon, *L'Abbesse des Ursulines
ou Le procès d'Urbain Grandier,* and Eugène de Pradel's "improvisation" for a
more popular audience.[36] Lusty monks and murderous priests were featured in
hundreds of cheap, crudely illustrated Gothic romances, such as Edouard Cas-
sagnaux's *Le Pénitent* (1833) or Charles-Henri D'Ambel's *Le Trappiste d'Aigue-
belle* (1832).[37] In 1831 Hugo published his immensely successful novel *Notre-
Dame de Paris,* a work of "high" literature conceived like a Gothic tale of epic
scope featuring the character of Claude Frollo, a priest haunted by feelings of
lust and murder. At the Salon of 1833, paintings by Boulanger and Couder were
inspired by the novel. Couder's *Scènes tirées de Notre-Dame de Paris* was even
shaped like a medievalizing altarpiece describing Claude Frollo's murder of Phoe-
bus, the lover of the gypsy Esmeralda (Fig. 11).[38] The crowning event was the
Académie de Musique's spectacular production of Giacomo Meyerbeer's *Robert*

Fig. 11. Louis Charles Auguste Couder, *Scenes from Notre Dame
de Paris,* Salon of 1833. Paris, Musée de Victor Hugo. Oil on can-
vas, 165 × 130 cm.(© Photothèque des Musées de la Ville de
Paris/cliché).

Fig. 12. *Robert le Diable,* performed in Paris at the Académie Royale de Musique in 1832. Lithograph by Antony Bernier (Nantes: Joubert, 1858), 48 × 62 cm. Paris, Bibliothèque Nationale de France, Opéra. (Photo: cliché Bibliothèque Nationale de France).

le Diable, a melodrama-like opera, first performed on 21 November 1831, which Delacroix, an opera lover, could have not missed.[39] The audience was presented with a magnificent spectacle acclaimed in the press as an *"apparition magique, fantastique, diabolique"*[40] (Fig. 12). Its highlight was a scene in which the ghosts of dead nuns danced voluptuously in a moonlit graveyard, a "nuns' bacchanal,"[41] in the words of contemporaries.

Delacroix relished the subversiveness of Gothic tales, and his distaste for church and altar exulted in the republican atmosphere of the early July Monarchy. With his projected Gothic picture in mind, he went back to Valmont and nearby Rouen in the fall of 1831, sketching medieval buildings, tombs, and sculptures.[42] We find echoes of his thoughts in the form of pencil jottings in a sketchbook page preserved at the Louvre.[43] Among subjects drawn from Byron and Scott, Delacroix also listed themes derived from trendy terror novels. Thus his note of "Scene of the convent of . . . –iano. Death of two nuns who poison themselves" evokes a typical scene of conventual horror, such as in Edouard Cassagnaux's *Les Deux Nonnes* (1834), with its account of two nuns who poison each other over the love of a man. Another note, "Urbain Grandier questioned by his judges – when they prevent the crowd from entering" alluded to an episode from the story of Urbain Grandier, a favorite topic of Gothic fiction as we saw. Yet another note "Agnès condemned by the abbess" was inspired from a story in Lewis's *The Monk*; still another pointed to a scene from Maturin's *Melmoth the Wanderer*: "The Spaniard condemned by the bishop in Melmoth."

He finally settled for Maturin. Charles Robert Maturin (1780–1824), an Irish protestant minister from Dublin, known as much for his notoriously eccentric behavior as for his violent sermons excoriating the Catholic church, wrote Gothic fiction much admired in his time, especially by Walter Scott and Byron.[44] His most famous novel was *Melmoth the Wanderer* (1820), a sprawling, intricate tale, which was translated into French in 1821. It told the story of a seventeenth-century Irish nobleman named John Melmoth who traded his soul with the devil in exchange for eternal life, a dubious gift that proved to be a curse. In episode after episode, the reader follows Melmoth's adventures as he desperately tried to free himself of his predicament.

Delacroix's *Interior of a Dominican Convent in Madrid* was inspired by a story in the book, "The Tale of the Spaniard" (Fig. 13). A young Spanish nobleman, Alonzo Moncada, forced by his family to enter a convent against his will in order to expiate a sin committed by his parents (he was born before they were married), was relentlessly persecuted by the monks. In the incident chosen by Delacroix, he was whipped and dragged barefoot over broken glass in the presence of the bishop. A subsequent episode described the ordeal of another young monk condemned by the Inquisition to starve to death in a dungeon with his mistress, whom he had secretly introduced into the convent. The story is a scene of cannibalism, as the starving young monk devours parts of his lover's body.

Fig. 13. Delacroix, *Interior of a Dominican Convent in Madrid,* 1831. Philadelphia Museum of Art. Oil on canvas, 130 × 163 cm. Purchased: The W.P. Wilstach Collection.

Fig. 14. Daguerre, *Théâtre de l'Ambigu comique. Elodie. Décoration du 5ᵐᵉ Acte,* c. 1820. Lithograph, 12.6 × 18 cm. Paris, Bibliothèque Nationale de France, Cabinet des Estampes. (Photo: cliché Bibliothèque Nationale de France).

Delacroix chose to depict the first episode, that of Moncada's meeting with the bishop. The violent scene included references to torture but also to the familiar topos of forced monastic vows. The vast gothic hall, drawn after Rouen's Palais de Justice, is steeped in menacing shadows. In the candlelight below, the diminutive figures of the monks – dashed out in quick, vibrant strokes of thick pigment, their faces distorted into caricatural scowls – flicker like the evanescent dwellers of an otherworldly inferno. Their victim, the young Moncada, appears in their midst clad in white, his arms held out in the manner of the crucified Christ.[45] The allusion is obvious: the emissaries of the Church are the torturers of Christlike innocence. The gloomy palette alludes to the darker side of human nature, but also to the abyss of hell replacing the glowing vision of a Christian paradise. Such parodic inversions – Church/inferno, monks/devils – emulated the strategies of ironic reversal in use in the Gothic genre. The picture's manichean opposition of moral and visual extremes – evil and good, sin and innocence, old age and youth, power and impotence, terror and pity, dark and light, high and low – resonated with the stark moral contrasts found in Gothic tales and Gothic melodrama.[46] Delacroix's scene parallels illustrations of similar episodes in Gothic novels, and his dramatic architectural setting is reminiscent of the hyperbolic stage designs of contemporary boulevard productions (Fig. 14).

Fig. 15. Lithograph after Renoux, *Interior of a Convent*. In Sazerac, *Salon of 1834*. Paris, Biblio-thèque Nationale de France, Cabinet des Estampes. (Photo: cliché Bibliothèque Nationale de France).

No image of spiritual haven, indeed, Delacroix's painting differs sharply from contemporary depictions of serene church interiors and convents, such as exhibited by Granet, Dauzats, or Renoux (Fig. 15) in the Salons of the early 1830s. At the Salon of 1834, where Delacroix's painting was first shown,[47] the critic Sazerac asserted, "No, this is not at all an interior such as the ones . . . Daguerre, Renoux, Dauzats . . . have acquainted us with their beauty of details and their picturesque effects." Indeed, Sazerac saw Delacroix's painting as a moral allegory whose bituminous palette and overwhelming sense of space stood as a metaphor for clerical fanaticism and abuse: "But my God! how rare is the light under these darkened vaults, how little does the air circulate within these sad premises, and, finally, how short and heavy are the figures of these monks enacting this scene of fanaticism."[48]

Paired with his scene from Maturin at the same Salon of 1834 was another important work by Delacroix, his portrait of *François Rabelais*, a work commis-sioned for Chinon, Rabelais's hometown, by Adolphe Thiers, Louis-Philippe's minister of the interior (Fig. 16).[49] Interest in Rabelais was revived in the 1830s as part of the period's prevailing spirit of rebellious renewal. Rabelais was associ-ated with militant anticlericalism, the exposure of government ills, and the sub-version of canonical authority in the arts and letters.[50]

Fig. 16. Delacroix, *Portrait of Rabelais,* 1833. Chinon, Musée des Etats Généraux. Oil on canvas, 186 × 138 cm. (Photo courtesy Roger-Viollet).

A social nonconformist and an enemy of organized Catholicism, Rabelais's personality was analogous to Maturin's, a fact that would have not escaped Delacroix. Both men were priests by profession and church renegades by avocation. Both wrote works of sprawling fiction in which a powerful imagination was matched with sharp social criticism of the ruling orders, nobility and clergy. Indeed, in 1824, the year he first mentioned his wish to do a Gothic subject inspired from Maturin, Delacroix also asked the painter Achille Devéria for engravings representing Rabelais, possibly in view of a future portrait.[51]

In conformity with Rabelais's unorthodox persona, Delacroix's portrait does not evoke its sitter as a meek and devout servant of the Church. Rather, the legendary *"curé de Meudon"* is a vital and energetic man of the world. He sits casually at his desk, his legs spread apart, one thickset hand clawing at the arm of his chair, the other curled around his quill. We glimpse a secular attire under his cassock and his open shirt reveals his strong neck and hairy chest. The papers

and books piled upon desk and floor and the entwined nude nymphs from the stucco decorations of the gallery of Francis I in the Fontainebleau palace, set immediately behind his head as if the incarnation of his innermost thoughts, hint at the eccentric clergyman's insatiable appetites, intellectual and sexual. Indeed, Rabelais assumes a Faustian quality of a secular savant-anchorite torn between the life of the spirit and more pagan callings of the flesh. And his provocative, penetrating gaze and discreetly pointed ear offer subliminal references to the diabolical, to Mephistopheles or Pan, deities of sensuality. One Salon critic, Laviron, remarked on "the shameless cynicism of the priest of Meudon" and chided Delacroix for his ambiguous rendering of those clawlike hands, "for hands, after all, whether those of Rabelais or of the devil, must be hands, and not crooked and stunted claws, such as those of M. Delacroix's portrait."[52] His Gothic imagination now aflame, Delacroix transformed Rabelais into a live inversion of ascetic holiness analogous to a Gothic tale's villain-priest in direct descent from Lewis's Ambrosio.

Gothic Aestheticism

Delacroix's choice of a subject from Maturin came at a significant moment in the Irishman's literary fortunes in France. Although well known since the early Restoration, it was under the July Monarchy that Maturin's French reputation soared. In the early 1830s the *Revue des deux-mondes* devoted several articles to the English Gothic novel, singling out Maturin as one of its best exponents, on a par with Radcliffe, Lewis, and Scott.[53] Above all, critics praised Maturin's "prolific, ardent and poetic imagination,"[54] particularly in his *Melmoth,* which transformed reality by highlighting its fantastic possibilities, and raised poetry "to the most poignant horror."[55] Amédée Pichot set him up as a model for artists seeking to convey extreme passion: "Maturin is proposed to the artists' brush as the very type of the frenetic; he must be represented with a foaming mouth."[56]

Suggestive poetry arose from Maturin's dissonant, irregular, and rough prose and from the disjointed, sprawling compositions of his novels, primarily his best known *Melmoth,* with its meandering plot and multiple, interlocking subplots. Critics spoke of Maturin's novels as made up of "scattered materials, unfinished elements, original features, strokes of genius, fragments of powerful dialogue . . . often with passages whose energetic execution would be worthy of the great masters," while all along "never bothering about overall harmony, or about polishing his work: the final edifice presented a certain barbaric and irregular grandeur."[57]

It is Maturin's imaginative interpretation of his subjects achieved through the use of suggestive mystery, narrative incongruity, and stylistic disjunction that must have also attracted Delacroix. His *Interior of a Dominican Convent* and his *Rabelais* incorporate some of the writer's devices, including uncanny *"diaboliste"*

overtones, and abrupt shifts of scale and light. Just as for Maturin's novels therefore, critics of Delacroix's *Interior . . .* referred to the painting's *"défaut d'unité,"* flawed drawing, and uneven finish, as well as to its lack of harmonious proportional relation between parts and whole, especially between the diminutive figures and the huge vaulted setting.[58] And the *Rabelais* was accused of careless execution, of being "broadly painted, very broadly painted; form is blurry and the style loose."[59]

But as for the novelist, defects in Delacroix's pictorial technique accounted for the ineffable poetic quality of his works. "M. Delacroix is a great poet who has the weakness of neglecting spelling," one critic wrote about the *Interior. . . .*[60] Another declared that quite obviously Delacroix "has immersed himself in the meaning and poetic character of this scene."[61] The *Rabelais,* too, stood as evidence that "the work of M. Delacroix is all imagination and fantasy, and it reproduces reality . . . here are poetic portraits and painters."[62] Moreover, as with Maturin, whose imaginative powers were said to generate *"effroi"* (horror), Delacroix's paintings, too, were linked to sentiments of fear and revulsion. For one critic the *Interior of a Dominican Convent* was a work "in which the soul engulfs itself in the wake of the eyes and from which it derives an impression full of terror."[63]

By the early 1830s, horror and terror had become the aesthetic battle cry of the *Petit Cénacle,* a group of militantly Romantic writers and artists, including Théophile Gautier, Charles Nodier (who had translated two of Maturin's works into French), Gérard de Nerval, Philothée O'Neddy, Pétrus Borel, Louis Boulanger, Camille Roqueplan, Decamps, Célestin Nanteuil, and the sculptors Jehan Du Seigneur, Préault, and Barye. The group was united in its explicit rejection of Church and bourgeoisie, of established authority, materialism, and utilitarianism. Their spiritual leader was Victor Hugo, whose polemical preface to *Cromwell* (1827) raised the vernacular grotesque or *"le laid"* – whether found in the medievalizing Gothic tale, folklore, or Rabelais's subversive writings – into an aesthetic of modernity destined to replace the exhausted academic classicism and bourgeois *"bon goût."*[64] Taking his cue from Hugo, Gautier's manifestolike preface to *Mademoiselle de Maupin* (1834) promoted repulsive horror as an antidote to desiccated classicism.[65] Boulanger's *Witches' Sabbath,* inspired by Hugo's ballad "La Ronde du sabbat" in which sacred and profane merged irreverently, applied Gautier's ideas to painting (1828; Fig. 17).[66]

It is hardly surprising, therefore, that at the Salon of 1834, Delacroix's *Interior of a Dominican Convent* would find an admirer in Gautier. The critic reveled in its gloomy palette, abrupt contrasts of light and shadow, and grotesque, impish figures, which he preferred to Granet's idealized monks:

The Dominican convent in Madrid introduces us into an interior of such beauty that we place it above everything that M. Granet has done, because of the gravity and melancholy of its color; moreover its figures are far more lively, far more animated than the puppets of ebony and ivory that M. Granet

Fig. 17. Louis Boulanger, *La Ronde du sabbat*, 1828. Lithograph by Villain (Paris: Gihaut, 1832), 230 × 192 cm. Paris, Bibliothèque Nationale de France, Cabinet des Estampes. (Photo: cliché Bibliothèque Nationale de France).

plants against the ink-colored walls of his underground passages and his churches.[67]

Indeed, Gautier seemed to have found his alter ego in Delacroix. His reviews of Delacroix's paintings often exuded his own obsession with horror, a condition he associated with ultimate poetry, as when he discussed Delacroix's *Hamlet and Horatio in the Graveyard* (Fig. 18) at the Salon of 1839 as a morbid scene of decay, disease, and putrefaction.[68]

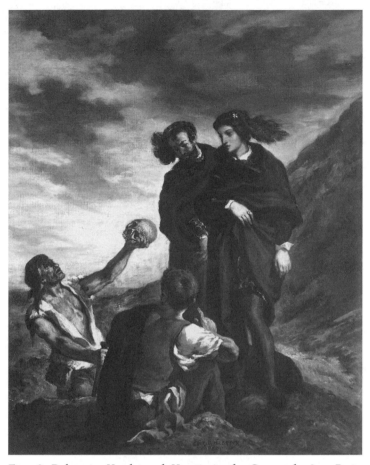

Fig. 18. Delacroix, *Hamlet and Horatio in the Graveyard*, 1839. Paris, Musée du Louvre. Oil on canvas, 81.5 × 65.4 cm (Photo courtesy Alinari/Art Resource, NY).

Delacroix's highly proclaimed contempt for the philistine middle classes and commitment to Romantic modernism made him a natural adherent to the Petit Cénacle in the 1830s.[69] He grew especially close to the writer Pétrus Borel, the group's most eccentric member, nicknamed *"Le Lycanthrope"* (the Werewolf) for his iconoclastic, cruel, and amoral writings, epitomized by *Champavert. Contes immoraux* (1833), a collection of short stories about murder, infanticide, rape, and incest, and his novel *Madame Putiphar* (1839), which Baudelaire compared to Maturin with regard to its cult of repulsive horror.[70] A radical in art, Borel also styled himself as a political radical and latter-day Jacobin, and went about sporting a phrygian bonnet and a conspirator's dagger.[71] His views found an outlet in *La Liberté. Revue des arts,* the short-lived art journal he published together with the sculptor Jehan Du Seigneur. Writing under the pseudonym Didron, Borel published inflammatory articles demanding absolute freedom for the arts

and the abolition of official art institutions, such as the Institut. (He always concluded with the motto: *"Mort à l'Institut! Mort au professorat!"*)

In 1831 when the July regime, increasingly conservative, banned from public view Delacroix's *Liberty on the Barricades,* the painter found support in Borel, who accused the government of suppressing Delacroix's work for fear of its subversive content and bold, antiacademic style.[72] Delacroix paid back the favor by contributing two, so far unknown, articles to Borel's journal in 1832 and 1833, in which, while protesting the belated opening of the Salon, he exposed the favoritism and privilege underlying the arts administration (see Appendix).[73] Using language whose pamphleteering abrasiveness recalls the vehemence of his early political cartoons, Delacroix heaped abuse on the government's favored Academic artists whom he characterized as "scandal-mongers, royalist charlatans, official artists who hold a patent for exploiting and monopolizing the arts, the whole thing to their own benefit and to the greatest glory of the French monarchy."[74]

Like Hugo, Gautier, Borel, and their peers, therefore, in the 1830s Delacroix saw the mode of terror both as a promise of aesthetic renovation for the arts and as an indictment of the bourgeois values that ruled July Monarchy society. But even as they criticized one portion of that class, they found support among its most enlightened and progressive members: intellectuals, art lovers, and art connoisseurs like Gautier, Sand, Dumas, the collector Alfred Bruyas, and the director of *L'Artiste* Achille Ricourt, among others, who bought and collected Delacroix's paintings, just as they eagerly acquired copies of Hugo's *Notre-Dame de Paris.*[75] In the 1850s, finally, his reputation sanctioned by his high public profile and his election to the Academy in 1857, his works became the unconditional favorites among art patrons high and low, spontaneously attracted to these entertaining images and shrewdly speculating on the ascending market worth of their maker.[76]

Gothic Lucre

A cluster of paintings spanning the whole length of Delacroix's career attests to his persisting infatuation with popular, dark Gothicism. In these works, the familiar tropes of Gothic intrigue are converted into visual strategies governing mood, imagery, and style.[77] Plots are filled with ominous forebodings, intimations of a guilty past, indications of a murder intended, madness, violence, and death. Somber colors, vague and empty spaces, and skillfully manipulated light and shadow enhance the atmosphere of suspense. In the uncertain candlelight of her darkened bedchamber, the dying Queen Christina of Sweden recognizes a former murderer in the attending monk Sentinelli, a scene inspired from Dumas's 1830 melodrama *Christine* (1835). Like another martyred Moncada dragged at the feet of the Inquisitors, the penitent Jane Shore wanders through the streets of London barefoot and clad in a white robe (1824). In a secluded cave, the nun Lélia, from George Sand's novel, mourns over the body of her

Fig. 19. Challiou/Bovinet, Illustration for Ann Radcliffe, *La Forêt, ou l'Abbaye de Saint-Clair* (Paris: Maradan, An VI [1798]), vol. 2, p. 82 (Photo courtesy of the Bancroft Library, University of California, Berkeley. PR 5202 R714 1798).

dead lover the poet Sténio while the mad monk Magnus, who is to strangle her with his rosary shortly thereafter, looms in the background (1847). The once mighty emperor Charles V is a dreamy monk in a cell playing his harpsichord to a mysterious novice (1831). Byron's guilt-ridden Giaour turned monk confesses to the killing of his rival Hassan in the oppressive secrecy of his convent cell (1835). A sister to the Gothic tale's *"nonne sanglante,"* as well as to a long line of forlorn Gothic heroines given to nightly wanderings amid ruined buildings, the murderous Lady Macbeth glides through the somber, deserted palace wrapped in a shroudlike drapery, lamp in hand (1849; Pl. 9). Lamp in hand and murderous purpose to boot, Othello creeps into Desdemona's dark room (1849; Pl. 8), much like Ann Radcliffe's character La Motte, in Chaillou's engraved illustration of *La Forêt ou L'Abbaye de Saint-Clair* (1798; Fig. 19). The heir to a series of incarcerated Gothic victims of aristocratic oppression (Fig. 20), the poet Tasso persecuted by his onetime patron, Alfonso d'Este, wastes in the prison-madhouse of Ferrara (1839; Fig. 21).

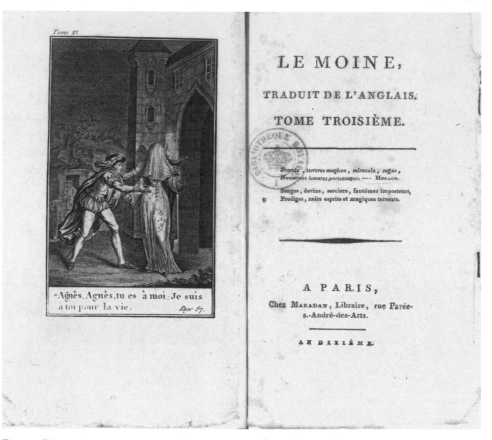

Fig. 20. "Agnès, Agnès, tu es à moi. Je suis à toi pour la vie." Frontispiece, M. G. Lewis, *Le Moine,* vol. 3 (Paris, Maradan, An X [1802]). Paris, Bibliothèque Nationale de France. (Photo: cliché Bibliothèque Nationale de France).

Modest in format, Delacroix's Gothic paintings were clearly intended for private ownership and private viewing. He funneled these works into the growing market of art collectors via a network of Parisian art dealers, including Giroux, Gaugain, Beugniet, Petit, Chéradane, Weill, Thomas, Tedesco, and the British art dealer Arrowsmith, with whom he maintained continuous business relations. Moreover, emulating the commercial strategies of publishers and writers of his time, Delacroix "serialized" his Gothic paintings to respond to market demands, producing them in multiple variants of size, color, and composition. Of George Sand's novel *Lélia,* whose 1854 illustrated *édition populaire* published by Michel Lévy Frères reached all levels of readership, he made two painted versions: one in 1847, for sale through the dealer Beugniet; the other in 1848, as a gift to the novelist who was his close friend. Likewise, his *Charles V at the Monastery of Yuste* came in three variants each of a different size, in 1833, 1837, and 1839. And he created two versions of his *Interior of a Dominican Convent.* The first, now at the Philadelphia Museum of Art, was acquired in 1836 by the duc d'Orléans for his private

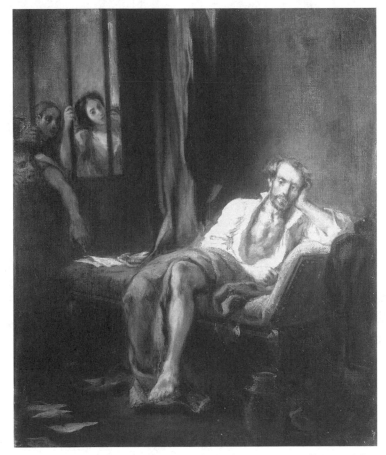

Fig. 21. Delacroix, *Tasso in the Hospital of St. Anna,* 1839. Collection Oskar Reinhart, Winterthur, Switzerland. Oil on canvas, 60.5 × 50 cm. (Photo courtesy Foto Marburg/Art Resource, NY).

gallery, a modernist display described by one contemporary as embracing *"toutes les belles témérités de l'art moderne."*[78] The second, a smaller replica intended for the Montpellier collector Alfred Bruyas, is currently at the Krannert Art Museum in Urbana, Illinois (1850).[79] In 1851 Delacroix offered his haunting *Lady Macbeth* to Théophile Gautier in homage and gratitude for his unwavering support through the years. Aggrandized and dramatized, finally, the structures of the horrific aesthetic found their way into Delacroix's grand Salon paintings, such as his *Massacres of Chios* and his *Marino Faliero,* with which we began. A climactic point was achieved with *The Death of Sardanapalus* (Salon of 1827–8; Pl. 3), whose histrionic grandiloquence echoed the grand contemporary melodramatic productions.

Indeed, in the end, it was the Gothic genre's potent aesthetic seductiveness that prevailed in Delacroix's mind. As late as 1860, reminiscing about his painting after Maturin in a letter to Gautier, Delacroix resumed unawares the mischievous humor of his youthful letters from Valmont:

The subject is taken from *Melmoth,* which you no doubt admire as much as I do, and the sublime story of the Spaniard who was confined in a monastery. He was dragged over broken glass and sharp points in the presence of the bishop, then whipped and flung into a foul dungeon together with his mistress. There follows the scene where, before they both die of hunger, the lover eats a piece of his beloved mistress's flesh.

With delightful tongue-in-cheek naiveté, he added: "[T]he story doesn't say what piece. I thought I had better not choose that scene."[80]

5 Orients and Colonies

Delacroix's Algerian Harem

Darcy Grimaldo Grigsby

Just returned from Leblond's. We talked a lot about Egypt; the journey costs very little. God grant that I manage to go there . . . In the meanwhile I must try to free myself from the ties that dull my mind and injure my health. Get up early in the morning. Think about learning Arabic . . . What can Egypt be like? Everyone is mad about it. . . . Living is cheaper out there. It would be best to go in March, and to come home in September; that would allow enough time to see Syria. Is it living to vegetate like fungus on a rotten trunk? I am completely immersed in the trivialities of my daily life.[1]

So wrote Delacroix in April 1824 at the age of 26. At the very outset of his career the painter was preoccupied by the dream of artistic and personal rejuvenation in the Orient. This comes as little surprise: Delacroix's oeuvre is associated more than any other with the romantic love for an exotic, sun-drenched, brilliantly saturated, and passionate Orient. But the artist's journal entry is more specific than this inherited tale implies. The Orient Delacroix sought was not solely a vaguely literary, imaginative space. It was precise, Egypt and Syria, and it was deeply rooted in French colonial history. Delacroix's "Orient" in 1824 was above all the Orient of Bonaparte and Gros, the site of imperial aspirations that were at once military, political, economic, *and* pictorial (Figs. 22 and 23). Bonaparte's Orient had been traversed by Frenchmen – soldiers and artists – who stood on its ground and hoped to seize control over it. Delacroix, the son of a Napoleonic administrator and brother of Napoleonic soldiers, was not content in 1824 simply to imagine that exotic, contested, and redundantly pictured space lost over two decades earlier: he wanted to go there. The young man's yearning was born of his belatedness, the epochal, generational distance between Gros's position in the Napoleonic Empire and his own during the Bourbon Restoration. If Gros had enjoyed the good fortune to live, in Delacroix's words, in a historical moment that matched his talents, the younger painter felt himself sadly destined to the sedentary nostalgia, the rotting vegetation, of the Restoration. Against the older artists' active engagement in Napoleonic military exploits,

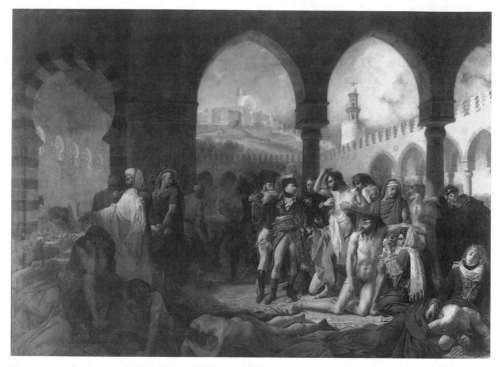

Fig. 22. Gros, *Bonaparte Visiting the Plague-Stricken of Jaffa*, 1804. Paris, Musée du Louvre. Oil on canvas, 5.23 × 7.15 m. © Photo RMN (Service de la Réunion des Musées Nationaux, Paris).

younger Restoration painters like Delacroix stood around Parisian billiard tables wistfully exclaiming, "Egypt! Egypt!" during an evening of gossip.

The artist was therefore in a difficult bind, aspiring to make an art whose very raison d'être and means of production had been exiled. The young man painted in the shadow of works like Gros's *Bonaparte Visiting the Plague-Stricken of Jaffa* (1804) (Fig. 22) and *Battle of Aboukir* (1806) (Fig. 23), Girodet's *Revolt of Cairo* (1810), and Géricault's later *Raft of the Medusa* (1819) – ambitious history paintings sharing epic scale, colonial subjects, and the exclusively masculine casts characterizing the homosocial culture of the school of Jacques-Louis David. In David's studio, the intensely invested relationship between master and competing male protégés generated powerfully affective, often homoerotic, paintings in which the classical male nude, the so-called *académie*, played a central, indeed foundational role.[2] The challenge facing the young artist who came to maturity after the fall of the First Empire was how to retrieve what the Orient could signify in Napoleonic canvases: how, in painting, to retrieve masculine prowess, both its inflated grandiosity and electrifying, visceral sensuality. Delacroix's answer was to shift the site of conquest to the domestic space he occupied. The young untraveled painter redefined the studio as the arena of colonization in which the foreign could be introduced and dominated even as it was valorized. Emulating the masculine iconography of revolutionary and Napoleonic art and studio practice, Delacroix's contemporary Horace Vernet, in

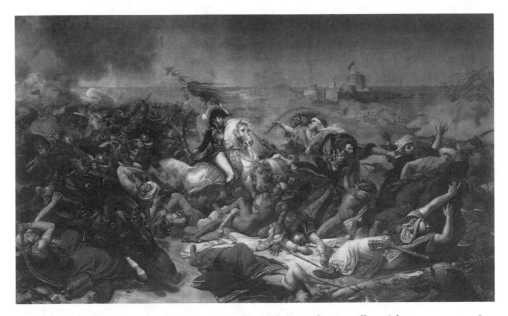

Fig. 23. Gros, *Battle of Aboukir*, 1806. Versailles, Château de Versailles. Oil on canvas, 5.78 × 9.68 m. © Photo RMN (Service de la Réunion des Musées Nationaux, Paris).

The Studio (1820), had depicted himself fencing in what could have been a jocular men's club, crowded with male friends and martial props. Delacroix, by contrast, redefined the studio as a private site for the sexual domination of women. Besides repeatedly "screwing," to paraphrase his Italian slang, his working-class models, Emilie, Hélène, Laura, Sidonie, and Zélie, among others, the young artist continually conflated (hetero)sexual intercourse and the act of painting. Delacroix's conception of the canvas as a "virgin" space requiring all his "juice" permitted his repeated confusion of fornication with real women and mastery over their pictorial counterparts.[3]

Not surprisingly, when a contemporary event finally presented itself to this young ambitious painter, this anxious inheritor to masculine Napoleonic art and painter of women, the results were confused and idiosyncratic. The subject itself posed a problem for Delacroix, a liberal who passionately admired Turks. Because the liberal cause célèbre was the Greek revolt against Ottoman rule, Delacroix was forced to paint on behalf of the Greeks. The result was an idiosyncratic picture that confused its first viewers. The *Massacres of Chios* of 1824 (Pl. 2) is a painting of a contemporary war that oddly disassembles a conflict purportedly between two peoples into a heterogeneous array of passive, despondent, and "orientalized" persons.[4] Critics looked in vain for a clear opposition, a sign of exemplary resistance and heroism, and saw instead, quite rightly, a misguided rescripting, *sans* Napoleon, of Gros's *Bonaparte Visiting the Plague-Stricken of Jaffa* (Fig. 22). Only Delacroix's imperious Turk rising up above the oppressive lid of the horizon managed to extricate himself from the queasy enmeshment of the painting's victims and he did so as the villainous abductor of

a beautiful, writhing, nude Greek woman. As Elisabeth Fraser has argued, Delacroix's contemporaries were discomfited by the moral ambiguity introduced by this woman's simultaneous victimization and pictorially authorized Rubensian beauty.[5] Understandably, the painting's ambivalence inspired uneasiness, even outrage, on the part of the philhellenic critics it purported to court.

Delacroix was not alone in his metamorphosis of Bonaparte's Orient into a space prominently identified with women. Over the past decade, artists like Ingres and even the military painter Horace Vernet had exhibited a number of odalisques, thereby replacing the exemplary and narcissistically seductive male *académie* with the exotic female nude. Many of the numerous paintings seeking to inspire compassion for the Greek cause also relied on an iconography of titillating female figures. Ary Scheffer's slickly painted, traditional pyramidal composition, *The Suliot Women* of 1827, for example, displays beseeching women who, upon defeat, chose suicide rather than submission to their enemy.[6] In Scheffer's picture, the women's partly draped, supine bodies wed pathos to the eroticism of female victimization. Pictures could, therefore, quite unproblematically present women as both victims and objects of delectation. Delacroix, however, unlike his friend Scheffer, compromised the fiction of the viewer's altruistic empathy with violated Greek women by offering a conflicting identification with the male aggressor.

In his next large-scale salon painting, Delacroix responded to the controversial reception of *Chios* not by excising male conquest but by shifting its context to the timeless realm of the odalisques rather than the contemporaneity of actual events that had dominated Napoleonic history painting. *The Death of Sardanapalus* of 1827 (Pl. 3) represents a retreat into a fantasized, literary Orient freed from the exigencies, pressures, and counteralliances of actual politics.[7] Liberated from the conflicts and imperatives posed by a real, if necessarily imagined, war between actual persons, Delacroix's 1827 harem extravaganza dissolved the gritty materiality, the congested, albeit illogical, dry thick muscular weight of *Chios* into a hasty, evanescent lather. The plot's unrestrained hyperbole – a supine sultan perched on an enormous vermilion bed orders the destruction of all his harem's treasures to avoid losing them to an enemy – is matched by a painting whose compositional confusion and loose handling attest to the slackness that results from a lack of circumventing restraints. The Orient fabricated in the privatized studio proved to be tedious, vapid, and embarrassingly self-revelatory despite the complexity of its Byronic literary inspiration. The circling dance of interchangeable nude women fails to secure the unimaginable phallic authority of an oriental despot whose diminutive head retreats from a swaddled body, which despite, or rather because of its preposterously enormous limbs, collapses into a uterine concavity.[8] The painting's excessive subject, spatial disequilibrium, illogical composition, and lurid palette ensured its notoriously hostile reception. The failure of *Sardanapalus* would haunt the artist, but the impulse to give form to an Orient identified with his own (hetero)sexual prowess would continue to determine his artistic choices.

What the painter desperately needed were some material constraints to the crude and ultimately far from interesting plot he had devised for his picture making within the confines of his Parisian studio. He needed constraints, and, paradoxically, release from his atelier would provide them. In 1830 just prior to its fall, the Restoration government had at last offered its painters a war as well as a colony by invading Algeria, the most powerful and most resented of the Barbary regencies. Eight years after his ineffectual plans independently to travel to Egypt, colonial history and a government mission would enable Delacroix at last to step foot in the Orient of pictorial as well as political exigency. Significantly, however, he would travel not to the site of war, not to a still resistant Algeria, but to neighboring Morocco as part of a diplomatic delegation seeking that regime's acceptance of the French seizure at its border. On 25 January 1832, Delacroix landed in Morocco with the diplomat comte de Mornay. Delacroix's aspiration had been realized; the moment within which he lived finally matched the epic scale of his ambitions. The question was whether it suited his talents as well as the Napoleonic Empire had suited Gros's.

Upon arrival, Delacroix immediately attempted to translate his experience into words and images and wrote to a close male friend:

> We have disembarked in the midst of the strangest people. The pasha of the city received us in the midst of his soldiers. It would require twenty arms and forty-eight hours per day to give an adequate idea of all this. The Jewesses are admirable. I fear that it will be difficult to do anything other than paint them: they are the pearls of Eden. Our reception was the most brilliant for this place. They regaled us with the most bizarre military music. I am at this moment like a man who dreams and who sees things he fears will escape him.[9]

Suddenly set down in the midst of "the strangest people" and a crowd of soldiers, Delacroix instantly began to fret about the challenges the foreign posed to his pictorial practice. The painter paused, however, to find solace in the ornaments with which he was familiar, a feminine string of pearls. Disoriented and alienated by the "bizarre" martial ceremony of strange men, Delacroix discovered a site of continuity in the beauty and sexual desirability of women. On his first day in Morocco, Delacroix's letter betrayed a reflex that would characterize but fundamentally problematize his experience as artist-interloper. For Delacroix's time in North Africa would be dominated not by private intercourse with women, but by public often threatening interchanges between men. Voyages necessarily disrupt studio practice, but for Delacroix such a disruption also challenged the very (gendered) premises of his picture making. To rob Delacroix of his Parisian studio was to trouble his conflation of pictorial and sexual mastery.

The Moroccan notebooks and drawings consequently attest to the pressures put on Delacroix's artistic process as well as the novelty of their function.[10] In Morocco, mastery would have to assume a different, provisional, and quantitative character: it would be forced to change form as well as subject and purpose. Efficiency in the registration of observations was clearly imperative as Delacroix

hurriedly created an archive for future studio performances in Paris. Album pages pragmatically intersperse text, drawings, and watercolors (Fig. 24).[10] Words bear much of the burden of conveying narrative situations as well as classifying. Although the shape or disposition of a turban, robe, or building was more easily described in a drawing due to the Frenchman's limited vocabulary for such distinctions, Delacroix was better equipped and more satisfied with his linguistic classificatory categories for colors and persons. The artist was trying above all to provide himself with aides-mémoire for pictures, not for an ethnographic account or a travelogue. He was not particularly interested, for instance, in the classification of inhabitants. Four terms alone, *Moors, Negroes, mulattos,* and *Jews,* functioned as his primary ethnic categories; not, one should notice, *Berber* or *Bedouin* or *Kabyle.* Often *Negro* and *mulatto* seemed to signify color as much as ethnic or racial identity; a simple contour drawing of a figure on a white page is frequently coloristically as well as racially defined by the word *negro,* for example.

Although many figures are isolated against the blank paper in order simply to describe costume or pose, the artist was also consistently attracted to the interplay of skin color and lighting effects. Both in drawings and words, he notes dark-skinned men against lit interiors or pale men sitting in the dark recesses of

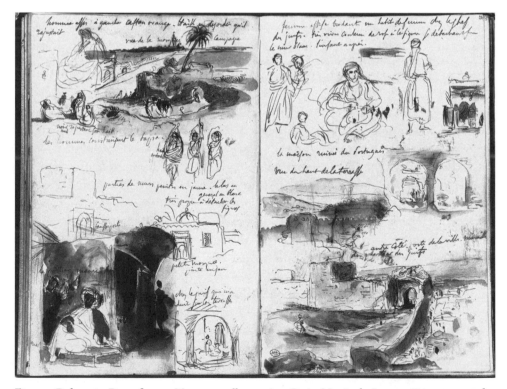

Fig. 24. Delacroix, Pages from a Moroccan album, 1832. Paris, Musée du Louvre. Département des Arts graphiques RF 1712 bis, 23 verso and 24 recto, 19.3 × 12.7 cm. © Photo RMN (Service de la Réunion des Musées Nationaux, Paris).

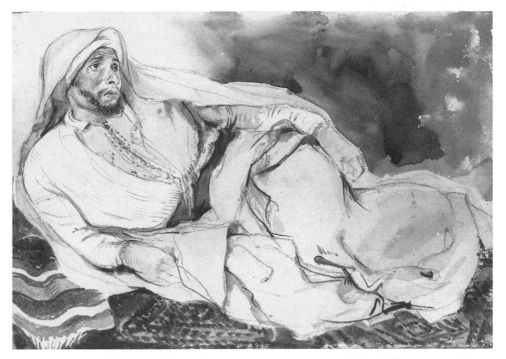

Fig. 25. Delacroix, *Arab Chieftain Reclining on a Carpet,* 1832. Paris, Musée du Louvre. Département des Arts graphiques, 19 × 27.4 cm. © Photo RMN (Service de la Réunion des Musées Nationaux, Paris).

a building or the luster of a sun-lit black man washing his black horse, "the negro as black and as glistening."[11] The emphasis then is on subtle lighting effects playing over quite schematically conceived skin colors. Only occasionally does a notation like "black moor squatting – small negro nose" indicate some attention to the subtle mixing of "racial" codes and to physiognomic traits associated with race.[12] The painter of the victorious Turk (*Chios*), the black slave (*Sardanapalus* and *Greece on the Ruins of Missolonghi,* 1826), and the "mulatta" (*Aspasie,* 1824) arrived in North Africa with a fairly crude template, and, with the significant exception of his acquired knowledge about Jews, he left with it pretty much in place. What he had learned, however, was a great deal about costume, setting, lighting, and Moroccan men's public behaviors and practices.

Those public behaviors among men posed their challenges. To begin with, as Delacroix confided in a letter, "Their prejudices are great against the beautiful art of painting, but a few coins here and there will appease their scruples."[13] The exchange of cash for belief likely accounts for many of the artist's individual drawings of inactive men posing, often in unmarked, implicitly interior, spaces, but also outside (Fig. 25). Indeed, indolent men – reclining, sitting, leaning – dominate his figural production. Everywhere, it seems, there were passive men conveniently posed for an artist's prolonged study; monumental *académies* often mysteriously blanketed, erotically enveloped. Yet the ease of observation suggested by these drawings is misleading. Moroccan hostility was directed not only

at the foreigner's picture making but at the foreigner himself. In North Africa, the Frenchman's wandering eye could not glide through the world disembodied and unseen, like a Parisian *flâneur* strolling the boulevards. Instead Delacroix continually made pictures in a crowd, safeguarded sometimes in Tangiers only by Abraham ben-Chimol, his Jewish guide, who told him when to put the sketchbook away, and at others, by regiments of soldiers needed to control an aggressive and hostile crowd whom Delacroix continually described as thrusting their bodies as well as their insults, stones, and gunfire "under his nose."

Besides being assaulted by the crowd, the painter and his fellow travelers were also repeatedly subjected to ceremonial performances of violence, the *courses de poudre,* equestrian demonstrations of firearms, whose dangers were none the less real for being spectacular. The painter was well aware that "at the reception of the Austrians who came six months ago, there were twelve men and fourteen horses killed by accident. Our small troop had much difficulty remaining together and finding each other in the midst of gunfire directed at our figures."[14] Delacroix was therefore imperiled by foreign men but, unlike the Napoleonic draftsmen who preceded him, he was not a Frenchman in the midst of war. Instead the belated traveler experienced a strangely alienated version of military violence among men, not heroic combat but diplomatic ceremony in which hostile Moroccans enjoyed the opportunity to shoot and Frenchmen were forced to duck.

None of Delacroix's drawings convey this menacing often claustrophobic assault so vividly and subjectively evoked in an occasional notebook notation – "my fear" – and many letters: "how tempted one feels to get angry."[15] Instead the drawings consistently remove the body of the artist from the scene and repeatedly assert a measured distance between disembodied observer and embodied observed. There is violence but it is a violence that, unlike the aforementioned letter's description, appears self-contained, a powerful unstoppable eruption, typically directed laterally, not toward the draftsman and viewer, and thus seemingly independent of the presence of Frenchmen. In drawing after drawing of charging Moroccan men on horseback as well as subsequent paintings, we see that half of Napoleonic military painting's syntax has dropped away (Fig. 26).[16] Oriental warriors no longer shoot at a European enemy; indeed they do not fire on anyone at all. The violence of Moroccan men across the horizontally disposed space of the Orient is simply, the pictures propose, the other side of their split nature: purposeless, undirected aggression punctuating prolonged periods of indolence. (This is what they do and have always done there.) That Frenchmen and Algerians and some Moroccans were killing one another nearby in a violent struggle to secure control over that ambiguously suggested North African landscape one would never know.

Instead the painter sublimated Moroccan animosity and threatening violence against his person into pictorial value. One letter conveys Delacroix's attempt to aestheticize and thereby familiarize the threat, even repugnance, of the foreign:

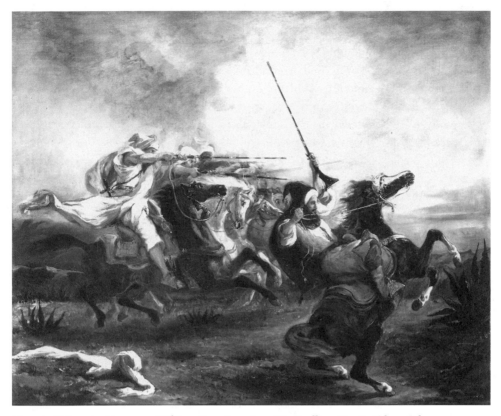

Fig. 26. Delacroix, *Moroccan Military Exercises,* 1832. Montpellier, Musée Fabre. Oil on canvas, 59 × 73 cm. Photo courtesy of the Musée Fabre, Montpellier. Cliché Frédéric Jualmes – reproduction interdite.

> Then you are surrounded by an execrable crowd for whom the Christian dress and figure are execrable and who say to your face all possible injuries, which happily you do not understand. It requires all my curiosity to brave the [insults] of this *canaille*. The picturesque abounds here. At each step there are tableaux already made which would make the fortune and the glory of twenty generations of painters. You believe yourself in Rome or Athens without the Atticism, but with the robes, togas and a thousand other of the most antique details. A rogue who repairs shoes for a few pennies has the dress and the form of a Brutus or a Cato.[17]

In this rush of disjunctive observations, Delacroix transforms the *canaille,* the unruly mob that had recently once again forced revolution on France, into the "picturesque." Removing the hostile crowd from the streets, Delacroix frames them as pictures, pictures moreover that would bring success to painters because this culture miraculously, one might say deceptively, managed in the eyes of outsiders to transform working-class "rogues" into classical heroes. Unlike the mob of Paris, the Moroccan crowd appeared the stuff of painting. In his commitment to appearances, Delacroix could recast the North African

canaille as sanctioned, dignified models of beauty, now drained of the burden of Davidian exemplarity.

However, the resemblances Delacroix repeatedly noted between Morocco and classical antiquity entailed frustrations for the painter who had distanced his art from homosociability and an exclusively masculine iconography: "This people is completely antique. This exterior life and these houses carefully closed: the women retired etc."[18] If Muslim men, whether threatening or inactive, were outside, Muslim women were inside. If Muslim men were everywhere visible, and visible in ways that seemed to render private behaviors public, for example, lying in streets as if in beds, Muslim women remained everywhere invisible. Delacroix was inevitably frustrated by the ways he was locked out of intercourse with Muslim women. Not only were their houses off limits but even their terraces could be gazed on only at tremendous personal risk. Delacroix could compensate for this deprivation in two ways, neither apparently entirely satisfying to him: by redirecting his gaze from Muslim women to Muslim men, or alternately, to Jewish women. Of course, the painter had immediately recognized that Jewish women were no more sexually accessible than "Moorish" women, but, at least, through the mediation of ben-Chimol, they were visible to him. Their lovely faces and ornate costumes and jewelry fill Delacroix's drawings, particularly the album now at Chantilly, which attests to a prolonged, even intimate, engagement with this community.[19] Nevertheless, Delacroix seemed already to have had another subject in mind. As early as 12 February, some three weeks after his arrival in Tangiers, he managed not only to find what he called an "Algerian woman's costume" but to draw a Jewish woman wearing it; he had earlier drawn another Jewish woman as a "Moor."[20] Repeating his Parisian studio habits, Delacroix was dressing women to play parts. Jewish women interested him but he was compelled to recast them as the Muslim women to whom he had no access, even as Muslim women who resided not in Morocco, but neighboring Algeria. From the outset of his voyage to Morocco, Delacroix wanted to paint the women of France's new colony.

At the Salon of 1834, two years subsequent to his return to Paris, Delacroix exhibited his first large-scale painting inspired by the Moroccan journey, what one critic called "the fruits of his voyage to Africa."[21] Delacroix's largest picture of 1834 addressed none of the subjects dominating the notebooks. It depicted neither men on horseback nor men in repose nor the North African landscape nor its architecture nor the Jewish community. Significantly, Delacroix did not offer his Salon audience a large-scale version of those beautiful, languorous, often reclining, men whom he had observed outside and paid to model inside. Instead he metamorphosed those seductive men into the sequestered women whose invisibility and inaccessibility had haunted his writings. He situated these women, moreover, not only in their private interior but in France's colony Algeria where he had spent less than three days during his six-month visit. Like *Chios*, *Women of Algiers in Their Apartment* (Pl. 6) is a painting deeply imbricated in both colonial politics and Delacroix's (hetero)sexualized pictorial process.[22] Here

after a stimulating, disorienting, alienating, and tedious voyage, Delacroix returned to the comforting familiarity of his earlier studio practice by choosing a subject perfectly suited to his own artistic and psychic propensities. No artist was better suited to exploit the fit between Parisian atelier and North African harem.

In 1824 Delacroix's harem fantasy had oddly inflected his purportedly phil-hellenic representation of the Greek war of independence by proposing an iden-tification with the Turkish despot's victimization of the seductive Greek woman with whom Frenchmen claimed to ally themselves. In 1834 the French seizure of Algeria permitted a simpler, less contradictory exploitation of the correspon-dence between sexual and political conquest: the Algerian sultan would be dis-possessed by the Frenchman who claimed his prerogatives. As popular prints continually emphasized, to wrest Algeria away from its ruler was to claim his harem, his property.[23] Delacroix therefore exploited, as Todd Porterfield has argued, a pervasive fascination.[24] Purportedly having entered a harem in Algiers due to the intervention of a colonial administrator, he delivered to his Parisian audience the harem won as a consequence of military victory.[25] The painter made available to every Frenchman the space previously under the lock and key of the solitary Oriental despot, now disempowered.

This is the political import of representing an Orient unveiled. But unveiling is, of course, an intensely charged and anxious act. It was precisely because the harem functioned as the ultimate form of military spoil that it was also the site of greatest anxiety and dissension. In the proliferation of prints about the Alger-ian conquest, the harem appeared only occasionally as a form of treasure. Most frequently it was featured in anticolonial images in order to deride the mis-guided Algerian campaign. The harem – personifying Algeria itself – was a space of promise, but also suspense, menace, and disappointment. Caricaturist after caricaturist exploited the joke of the treasure that proved to be a booby prize. In such prints, the "booty" sought by bumbling, unsophisticated, and desirous French soldiers was revealed to be only women's bodies, and not particularly attractive ones at that.[26] In one image, Frenchmen arrived in Algeria seeking to reenact the rape of Hersilia, each man singly carrying off his lithe, elegantly spi-raling victim, and were forced instead collectively to bear the overwhelming bur-den of the massive, homely Sultana (thereby inverting the harem paradigm: Rather than an abundance of women for each man, here each woman required a crowd of men). In such caricatures, Frenchmen simplemindedly risked life and limb to grab what they were told was their reward and found only old, fat, or motley white women, or large, full-breasted, sometimes shockingly denigrated black women, or, in one especially disturbing image, a monkey instead (Figs. 27 and 28).[27] In many prints, the harem, like Algeria, seemed to have promised the Orient but delivered in its place a devalued repugnant black Africa. Algeria, in such racist anticolonial images, was a degraded black woman rather than the traditionally prized white harem woman, Georgian or Circassian, imported from the Caucasus region and celebrated in paintings like Ingres's *Grande Odalisque* exhibited at the Salon of 1819.

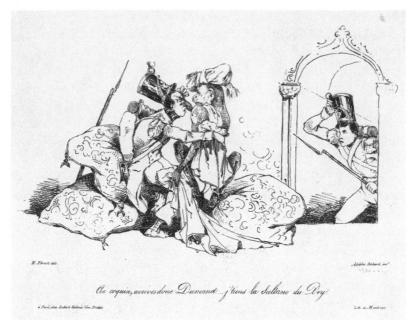

Fig. 27. "Prize of the Seraglio. . . . I Have the Dey's Sultana" (*Prise du sérail. Ce coquin, arrives donc Dumanet . . . j'tiens la Sultane du Dey*). Lithograph by E. Forest and Adolphe Richard (Paris: Aubert, 1830). Paris, Bibliothèque Nationale de France, Cabinet des Estampes. (Photo: cliché Bibliothèque Nationale de France).

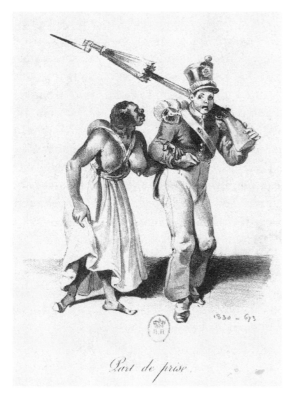

Fig. 28. "Prize-Money" (*Part de prise*). Lithograph by Lemercier (Paris, 1830). Paris, Bibliothèque Nationale de France, Cabinet des Estampes. (Photo: cliché Bibliothèque Nationale de France).

The harem was therefore a particularly fraught space well traversed by both traditional and contemporary French literature and imagery, including Delacroix's own debacle, *The Death of Sardanapalus*. Delacroix had selected the simplest, most self-evident, and resonant subject for his debut as a painter of North Africa. He knew only too well, however, that he had also chosen a subject that was vulnerable not only to projection but to devaluation, even mockery. The literary hyperbole of *Sardanapalus* had been received with derision. Delacroix's response was to turn toward the tantalizing glimpse of an actual colonial harem, but by 1834 the Algerian harem had also become a trafficked and derided space. Although Delacroix has been credited as the first artist to open the colony's harem up to view, it is important to stress that the Algerian harem had already been brutally unveiled and ridiculed. In the *Women of Algiers*, the artist would have to contend not only with the notoriety of his 1827 painting but with the desacralization of the Algerian harem (*haram* means sacred) in popular imagery.

Delacroix's response to such pressures was to reconstruct the interior – "in their apartment" – and to cast a dignified hush over a space that had been the site of disorderly commotion in popular prints as well as *Sardanapalus*. Here are dressed women who, self-contained, even remote, impassively occupy a calmly logical space. In the caricatures, foolish Frenchmen tried to force women out of the harem, to abduct and thereby exteriorize the treasure. In *Women of Algiers*, Delacroix insisted on the harem's removal, interiority, and stasis, and excised those bumbling men from view. The Parisian spectator became one more invading Frenchman but a wiser, more decorous one who knew that the value of the harem woman resided in her occupation of a separate interior space. Delacroix stressed that the viewer had been allowed *in* not that the harem women had been forced *out*.

And, against the crude exaggerated character of the prints, he produced a painting that was grand, magisterial, quiet, and elegant, as well as forthrightly declarative of its serious ethnographic and aesthetic credentials. The power of the picture resides in its successful integration of discrepant descriptive and generalizing registers. On the one hand, the tableau flaunts Delacroix's new-found knowledge in its plethora of sumptuous details that describe how things look: patterns of tiles, pillows, rugs, jewelry, and fabrics. No matter that the Arabic script says nothing; its effect in the Parisian salon was to suggest a hard-won empirical expertise.[28] On the other hand, those details are everywhere subordinated to the self-evidently painterly handling of the composition's overall atmospheric lighting: the dusky late afternoon interplay between golden light and veiling, cushioning shadows.

Similarly, Delacroix renders harem women visible but he carefully suppresses the visceral specificities of female flesh. Compared to *Chios* and *Sardanapalus* or the small nude odalisques painted in his studio in the 1820s, paintings like *Woman with a Parrot* and *Woman in White Stockings*, the *Women of Algiers* is remarkably withholding of corporal physicality, of the breadth and volume and surfaces of women's bodies. If limbs are everywhere visible, much else is not.

Look for instance at the remarkable refusal to offer the swelling volume of breasts. Each of the women wears a low-cut blouse, but a flat expanse of inert pigment refuses to articulate cleavage. There is no access here; indeed there seems to be no knowledge. Instead the sensuous rise and fall and luminosities of the female body are suggested by the marvelous pulsation of partially transparent cloths, places where fabric and flesh are confused in the inhalation and exhalation of a flickering surface. Delacroix had put his intensive study of and forced reliance on costume to good use – cloth here is the vehicle through which flesh is imagined and materialized. The women then are metaphorically transmuted into luxuriant stuffs; they are both made visible and withheld in the ornamented, richly variegated surfaces of the Orient's things. Delacroix had not had access to the Oriental woman's body but, in his observation of enveloped men and women, he had become finely attuned to the erotic charge of fabric caressed, sometimes penetrated, by light.

Delacroix's harem is therefore sensual as well as decorous, generalized as well as ethnographic, generous as well as withholding, and white not black. The black woman who served as a demonic, foolish, or repugnant specter in the caricatures is figured by Delacroix as a discreet foil. If he had repeatedly noted "negresses" in his voyage sketchbooks, pausing to describe in both text and image a black woman running toward him with "tits" [*tétons*] visible beneath her blouse, he chooses in his salon painting to turn her away from the viewer.[29] The standing servant serves at once to define the seated harem women as white not black and to mediate between the apartment's interior and the picture's exterior. Her hovering role recalls the conclusion to the notebook annotation just cited: "This exterior life and these houses carefully closed: the women retired etc. The other day, a quarrel of sailors who wanted to enter into a Moorish house: a negro threw a slipper at their noses etc."[30] The interior that sequesters the odalisque is guarded by the negro whose slippers serve as ready missiles. Africa is not Algeria's sensual center but its border guard. In Delacroix's painting, the new colony still promises its "Oriental" treasure – white women, textiles, gold, and jewels. Delacroix had repeatedly admired the "primitive" simplicity of the white-robed Moroccan, cleansed of "Turkish alloy," but when it came to delivering the French colony to his salon audience, he emphasized Ottoman-style wealth and luxuriance.[31]

In *Women of Algiers,* the harem is richly intact. Indeed, even in its revelation, it retains some of its mysterious allure, the veiling shadows, the deep darkness of its recessive spaces, the promise of those brilliant reflections in the blackness of its partially opened cupboard. Given the crude, bawdy, and ridiculing tenor of the numerous prints rebuking the Algerian campaign and the harem's false illusions, Delacroix had managed quite effectively to recuperate a tarnished ideal and in so doing to bolster the colonial promise. But his painting too was subject to viewers' projections, especially given that colonial ambitions were complex and entirely undecided in 1834, especially given the ways women's bodies consistently serve as screens.

Although Delacroix had carefully returned a grand stasis to the trafficked

space of a colonized harem, many reviewers worried that he had failed to make history painting. Critics' repeated recourse to images of nothingness and absence in their description of Delacroix's painting – "this composition signifies nothing" – suggests an apprehension of a loss of narrative.[32] Most simply, these writers were criticizing the tableau's renunciation of the exemplary action traditionally requisite to history painting: Delacroix had, after all, replaced large-scale Napoleonic battle painting with "Oriental" women as still life. Delacroix had seized the precedent of the odalisque, but he had audaciously magnified its size to that of history painting. By excising the male abductor who had proven problematic whether due to his villainy (*Chios*), passivity (*Sardanapalus*), or foolishness (prints), Delacroix had managed to recuperate the harem, but a large-scale picture of a harem solely occupied by women could, in relation to history painting, seem a non-event; indeed, despite its sheer material and symbolic plenitude, a semantic void. Stasis was too easily confused with absence: absence of value, absence of action, absence of history. Absence of phallic mastery: the male abductors, however problematic, were missed by many. Only a minority of critics, above all Alexandre Decamps and Gustave Planche, proposed a defense of the tableau's *"rien"* as Delacroix's masterful accomplishment of pure painting, pictorial effects remarkably freed of the narratives that had distracted the viewers of earlier, semantically saturated works like *Liberty Leading the People* (1831) (Pl. 5). Here were Algerian women who (unlike Parisian women) signified nothing and could therefore permit the expression of painting and painting alone. "It is painting and nothing more."[33]

Attributes of painting are seldom held apart from the women depicted, however. It was impossible not to conflate Delacroix's style and his harem women. Several critics condemned the artist by castigating his *houris'* failure to elicit desire: "Let's say it, if this is the type of Mohammed's women, let us not become Turks soon."[34] Another writer, accepting that personal taste would determine whether these harem women seemed attractive to Parisian viewers, resorted to the criterion of accuracy rather than appeal when he insisted that Delacroix's figures deserved appreciation.[35] The representation of the harem that made claims to ethnographic veracity could be defended on the basis of authenticity but not without risk. Although Ingres's *Grande Odalisque* could be rejected or appreciated as a demonstration of Ingres's taste – his pictorial ideal – Delacroix's *Women of Algiers* understood in relation to his actual voyage confused representation and the purportedly represented. If you did not like Delacroix's style or his taste in women, you were also subjected to doubts as to whether you liked Algerian harem women. A painting of the colony's most treasured women might suggest they were undesirable.

Ultimately the problem was this: the colony's harem could not be materialized even by as expert a poeticizing painter as Delacroix and remain a harem. To render concrete the imaginary ideal was de facto to undo it. Despite critics' anxieties regarding its blunt nothingness, the harem was a space that would not remain, as Decamps and Planche had hoped, merely, sheerly, pictorial. In fact, it

too easily compelled narrative. As hard as Delacroix had worked to block the predictable and tawdry tales spun by the caricaturists, his tableau would be read and it would be read as a story about the French colonization of Algeria.

No critic better described the quandaries plaguing the painter of colonial subjects than the reviewer for the newspaper *L'Impartial* who compared Delacroix's tableau to a work by Colonel Jean-Charles Langlois, a specialist in battle paintings and panoramas who, like Delacroix, had also recently been in Algeria. Significantly, although Langlois also exhibited a Napoleonic-style painting of a recent French military victory in Algeria, *The Battle of Sidi-Feruch*, this critic focuses on his *Portrait of the Wife [femme] of a Rich Inhabitant of Algiers*. He begins by opposing Parisian politicians who founder in debates about the colonization of Algeria to the artists who pragmatically began the hard work of colonists. Nevertheless the job this critic expects artists to perform proves to be as undecided and rife with contradiction as colonial policy. Rejecting landscape painters of the Orient as fabricators within their Parisian studios, the reviewer argues that those artists who courageously make "excursions into climates of fire" should tell truths. They should provide material evidence of the "gains" made by French civilization, its progressive entry into the colony's most impenetrable spaces, above all, he implies, the spaces of its women, its *"femmes."* Artists and writers alike were therefore, as Edward Said has famously argued, expected both to tell truths and to deliver what was already taken to signify the Orient.[36] Only by doing so could a French audience appreciate its nation's colonial success. The author's astonishing presumption that Langlois's *"femme d'un riche habitant d'Alger"* was the wife or mistress of a French colonist rather than a native Algerian indicates the eagerness to claim such a proprietary relationship to the colony's women.

However, while *L'Impartial*'s critic trots out all the clichés associated with the harem – its mystery, remoteness, and voluptuous, luxuriant indolence – he also values the signs of the impact of French intervention: "It seems that French civilization reaches closer and closer, and that she already has effected miracles if one believes the somewhat negligent pose and somewhat heterodox costume of the *Wife of a Rich Inhabitant*." Significantly, the progress of colonization is made visible in the *nonconformity* of women to timeless Oriental customs: it is the wife's "negligent pose" and "somewhat heterodox" costume that signals her entry into a French as opposed to indigenous social system. For this critic, colonialism is made manifest in change, *not* in an ethnographic mapping of an unchanging culture.[37] Like the popular prints, *L'Impartial*'s reviewer emphasizes that the colony's women must be made the property of exchange between Frenchmen not Algerians. But, turning to Delacroix's tableau, he also betrays that such an appropriation collapses the very difference at once desired and abhorred by Frenchmen:

> M. E. Delacroix has entered even further into the confidences of the rich inhabitants, at least one is allowed to believe so because he has dared to introduce us with him into the residence of the city's women and into the

most secret of their apartments, the corner where they rid themselves of their slippers to smoke and do nothing. . . . Has M. Langlois embellished the sultanas of M. Delacroix by making them mount the sofa? [Or] has M. Delacroix made the sultana of M. Langlois ugly by making her recline on the earth? . . . The only difference, I suggest, is that the Georgian on the sofa appears much more distinguished, while the Georgians with only legs for armchairs have an unceremonious air which immediately puts you at ease. Their large round and illuminated heads, their eyes without eyebrows, their somewhat common poses and gestures prove moreover that they belong to this respectable class of working-girls [grisettes] who undoubtedly close their doors no more carefully in Algiers than in Paris.[38]

The harem's impenetrability rendered it the most urgently desired space to penetrate. However, its opening as a result of colonial gains abruptly rescripted the inaccessible harem woman as an object of European economic exchange. The open door evoked at the end of this consideration of Delacroix's tableau is a door permitting the flow of cash and women in the economy of prostitution as well as colonization. Only the decorous height of a sofa seemed to preserve the prestigious indigenous wife from descending to the depths of the all too "common" and all too familiar *"grisette."* "What poverty!" one critic exclaimed before Delacroix's painting; how "vulgar" raged another.[39] Rendered visible, "priceless" Oriental femininity sadly entered the economics of class. Doing "nothing" quickly slipped into doing the basest kind of work.

Colonialism therefore, like the representation of the harem space, threatened not only to devalue the Orient's most famous "treasure" but unacceptably to collapse two (segregated) registers of colonial desire: the romanticized, indeed aestheticized, fantasy of sexual fulfillment and the workaday drive for commercial profit. The harem made visible to the Frenchman could no longer be the harem fantastically removed, an imaginatively, titillatingly inviolate site of one man's supreme sexual fulfillment. Colonized, it was instead the space of a commerce in women by a crowd of men. If not individually, monogamously, anchored to a male proprietor (*femme d'un riche habitant*), Algerian women (*les femmes d'Alger*) could be understood to circulate among many, thereby rendering men as interchangeable as their female objects of exchange. The male despot pictured in *Chios* and *Sardanapalus* had posed difficulties of alliance and authority, but to replace him with an endless stream of viewers was to compromise the fantasy of ultimate masculine potency.

To read Delacroix's *Women of Algiers* as a performance of the most powerful, symbolically resonant colonial prerogative is therefore to describe only the captivating promise of both the tableau and the French colonial project, not their inadvertent consequences: the detumescent unease attendant on loss, the loss of despotic sexual power, and perhaps more importantly, the loss of fantasized difference, that is, the loss of the allure of the colonial object. Even Delacroix's grand, solemn painting was haunted by the crowd of men circulating familiar and unattractive women in contemporary prints. Colonial promise had already in 1834 come to be tainted by the tawdry even humiliating realities of colonial

commerce. In Delacroix's painting, the luminous pocket watch that so prominently hangs at the central woman's breast functions as a token of exchange, a sign of the heterodoxy, the impact, that simultaneously promised and robbed the Frenchman of his treasured colonial object. The colonizer's access to the harem meant his loss of it.

It would be wrong, however, to end here in the vulnerable, prostituted space of the colonized harem. To do so would be complicitous with the achievements – however fragile and compromised – of Delacroix's beautiful painting. Let us return, even briefly, to the outside. In 1833 a government commission submitted a report harshly condemning French conduct in Algeria:

> We have seized private property without any payment. . . . We have profaned temples, tombs, interiors of houses, sacred asylums for Muslims. . . . We have massacred persons granted safe-conduct; we have on a suspicion murdered entire populations who proved to be innocent. . . . In a word, we have outflanked in barbarism the barbarians whom we came to civilize.[40]

Delacroix's painting exhibited a year later may have been incapable of removing itself entirely from the sordid repercussions of colonial speculation, but, relative to reports like these, it brilliantly managed to distance the colonial project from the tragic realities of its despicable violence. Ultimately, to assimilate the colonization of Algeria to a derogatory image of Parisian prostitution was to perpetrate a deception by domesticating its brutal rape. (What did harem women, even if irrevocably recast as modern prostitutes, have to do with the colonizers' sale of jewelry still hanging from the shredded parts of women's bodies subsequent to a massacre in 1832?).[41] To liken the colony to a harem turned brothel was, moreover, to render invisible the war and the fact of Algerian resistance. That Delacroix's voyage was to Morocco not Algeria may have been decisive to his subsequent embrace of the Orientalist dream, a dream in which men performed ritualistic, ceremonial violence directed against no one, and women remained flickering jewels within the shadowy, cushioning recesses of their gold-rimmed boxes.[42]

Throughout his life, Delacroix would return to the subjects and pictorial solutions inspired by his voyage to Morocco. The mature painter would depict warfare among Oriental men in rapid, gestural paintings like *Arabs Skirmishing in the Mountains* of 1863, as well as their seemingly unmotivated, irrational violence in congested pictures like the two versions of *The Fanatics of Tangier* (1838 and 1857). Delacroix would also return to the scenes depicted in the notebooks, not only Arabs playing music or a Jewish wedding, but also indolent men and women. Over a dozen years after his voyage, Delacroix would also return to his colonial harem, producing a couple of variations of the *Women of Algiers* and several related odalisques.

The older artist was convinced that temporal distance from his youthful voyage had permitted him pictorially to distill its significance: "I only began to do something acceptable, on my voyage to Africa, when I forgot the little details

and instead remembered in my paintings only the striking and poetic; until then, I was pursued by the love of exactitude which most people take for truth."[43] The forgetting evoked here in the name of poetry had necessarily already begun in Morocco – all representation requires editing – but elapsed years would entail further significant losses. The specificity of the painter's actual encounter with an unfamiliar culture would in his later paintings be increasingly subsumed within an Orientalist idiom whose generalization collapsed the very differences – between pictorial genres as well as persons, times, and places – that had made his early works so forcefully if problematically idiosyncratic. The productive tension and discomfort, the searching, desperate experimentation and urgency of the artist's first struggle to make history painting out of the Orient would relax into a comfortable production of similar images. In Delacroix's mature, relatively small-scale Orientalist paintings, Greek subjects like *Episode from the Greek War of Independence* (1856) cannot easily be distinguished from literary works like the Byronic *Combat of the Giaour and Hassan* (1835) (Fig. 52) or from Moroccan-inspired pictures like *Arab Saddling His Horse* (1855). The distinctions between contemporary politics, history, literature, and ethnography were increasingly forfeited in small pictures whose redundancy flaunted in their place a signature style. The extraordinarily disparate although confused genres and Orients of *Chios*, *Sardanapalus*, and *Women of Algiers* were ultimately assimilated into a practice dependent not on the specific tensions engendered by generic, cultural, and historical pressures but on Delacroix's performative capacity to alchemize the frisson of the foreign into "poetry."

Eight years after exhibiting *Women of Algiers*, Delacroix retrospectively assessed the repercussions of French colonialism. In a text recently discovered by Michele Hannoosh, the artist indicated, in terms akin to the 1833 government report, a poignant and quite moving awareness of the tragic implications of the French conquest of Algeria.[44] However, by 1842, Delacroix had become fluent in the transformation of brute matter into pictorial value, the metaphorization of male violence and female sexuality into bravado exercises of "nothing" but painting. Despite the reservations he nurtured privately, the painter exploited this talent for the rest of his career.

6 "A Science and an Art at Once"

Delacroix's Pictorial Theory and Practice

Petra ten-Doesschate Chu

Introduction: The Legendary Colorist

During his lifetime and especially after his death, Eugène Delacroix was hailed as a powerful agent of renewal of nineteenth-century painting. Most critics agreed that his originality was most clearly seen in his daring and innovative use of color.[1] By the end of the century, he had become quasi legendary as a revolutionary colorist. The Post-Impressionists saw his example as essential to their own artistic formation.

Vincent van Gogh emphasized not only Delacroix's greatness as a colorist but his innovative practice; he had been even more advanced in his use of color than the Impressionists.[2] In a letter to his brother Theo, he wrote, "Certainly, color is progressing *primarily under the influence of* the impressionists, . . . but already Delacroix had reached more completeness than they."[3] His own art was more akin to Delacroix's than to Impressionist painting. "I should not be surprised if the Impressionists soon find fault with my own way of working for it has been fertilized by Delacroix's ideas rather than by theirs," he wrote to Theo in 1888.[4]

Paul Signac traced his entire method, and that of the Neo-Impressionist group to which he belonged, back to Delacroix. In the preface to his *D'Eugène Delacroix au néo-impressionisme,* he states his intention to show that "their much-decried method is traditional and normal; that it is entirely anticipated and almost formulated by Delacroix and that it unavoidably had to succeed to that of the Impressionists."[5] Much of Signac's book is comprised of quotes from Delacroix's *Journal* as well as from essays about the artist by contemporary critics.[6] These are presented as an aphoristic "bible" of Neo-Impressionism. "Let us invoke the authority of the lofty and lucid genius of Eugène Delacroix: the rules of color, of line, and of composition . . . that sum up *division,* have been promulgated by that great artist."[7]

From today's perspective, most paintings by Delacroix that would have been available to the Post-Impressionists[8] seem dark and dull in comparison with their own.[9] If we wonder how these artists could have looked to Delacroix for guidance, the answer appears to be that the Post-Impressionists were less famil-

iar with Delacroix's painted oeuvre than with the literature about the artist. Nearly all had read the three classic essays on Delacroix by Charles Baudelaire, Charles Blanc, and Théophile Silvestre.[10] From these essays, artists like van Gogh and Signac had formed an idea of Delacroix's pictorial "rules," which became a more important source of inspiration to them than his paintings. They did not realize, however, that their understanding of these "rules" had less to do with Delacroix's own ideas (his diaries were not published until 1893–5),[11] than by those of others, notably Charles Blanc. The latter's article on Delacroix, although based on an intimate acquaintance with the artist and his paintings, contained an important section on color theory that reflected the author's own investigations into the subject.[12] Blanc's discussion of color harmony and color contrast, in particular, was based in large part on the scientific color theories of Charles Bourgeois and Michel-Eugène Chevreul. Although Delacroix appears to have been familiar with some of these ideas (as we shall see), Blanc stretched the point when he intimated that they were at the heart of the artist's thinking.[13] By overemphasizing the scientific and theoretical aspects of Delacroix's use of color, Blanc misled the young artists who read his article.[14]

Delacroix himself always stressed that his approach to painting was based on a balancing of theoretical and scientific considerations with the observation of nature and an innate sense of plastic expression. In his notes for a projected *Dictionary of Fine Arts,* he wrote, " To produce a picture . . . is a science and an art at once . . . ," by which he seems to have meant that the creation of a work of art calls at once for rules, method, and acquired skills, and for talent, intuition, and naiveté.[15] In Delacroix's opinion, talent and intuition came first and the rules were arrived at later: "Art is so long that, to arrive at the systematizing of certain principles which really govern every department of art, the whole of a lifetime is needed. Men of born talent instinctively find the means of expressing their ideas; with them there is a mixture of spontaneous impulses and of gropings, across which the idea comes to light with a charm."[16]

I shall be discussing Delacroix's pictorial theory and practice, as well as the importance for his art of the study of the old masters. It is my intention to show that one of the crucial aspects of his artistic approach was a dual allegiance to theory and practice, to intuition and experience, to reason and sentiment, and to rules and freedom. It was a duality that was already acknowledged by the artist's contemporaries. Baudelaire, in his necrology of the artist, put it in a most succinct and poetic form as he wrote, "Delacroix was passionately in love with passion, and coldly determined to seek the means of expressing it."[17]

Delacroix's Pictorial "Theory"

Introduction

Although Delacroix emphasized that art, in the first instance, is innate and spontaneous – an art rather than a science – he was by no means uninterested

in art theory. On the contrary, his diary and his letters reveal that he was constantly thinking about theoretical questions, yet always in close relation to pictorial practice. Although he never produced a coherent theory,[18] Delacroix had very clear ideas about painting, which were derived in large measure from his study of the paintings of the old masters and, particularly during the later part of his life, from his direct observations of nature. His wide readings, and conversations with artists, writers, as well as musicians (whose remarks about tone and harmony were, as we shall see, important to his conception of color harmony and the overall harmony of a picture), further helped to shape his ideas.[19]

Color vs. Contour

At the heart of Delacroix's pictorial theory was the concept that color was more important than contour. He wrote in a diary entry of 1852: "All painting worthy of the name . . . must include the idea of color as one of its necessary supports . . . ; color gives the appearance of life. . . . The contour is . . . a thing of idea and convention."[20] Delacroix, then, associated contour with ideality and convention, and color with reality and "life." In a letter of 1849 to the critic Jean-Louis Peisse, he went so far as to deny the presence of contour in nature altogether: "I am at my window, and I see the most beautiful landscape: the idea of a line does not come to my mind. The lark sings, the river sparkles with a thousand diamonds, the foliage murmurs; where are any lines to produce these charming sensations?"[21]

Color was not only more crucial than contour, it also had to come first in the creation of a picture. Comparing painting with sculpture, Delacroix noted that just as the sculptor builds up a clearly defined form out of formless clumps of clay, so painters should mass things in with color, and contour would come about as a natural consequence.[22] In his notes for a *Dictionary of the Fine Arts,* he wrote, "*Contour.* It should come last, contrary to the present-day habit." And he added, "Only a very experienced man can use it accurately."[23]

By stressing the primacy of color over line, Delacroix took a firm stance in the long-lasting debate in French artistic circles about the relative importance of color and contour. This debate went back to the late seventeenth-century controversy between the so-called *Rubénistes* and the *Poussinistes,* revived in the early nineteenth century as one of the main points of controversy between Romantics and Classicists.[24] The former advocated the essential importance of line and contour as the elements in art that alone could be perfectly beautiful.[25] The latter, in rejecting the idea of absolute beauty, also rejected the notion of the supremacy of contour in art.[26] Instead, they felt that color, as Goethe put it, "may be made subservient to the highest aesthetic ends."[27]

In Delacroix's own time, the superiority of color over line received unexpected support from Saint-Simonist and Fourierist art theorists and critics, such as Désiré Laverdant and Eugène Pelletan.[28] These men discarded the concept of an ideal, linear beauty, which to them represented "immobility" and "absolute subjection to the past."[29] Instead, they promoted an *école de vie,* a sensual and

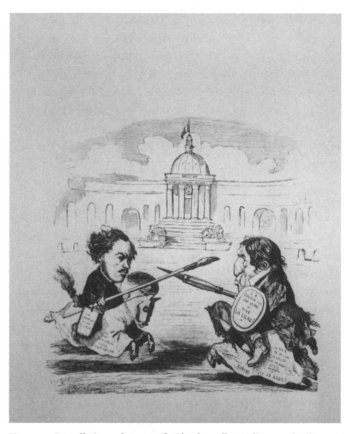

Fig. 29. Bertall (pseudonym of Charles-Albert d'Arnoux), "Ingres and Delacroix Joust in Front of the Institut de France." Caricature in *Journal pour rire*, 1849. Reprinted from T. Prideaux, *The World of Delacroix* (Time/Life Books), p. 128.

passionate school of art that promoted the supremacy of color.[30] They made Delacroix the standard-bearer of their ideas. In his art, according to Laverdant, "every color, every nuance is carefully mixed, fused, and combined, so that at a distance there emerges from this confusion and variety a tonal unity which is truth itself."[31]

Delacroix's championing of color was seen, by his contemporaries, in direct opposition to the ideas of Jean-Dominique Ingres, the propagandist par excellence of line.[32] Charles Blanc, in his article about Delacroix, put it most succinctly, "[A]s opposed to M. Ingres, who invents his color for his form, Delacroix invents his form for his color." In an often reproduced cartoon by Bertall of 1849 (Fig. 29), Delacroix and Ingres are represented as two jousting knights. Ingres is armed with a crayon holder and a shield emblazoned with the words, "Color is utopia, long live the line"; Delacroix brandishes a brush and carries a paint pot that states, "Line is Color." Ingres represents tradition and "style," Delacroix innovation and rebellion against stylistic formulas. Hence their characterization as the "Thiers of line" and the "Proudhon of color."[33]

Just as in the seventeenth century the battle between line and color had created the split between *Poussinistes* and *Rubénistes*, so in the nineteenth century the Classicists, rallying around Ingres, admired Raphael and Poussin, and the Romantics favored Rubens, Rembrandt, Velazquez, and the Venetian painters. Delacroix, although imbued early on with a respect for Raphael and Poussin,[34] increasingly rejected their example as his career matured. Poussin, especially, exasperated him even though he never denied his originality and talent.[35] For although he saw in Poussin's work a "strength of conception, correctness carried to the last degree," he missed in his work a "harmony of line, of effect, and of color."[36]

The Effect

This leads us to a second important aspect of Delacroix's pictorial theory, one that concerned the relationship among line, chiaroscuro, and color. Delacroix saw these elements of painting not as isolated entities but as integrated parts of a whole. His conflation of color and chiaroscuro was a departure from traditional (i.e., academic) painting theory in which chiaroscuro and color were considered two separate and unequal elements of painting. To the academics, the "effect" of a painting depended primarily on the contrast of light and dark (denoting the highlighted and shaded areas of objects) and the subtle gradation of the half-tones or *demi-teintes* in between. Color was subordinate to the chiaroscuro effect.[37] To Delacroix, however, color and chiaroscuro were one. "The two conceptions of painting . . . that of color as *color,* and of light as *light,* have got to be reconciled in a single operation," he wrote in his diary in 1850.[38] He further elaborated on this idea in his diary two years later:

> One should lay in one's picture so that it has the look of representing the scene on a gray day, without sun, without clear-cut shadows. Speaking radically, there are neither lights nor shades. There is a color mass for each object, having different reflections on all sides.[39]

To Delacroix, then, chiaroscuro was not a matter of white highlights and dark brown or gray/black shading, with, between them, a series of half-tones achieved by mixing more or less white or black with the local color of the object depicted. In his radical solution there was only color. The color of the shaded areas of a painted object was determined by the reflected colors of that object's surroundings. Indeed, as Delacroix said, "There are no shadows properly so-called. There are only reflections."[40] The smoother and shinier the surface of the object represented, the more powerful the reflections. To Delacroix, it could become "a mirror reflecting the surrounding colors."[41]

For nonshiny objects, Delacroix followed some general rules. Shading and half-tones were to be painted in complementary, that is, maximally contrasting colors. In a page in a travel notebook of 1834, he drew a diagram (Fig. 30) showing the relation of the three primary colors (red, blue, and yellow) to the three secondaries (purple, orange, and green). In the text below he noted that in the shaded area of an object one should use touches of the local color's complemen-

Fig. 30. Delacroix, *Color Diagram*. Travel album, 1834. Chantilly, Musée Condé (Ms. 390).

tary, rather than mix the local color with black, creating a "dirty" half-tone. Using the example of two little chicks, one yellow, the other russet red, Delacroix prescribes purple for the shaded areas of the first, green for those of the second.[42]

Baudelaire described Delacroix's novel approach toward modeling with color in his review of the 1845 Salon:

> Has the public any idea of how difficult it is to model in colour? It . . . means first discovering a logic of light and shade, and then truth and harmony of tone, all in one sudden, spontaneous and complex working. Put in another way, if the light is red and the shadow green, it means discovering at the first attempt a harmony of red and green, one luminous, the other dark, which together produce the effect of a monochrome object in relief (*tournant*).[43]

Baudelaire explained Delacroix's use of contrasting colors as an attempt to achieve harmony. Delacroix himself, referring to the painting of human skin, phrased it somewhat differently:

> One thing is certain and that is that by making the flesh red or purplish, and by using highlights of the same type, there is no longer any contrast, and you therefore get the same tone everywhere. If, into the bargain, the half-tints are violet also, as I have rather the habit of making them, it necessarily follows that everything is reddish. Therefore one absolutely must put more *green* into the half-tints, in this case.[44]

Baudelaire and Delacroix both speak of the desirability of juxtaposing complementary colors – red and green. Baudelaire emphasizes harmony; Delacroix is speaking of contrast. Yet this is only a superficial distinction; the artist's goal in adding a contrasting green to the predominating red tone of a painting is to create a harmony through contrast.

Delacroix's conception of color harmony through contrast was a departure from traditional ideas about the subject, as Blanc noted.[45] In the academic tradition, the colors in a painting were harmonized by blending adjacent tones to create a unified effect. The idea of harmony through contrast was first introduced by Michel-Eugène Chevreul in his *De la Loi du contraste simultané des couleurs et de l'assortiment des objets colorés,* which was published in 1839.[46] Chevreul, a scientist working for the Gobelin tapestry manufactory in Paris, made a clear distinction between "harmonies of analogous colors" (which he subdivided in harmonies of scale, of hues, and of a dominant colored light) and "harmonies of contrast" (contrast of scale, contrast of hues, and contrast of colors). To Chevreul, the latter harmonies were more satisfying because "The greater the difference between the colors, the more they mutually beautify each other; and inversely, the less difference there is, the more they will tend to injure each other."[47] But Delacroix probably did not learn about Chevreul's ideas until 1848, when he seems to have attended a series of lectures by the scientist.[48] At that time, however, his pictorial practice was well developed and it must be assumed that Chevreul only confirmed Delacroix's own ideas.

Painting and Music

In order to suggest the power of Delacroix's color harmonies, Blanc used a series of adjectives and nouns more closely related to cooking and music than to art:

[Color] harmony, . . . Delacroix liked it splendid and stirring, soured by dissonances and, so to speak, deliciously bitter . . . through the hand of the master, those hostile tones, finding in each other mysterious analogies, became reconciled in their conflict and formed before long a fraternal fanfare.[49]

He seems to suggest that Delacroix's color harmonies were so powerful that they could affect viewers' sense of taste as well as their sense of hearing. This "synaesthetic" appreciation of Delacroix's art was in close accordance with the artist's own ideas. Delacroix was particularly interested in the analogies between painting and music, which he loved. In his unpublished essay *Réalisme et idéalisme,* he stressed that, from an emotional point of view, the experience of the effect of a painting was identical to the experience of music:

There is an impression that results from a certain arrangement of colors, of lights, and of shades, etc. It is what one calls the music of the painting. Before even knowing what the painting represents, one enters into a cathedral, . . . and often one is captivated by that magic *accord* [the French word *accord* means both "chord" and "accord"]; . . . that emotion addresses itself to the most intimate part of the soul.[50]

It is not surprising that these ideas, in turn, would resonate with Charles Baudelaire, whose sonnet *Correspondances* is often seen as the poetic manifesto of Romantic synaesthetic ideas.[51] In his poem *Les Phares,* published together with *Correspondances* and devoted to eight of his favorite artists,[52] Baudelaire likens Delacroix's art to "strange fanfares" (as Blanc had), passing through a haunted landscape "like a stifled sigh by Weber."[53] In his review of the International Exhibition of 1855, Baudelaire elaborated on his notion of the musical quality of Delacroix's paintings, "[T]hose wonderful chords [*accords*] of color often give one ideas of melody and harmony, and the impression that one takes away from his pictures is often, as it were, a musical one."[54] In other words, both Delacroix and Baudelaire stressed that color in painting can summon emotions in the viewer that are independent of the subject depicted and that can be as powerful as those elicited by music.

Touching the Beholder's Soul

The Romantics considered music the art form most apt to arouse emotions in those who experienced it.[55] To Delacroix, painting, through its colors, was the only art form that could compete with music in that respect. The association of color with emotion was a crucial aspect of Delacroix's thinking about painting. In 1851, moved by a painting by Eustache Lesueur, he described color's expressive power, adding, "Contrary to common opinion, I would say that color has a far more mysterious power and perhaps a stronger one [than line?]; it acts, so to speak, without one being aware of it."[56]

Baudelaire linked the emotional effect of Delacroix's paintings with his masterful use of color and suggested that it could have both a sensual and spiritual effect on the viewer:

> A picture by Delacroix will already have quickened you with a thrill of supernatural pleasure [*volupté*] even if it be situated too far away for you to be able to judge of its linear graces or the more or less dramatic quality of its subject. You feel as though a magical atmosphere has advanced toward you and already envelops you. This impression . . . is certain proof of the true, the perfect colorist.[57]

Delacroix himself spoke of color's "exquisiteness, . . . from the standpoint of the effect on the imagination."[58] Because the purpose of a painting, to Delacroix, was to stir the imagination and ultimately "the soul" of the viewer, color was indeed a priceless vehicle.[59]

Yet, in spite of its expressive power and its superiority over line, chiaroscuro, and composition – Delacroix nonetheless viewed color as no more than a material aspect of a painting. The true merit of a picture, to him, was indefinable. It was what the artist's soul had added to the colors and the lines, an indescribable essence that went directly to the soul of the beholder.[60] To Delacroix, the ultimate effect of a work of art on the beholder's emotions resulted from that precious breath of the artist's spirit that animated the material aspects of the painting.

The Lessons of the Masters

Although Delacroix's ideas about color and about painting in general may be related to his wide readings in the areas of art theory and color science,[61] as well as to his numerous conversations with artists, writers, and musicians, undoubtedly the most important source of the artist's pictorial theory and practice was his meticulous scrutiny of the works of the old masters in the Louvre. Throughout his life, Delacroix visited the museum to ponder their secrets. In his youth, and even later on in life, he often made copies of sixteenth- and seventeenth-century paintings by way of an initial acquaintance. Invariably, he would later return to these same works for more intensive study. For example, in the early 1820s, Delacroix copied one of the nereids in Rubens's *Landing of Maria de Medici at Marseilles* (Figs. 31 and 32), but that did not prevent him from returning to the Maria de Medici series throughout his life to further scrutinize this detail, or, for that matter, others in Rubens's painting cycle. In 1847 he wrote in his *Journal*, "Rubens is loose in his naiads so as not to lose his light and his color," and in 1849, he observed, "In the long gallery, admired the Rubens . . . the sirens never seemed to me so beautiful. Abandon and the most complete audacity can alone produce such impressions."[62]

It may seem surprising that, with all his interest in the works of the old masters, Delacroix never traveled to Italy or, for that matter, anywhere else in Europe except for a brief trip to Belgium and Holland in 1839 and a few days in Antwerp and Brussels in 1850. Even though these trips, especially the second one, seem to have been quite inspirational,[63] it appears that, on the whole, the Louvre sufficed Delacroix for his pictorial research needs. We may narrow the scope, if not the intensity, of his research down even further for, within the Louvre, Delacroix returned again and again to a handful of works by sixteenth- and seventeenth-century masters. These, he believed, contained all one needed to know about art.

> All the great problems of art were solved in the sixteenth century. The perfection of drawing, of grace, and of composition in Raphael. Of color, and of chiaroscuro, in Correggio, Titian, in Paul Veronese. Rubens arrives, having already forgotten the traditions of grace and simplicity. Through his genius he creates an ideal once more. He draws it up from his own nature. We get strength, striking effects, and expression pushed to its limit. Rembrandt finds it in the vagueness of reverie and of the *handling?*[64]

Delacroix thus studied the Italian Renaissance masters, especially Titian, Veronese, and Raphael, to learn about the formal aspects of painting – line, composition, color, and chiaroscuro. He looked to Rubens and Rembrandt to help him infuse expressive power into his painting.

Opposite the work of his artistic heroes, Delacroix placed a group of negative artistic exemplars. These included the works of the painters of the Italian Baroque from the Caraccis onward, and works from the French Baroque and Rococo schools. In Delacroix's view of the history of art, the Caraccis, through their institution of the academy, were responsible for the decadence of Italian as

Fig. 31. Delacroix, copy of a Nereid from Rubens's *Landing of Maria de Medici at Marseilles,* c. 1822. Basel, Kunstmuseum. Oil on canvas, 46.5 × 38 cm. (Photo: courtesy Oeffentliche Kunstsammlung Basel, Martin Bühler).

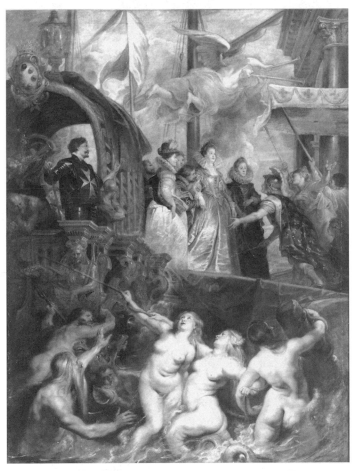

Fig. 32. Rubens, *Landing of Maria de Medici at Marseilles,* c. 1622. Paris, Musée du Louvre. © Photo RMN (Service de la Réunion des Musées Nationaux, Paris). Oil on canvas, 394 × 295 cm.

well as French painting as they brought about a "series of mongrelized schools, among which the last word was furnished by the Vanloo school."[65] The greatest fault Delacroix saw in the works of the masters of these "schools" was an excess of dexterity of execution, of facility and cleverness.[66] It was up to his generation, Delacroix felt, to "bring back the taste for the simple and the beautiful"[67] and, at the same time, to re-emphasize the importance of imagination, for "the true painter is the one in whom imagination speaks before all else."[68]

Delacroix's interest in the old masters is best called eclectic. Not only did he pick his artistic heroes selectively from various periods and countries; he also singled out specific qualities in their works as admirable while flatly rejecting others that he found less than laudable. A certain "anxiety of influence" often colors the passages devoted to his favorite masters, and the highest praise may be offset by a disparaging remark.

For example, Delacroix looked to the work of Veronese to learn about simplicity of execution.[69] He much admired Veronese's breadth in handling oppositions of light and shade and his ability "to refrain from doing too much."[70] At the same time, however, Delacroix criticized his lack of imagination, commenting, "[In his work] there is no dramatic interest whatsoever: whether he paints the Christ or a middle-class Venetian, he always gives us the same indoor clothing, the same blue background, and the same little negroes carrying little dogs; the whole thing is, to be sure, arranged with harmonious lines and colors."[71]

While praising Veronese for his execution, Delacroix blamed him for his lack of imagination and power of conception. By contrast, he hailed Rubens for his verve and imagination but criticized him for occasional lapses in execution. "Rubens is a remarkable example of the abuse of details. His painting, in which imagination dominates, is everywhere superabundant; his accessories are too much worked out; his picture is like an assembly where everybody speaks at once."[72] Clearly, Delacroix's own ideal of painting was somewhere halfway between what he saw as Veronese's naïve imitation and simplicity of execution and Rubens's imagination and verve. In a passage in which he discusses the difficulty of bringing painting "to its full effect," Delacroix admitted, "My recollection of the great painters does not present me at this moment with an absolute model of that perfection which I ask for."[73] Perhaps this was impossible; after all, each artist's ideal of perfection is different. For ultimately, to Delacroix, an "artist must have the courage to stand by his own sentiment, and prefer that to everything else."[74]

In the end, Delacroix's main object in looking at the works of the masters was to learn from them in matters of technique and execution. In numerous passages in his diary he carefully analyzes details of paintings by artists he admired. Climbing on chairs, ladders, and scaffoldings, he examined the works of his favorites to try to reconstruct their methods.[75] Thus he determined that Rubens must have used a fine pointed brush instead of a wide flat one to achieve the smooth and finished execution that Delacroix admired in his paintings.[76] He compared the way Rubens and Veronese painted flesh: "Rubens frankly places the gray half-tint of the edge of the shadow between his local tone

for the flesh and his transparent rub-in . . . Paul Veronese lays on flat the half-tint of the flesh and that of the shadow."[77] (Delacroix preferred Veronese's way, which, he felt, gave an astonishing amount of illusion.)[78] He admired the freshness of color in the works of many of the Flemish painters and attributed it to the fact that these artists painted on white grounds. "The brilliance of pictures by Van Eyck and those by Rubens later on doubtless comes from the white of their panels."[79] It is noteworthy that such intense study of the technique of the old masters continued almost to the end of Delacroix's career. Even at age 52, he climbed on a stepladder to examine Rubens's *Christ on the Cross* in the Antwerp museum and he actually made a new discovery. "How is it that I never noticed before now to what extent Rubens proceeds by means of the halftone, especially in his very fine works. His sketches ought to have put me on the track."

His indefatigable study of old-master paintings helped Delacroix, as an artist, continually to renew himself. Thus his work, even to the end of his life, never became mannered or stale because it was infused by ever new observations made in the works of the artists he admired.

Delacroix's Pictorial Practice

Introduction

In discussing Delacroix's pictorial practice, it is useful to distinguish three phases in his career. The first phase, between 1822 and 1831, may be called the "Salon" phase. In this period, Delacroix exhibited a series of *"grandes machines"* at the Salon, beginning with the *Barque of Dante* in 1822 and ending with *Liberty Leading the People* in 1831. During this first phase, Delacroix studied the works of old and contemporary masters while groping to find his own style.

With Delacroix's trip to Morocco in 1832, he moved on to a new artistic phase. The trip was an important catalyst, not only because it confronted the artist with scenery, light, and colors quite different from those in Paris, but also because it led to his practice of watercolor. This caused him to reflect on the advantage of working on a light ground for the purpose of achieving fresh colorist effects.[80] A year after his return from Morocco, in 1833, Delacroix was commissioned to decorate the Salon du Roi at the Palais Bourbon. These two events led to what we might call the "decorative" phase in Delacroix's career, a phase that lasted from 1832–3 to 1851, and which was dominated by the completion of two important series of decorative paintings for the Palais Bourbon (the Salon du Roi, 1833–7, and the Library, 1838–47), and the Palais du Luxembourg library (1840–6).[81] This second phase has two important aspects. One, working on decorative ensembles helped Delacroix conceive his paintings in broad masses of color and reach an increased simplicity of effect.[82] Two, Delacroix's reliance on assistants made it necessary for him to analyze and formalize his own pictorial practice so he could explain it to them and they could imitate it.

The final phase of Delacroix's career was one during which he focused, for the most part, on medium-size easel paintings. This turn to smaller paintings

has been attributed both to practical reasons (market demands as well as the artist's diminished energy) and to the artist's withdrawal from the public art world into a private world of intense artistic quest.[83]

The Early Salon Paintings

The Barque of Dante (Pl. 1), Delacroix's first Salon submission, was an important artistic statement by a young artist trying to free himself from the rigid rules of pictorial practice he had learned in the studio of Pierre-Narcisse Guérin. The painting, a tangle of struggling nudes and figures in medieval costume, against a backdrop of fire and water, appears to have been chosen precisely because it seemed impossible to paint following the classical precepts of the Davidian school. How could a firm contour contain the passion bursting forth from the scene? How could smooth paint surfaces suggest the waves of the water, the fiery depths of hell, or the contorted bodies of the drowning victims? In this early painting, Delacroix already gave evidence of his preoccupation with a spontaneous touch and a deliberately irregular paint surface in which heavy impasto alternates with thinly painted areas.[84] Nearly all critics commented on these painterly aspects of Delacroix's picture. Adolphe Thiers praised the artist's broad and powerful brushwork while Charles-Paul Landon and Etienne Delécluze criticized its unrestrained execution. The former wrote that Delacroix's touch was choppy and incoherent, the latter called *The Barque of Dante* a *"tartouillade,"* a studio argot term that meant something like "a badly drawn bravura piece."[85] Many of those who were enthusiastic about Delacroix's painting compared his handling of paint with the virtuoso brushwork of Rubens.[86] Some critics noted a similarity between Delacroix's paint handling and that of Géricault, whose *Raft of the Medusa* (Fig. 1) had also shown nude victims floating on water.[87] And indeed, like Géricault, Delacroix painted his nudes in a dramatic Caravaggesque manner, with heavily impasted highlights and dark brown or even black shading.

Although the execution of *The Barque of Dante* shows a dramatic departure from the smooth polished brushwork of Guérin and the Davidian school, it is not particularly innovative from a colorist point of view. Only the famous drops of water on the bodies of the drowning nudes (Fig. 33) hint at Delacroix's later, more daring use of color. Instead of being painted in the traditional manner, with touches of white and gray, they are rendered by means of small dabs of color: white, red, green, and yellow. According to Delacroix's student Pierre Andrieu, this use of color was determined by Delacroix's study of the color gradations of the rainbow, "that palette of creation."[88] It also presents evidence of his dawning interest in reflection. Each waterdrop could be seen as that "mirror reflecting the surrounding colors," of which he would write later in his notes for the *Dictionary of Art.* Indeed, on careful inspection we notice that the drops contain, in heightened intensity, several colors used in modeling the nudes.

The interest in reflection is more obvious in Delacroix's next major painting, *Scenes from the Massacres at Chios,* exhibited at the Salon of 1824 (Pl. 2). In this, perhaps the most experimental work of Delacroix's first phase, the artist deliber-

Fig. 33. Delacroix, *The Barque of Dante*, 1822 (detail). Paris, Musée du Louvre. © Photo RMN (Service de la Réunion des Musées Nationaux, Paris).

ately sought to change his manner. Delacroix knew he wanted to "abandon" the Caravaggesque style of *The Barque of Dante*, although he was not sure about the nature of his new style.[89] Thus he headed to the Louvre and the Luxembourg museums in search of ideas.[90]

The old woman in the foreground of the *Massacre* most clearly shows Delacroix's artistic innovations. From her red-rimmed eyes (a device learned from Gros, who had used it in the *Plague-House at Jaffa*) to the red shadow, flecked with green, cast by the wide sleeve on the woman's arm, we see here, more clearly than in *The Barque of Dante*, that interest in color reflection and the use of complementary colors which played such an important role in Delacroix's later work.

The use of small touches of different color to enliven an underlying color mass – as seen in the arm of the old woman – has often been linked to Delacroix's acquaintance with the work of Constable. On 19 June, during the final stages of his painting of the *Massacre*, he saw three paintings by Constable (intended for the Salon of 1824) at Arrowsmith's gallery in Paris.[91] In truth, it was not until the *Massacre* had been sent off to the Salon that the full impact of Constable's work on Delacroix made itself felt. After his painting had already been approved by the jury, but before the opening of the Salon, Delacroix requested permission to repaint it. According to his old friend Frédéric Villot,

> [H]e took down his picture and carried it to the Salle des Antiques, then impasted the highlights, added rich half-tones, and replaced oil by varnish, which crystallized his colors and made them sparkle like gems. Often he changed his flat brush for a short-hair pointed brush, so as to get more delicate effects. With several layers of glaze, he gave translucency to shadows and a soft sheen to the lights. The extreme fineness of his brush strokes built up sumptuous color effects.[92]

The application of short delicate strokes of color on top of the paint surface, known as "flossing" (*flochetage*), was indeed something that Delacroix may have learned from Constable, who used this technique to suggest the effect of sunlight illuminating his meadows. In the *Massacre,* these touches were applied to an already finished painting with carefully modeled forms. As Delacroix became more comfortable with this technique, he would apply it directly to the underpainting.[93]

The third major experimental work among Delacroix's Salon paintings of the 1820s, the *Death of Sardanapalus* (Pl. 3), shows this more confident use of the flossing technique. In this large, flamboyantly Romantic painting, Delacroix pushed color to the limit, using a new technical procedure of applying thin oil glazes to a lay-in of distemper.[94] Frequently used in scene painting, distemper is a mixture of powdered pigment and liquid size, which has a matte but bright surface when it dries. Delacroix apparently hoped that by using this rather than oils, he could obtain the luminosity of pastels and watercolors.[95] In order to reach his goal, he made a series of pastel studies for details of the painting, which he subsequently attempted to "translate" into oils.[96] This is especially clear in the foot of the kneeling male figure in the foreground on the right (Fig. 34). Following his pastel sketch, Delacroix has suggested the highlights and shaded areas not by heavily impasted light and thinly glazed dark tones but rather by thin color cross-hatchings, which are painted on the ground of distemper.[97]

The Master

Whereas the 1820s were a period of experimentation for Delacroix, the 1830s witnessed the consolidation of his pictorial method. A desire for a blond tonality and sumptuous color effects, an interest in relief, and the aspiration to integrate contour, color, and chiaroscuro were, at the time, his main preoccupations. We can form a fairly complete idea of Delacroix's mature practice by reading the detailed description, by his student Louis de Planet, of the process he followed in making a reduced copy of Delacroix's *Jewish Wedding at Morocco* as a model for an engraving.[98] Having made a drawing after the painting on the canvas, Planet made a *grisaille* lay-in or *ébauche,* just as, he claimed, Delacroix had done for the original painting. The *grisaille* was prepared in brown, black, and lead white, with firm contours. It differed from the underpainting of academic painters in several respects.[99] First of all, it was painted in broad masses of contrasting lighter and darker tones, as opposed to academic *grisailles,* which showed much softer gradations from light to dark achieved by numerous *demi-teintes* or middle tones.[100] Secondly, it was painted in a limited tonal range, tending toward the light (*chiaro*) rather than the dark (*oscuro*) end of the tonal scale.[101] Thirdly, Planet was told by Delacroix to use heavy impasto in the highlighted (projecting) areas, in order to give "body" to the painting. In itself, this was not different from academic practice, in which heavy impasto in *grisailles* was also encouraged.[102] But academic painters were in the habit of scraping the *grisaille* after it had dried, so the colors could be applied to a smooth surface. Delacroix, in contrast, left the impasted highlights intact so they served as a raised "bed" for the glazes.[103] Indeed, it was primarily through the *ébauche* that Delacroix sought to achieve a

Fig. 34. Delacroix, *The Death of Sardana-palus,* 1827 (detail). Paris, Musée du Louvre. Oil on canvas. © Photo RMN (Service de la Réunion des Musées Nationaux, Paris).

surface relief in his paintings so as to enhance the illusion of three-dimensionality.[104] The surface relief of the *grisaille* underpainting was a guarantee, to Delacroix, that his paintings would never be flat and dull. As Planet put it, "[I]f the glazes disappear, as the result of any kind of accident, those masses, clearly delineated and heavily impasted, will always remain. The painting will then resemble those old, worn, antique bas-reliefs, in which, over time, all the detail has gone; . . . but which, . . . still conserve the marks of indelible beauty."[105]

When the *grisaille ébauche* had fully dried, the colors were laid in. Planet first carefully prepared his palette, again following Delacroix's own practice.[106] Colors ranged from lead white, via various yellows and reds, to green and cobalt blue, several browns and blacks, and, finally, Prussian blue. Isolated from this color "scale," on the other side of the palette, he placed two tones of lake, used primarily for glazing. With these, he prepared the generic, local colors for the different parts of the painting (faces, clothing, architecture, etc.). As much as possible, he tried to use pure, unbroken colors. After having mixed all the colors on the palette, he started the actual painting. In shorthand form, Planet describes the painting process as follows:

> Heavy impasto. Use sable brushes for that. Try to paint several details at the same time to link them together. Clearly separate lights and shades. Begin draperies with warm and transparent tones; as for the costumes, where there is a large variety of brilliant colors, [in] belts, gold-embroidered vests, hyacinth blues, everything that must stand out in lively colors, keep that work for last, put in those tones only when all else is finished. Before abandoning a group, put in those accents with light, clear glazes, and then go over them with vigorous impasto, always using a liquid color.[107]

From Planet's description, it is clear that by 1840, Delacroix had developed a three-stage painting process. In the first stage, he would prepare a heavily

impasted *grisaille ébauche* with low value contrast. On top of that, in the second stage, he would lay in the color masses, as much as possible using local colors. In the third stage, he would modify the local colors with touches of pure hues, in order to suggest the absorption and reflection of light by three-dimensional objects with more or less irregular surfaces.

To finish the painting, Delacroix would sometimes use a layer of removable or permanent varnish. Although he felt some varnishes, such as copal, could lend extra luster to colors, they also could cause the surfaces of his paintings to become too polished for his taste. Moreover, varnishes tended to turn yellow and even brownish over time, thus distorting the color harmonies and spoiling the freshness of the colors.[108] To take advantage of the sparkle of varnish while still maintaining a lively paint surface, Delacroix would often mix varnish with colors to give them greater luminosity and transparency. He also did not hesitate to paint over the layer of varnish, as he did, on a large scale, in the *Massacre at Chios*, and on a smaller scale in many later works.[109]

The Late Work

The second half of the 1840s was a time of many changes, which set the stage for the third phase of Delacroix's career.[110] This phase was marked by a renewed interest in nature and by a turn to new subject matter, such as landscape and still life, which allowed for a certain amount of experimentation. The beginning of this new period in the artist's career coincided with the artist's resumption, in January 1847, of his journal after a fifteen-year hiatus. The very first entry describes a visit to the Jardin des Plantes, which made a profound impression on him:

> Whence comes the impression which the sight of all that produced on me? From the fact that I got out of my everyday ideas which are my whole world, that I got out of my street, which is my universe. How necessary it is to give oneself a shaking up, to get one's head out, to try to read in the book of creation, which has nothing in common with our cities and with the works of men.[111]

The impact of this visit was symptomatic of a changed outlook and new interests. He began drawing tigers and lions in the zoo of the Jardin des Plantes and sketching landscapes as he traveled around France. Between 1848 and 1850, he also painted a group of five large flower and fruit still lifes, a genre that he had all but ignored previously.[112] It is as if, after years of painting imaginary scenes from history, literature, and mythology, he felt a need to reconnect with reality, as if he wished to test his firmly systematized artistic practices against the observation of nature.

The *Still Life with Flowers and Fruits* (Fig. 35) is interesting in this respect. Although it contains several fruits, notably the bunches of grapes, that are painted in the academic chiaroscuro manner codified by Roger de Piles (Fig. 36), it also shows his own innovative manner of suggesting three-dimensionality through colored reflections. Note, for example, the reddish reflection on the green pear at the top, the green reflections on the pink peaches at the bottom,

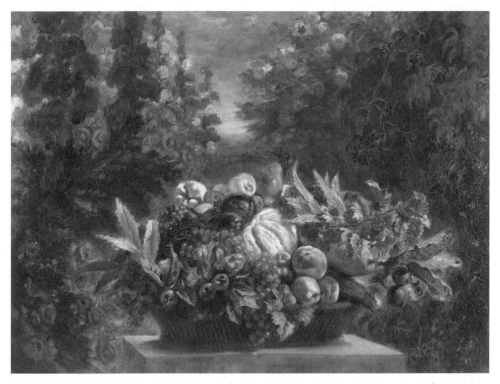

Fig. 35. Delacroix, *Still Life with Flowers and Fruit*, c. 1848–9. Philadelphia Museum of Art. Oil on canvas, 108.4 × 143.3 cm. John G. Johnson Collection at the Philadelphia Museum of Art.

Fig. 36. Roger de Piles, "Clair-obscur." Illustration in *Cours de peinture par principes* (Paris, 1708). Reprinted from E. de Jongh, *Still-Life in the Age of Rembrandt* (exhibition at the Auckland City Art Gallery, 1982), p. 110.

and the green reflection all around a little red apple (below the large melon), which would not be out of place in a painting by Cézanne. Nothing we see here is different from Delacroix's earlier pictorial practice, but there is a new simplicity in the juxtaposition of broad areas of color, unmodulated by flossings, hatchings, or touches of complementary color. This new simplicity of effect, which relies on the initial lay-in of color rather than meticulous detailing of the final layer, is also visible in other paintings of the same period, most notably in some of the religious scenes of the late 1840s. The large *Lamentation* (*The Entombment of Christ*) (Pl. 7) of 1847–8 is a case in point.[113] With its large areas of unbroken color and bold chiaroscuro contrasts, it is reminiscent of Venetian paintings, such as Titian's *Entombment* (Madrid, Prado), as well as some of Delacroix's oil sketches, which were equally simple and immediate.

In his diary, Delacroix wrote at length about the genesis of the *Lamentation* and about his preoccupation with preserving the effect of the sketch. Having begun the painting early in February 1847, by the middle of the month he had completed a *grisaille ébauche*.[114] On 1 March he did the color lay-in, with which he was so satisfied that he felt a certain reluctance toward finishing it: "I am satisfied with this lay-in, but when one adds details, how can one preserve that impression of the whole which results from very simple masses?"[115] Thus Delacroix, like so many nineteenth-century artists, experienced a tension between the desire to preserve the freshness of the sketch and the necessity to finish the picture by putting in the details.[116] The next day, 2 March, he was still thinking about the "sketch vs. finish" conflict, and he wrote, " One of the great advantages of the lay-in by tone and effect without bothering about the details, is that one is compelled to put in only those which are absolutely necessary. . . . The real thing would be, once the lay-in is established, to push each section as far as possible, yet not to allow the picture as a whole to advance."[117]

For all his interest in the boldness and simplicity of the sketch, Delacroix could ultimately not accept it as a finished product. In 1853, after elaborating at some length on the charm of the sketch,[118] he nevertheless asserted the importance of finish: "[T]he artist does not spoil the picture by finishing it; only when he renounces the vagueness of the sketch, he shows himself more completely in his own personality, thus revealing the whole direction of his talent but also its limits."[119] It was in the finishing touches that the artist could display his originality and talent. They were the artist's pictorial "imprimatur."

Hence, even in the artist's late works, we see a powerful interest in the "epidermis" of his pictures, or, in what Delacroix himself referred to as their "relief." His last monumental exhibition painting, *The Lion Hunt* (Bordeaux, Musée des Beaux-Arts) (Pl. 11), commissioned by the French government in 1854,[120] shows a renewed emphasis on color and relief. Although a fire destroyed the upper part of the painting, the fragment that remains shows what contemporary critics referred to as "an explosion of color," and a rich, variegated surface texture built up with color hatching, stippling, and flossing. *The Lion Hunt* resembles Rubens in its rich coloring and bravura brushwork as well as its subject matter.

There can be little doubt that in this large painting, his last monumental work, Delacroix aimed consciously at competing with Rubens, whose hunting scenes he had admired throughout his life.[121] As late as 1860, he commented on the "prodigious life" of Rubens's paintings, which, he felt, resulted from their "prodigious relief."

Conclusion

Delacroix's pictorial practice was shaped by conflict. Aiming both at simplicity of effect and a richness of color and texture, striving for the calm of Veronese and the turbulence of Rubens, Delacroix was forever torn between his classic sense of order and his innate Romantic impulse. To resolve that conflict was the driving force of his art.

It has been suggested that, in the very duality of his enterprise, Delacroix represented the eclectic aesthetic that had been developed by his contemporary, the philosopher Victor Cousin.[122] This aesthetic was rooted in a philosophy of judicious selection: "[T]o reject no system and to accept none entirely, to neglect this element and take that, to select from all what appears to be good and true, and consequently durable."[123]

Yet, although Delacroix was no doubt influenced by the ideas of Cousin, I suggest that we characterize his approach to art as Hegelian rather than eclectic in Cousin's sense. For Delacroix did not pick and choose discriminatingly from all artistic options available to him. In fact, we have seen that there were many he rejected outright. Instead, he tried to create a synthesis between opposites. In the very last entry in his *Journal*, he wrote, "The first merit of a picture is to be a feast for the eye. That is not to say that reason is not needed in it."[124] This line could be seen as the summation of his synthesizing approach to art. It was an approach aimed at fusing sensuality and emotion with reason, freedom with rule, and science with art.

7 Delacroix's Dialogue with the French Classical Tradition

Dorothy Johnson

Delacroix is often and justly defined as the quintessentially Romantic artist. He is seen, again rightly, as a great innovator, a prodigious producer of novatory paintings who bestrides the Romantic era like a colossus. This essay will in no way challenge this delineation of the artist but rather will seek to nuance the view of him that has become traditional by, somewhat paradoxically, extensively investigating his subtle but deep relationship to another tradition, that of French classicism as defined by the Royal Academy of Painting and Sculpture in late seventeenth-century France.

Delacroix's attachment to the classical tradition as embodied in the Academy was certainly noted by his contemporaries, above all by Baudelaire. And it is eloquently attested to by the fact that he never ceased to desire to be a member of the Academy, a wish finally granted when, after seven unsuccessful attempts, he was elected in 1857 after a long, brilliant, and triumphant career. Right after his election he began his notes for an art dictionary in which he revealed his esteem for the classical tradition in numerous categories. Under the heading "classical" he defines the probity and simplicity of a classical aesthetic:

> *Classical.* To which works is it more natural to apply this name? Evidently to those which seem destined to serve as models or as the rule in every way. I would willingly call classical all works that conform to rules in all of their elements, those which satisfy the mind not only through an exact, imposing or piquant painting of feelings and things, but also through unity and logical order, in a word, through all those qualities which increase the impression made by achieving simplicity. . . . Respect for tradition is nothing but the observation of the laws of taste without which no tradition would be lasting, etc.[1]

In his definition of "classical" in 1857, Delacroix was restoring the word (that during the Restoration and July Monarchy had often been used perjoratively in the debates of Romanticism versus Classicism) to its late eighteenth- and early nineteenth-century usage. "Classical" as defined, for example, in Diderot's *Encyclopédie*

and used by writers on literature and art, meant works of the highest quality, worthy of serving as perfect, artistic models; during the early years of the nineteenth century "classical" in this sense referred as well to the models of seventeenth-century French classicism embodied in academic theory and doctrine (which included ancient as well as Renaissance art).[2] Delacroix's articles on the theory of the beautiful, "Questions sur le beau" (1854) and "Variations du beau" (1857), written with pedagogical intentions, were informed as well by this definition of classical. In these writings, which engage the central aesthetic issue of the French Academy since its foundation, the painter defines his Platonic conception of the immutable essence of beauty while describing the continual permutations of its manifestations throughout art history.[3]

We shall see in this essay it was precisely the elements of the classical aesthetic and its relationship to the French classical tradition as embodied in the Academy that produced a fruitful confluence (or sometimes friction) which often served as a catalyst to Delacroix's painting. For, although Delacroix was a forward-looking artist and was credited by his successors, the Impressionists, as forging a path for them to follow in terms of a progressive, or avant-garde art, Delacroix himself, Janus-like, looked continually to the past as well as the future. Even Baudelaire inscribed the artist within an art historical continuum and continually compared him to renowned artists of the past, particularly painters of the Renaissance and Baroque periods who, by the early nineteenth century, had come to constitute the canon of the French classical tradition: "Heir to the great tradition, that is, scope, nobility and pomp in composition, and worthy successor of the old masters, he exceeds them in his mastery of sorrow, passion and gesture."[4] We have strong evidence in both his extensive corpus of writings and in his painted oeuvre that Delacroix concurred with Baudelaire, that he thought of himself as a "worthy successor" to the "old masters" of the French classical tradition – the theory, practice, principles, and teaching of art – as embodied and transmitted by the Royal Academy of Painting and Sculpture since its founding in the seventeenth century.

Being the heirs of Romanticism in the arts, we often underestimate or fail to realize the procrustean power and authority that the Academy exerted over aspiring artists. The impact and legacy of the French Academy was profound and far reaching because it remained a vital force in the teaching and making of art from the late seventeenth until the late nineteenth century (most progressive or "avant-garde" artists and artistic movements in France in the eighteenth and nineteenth centuries tended to define themselves in terms of their rebellion against or transformation of the precepts of the French Academy). Delacroix's dialogue with the French classical tradition was lifelong and can be seen in almost every facet of his painted oeuvre as well as his meditations on art. In this essay I assess Delacroix's dialogue with the French classical tradition through an examination of salient examples that reveal both his debts to this tradition as well as his daring attempts to innovate within it.

Delacroix's written meditations on art, the theories of styles, modes, compo-

sition, form, and color that concern him, the works and artists of the past he admires and emulates, the types of subjects he chooses for his paintings and the commissions he elicits, his belief in the didactic function of art as well as his considerations of the public and private destinations of his paintings – all of these facets of his artistic production often reveal his engagement with the French classical tradition of art based on the doctrine and teaching of the Royal Academy of Painting and Sculpture as established in the seventeenth century and further developed in the eighteenth century.[5] The Academy made rules to govern every aspect of the making of art in France, including the choice of appropriate artists of the past and present to emulate, types of subject matter, sanctioned theories and systems, conventions governing compositional structure and style as well as the official state-supported exhibitions of art, the annual or biennial Salons.

Prominent among many of the guiding principles of the seventeenth-century French Academy that had endured in the early nineteenth century was the codification of a hierarchy of genres in which history painting reigned supreme, an emphasis on archetypes (paintings that served as a standard of excellence and were worthy of emulation), a belief in a visual language of painting that nonetheless depended on the written word, and an insistence on the didactic role of art. Because the Royal Academy of Painting and Sculpture had been established in order to give intellectual stature to artists and the visual arts and to distance art practice from the guild system by asserting art as a branch of knowledge (of the liberal arts), artists were required to be educated, to be humanists and thinkers, not mere practitioners who had mechanical talent.[6]

During Delacroix's formative years in the second decade of the nineteenth century, as in the past, if an artist wanted to be assured of a successful career in the arts in France, he submitted to long years of training at the Academy, studied in the atelier of a respected academic artist, competed for prizes in various categories at the Academy itself, all of which led, for the one or two most successful students in any given year, to the coveted five-year fellowship to Rome, the Prix de Rome as it was called, which virtually guaranteed the student an official, academic career upon his return to Paris. Delacroix embarked on this academic journey to official success.

After studying classics, philosophy, history, and literature at the Lycée Impérial (later, Louis-le-Grand) in Paris and entertaining the idea of becoming a writer, in 1815, at the age of 17, Delacroix entered the atelier of the well-known Neoclassical painter, Guérin. In 1816 he entered the Ecole des Beaux-Arts and embarked on a traditional academic education.[7] It is important to note that in 1816, after Louis XVIII acceded to power following the Hundred Days, the Neoclassical archaeologist and theorist Quatremère de Quincy, proselytizer for "ideal beauty" in art since the late eighteenth century, was appointed perpetual secretary of the Classe des Arts. In accord with the general directions of the Restoration, Quatremère de Quincy "restored" to the Academy of Art many of its seventeenth-century founding principles, including an emphasis on the "historical style," but also an insistence on the seventeenth-century Academy's ideas of

invention and originality (which were related to intellectual rather than stylistic decisions).[8]

This revalorization of the Academy's seventeenth-century classical past in theory, doctrine, and educational practice made an indelible impact on Delacroix during his formative years and would dramatically influence his painting as well as his writing about art for the rest of his career. His journal is filled with references to the classical tradition in art, especially to canonical artists and their works from the Renaissance and Baroque periods, including Raphael, Titian, Veronese, Rubens, Rembrandt, and Le Brun. He also published articles that served as homages to artists who embodied the seventeenth-century French classical tradition, such as Poussin. Delacroix emphasizes Poussin's intellect and reason combined with imagination and invention as well as his refusal to copy servilely his predecessors.[9] Similarly, in his article on Raphael (who had served as a beacon for the seventeenth-century French Academy), Delacroix praises gifts of invention and thought and the artist's ability to give new life to former models of emulation.[10] In his articles on artists and artistic theory as in his writings on the beautiful noted earlier, Delacroix inscribed himself within and responded to the classical academic tradition established in the late seventeenth century for, like so many of his academic forbears, he wanted to teach, to communicate his ideas about art and thereby influence others.[11] To this end, after his appointment to the Academy finally in 1857, he also began detailed notes for a projected dictionary of the arts (as mentioned earlier).

Delacroix's career, however, did not follow the academic trajectory he anticipated, for from the very beginning he did not succeed in the various student competitions, and, after several years of struggle, he decided to embark on an independent career by seeking to have a major painting accepted for exhibition at the Paris Salon.[12] In so doing he was taking a great risk, but his gamble paid off. His first major official painting, *The Barque of Dante* (Pl. 1), was accepted by the jury for exhibition at the Salon of 1822. It was fairly well received, purchased by the government for the museum of modern art (the Musée du Luxembourg), and established Delacroix's reputation.[13]

Delacroix and the Hierarchy of Genres

The Barque of Dante, Delacroix's first official painting, merits further consideration here, because, as his first Salon painting, Delacroix intended it to announce to the public who he was as a painter and what he stood for. It is important to note that the work was not commissioned – the choice of theme and interpretation were the artist's alone. Delacroix chose the subject from Canto VIII of Dante's *Inferno* in which Dante, the pilgrim to hell, crosses the river Dis with his guide and predecessor in epic poetry, Virgil. The boatman Phlegias is seen from behind while the tormented souls of the damned struggle in the water or try to climb onto the boat. With this brilliant choice of a significant moment from an epic poem, Delacroix revealed his profound understanding of Dante's

Inferno, which centers on the friendship of Dante and Virgil and juxtaposes the classical poet's understanding of hell (the eternal suffering of condemned sinners) to the medieval poet's continual shock and horror; Virgil's serenity serves as a foil and bulwark for Dante's fear.

With this painting Delacroix defined himself as a history painter within the French classical tradition, for, in keeping with academic norms and expectations for history painting that had prevailed since the seventeenth century, he depicts a large, complex group of figures (both nude and clothed to demonstrate his mastery of the human form). He has chosen a significant moment from a well-known literary source and has made this narrative comprehensible to the spectator through expressivity of physiognomy, pose, and gesture. The compositional structure itself conforms to prevailing academic conventions (the shallow, rectangular, stagelike space of the Neoclassical format in vogue since the second half of the eighteenth century). Time-honored classicizing visual precedents could be cited for the figures of Dante and Virgil as well as the boatman Phlegias (who was based on the Belvedere torso), and the figures of the damned souls reveal the direct influence of Rubens and Michelangelo, two artists who were accepted in the classical canon in early nineteenth-century France. The dramatic use of color and the freer brush style that diverges from the highly polished "Neoclassical" finish were also reminiscent of Rubens and had been seen earlier in the century in the works of Gros and Géricault. Many aspects of the painting, in fact, point to Delacroix's understanding and embrace of the French classical tradition, in which history painting, with its particular conventions and norms, was considered the most important category of academic painting.

The notion of a hierarchy of genres, or graded values in the types and subjects of painting, had been established in the seventeenth century at the Royal Academy of Painting and Sculpture and had dominated theory, doctrine, and the making of academic painting in France ever since. History painting was placed at the top of the hierarchy because it represented significant actions and events that served a didactic function with portraiture, domestic scenes from everyday life, landscape, animal painting, and still life situated in descending order of importance beneath it.[14] The significance of history painting was also conveyed through its expected monumental dimensions, which often had an ideological as well as intellectual basis (the state and church could best afford to commission such works and could therefore influence choice and interpretation of subject matter). Greater size also indicated a greater amount of time in the execution and greater material expenses, which were all indicators of enhanced value. Because history painting was considered the most complex and demanding of all of the possible categories of painting both intellectually (invention based on literary, historical, religious, or mythological sources) and technically (the depiction of a large number of figures engaged in a complex narrative), it followed that only the most skilled, educated, and accomplished artist could work in this category.[15]

Although *The Barque of Dante* was not commissioned, Delacroix essentially followed these academic tenets concerning history painters and painting. Even conservative critics considered it to fit well within the bounds of a prevailing

Neoclassical aesthetic, and the state immediately purchased it.[16] But following the success of *The Barque of Dante,* Delacroix attempted to expand the boundaries or limits of conventions within the classical tradition. At the Salon of 1824 he exhibited the *Scenes from the Massacres of Chios* (Pl. 2), an uncommissioned work of monumental dimensions based on a savage episode from contemporary history – the Greek War of Independence.[17] Although representations of contemporary history, which emerged in French art during the Revolution, had become accepted in academic painting under the Consulate and Empire due largely to Napoleonic patronage, the values of such subjects were still being contested in the early 1820s. *Scenes from the Massacres at Chios* had drawn huge crowds, but many critics had been harsh, denigrating what they rightly perceived as divergences from prevailing Neoclassical academic norms and desiderata, namely a compositional structure with variegated groups but no central focus, the drawing (found to be "flawed"), the broad and bright palette, and the freer application of paint – the expected smooth, finished surface was lacking (even Gros, Delacroix's former strong supporter, found the painting untenable).[18] This work, in fact, was seen at the time and still is often understood today as standing in dramatic contradistinction to Ingres's *The Vow of Louis XIII* (Fig. 3), a work that paid overt homage to both Raphael and the seventeenth-century French classical tradition and was acclaimed at the Salon of 1824. Critics would use these two paintings to establish a polemical rivalry that would endure until the end of the twentieth century in art historical discourse between classical academic values as embodied in Ingres's work and a burgeoning Romantic aesthetic, as expressed in the painting of Delacroix.

But although Delacroix diverged, in part, from prevailing Neoclassical conventions, he nonetheless was still working within the framework of the academic tradition. The important Romantic critic Adolphe Thiers characterized *Scenes from the Massacres at Chios* as "another type of classical genre," and Lee Johnson has recently noted, "With the passage of time, it is the essential continuity of the Davidian tradition that seems ever more striking."[19] To represent the *Scenes from the Massacres at Chios,* inspired by the Turkish massacre of almost ninety thousand unarmed Greeks on the island of Chios, Delacroix followed the research methods of an educated academic artist. He put an enormous amount of time and effort into the huge canvas, including research into contemporary accounts of the horrific event as well as into costumes and mores, all at his own expense, since the painting was not commissioned.[20] The format, with the protagonists depicted in the immediate foreground in expressive groupings, was akin to representations of battles as formulated in the seventeenth century and revived under Napoleon. The work's shallow, stagelike setting was characteristic of Neoclassical compositional structures and aligned with the classical French tradition of history painting in terms of its "grand style," including its monumental dimensions. The role of dimension as a means of exerting a powerful impact on the spectator was not lost on Delacroix, who often worked on a monumental scale and who, later in his career, painted vast mural decorations for national sites, civic buildings, and churches. In his *Journal* Delacroix

frequently meditated on the importance of size and its "sublime" effects that were often lost in smaller pictorial versions or engravings: "Proportion counts for a great deal in the absolute power of a picture."[21] The "power" conveyed through monumental dimensions was also related, of course, to the ideology of size. We remember that in academic terms the greater dimensions of history painting indicated greater significance, time spent, cost, and value.

As we have seen, many critics acknowledged that the *Scenes from the Massacres at Chios,* however innovative or divergent from conventions, nonetheless could be inscribed within the bounds of academic norms and expectations; the painting, like *The Barque of Dante,* was normative enough to be purchased by the French government.[22] This was not the case, however, with *The Death of Sardanapalus* (Pl. 3), a work that the journalist and art critic Louis Vitet described as going "beyond the bounds of independence and originality."[23] This huge painting, also uncommissioned and exhibited at the Salon of 1827, met with critical disapproval; even Delacroix's friends and supporters found it unacceptable. This time Delacroix's gamble failed. Not only did the government refuse to purchase the work, they censured the artist and warned him not to paint in such a manner again if he wished to receive state support. Delacroix remembered this with great bitterness toward the end of his career.[24]

Delacroix chose as the protagonist the dissolute king of Syria, Sardanapalus, last descendent of Semiramis, a weak and corrupt leader; in so doing he challenged the time-honored convention in the French classical tradition of representing kings as great leaders engaged in heroic acts that impart a positive moral lesson. Faced with defeat from his enemies and his own rebel armies, reclining on his bed that will become his funeral pyre, Sardanapalus decides to commit suicide after having all of his possessions – material, animal, and human – destroyed before his eyes. The "significant moment" chosen by Delacroix (inspired by Byron as well as antique sources) is a moment of great evil rather than good.[25]

The image, in fact, provides an ironic deconstruction or parody of a favored category that enjoyed widespread popularity in eighteenth-century French academic painting – namely, the deathbed image, a form of *exemplum virtutis* that was inspired by mid-eighteenth-century Neoclassical reforms at the Royal Academy of Painting and Sculpture.[26] In eighteenth-century representations the protagonist, whether of humble or aristocratic origins, imparts a noble legacy on his deathbed – David's *The Death of Socrates* of 1787 (Fig. 37) in which the philosopher discourses on the immortality of the soul to his disciples, just before drinking poison, is one of the best known eighteenth-century paintings in this category that derived from seventeenth-century French classical prototypes. Poussin's *Testament of Eudamidas* (1643–4) and *The Death of Germanicus* (1627–28, Fig. 38) were the paradigmatic models for this category. In the *Death of Sardanapalus,* an ignoble death of an ignoble ruler, Delacroix reveals the results and legacy of a weak and dissolute rather than a noble character. In keeping with the French classical tradition, however, the painting does serve a didactic function, for it conveys a terrifying admonition – an evil king will gov-

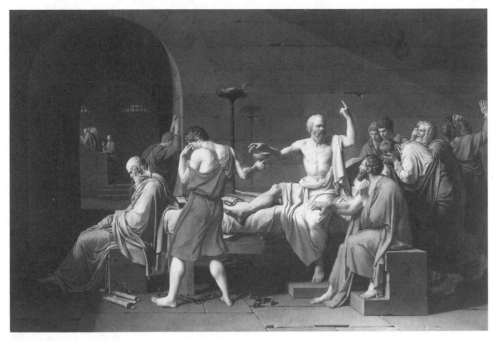

Fig. 37. David, *The Death of Socrates*, 1787. New York, The Metropolitan Museum of Art, Catharine Lorillard Wolfe Collection, Wolfe Fund, 1931. Oil on canvas, 129.5 × 196.2 cm.

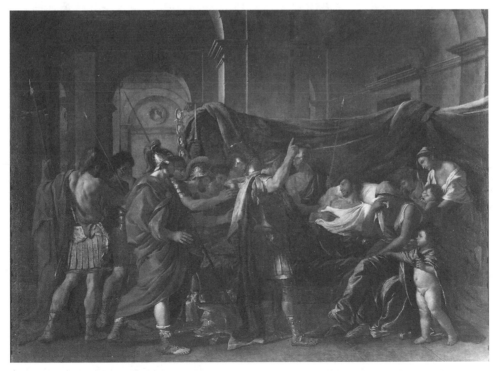

Fig. 38. Poussin, *The Death of Germanicus*, 1627–8. The Minneapolis Institute of Arts. (Photo Lauros-Giraudon/Art Resource, NY).

ern badly and the final result is the fall of a regime, destruction and death. Sardanapalus will have no legacy but the horrible memory of his final acts, since he takes everything with him. It is not surprising that the monarchical regime of the Restoration did not welcome this painting, which imparts such a fierce lesson about an evil monarch and his misrule.

That Delacroix was in dialogue with the French classical tradition of the *exemplum virtutis* of the noble death is confirmed by a later painting that refers directly in composition and style to Poussin's – this is *The Final Words of Marcus Aurelius* of 1844–5 (Fig. 39). In depicting the last words of the dying philosopher ruler of Rome, Delacroix focuses on the nobility of the dying leader surrounded by his devoted disciples, but Marcus Aurelius's legacy is his son to whom he points, the youthful and fawning Commodius, who will become a tyrant, a corrupt ruler of the Empire. The pessimism of the 1845 painting puzzled most of Delacroix's critics because the example of virtue and the deathbed legacy in the past had been positive and morally uplifting, but the Neoclassical format and style were understood to be conventional and conservative, very much in the French classical tradition. A notable exception was Baudelaire, who appreciated its pessimism and analyzed the painting at length as a work of great genius.[27]

If *The Death of Sardanapalus* expanded the conventions of classical history painting in terms of the choice of the significant moment with the depiction of an antihero, Delacroix was even more daring in his decision to create a compositional structure and space that seemed to bend in almost every way the rules of Renaissance perspective that had been codified by the seventeenth-century French Academy. As has often been noted, Delacroix offers a radical alternative to the shallow, stagelike setting favored by the still-prevailing Neoclassical aesthetic by constructing his composition on a dynamic fluidity of forms that swirl around an empty center – the broad expanse of the foot of the bed. Although dramatic diagonals and dynamic movement had been characteristic of Rubens, who was greatly admired and appreciated in the French classical tradition, as we shall see, nothing in Rubens prepares us for this denial of stable space. Delacroix, in fact, emphasizes the instability of forms in space; objects and figures are dramatically tilted and seem about to tumble or slide into the spectator's space. This experimental use of illusionistic space, of course, accords well with the theme of a collapsing regime that tumbles into violence and chaos. The artist reveals how thoroughly he understood the ideational basis of Renaissance perspective, which functioned as symbolic form to convey an understanding of the world.[28] He had so pushed to the extreme the bounds of academic conventions, however, that even the critics who were usually favorable found the structure of the composition incomprehensible and unacceptable. As in the *Scenes from the Massacres at Chios*, Delacroix was again criticized for his flawed drawing (the figures were not in scale and this was understood as a failure to accord with academic conventions of the placement of figures and objects in recessive space), and his use of brilliant color was seen as startling and inappropriate.[29]

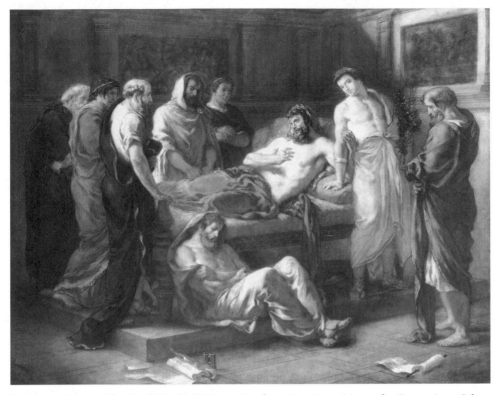

Fig. 39. Delacroix, *The Final Words of Marcus Aurelius*, 1845. Lyon, Musée des Beaux-Arts. Oil on canvas, 256 × 337.5 cm. © Photo RMN (Service de la Réunion des Musées Nationaux, Paris).

Delacroix's *Execution of Marino Faliero* (Fig. 40), also inspired by Byron and also exhibited at the Salon of 1827, received a more favorable critical reception. This is surprising, for it also had an unusual compositional structure and a strange construction of space – as in the *Sardanapalus*, an expressive void commands attention.[30] The body of the doge of Venice, decapitated for his supposed treachery, lies on the steps of an enormous empty staircase that is central to the composition. Critics noted this strange void where we would expect a central action to be taking place as well as the odd scale with the crowds of people surging up the staircase from below and the doges and army above. But because prototypes in Venetian art could be cited for this painting, the critics found the work more acceptable than the *Sardanapalus* for which they could find none.[31]

Delacroix was deeply hurt by the response to *The Death of Sardanapalus*, which he continued to cherish as one of his best works throughout his life. He heeded, however, the critical response, and in his next major Salon painting, *Liberty Leading the People* (Pl. 5), exhibited in 1831, he returned to a much more conservative, classical construction of space and introduced the traditional device of an allegorical figure, a device that had been much favored in seventeenth- and eighteenth-century French history painting (the use of allegory in painting was much debated from the Revolution to the early decades of the

nineteenth century). In a conventional pyramidal construction the artist depicts
a highly unusual subject, one that he chose himself, taken from contemporary
political events in Paris – the "Three Glorious Days" of the July Revolution dur-
ing which time insurgents, men, women, and children from differing classes of
society, overturned the repressive government of Charles X.[32] The Romantic
critic Théophile Thoré signaled the "real" rather than idealized allegorical figure
of Liberty (she appears to be a woman taken from contemporary life) as the true
locus of innovation in an otherwise conservative composition.[33] This unusual
introduction of a "real" allegory (which prefigures, of course, Courbet's *The Stu-
dio, a Real Allegory of Seven Years of My Life as an Artist*, a work much admired
by Delacroix) reveals the artist's interest in renewing traditional devices that
were part of the language of academic conventions and making them modern,
accessible to the modern spectator (more will be said about this later).

The *Liberty Leading the People* was the first and only instance in which
Delacroix chose to represent a contemporary French political event in a large-
scale history painting. An overview of the vast number of paintings that consti-
tute his corpus of history paintings reveals that he worked in a remarkably wide
and diverse range of subjects inspired by world literature of various epochs,
including Dante, Shakespeare, Goethe, Byron, and Scott, by religion, especially
the Old and New Testaments, by mythology, as well as by all types of historical
sources. Many of his small-scale historical paintings, made for private collec-
tors, belong to the emergent Romantic category of anecdotal history, while his
large-scale Salon paintings and commissioned murals created for the public
domain can be understood much more readily in terms of the established con-
ventions of the French classical tradition.[34] Like seventeenth- and eighteenth-
century painters before him, Delacroix depicted large-scale images based on
ancient, medieval, and modern history and he successfully solicited large-scale
mural commissions from church and state.[35] He has no rival in the Romantic
period for his vast range and consistently innovative treatment of historical sub-
jects and is still remembered as the greatest religious painter in France of the
nineteenth century as well as the artist who revitalized mythological themes and
made them modern.

It is important to remember, however, that as a history painter who viewed
himself in dialogue with the French classical tradition, Delacroix, like many of
his predecessors, including the first director of the Royal Academy of Painting
and Sculpture, Charles Lebrun, also worked in the so-called lesser categories of
the hierarchy of genres. Throughout his career he created brilliant, varied, and
innovative works in all categories of the hierarchy including portraiture, genre,
landscape, animal painting, and still life. This vast corpus of paintings, when
considered as a group, reveal an artist who experimented continually with
choice and treatment of subject, style, and technique. His great self-portraits
reveal the level of intense psychological penetration of which he was capable
(Fig. 41). In his images of everyday life he specialized in depicting what he imag-
ined to be everyday life in cultures other than his own, as in his *Women of*

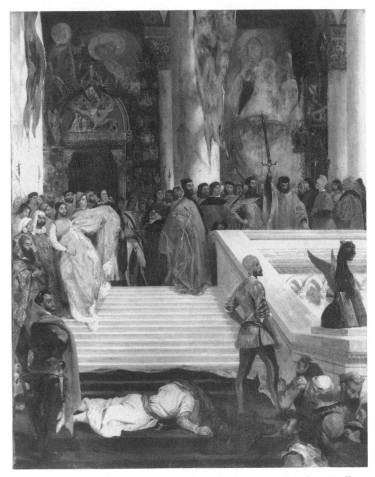

Fig. 40. Delacroix, *Execution of Marino Faliero*, 1826. London, Wallace Collection. Oil on canvas, 146.4 × 114.3 cm. (Reproduced by permission of the Trustees of the Wallace Collection, London).

Algiers (1834; Pl. 6) inspired by his 1832 trip to Morocco and Algiers. Influenced particularly by Rubens, he also came to specialize in representations of hunts, such as the violent and brutal *Lion Hunt* of 1855 (Pl. 11), in which men engage in carnal battles with savage beasts with horses as the hapless victims of both. Delacroix, in fact, was one of the great animal painters of all time, focusing as he did on the nature and psychology of animals in their native habitats, as in *Lion Devouring a Rabbit* of 1851–6. And, while the beauty of his landscapes that constitute the expressive background of many of his most celebrated historical and religious paintings has often been remarked on, his lyrical independent landscapes, such as the *Cliffs at Etretat,* in which the solidity of forms seems to dissolve into color and light, had a profound impact on the Impressionists. If this were not enough, Delacroix also painted magnificent still-lifes such as the fascinating *Still Life with Lobsters* of 1827 (Fig. 42) with its compositional and iconographical oddities.

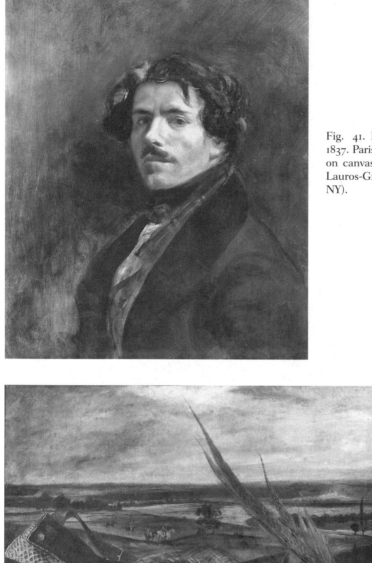

Fig. 41. Delacroix, *Self-Portrait,* 1837. Paris, Musée du Louvre. Oil on canvas, 65 × 54.5 cm. (Photo Lauros-Giraudon/Art Resource, NY).

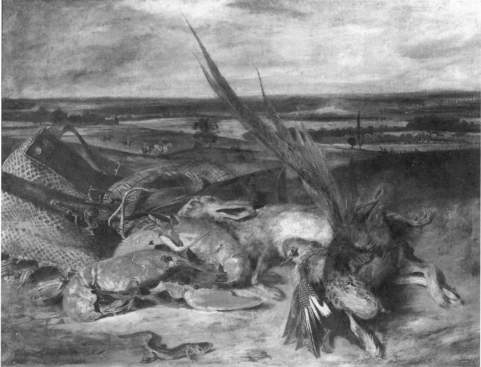

Fig. 42. Delacroix, *Still Life with Lobsters,* 1827. Paris, Musée du Louvre. Oil on canvas, 80.5 × 106.5 cm. (Photo Lauros-Giraudon/Art Resource, NY).

Hallowed Archetypes

The art historical literature emphasizing the filiation between Delacroix and Rubens originated during Delacroix's lifetime. Baudelaire called Delacroix "the French Rubens," and Delacroix himself wrote extensively about Rubens ("this Homer of painting") from whom he learned to create an alternative to the stasis and what were, for him, the empty conventions of the Neoclassical style that still dominated academic art in the 1820s.[36] In his desire to create movement and dramatic energy through a dynamic compositional structure, vigorous and energetic drawing, and intense and vivid color, it is understandable that Delacroix would turn to one of the greatest artists of the past who had exemplified all of these things. Rubens, in fact, had been considered one of the great figures in the French classical canon since the early eighteenth century. Because of his stature as an international court painter and his specific ties with the French monarchy (his monumental Marie de Medici cycle had exerted a continual influence on French art since its completion and was still on view during Delacroix's lifetime), Rubens had held a significant position in the theory and practice of French academic art throughout the eighteenth century (Jacques-Louis David, the leader of the French Neoclassical school that favored Poussin and an emphasis on line, as well as artists such as Gros and Géricault, had been profoundly influenced by Rubens). Debates on line versus color at the Royal Academy of Painting and Sculpture at the end of the seventeenth and beginning of the eighteenth century had pitted Poussin, the draftsman, against Rubens, the colorist (just as Ingres would be later pitted against Delacroix). By the early eighteenth century, largely due to the polemical writings of the influential Roger de Piles, Rubens and the proponents of color were in the ascendent.[37] Poussin would return to the fore as an artist to emulate after the Neoclassical academic reforms of the mid-eighteenth century. Nevertheless, the battle of line versus color would continue in French academic theories of art throughout the nineteenth and well into the twentieth century; one thinks of Matisse and the Fauves, the colorists, pitted against Picasso and the Cubists, proponents of line. Significantly, in the academic debates of the seventeenth and eighteenth centuries, color was associated with emotion, line with intellection (form and idea).[38]

Delacroix refocused attention on the academic debates of line versus color by taking Rubens as a model for creating an alternate aesthetic to the prevailing Neoclassical model that was based on the primacy of drawing. His contemporaries understood very well what he was attempting to do – in fact, conservative critics such as Etienne Delécluze consistently faulted his draftsmanship, claiming he was a mere colorist.[39] Baudelaire rushed to the artist's defense by emphasizing the significance of color in his oeuvre.[40] Delacroix himself declared that his artistic goal was to conjoin line and color. In addition, he defended color in painting not only as a vehicle for the expression of emotion but as a form of intellection; for him color as well as line could embody ideas.[41]

By reviving seventeenth-century academic debates of line versus color,

Delacroix once again revealed the extent to which he was in dialogue with the French classical tradition. And by taking Rubens as a model he demonstrated his accord with one of the most important educational precepts of the French Academy since its founding – that of emulation. The earliest published conferences at the Academy consisted of lectures about the great history paintings in the king's collection (which later formed the basis of the Louvre). In these lectures, which were given to the group of academicians in front of the paintings themselves, the subject, composition, and style of a single work were analyzed for the purpose of teaching artists how to improve their art by imitating their illustrious predecessors. These included the great Renaissance masters, of course, such as Raphael and Titian, but also such seventeenth-century "classical" French artists as Poussin.[42] The notion that great artists provide paradigms for emulation still dominated academic theory and pedagogical doctrine in the early nineteenth century.

Delacroix revered certain great artists of the past and throughout his career studied and wrote about their works. He viewed himself as working in a historical continuum, a tradition that began with Italian Renaissance art and reached its apogee of codification in the French Academy. He believed he was the true heir to this tradition because he understood it and sought to perpetuate it. Delacroix's view of himself as, in part, the incarnation of the classical tradition in art was predicated on his belief that art in the past had reached heights which could never be surpassed.[43]

From the very beginning of his career Delacroix sought prototypes he could transform in his art. In the early 1820s he drew assiduously from widely disseminated collections of antique coins and then lithographed them, thereby establishing for himself a type of dictionary of antique male and female heads and figures as well as animal compositions to which he would refer throughout his career.[44] During the 1820s he continued to copy the past masters in the Louvre collections, and his early religious commissions reveal the strong role played by established hallowed precedents. His first commissioned painting, for example, *The Virgin of the Harvest* of 1819, painted for the parish church of Orcemont, owes a profound debt to Raphael, particularly to the *Belle Jardinière*, 1507, which Delacroix knew from the Louvre.[45] The Royal Academy of Painting and Sculpture had always considered Raphael to be another bulwark of the French classical tradition, and this remained constant during the first half of the nineteenth century.[46] Ingres, for example, frequently paid homage to Raphael through his paintings (as in the *Vow of Louis XIII*); significantly, Delacroix, his putative antipodean rival, would do the same. Toward the end of his career, for example, in the mural programs commissioned for the Chapel of the Holy Angels at St. Sulpice (1856–61), Delacroix painted two of three monumental compositions as a form of direct homage to Raphael – *Michael the Archangel Vanquishing the Devil* and *The Expulsion of Heliodorus from the Temple* (Fig. 43); the powerful *Jacob Wrestling with the Angel* (Fig. 44) is the only one of the three not in dialogue with Raphael – lesser known precedents have been identified in this case.[47]

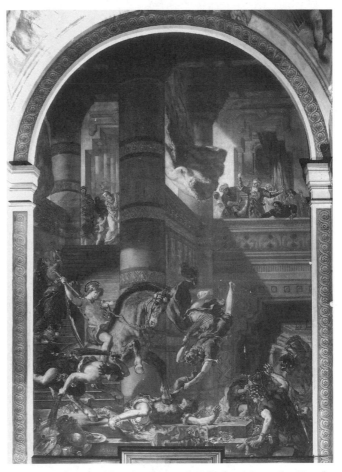

Fig. 43. Delacroix, *The Expulsion of Heliodorus from the Temple*, Paris, Chapelle des Saints-Anges, Saint-Sulpice, 1860. Oil and wax on plaster, 751 × 485 cm. (Photo Lauros-Giraudon/ Art Resource, NY).

Although an exhaustive iconographic study of Delacroix's works would reveal a multitude of precedents based on types from renowned examples of the past (including his series of animal hunts, which were directly inspired by Rubens and Rembrandt), the pictorial sources that inspired him are most obvious in his corpus of religious paintings. Delacroix recognized religious painting, highly esteemed by the French Academy at its inception and reassigned a certain pride of place during the Restoration, as the most conservative of categories within the overall genre of history painting, linked most directly to tradition, doctrine, and belief. Although he did not adhere to any formal religion, Delacroix was fascinated by the art, architecture, and rituals of the Catholic church. He painted a considerable number of religious subjects, notable for their emotional and psychological intensity. Baudelaire singled him out as the greatest religious painter of the "secular" nineteenth century. In his writings Delacroix reflected on religion and even lamented the loss of religious belief in contemporary society.[48] In order to depict profound religious sentiment in an age that had turned away

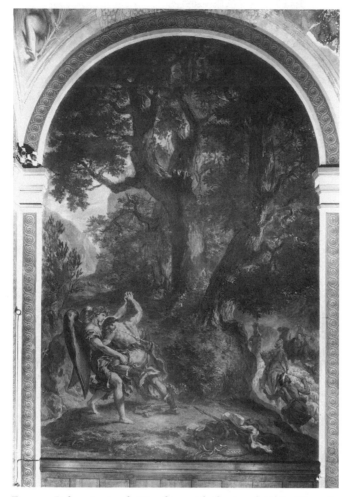

Fig. 44. Delacroix, *Jacob Wrestling with the Angel*, Paris, Chapelle des Saints-Anges, Saint-Sulpice, 1855–61. Oil and wax on plaster, 751 × 485 cm. (Photo Lauros-Giraudon/Art Resource, NY).

from religion as a dominant force, Delacroix looked to the great religious painters of the past, particularly Raphael, Titian, Rembrandt, and Rubens, to discover their modes of expressing profound religious feeling. That Delacroix painted many smaller easel paintings with religious themes would seem to suggest a more personal engagement.

Delacroix's series of paintings of the *Crucifixion* can serve as paradigmatic examples of how he engaged in a dialogue with works of the past masters. In 1835 Delacroix painted an emotional, large-scale *Crucifixion* that was first in a series of very beautiful and expressive *Crucifixions*.[49] He painted several versions of this subject in the 1840s and 1850s after a trip to Belgium and Holland in which he saw and drew from some of Rubens's greatest religious masterpieces, including his famous *Crucifixion* at Antwerp.[50] Théophile Thoré remarked that Delacroix's *Christ on the Cross* exhibited at the Salon of 1847 (Fig. 45) "recalls Rubens's most beautiful Crucifixions" but then went on to say that Delacroix

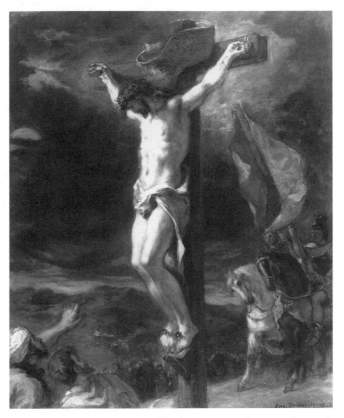

Fig. 45. Delacroix, *Christ on the Cross,* 1846. Baltimore, The Walters Art Gallery. Oil on canvas, 80 × 64.2 cm.

would have achieved the same religious feeling and expression even without Rubens as a predecessor, thereby revealing the importance for Romantic critics of the idea of originality of a work without precedents, an idea to which Delacroix did not adhere.[51]

In accord with Delacroix's vision of the French classical tradition, the established prototype did not preclude originality. Pictorial sources from art of the past, in fact, served as the prelude to inspiration and to a form of expression that must always be the artist's own. In an entry in his *Journal* of 15 May 1824 Delacroix addressed this issue in the following terms: "What creates men of genius or rather, what they create, is not new ideas but the idea, which possesses them, that what has been said has still not been said enough."[52] Delacroix believed the great ideas in art are not necessarily novel but, in fact, are often the same basic ideas that need to be expressed again, repeated for each new generation. But we need to keep in mind that Delacroix, although believing in the traditions and themes of past art, also profoundly believed that art needed to communicate in the language of the present; art could not and should not ever attempt to resuscitate past modes for this would lead to empty "recipes" and sterile conventions.[53] Delacroix's dialogue with art and artists of the past was dynamic; he did not try to reproduce past styles, structures, and modes, but to

translate into a modern language of art the ideas and the spirit that motivated the great works of the classical tradition; authentic emulation embodied this truth.[54] For Delacroix great art of the past should be studied and revered. It should inspire but not dictate to contemporary art, which must formulate a new language, one that will touch contemporaries because it will be a language they will understand.

The Language of Painting

Delacroix's journals, correspondence, and articles are filled with his meditations on the language of painting. This is not surprising because Delacroix, as a prolific and eloquent writer, as Michèle Hannoosh has emphasized, made constant connections between written language and the language of forms that was peculiar to the visual arts, particularly to painting.[55] He often remarked on the essential difficulty and challenge of art criticism – namely, how a visual experience becomes translated into words.[56] As is well known, this problem of the verbal versus the visual, discourse and art, had been a central theme of the seventeenth-century French classical tradition and had pervaded academic writings on art since the earliest conferences at the Royal Academy of Painting and Sculpture. Steeped in Italian Renaissance theory, doctrine and practice, the seventeenth-century French Academy adopted the Albertian model of the artist as humanist, scholar, and intellectual; the Italian Renaissance tradition had indelibly linked painting and discourse.[57] The French Academy in the classical age had insisted that intellect, the mind, should reign supreme over the practice of art; this is what was used, we remember, to distinguish the artist from the artisan. Thus the pedagogical goals of the seventeenth-century Academy, goals which remained constant through the nineteenth century, if not always enforced, were to educate students to reason and reflect on art and to study the disciplines related to it (anatomy, history, perspective, etc.) as well as to master technical skills. History painting, above all, brought together painting and discourse because it invariably depended on a written source, whether historical, literary, religious, or mythological. In the seventeenth century the word was considered supreme, and although much ink would flow in the eighteenth century about the pros and cons of *ut pictura poesis* and differences in the aesthetic modes of the visual and the verbal would be analyzed, the hegemony of the word in the visual arts, especially in history painting, would persist as a foundational academic precept through the nineteenth century.[58] Following the path established by Italian Renaissance art theorists, the seventeenth-century French Academy analyzed components of the visual arts according to categories of classical rhetoric as defined by Cicero and Quintillien; thus the vocabulary for a visual language itself was predicated on classical and Renaissance rhetorical models.[59] This is the tradition that Delacroix, like all aspiring history painters, inherited in early nineteenth-century France.

 In his important article on "Des Variations du beau" (*Revue des deux-mondes*,

15 July 1857), Delacroix laments the continued dominance of the word in the visual arts in France, particularly in painting. In an eloquent passage he analyzes the problematic rapport between a painted narrative and its literary source with the further complication of the critics who interpret subject matter rather than look at the representations of forms. Delacroix writes,

> It is a completely French obsession that no doubt has to do with our penchant for everything that pertains to the word. In France the painter wants to please the writer; the man who holds the brush is dependent on the man who holds the pen; he wants to make himself understood by the thinker and the philosopher.[60]

Delacroix inherited from the French classical tradition the mania for a dependence on the word, for although he continually struggled with evolving an eloquent pictorial language of form and color, he nonetheless, in his history paintings, relied on literary, historical, religious, or documentary sources, and he devoted a great deal of time and effort to analyzing his ideas, responses, and activities as an artist. In his writings Delacroix continually explored and sought to emphasize what was unique in the language of painting and how this language of form and color communicated quite differently from the written word.[61] In a brilliant passage from his *Journal*, dated 20 October 1853, Delacroix differentiates between the written word (which when seen on the page also has an important visual component) and the language of painting:

> You enjoy [in painting] the true representation of these objects, as if you were actually seeing them, and, at the same time, the meaning which these images hold for the mind stirs and transports you. These figures, these objects, that appear to a certain part of your intelligence to be the thing itself, seem like a solid bridge on which the imagination leans, in order to penetrate fully the mysterious and profound sensation of which the forms [in painting] are, in some way, the hieroglyph, but a hieroglyph that speaks very differently from a cold representation that merely occupies the space of a printed letter; [painting] is a sublime art in this sense, if one compares it to that [writing] in which the thought only reaches the mind by way of letters placed in a conventional order. Painting is a much more complicated art, if you will, because the printed sign is nothing and the thought seems to be everything but a hundred times more expressive if, independently of the idea, one considers the visible sign, the speaking hieroglyph – a sign without value for the mind in the work of a writer becomes, in the work of the painter, a source of the keenest pleasure, namely, the satisfaction that the spectacle of things, beauty, proportion, contrast, harmony of color give as well as all that the eye considers with so much pleasure in the exterior world, all these things being a fundamental need of our nature.[62]

For Delacroix the language of painting, like the written word, communicates thought and ideas but very differently, for the visible signs in painting, its visual language of form and color, function as speaking hieroglyphs. This passage, which differentiates between the communicative modes of painting and writing, also implies that, for the artist, history painting stood in a complex and ambigu-

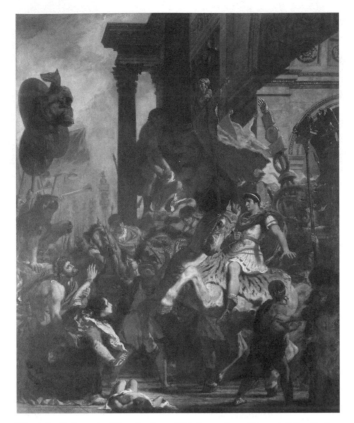

Fig. 46. Delacroix, *The Justice of Trajan,* 1840. Rouen, Musée des Beaux-Arts. Oil on canvas, 490 × 390 cm. (Photo Lauros-Giraudon/Art Resource, NY).

ous relationship with its literary source or sources. A dramatic example of the distinctive language of painting vis-à-vis its literary or historical inspiration is Delacroix's *Justice of Trajan,* exhibited at the Salon of 1840.

The Justice of Trajan (Fig. 46) is a work of enormous dimensions – 4.90 × 3.90 meters (approximately 16 × 12½ feet) and, like the majority of his monumental historical canvases made for exhibition at the Salon, it was created as an independent work without a commissioning agent and painted at the artist's own expense (it was purchased by the state in 1842).[63] Delacroix depicts a dramatic legendary episode from the reign of the Roman emperor Trajan: Trajan leaving the city of Rome with his armies to wage war is confronted by a widow who asks for justice – her only son has been killed, trampled to death by the horse of a Roman soldier (in some accounts, Trajan's son). The forward movement of the emperor and his army is brought to a halt by the dramatic figure of the pleading widow who, kneeling before the body of her young son, blocks Trajan's path.

Delacroix conveys the grandeur, pomp, and power of Rome through the architectural setting with the detailed depiction of a triumphal arch, through

the conglomeration of monumental military and imperial objects and accoutrements that accompany the army, including trophies, through costume and through the portraitlike figures on horseback, including the emperor himself. The painting communicates through a powerfully expressive visual language based on eloquent pantomime and gesture as well as expressive physiognomy – the hallowed language of history painting in France as it was established in the seventeenth-century.

Although the painting met with some of the typical accusations of negligence in drawing, composition, and color that Delacroix had come to expect, many critics, including Baudelaire (who extolled the work), and the public, were captivated by Delacroix's dramatic reimagining of a legendary episode from ancient Roman history that revealed the virtue of great political leadership, for Trajan does grant justice and mercy to the poor widow who implores him.[64] But the painting also makes a dramatic case for the potential of the individual vis-à-vis the state – a humble woman, with moral right on her side, stops an emperor and his army. Many critics noted the general influence of Rubens and Veronese, but Delacroix may also have had in mind a specific eighteenth-century French monumental history painting, one that he would have seen in the Louvre, Hallé's *Justice of Trajan* from 1765.[65]

One of the most remarkable features of this remarkable composition, one of many in which Delacroix engages classical themes from Greek and Roman antiquity, is its relationship to the literary source on which it was based. For although the theme derives from legendary Roman history, Delacroix based his interpretation on its recounting in Canto X of Dante's *Purgatorio*. In the Salon booklet Delacroix reprinted the specific lines from Descamps's French translation of the medieval epic that make clear the moral meaning of Trajan's imminent decision to have pity on the widow and to grant her justice.[66] But this passage from Dante itself already constitutes an example of *ekphrasis*, for Dante, in purgatory, describes a magnificent white marble relief that represents the *Justice of Trajan*. Dante describes in poetry a work of sculpture that Delacroix then retranslates into painting. Delacroix's painting becomes an example of *"visibile parlare"* (visible speech), to utilize Dante's striking and gravid phrase from the very passage in Canto X in which he describes the expressive pantomime of the marble relief of the *Justice of Trajan*.[67] Delacroix subtly nuances thereby the painting's relationship to its literary source and demonstrates his belief in painting construed as a language, an art of signs, of the "speaking hieroglyph."

As we have seen, Delacroix's subtle dialogue with the French classical tradition was profound, lasting, and fructive, and went far beyond any simple embrace of or opposition to classical academic conventions. Instead, the artist often strove to innovate where he could within the tradition, thereby expanding its boundaries, and radically transformed or even rejected the tradition when he had to based on the inner imperatives of his art.

8 Delacroix and Modern Literature[1]

Paul Joannides

To Lee Johnson

The Reality of Fiction

Around 1821 Delacroix painted his earliest self-portrait (Fig. 47).[2] Although the picture is small he showed himself full-length, clad in seventeenth-century costume; were his features not clearly identifiable one would take the painting as a narrative scene. He appears not *in propria persona* but *en rôle*. Whose? An inscription formerly on the painting's stretcher read *Raveswood,* clearly a misspelling of Ravenswood, the doomed hero of Scott's *The Bride of Lammermoor,* published in France in 1819. But is this correct? In Delacroix's single sure representation of Ravenswood, the lithograph of *Ravenswood and Lucy by the Fountain* of 1830, he is shown with a long moustache.[3] Partly as a consequence, it has been argued that the portrait represents Delacroix as the protagonist of Byron's autobiographical *Childe Harold* or as Hamlet.[4] The lost inscription probably had the truth of the matter – and a preliminary sketch for the lithograph omits the moustache[5] – but, since Hamlet provided the common model of Scott's and Byron's heroes, the alternatives retain resonance. The figure's stance, neither stationary nor in motion, and his gestures, neither relaxed nor active, suggest hesitation, uncertainty, inner struggle to reach decision. The setting is shadowy and indeterminate, the palette sombre. Concept, image, and technique combine in a visual style that exudes tension and insecurity.

Delacroix's fusion with a troubled fictional character created by a modern foreign author is emblematic.[6] Ravenswood was a fiction that Delacroix could introject, and he could project into that fiction his own anxieties – which, in the early 1820s, had a strongly erotic dimension. Perhaps significantly, the other episode that he treated from the novel was the aftermath of Lucy's deranged assault on Bucklaw on their wedding night.[7] Fictions in prose and poetry – especially by for-

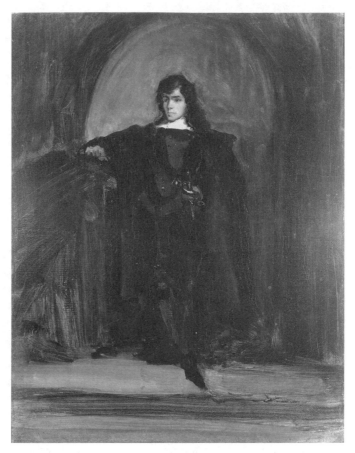

Fig. 47. Delacroix, *Self-Portrait as Ravenswood*, c. 1821. Paris, Musée du Louvre. Oil on canvas, 40.9 × 32.3 cm. © Photo RMN (Service de la Réunion des Musées Nationaux, Paris).

eign authors – were central to Delacroix's imagination and to his oeuvre, and he returned to them again and again. Structuring the imaginary, they determined the symbolic. And with his astonishingly labile capacity for visualization, Delacroix was able to achieve a visual and psychological authenticity in his representations that far outdistanced those of others. As his images of the Greek War of Independence have attained the status of national record in Greece, as his treatments of North Africa are valued for their comprehension and authenticity by Algerians and Moroccans, so Delacroix produced more subtle readings of Byron, Scott, and, above all, Shakespeare than any English artist, and an interpretation of *Faust* that Goethe considered in some respects superior to his own original.[8] Delacroix, at least by the end of his life, was conscious of some of the reasons for his commitment. He noted on 30 January 1860, "Some artists can choose their subjects only from foreign works that lend themselves to vagueness. Our own authors are too perfect for us. . . . The more perfect the work that inspired a picture, the less opportunity an allied art will have of producing a com-

parable effect on the imagination'." The "imperfections" of foreign literature, the frequent formal openness of Delacroix's favorite authors, allowed space for his imagination to expand.[9]

Occasionally Delacroix treated subjects that were obscure, and a few identities have been retrieved only with difficulty. But in Delacroix's paintings – unlike those of most of his contemporaries – such losses rarely affect communication. Delacroix distilled even from the slightest anecdotes some psychological universal, intensely rendered, and his visual knowledge allowed him to select from a wider range of techniques and staging than his contemporaries, investing his images with a range of echoes and allusions that, compressed, transform narrative into poetry. Delacroix's images, rich for those who know his sources, remain rich for those who do not.

The Repertoire

Delacroix's first major painting, shown at the Salon of 1822, depicted an episode from Dante's *Inferno;* at the Salon of 1859, the last in which he participated, he showed subjects from Shakespeare's *Hamlet,* Scott's *Ivanhoe,* and Tasso's *Jerusalem Delivered.* Although modern, often contemporary, literature dominates the first two decades of his career, classical literature – as well as the history and mythology of the ancient world – played a significant part from the late 1830s onward, coincident with his work on the Library of the Palais Bourbon, although there and elsewhere it is interpreted in a manner radically unlike that of most of the artists of his time. Renaissance romances also became significant in the last decade of Delacroix's activity, with five substantial paintings from Ariosto and three from Tasso.[10] But most distinctive remains Delacroix's reliance on modern literature, and his treatments of *Torquato Tasso in the Hospital of St. Anna, Ferrara* of 1824 (Fig. 5) and 1839 (Fig. 21) dealt with the poet's biography, not his works, and are indebted to Byron's *Lament of Tasso.*[11] Modern literature occupies in Delacroix's oeuvre a more extensive place quantitatively and plays a more profound role qualitatively than in that of any of his contemporaries. Notable, however, is that for pictorial purposes Delacroix showed minimal interest in modern French writing: Delavigne, Vigny, and Lamartine are absent from his work, and, although Hugo may lie behind the *African Pirates Abducting a Young Woman* of 1852, that is Delacroix's only painted subject from the greatest exponent of literary romanticism in France.[12] From Alexandre Dumas, he took the subject of only one minor painting, *Queen Christina and Sentinelli;*[13] from George Sand, whom he liked and admired, he twice painted, on a small scale, the subject of *Lelia Mourning Stenio,* in slightly different forms.[14] Chateaubriand alone inspired a major painting, the *Natchez,* apparently sweet, covertly bitter, because the baby, watched by the exhausted mother and held by the proud father, is soon to die.[15] In contrast, Delacroix displayed enormous interest in German and British writers, either still living at the beginning of his career, or, in effect, newly disin-

terred, like Shakespeare. Delacroix read German literature in translation, and his interest was confined to Goethe; he seems never to have tackled Bürger or Schiller. Although he could understand English, after his early years he read British writers too in translation. Unlike the most adventurous of the preceding generation of French painters, he showed no interest in Ossian or the Ossianic, or in Edward Young's *Night Thoughts.*

The major currents of Delacroix's interest emerge from a few rudimentary statistics. If we look at Lee Johnson's catalogue we find that, of the eighty-one subjects from postclassical literature, six are from Goethe, and fifty-seven from writers in English. They break down further as follows. From Goethe Delacroix painted four subjects from *Faust* – two repetitions of *Marguerite in Church,* one only a sketch,[16] and two of the *Death of Valentin,* one in 1826, the other in 1847.[17] From *Goetz von Berlichingen* Delacroix painted three different subjects, all of which more or less duplicate his lithographs.[18] Among the English writers of lesser interest to Delacroix there is one painting of the *Penance of Jane Shore* from Nicholas Rowe's play (plus a lithograph, prompted by the visit of the English theater to Paris in 1827),[19] and one from Mathurin's *Melmoth the Wanderer.*[20] There are three repetitions of *Tam Pursued by Witches* from *Tam o'Shanter,* Delacroix's only subject from Burns.[21] He also painted *Milton Dictating Paradise Lost to His Daughters,* but this should probably be seen less as a literary subject than as a representation of the artist in adversity, a theme that recurs throughout Delacroix's life.[22] *Paradise Lost* was popular among French painters, but Delacroix seems never to have treated it.

The British writers who made the most profound impression on Delacroix were Byron, Scott, and Shakespeare. He painted over ten subjects from Scott, all from the novels, not, apparently, the narrative poems. The two novels that impressed him most were *Quentin Durward,* perhaps for its French setting, and *Ivanhoe,* in which the Saxon-Norman divide may have triggered his interest. Both themes obviously related to the structure of national feeling in the immediate aftermath of the Napoleonic wars. And the Scottish writer provided Delacroix, like so many of his contemporaries, with an avenue to France's own history. But both novels are also among Scott's most thrilling, and Delacroix seems always to have been taken with rapidly paced storytelling and cross-cutting between parallel narratives.

However, Delacroix's interest in both novels requires clarification. Thus four of his five paintings from *Quentin Durward* represent the *Murder of the Bishop of Liège,* from Chapter 22. These comprise a major painting, first exhibited in 1829 (Fig. 48) but worked on for some time before that, two preparatory sketches, and a reduced variant, probably painted in the later 1830s, after which he did not return to the novel.[23] The fifth painting, *Quentin and the Balafré* of 1829, is a small, incisively characterized, edgily comic scene, in imitation of Teniers. Although a slight work, it shows how Delacroix turned to Dutch genre painting to find an appropriate manner for one of those comic moments whose alternation with those of high seriousness is a characteristic feature of English

literature.[24] It was this alternation that posed such obstacles for French appreciation of Shakespeare, and which, swallowed whole, is theorized in Hugo's preface to *Cromwell*. In the case of *Ivanhoe*, the assault on the castle as witnessed by *Rebecca and the Wounded Ivanhoe* and the *Abduction of Rebecca* by the henchmen of Sir Brian de Bois-Guilbert were each painted twice. The first subject was painted in 1823 and repeated in slightly modified form, probably in 1858;[25] the second was painted in 1846 and again, visualized very differently, in 1858.[26] The fifth subject from *Ivanhoe*, a now-lost painting of the early 1830s, *The Black Knight and the Hermit of Copmanhurst*, parallels *Quentin and the Balafré* in that it is also sharply comic and painted in a neo-Dutch style, one strongly influenced by Ostade.[27] Suprisingly, in view of Delacroix's fascination with the Orient, only one – lost – painting by him seems to have been from *The Talisman*.[28]

From Byron, who, in his early years, probably excited Delacroix most intensely, there are some twenty subjects. He tackled *The Giaour* most frequently, producing six paintings from that poem. All bar one involve combat, pursuit, or victory.[29] The exception, a small depiction of *The Giaour's Confession* – a conventional scene that, unlike the *Combat*, was also treated by other painters – was made as a gift for George Sand, which may account for its relative sentimentality.[30] *The Bride of Abydos* inspired four paintings, comprising two pairs of similarly composed works. Both pairs illustrate slightly different moments from one of the poem's final scenes, the attempted – but ill-fated flight of Selim and Zuleika.[31] Both Delacroix's paintings from *Lara* depict, in radically different stagings, the hero's death.[32] His three from *Don Juan* – one a preparatory sketch – depict the plight of the shipwrecked men.[33] Although he never treated the *Corsair* in oils, there are two watercolors of *Gulnare Visiting Conrad in Prison*, one a fully finished exhibition piece, shown at the Salon of 1831.[34] But two of Delacroix's largest and most masterly paintings from Byron, the *Execution of Marino Faliero*[35] (Fig. 40) and *The Two Foscari*,[36] exist in single versions, and the same is true of the impassioned and affecting 1834 *Prisoner of Chillon*:[37] all three treat the theme, explored also in the 1831 *Interior of a Dominican Convent in Madrid* (Fig. 13) from *Melmoth the Wanderer*, of the individual ruined by state or institution, whose inexorable power is symbolized by oppressive architecture – an issue not without echoes in Delacroix's own career and in that of the patron of both the *Dominican Convent* and the *Prisoner of Chillon*, the young duc d'Orléans.

Among English writers, however, it was Shakespeare who affected Delacroix most profoundly. As early as 1820 he had remarked on "the tallant of the author in the living painting and investigation of secret motions of the human heart."[38] In all he painted some twenty-five pictures after Shakespeare. By the mid-1820s he had treated subjects from *Romeo and Juliet*, *Hamlet*, *Macbeth*, and *Othello*, but it was in his middle years that he took the true measure of Shakespeare's greatness. *Hamlet* was by far the most favored text: eleven paintings were inspired by various scenes of the play including at least four versions, three of them masterpieces, of *Hamlet, Horatio and the Gravedigger*, plus two litho-

Fig. 48. Delacroix, *Murder of the Bishop of Liège,* 1829. Paris, Musée du Louvre. Oil on canvas, 91 × 116 cm. © Photo RMN (Service de la Réunion des Musées Nationaux, Paris).

graphs of 1828 and 1843 as well as numerous drawings.[39] Delacroix treated *Othello* in six paintings, one of which remained a sketch,[40] and *Macbeth* in three: two of which, showing *Macbeth and the Witches,* one vertical in format, the other horizontal, are early.[41] He painted three different scenes from *Romeo and Juliet* executed at wide intervals, the earliest of which remained unfinished.[42] And *Antony and Cleopatra* inspired two paintings, both of *Cleopatra and the Peasant,* the first a masterpiece, the second somewhat inchoate.[43]

The first decade of Delacroix's activity was crucial. When he turned to writers still living when he was a young man, he made use only of work that appeared before 1826. He produced no visual treatments of any novels published by Scott after that date and nothing of Byron's postdating the three "political" plays of 1821. And much of Delacroix's repertory of subjects from these writers and from Shakespeare was established by the end of the 1820s, even if not in the form of finished paintings.[44] Certain subjects, although first treated in securely datable paintings only later in his career, were nevertheless addressed in the first decade of his activity. *The Shipwreck of Don Juan* dated 1840 and shown at the Salon of 1841 is a case in point, because it is likely that the two preliminary drawings in the Louvre and the large oil sketch in the Victoria and Albert Museum (Fig. 49) were all executed in the mid-1820s.[45] Delacroix's earliest known oil painting of *The Death of Lara* dates from 1847, but he had treated the subject in a richly worked watercolor that is probably identical with lot 87 in the

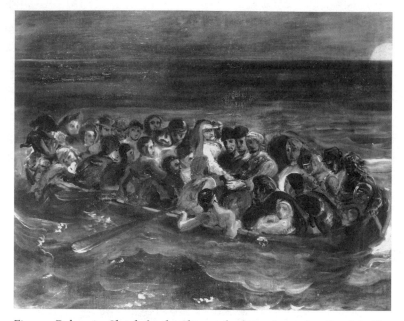

Fig. 49. Delacroix, *Sketch for the Shipwreck of Don Juan*, 1827. London, Victoria and Albert Museum. Oil on canvas, 81.3 × 99.7 cm. (Photo courtesy Art Resource, New York).

Arrowsmith sale of February 20, 1826 (Fig. 50); this, in turn, may have been a response to the lithograph of the subject designed by Géricault in 1823.[46] It is significant that he created a poignant but comparatively distanced image in the watercolor, but consciously evoked a Pietà in the 1847 painting. Again, although Delacroix did not paint and exhibit *The Abduction of Rebecca* from *Ivanhoe* until 1846 – his vertiginous image perhaps prompted by the inadequacies of Léon Cogniet's stiff and prettified 1828 painting that was re-exhibited at the Bazar Bonne Nouvelle that year – he had experimented with the subject in a small watercolor as early as 1822–3 (Fig. 51).[47] *The Bride of Abydos* may also have been treated in the 1820s; Delacroix made a list of likely subjects from the poem in 1824 and was clearly much impressed by it; although no representation of Selim and Zuleika has yet been identified in his vast graphic oeuvre, that reserves many surprises. *Romeo Says Farewell to Juliet* was first painted in 1845, but a related drawing is found in a sketchbook of c. 1823.[48]

 The Giaour haunted Delacroix. Byron's poem, subtitled *Fragments of a Turkish Tale,* is one of his greatest dramatic achievements. Making use of multiple-viewpoint narration, flash-backs, and time-lapse descriptions, it compels the reader to participate in constructing the course of events. The poem invites the reader's imaginative participation, and the velocity of the verse creates – still – the excitement achieved by rapid cross-cutting in film. Delacroix responded intensely to this. He made a lithograph of the *Giaour Trampling Hassan's Body* in 1827, probably in response to one of the same subject designed by Géricault in 1823;[49] but it was the *Combat of the Giaour and Hassan* that inspired him most strongly. He painted it in varying forms in 1826, 1835, and 1855, and in the

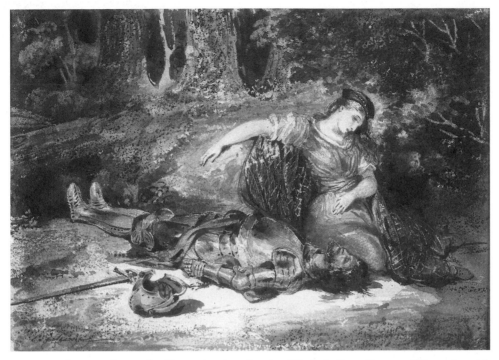

Fig. 50. Delacroix, *The Death of Lara,* 1824. Los Angeles, The J. P. Getty Museum. Watercolor with body color and graphite, 17.9 × 25.7 cm. (7 1/16 × 10 1/8 in.). (Photo courtesy of The J. P. Getty Museum, Los Angeles).

Fig. 51. Delacroix, *The Abduction of Rebecca,* c. 1822. Paris, Musée du Louvre. Watercolor, 32.5 × 20.7 cm. © Photo RMN (Service de la Réunion des Musées Nationaux, Paris).

Fig. 52. Delacroix, *Combat of the Giaour and Hassan*, 1835. Paris, Musée du Petit Palais. Oil on canvas, 74 × 60 cm. (Photo courtesy of the Musées de la Ville de Paris).

later 1820s made a series of sketches that are among the most remarkable representations of rapid action ever drawn, and which could have served as the basis for further paintings.[50] His depictions of the encounter, described metaphorically in the poem, show a fight to the death. In the 1826 version, the two horsemen station their horses side by side: Hassan lashing down with a mace like a released spring, the Giaour's leveled sword revealing his intransigent hatred and, simultaneously, his cool head. On the ground, to Hassan's rear, in an invention purely Delacrucian, one of the Giaour's men is about to hamstring Hassan's horse. In this version, painted while the Greek War of Independence was still undecided, Delacroix emphasizes the Giaour's "arnaut garb" and set the personal combat within a broader scope. It was, of course, first shown to the public at the Exposition au profit des Grecs in 1826. The second version, of 1835 (Fig. 52), excludes anything not immediately germane to the clash. The two riders fill the picture surface, fighting head to head, each heedless of his own danger in his eagerness to kill his enemy. The two men's hatred is paralleled by the savage collision of their horses, infected with blood lust by their maddened riders. Here, Delacroix turned to a high-art source, the central group in Leonardo's

Battle of Anghiari, which he knew through Edelinck's engraving after Rubens's copy, imbuing the conflict with a timeless grandeur absent from the more reportorial version of 1826. To this visual enrichment Delacroix added a narrative one: the anonymous fallen figure in the lower center, his hand near a broken sword, his turban unrolled, is a proleptic indication of Hassan's imminent fate, for these link with Byron's description of Hassan's corpse: his turban "far behind him rolled," his severed hand still clasping a shattered sword.

To the texts that inspired him in his twenties and early thirties, Delacroix remained faithful for the rest of his life. He turned repeatedly to the same works, and to the same episodes in the same works, and although he occasionally investigated new episodes from familiar sources, felt little pressure to enlarge this range. And if Delacroix was loyal to his own early interests, he was loyal also to his creative integrity. Repeated recourse to the same texts naturally encouraged a degree of self-reference in his later work, but, although he sometimes followed the same arrangements, he rarely made simple repetitions – more often he rethought one or more of his expressive tools – staging, color range, lighting, or handling – a director preparing different productions of the same play.

It is open to question, for example, whether Delacroix reread *Hamlet* when he painted his *Hamlet and Horatio in the Cemetery* of 1859 (Fig. 53).[51] For this his starting point was his lithograph of 1828, not, significantly, the intervening versions of 1835–43, which concentrate either on Hamlet and Horatio, or the two friends and the two gravediggers. His last version of the subject, compositionally like his first but staged in reverse, is wider in scope, and includes the funeral procession of Ophelia. But the mood is very different from that of 1828. In the lithograph the emphasis is on the grotesque and the perverse as Hamlet quizzes the skull. In the painting, the universal fact of mortality dominates, and fiery reds and oranges evoke the image of a more general judgment. Although Delacroix's reuse of this scheme may have been in part an attempt to recapture the liveliness and attack of his youth, he employed it also as a meditative structure, which places Hamlet in a wider context and registers, unemphatically, his inadvertent guilt. The Faustian individualism of the first version is revised in accordance with Delacroix's detached and Olympian later manner.

It is evident from this relation – and many others – that Delacroix's paintings intertwine with his lithographs, and when these are included in an examination of his imagery and subject matter, the balance sheet becomes more complex. Delacroix lithographed compositions that he had painted and painted compositions that he had lithographed. Usually, when such repetitions occur, the lithograph comes first, but not invariably. Thus one of his two oils of *Macbeth and the Witches* was physically worked over his intense lithograph.[52] But *Hamlet Sees the Ghost of his Father* and the *Death of Ophelia,* both lithographed in 1843, were adapted from paintings executed respectively in 1825 and 1838.[53] Delacroix also treated literary subjects in prints that he did not tackle in painting. Among his contributions to the series of lithographs from Scott issued by the publisher

Fig. 53. Delacroix, *Hamlet and Horatio in the Cemetery*, 1859. Paris, Musée du Louvre. Oil on canvas, 29.5 × 36 cm. © Photo RMN (Service de la Réunion des Musées Nationaux, Paris).

and dealer Henri Gaugain in the late 1820s, but never completed, are three episodes from *Ivanhoe* that he did not repeat, as well as one from *Redgauntlet*, a novel with which he would not otherwise be associated.[54] A wash drawing in Stockholm of the unusual subject *Quentin Durward Overhears the Plot of Hayraddin and Lanzknecht Heinrich* (from *Quentin Durward*, Chapter 17), would have translated well into one of Gaugain's lithographs and was probably intended for this series (Fig. 54).[55] And, although no paintings or drawings by Delacroix of any of Shakespeare's history plays have so far been recognized, in 1834 he published a lithograph of *Young Clifford Finding His Father's Body*, from *Henry VI, Part 2*, a play in which he could hardly have been anticipated to show much interest and one virtually ignored by other French artists.[56] The fact that he treated this subject in close proximity to his great medieval battle pieces – *Poitiers, Nancy,* and *Taillebourg* – might encourage us to study these anew for Shakespearian echoes.[57]

Delacroix's lithographs include three suites based on single works, all plays: *Faust, Hamlet,* and *Goetz.* The eighteen lithographs of *Faust* were done in a short period, 1826 to 1828.[58] The sixteen from *Hamlet* were executed in two groups (of nine in 1834–5, seven in 1843).[59] The seven stones of the *Goetz* series, not among his most successful, seem to have been executed between 1836 and 1843.[60] It is not known why Delacroix interrupted work on the *Hamlet* series for eight years, but the German artist Retzsch produced several series of line engravings illustrating various plays of Shakespeare, and Delacroix may have

Fig. 54. Delacroix, *Quentin Durward Overhears the Plot of Hayraddin and Lanzknecht Heinrich*, c. 1828. Stockholm, National Museum. Ink wash on paper, 27 × 21 cm. (Photo courtesy Nationalmuseum).

been prompted to continue his own by knowledge of them; he certainly knew Retzsch's *Faust* series, for he referred to it in a letter to Philippe Burty of 1862. The slight, neurasthenic Hamlet of Delacroix's first group, closely congruent with the Hamlet of the 1839 *Hamlet and Horatio in the Cemetery* (Fig. 18), gives way in the second to a more virile, forceful type, and it is notable that the emphasis on hesitancy diminishes after 1840.

The lithographs of Faust (Pl. 4) are all of a piece, and it is unsurprising that Goethe praised them. They represent one of Delacroix's highest, but most disturbing achievements. For them he created a new style, one in which humor and evil cohere and reinforce each other. The alchemy by which Delacroix achieved this is extraordinary, and it characterizes a particularly dangerous moment in his art. It consists in extreme figural elongation, overt ball-and-socket jointing for elbows and knees — emphasized by the slashed puffs of neo-sixteenth-century sleeves and breeches — angular disposition of limbs, and scaly, spiky costumes that seem to have a life independent of their wearers. Such com-

ponents give his figures an arachnid quality, which Delacroix further reinforced by their mantis-like features. The actions are staged stiffly and jerkily, like the interlocutions of stick insects, and the eccentric lighting employed in some of the scenes creates a hellish effect. The style was compounded from a range of sources, early sixteenth-century German and Swiss prints, Urs Graf in particular, reminiscences of Fuseli and Theodore Von Holst, some of whose work he may have seen in London, and by the lighting experiments of Rembrandt. But it cannot be reduced to its components, and Delacroix's "satanic" style of 1826–8 represents an extreme in his work, a moment when he tapped into energies that – while they were never entirely lost to him – he did not exploit again in such pure – or impure – form. It is surprising that at this moment in his career he did not choose to illustrate *Richard III*, a play for which he had expressed enthusiasm as early as 1820.

After the mid-1830s, together with repetitions of favorite themes, Delacroix attempted a limited number of new subjects, which he generally treated no more than once. He did not, it seems, investigate Scott anew, but he did Byron, with *The Two Foscari*, exhibited in 1853. Shakespeare, understandably, became still more important for Delacroix in later life and provided more subjects, but he stuck to most of the same plays, maintaining a constant interest in *Hamlet*, and not, for example, showing any interest in the *Tempest*, which several French artists treated. *Othello*, from which Delacroix had painted the *Willow Song* in a lost painting of 1825, makes a reappearance and became a preoccupation in the 1840s and 1850s. This may, in part, have been a response to the suite of etchings of 1844 by Théodore Chassériau, and in part to the success of Rossini's opera, but it also gave him the opportunity to immerse himself once more in the Venetian masters, and to set personal tragedy against visual luxury – it may be significant that *The Two Foscari* is also a Venetian scene. But his subjects from *Othello* painted in the 1840s are of particular interest because they exemplify a significant common theme of his later Shakespearian work, a new concentration on the feminine.

This is introduced by his great *Cleopatra and the Peasant* of 1838 (Fig. 55).[61] Remarkably for an artist whose native language was not English and whose English was probably by then very rusty, he produced a painting that more successfully than any other registers the erotic play in the interchange between queen and clown. The positioning of the two is close, the hirsute and shaggy clown, emphatically and potently masculine, encroaching on the thin but intense form of the queen, whose arms, with poetic irony, are arranged in the classical pose of modesty. Her face – probably that of the actress Rachel – is turned with fascination to the wriggling asp, raising itself from the basket of figs. The bitter humor of the text, the sexual double entendre of "the pretty worm of Nilus . . . that kills and pains not," is matched visually by Delacroix with the discreetly sexual associations of asp and figs. Cleopatra's fixity on death continues and transforms her eroticism – "I wish you joy o' the worm."

It was this focus on the female that also revived his interest in *Macbeth*,

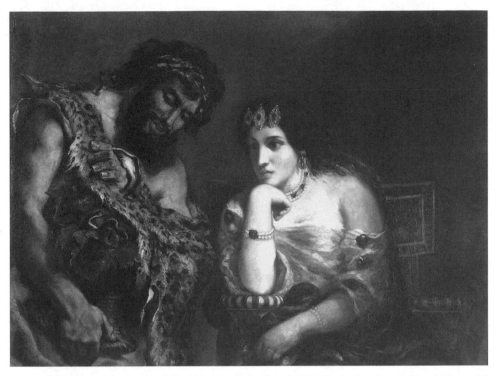

Fig. 55. Delacroix, *Cleopatra and the Peasant*, 1838. Chapel Hill, North Carolina, Ackland Memorial Art Center. Oil on canvas, 97.8 × 127 cm (38 ½ × 50 in.). (Photo courtesy of the Ackland Art Museum, the University of North Carolina at Chapel Hill, Ackland Fund).

ignored for a quarter century. His painting of *Lady Macbeth Sleepwalking* (Pl. 9) may have responded to Charles Muller's large and bombastic treatment of the same subject at the Salon of 1848, but it is unlikely that he would have been provoked by Muller's inadequacies to execute his own version had a predisposition not existed.[62] Delacroix painted a small concentrated picture, in which the thane's haggard wife, clad in a nightdress that already resembles a winding sheet, repeats her obsessional action. Nurse and doctor are pushed into the background: unlike Muller's version, the concentration is on the wasting agonies of conscience. Likewise, in his renewed interest in *Othello*, Desdemona is the focus. In *Desdemona Cursed by Her Father*, Delacroix adopts the format of a noli me tangere, but whereas Christ's avoidance of the Magdalen is gentle, here the rejection is violent and disturbing – an inversion of a natural relation expressed by the disruption of a familiar arrangement.[63] Contrastingly, in *Othello and Desdemona* (Pl. 8), painted c. 1847–9, Othello sneaking into his wife's chamber is already reduced and demeaned: the desperate neurotic – a remarkably advanced, even feminist, interpretation – not the misled hero.[64]

But perhaps the most significant representations of the period from this point of view are the versions of *The Death of Ophelia*. First treated in a painting of 1838, whose conception was inspired by a print by Smirke,[65] Delacroix was sufficiently attracted by the subject to return to it in his lithograph of 1843

and two further paintings, one of c. 1844 and the other of 1853 (Pl. 10).[66] He reg-
isters the fatal consequence of Ophelia's turmoil, but represents it with a visual
beauty that attempts an equivalent of Shakespeare's sublime description: Ophe-
lia subsides rather than falls into the stream, her thin robes spreading across the
water, the flowers spilling from her hands, the branch remaining attached so
that her body – in an extraordinary invention – remains parallel to the water's
surface as she lays her comely form not in it but upon it. Still separate from the
river, Ophelia is nevertheless joining it: the pictorial technique unites flesh and
clothing with water, as if drowning were metamorphosis. The simultaneity of
sorrow and the exquisite in Gertrude's lines is held in balance in Delacroix's
image.

Intertextuality and Subversion

Delacroix's response to his literary sources matched their own richness. In his
Self-Portrait as Ravenswood, he perhaps registered, if only subconsciously,
Scott's source in *Hamlet.* He probably did the same in a scene from Chapter 8
of Scott's novel of the English revolution, *Woodstock,* which he treated twice, in
a watercolor of 1827 and a painting of 1828.[67] In this episode, the single one
Delacroix took from the novel, the disguised Cavalier, Wildrake, planning to
assassinate Cromwell is brought to the Lord Protector's study at Windsor Cas-
tle. Hesitating in the doorway, he overhears Cromwell's soliloquy to the portrait
of Charles I. Scott clearly based his scene on the scene from *Hamlet,* Act III
scene 3, in which the prince overhears Claudius at prayer and refrains from
killing him. Delacroix must have appreciated this, for in 1843 he treated pre-
cisely this scene in his lithograph – repeated in a painting: "Now might I do it
pat," in which the arrangement is similar, if more dynamic.[68]

 Such echoes within and among his sources encouraged Delacroix to devise
his own. Certain key motifs in his favorite fictional texts are found transformed
in Delacroix's work, appearing in paintings apparently unrelated. On occasion,
when treating subjects that might have appeared to call for objective, distanced,
treatment, Delacroix animated them by referring to fictional themes which had
excited him. One of the more obvious of these mutations is signaled by a long-
held confusion between the painting exhibited at the Exposition au profit des
Grecs in 1826, the *Turkish Officer Killed in the Mountains,* and the Byronic sub-
ject of the *Giaour Contemplating the Dead Hassan.*[69] Unsurprisingly, the Turkish
officer was frequently identified as Hassan, and, although the subjects are, in
fact, distinct, Delacroix made use of Byronic motifs in his apparently reportorial
painting: the "unclosed eye," the unrolled turban. Confusion between them is
not simply critical carelessness: it reflects a real transposition. Similarly there
has also in the past been some confusion between the *Scenes from the Current
War in Greece* and the immediately contemporary *Combat of the Giaour and*

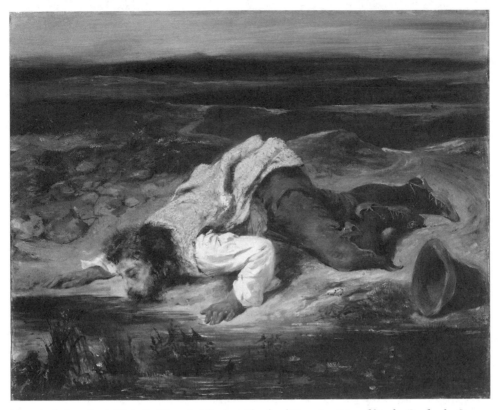

Fig. 56. Delacroix, *A Mortally Wounded Roman Shepherd Dragging Himself to the Bank of a Stream to Quench His Thirst*, c. 1825. Basel, Kunstmuseum. Oil on canvas, 33 × 41 cm. (Photo: courtesy Oeffentliche Kunstsammlung Basel, Martin Bühler).

Pacha, both shown in 1826.[70] Again the two subjects are distinct, but the first could, in theory, represent the moment before that shown in the second. And that they merged in Delacroix's mind is suggested by the fact that in 1856 he painted both a new version of *Scenes from the Current War in Greece* and his third and final treatment of the *Combat of the Giaour and Pacha,* which, although it retains some elements from 1835, is now so generalized that it becomes a general vision of Near Eastern combat rather than a specific event.[71]

But overlap between Byron's Oriental tales and episodes – perhaps inspired by *fait divers* – from the Greek War of Independence is understandable: Jal, in his review of the Salon of 1827, confused Vernet's *Victorious Giaour* with a Greek war subject, and Delacroix's allegorical *Greece on the Ruins of Misso-longhi* of 1826 may, in part, have been inspired directly by a passage in Byron.[72] Less expected is to find that a painting of 1825, exhibited in 1827 as *A Mortally Wounded Roman Shepherd Dragging Himself to the Bank of a Stream to Quench His Thirst* (Fig. 56) but also referred to by Delacroix as, and lithographed under the title of, *The Death of the Brigand,*[73] is clearly based on a passage from the second canto of *Lara:*

. . . and some too near that rolling torrent lie
Whose waters mock the lips of those that die;
That panting thirst which scorches in the breath
Of those that die the soldier's fiery death,
In vain impells the burning mouth to crave
One drop – the last – to cool it for the grave;
With feeble and convulsive effort swept.
Their limbs along the crimson turf have crept,
The faint remains of life such struggles waste,
But yet they reach the stream and bend to taste:
They feel its freshness, and almost partake –
Why pause? No further thirst have they to slake –
It is unquenched, and yet they feel it not;
It was an agony but now forgot.

Less expected is a literary borrowing in the *Scenes from the Massacres at Chios* of 1824 (Pl. 2).[74] In this painting, which otherwise concentrates on the passivity of the victims in a manner all too prescient of twentieth-century slaughters, there is a single dramatic incident. A Turkish officer has tied a half-nude Greek girl to his saddle; a young man rushes forward to try to save her and the officer deliberately draws his scimitar to cut him down. Delacroix placed this episode at the right edge, half cut off, perhaps feeling that any greater prominence would undermine his otherwise flat presentation of the scene. And this is understandable for, however much it may respond to press reports of kidnappings and rapes, the conception of the episode is clearly a transposition of *The Abduction of Rebecca* from Scott's *Ivanhoe*, which Delacroix had treated only a year or two before (Fig. 51).

Visual conflation between the Near East of Byron's Turkish tales and the North Africa of Delacroix's experience and imagination is obvious. *The Collision of Moorish Horsemen* and the 1835 *Combat of the Giaour and Pacha* are very similar in arrangement, and it is likely that one affected the other.[75] Similarly, the final version of *The Death of Lara* of 1859, the first to include Lara's horse and to be framed from a high angle, has clear analogies with Delacroix's final masterpiece, the *Collection of the Arab Taxes,* which, were its subject unknown, might be identified as the battle between the forces of Lara and Ezzelin.[76] Interestingly, however, the concentrated existential emphasis of the earlier treatments of Lara's death is much reduced in 1859: the arrangement is reminiscent of a conversion of Saul, and the broad sky that occupies the upper part of the painting implies, if not metaphysical optimism, at least some kind of transcendence.

Furthermore, Delacroix's penetration of his preferred authors allowed him to invent scenes in a manner that corresponded to their conceptual style. Thus it was recognized at the time – and expressed with great clarity in the twentieth century by Georg Lukács – that Scott's method of placing fictional characters in the foreground and weaving their stories through major events created a more engrossing and veristic history than fictional works which took major historical

actors as their central characters. Delacroix well understood this principle of the fictional *coulisse,* and when he painted grand historical scenes, such as his *Battle of Poitiers* and *Battle of Taillebourg* in which two French kings hold central place, in both pictures he sets them back from the front plane, framed by struggling figures whose historical anonymity is compensated by a fictional wealth of characterization. The *Murder of the Bishop of Liège* displays the method most clearly: the action takes place in the middle ground, seen across, as it were, Quentin Durward, present in the foreground in disguise, but unable to intervene because his primary duty – and emotional adherence – is to his protectee, Isabelle de Croye.[77] Isabelle is probably to be seen at the left, and the small son of Guillaume de la Marck, whom Quentin will seize as a hostage, is also close beside him: the historical event is seen through the eyes of Scott's characters.

As well as treating his chosen texts faithfully, Delacroix was also prepared to subvert them. There is, for example, a strong element of wit in the 1846 *Abduction of Rebecca* in which the comparatively voluptuous heroine, having fainted, is lifted onto the horse with some difficulty by Brian de Bois-Guilbert's two followers.[78] This is a far cry from the doll-like form perched in decorous side saddle in Léon Cogniet's painting and to some extent plays against Scott's own description. But much more profoundly subversive is Delacroix's treatment of *Sardanapalus* (Pl. 3).[79] In 1827 any literate person would have attached the subject to Byron's play but, as has often been noted, Delacroix's enormous painting bears no relation whatsoever to the finale of the play, in which Sardanapalus dies with a single loyal Greek concubine – the play is also about Byron's hesitant resolve to join the Greek cause. Delacroix's painting represents a voluptuous hecatomb, its massing of slaughter and self-slaughter violently at odds with Byron's rather conventional heroics, the horror increased by the rich color scheme and evident delight in the flesh-painting, that of Delacroix's most relaxed and sensuous nudes. The text cited by Delacroix in the Salon catalogue has still not been identified and may well have been his own confection. But to choose the subject was in itself clearly a gesture of provocation vis-à-vis Byron, and makes it clear that Delacroix was by no means in subjection to the ideas of the poet. In the *Sardanapalus,* it is as though the cruel energy of the *Faust* lithographs had eroded the Byronic text and reunited the subject to a world of Molochist mass sacrifice, an effect enhanced by the astonishing red of the bedspread, which, mixed with gold, runs through and out of the painting like a river of blood. Something similar is to be seen in Delacroix's treatment of certain subjects from classical literature. His versions of *Medea,* for example, running from her pursuers, her baby sons spilling from her arms, her knife threateningly poised by their soft flesh, represent a scene that the Shakespeare of *Titus Andronicus* and *Macbeth* might have imagined, not Corneille.[80] And, with his characteristic mastery of the deferred payoff, Delacroix evokes the unnatural bitterness of her action all the more strongly by basing his group on the prototype of Andrea del Sarto's *Charity.*[81]

Visual Sources and Genre Blending

Delacroix's treatments of literature were, of course, considered responses to the texts. But it is clear that his paintings were at times influenced by the para-texts of book illustrations. The passage from the *Journal* on the death of Selim in *The Bride of Abydos* is a case in point: "The end of the Bride of Abydos; The Death of Selim, his body tossed about by the waves and that hand – especially that hand – held up by the waves as they break and spend themselves upon the shore."[82] As far as is known Delacroix did not treat this subject, but it was included by Thomas Stothard in his Byron illustrations of 1814 (Fig. 57), and was taken up by Alexandre Colin, perhaps under Delacroix's inspiration, in the suite of line engravings of subjects from Byron that he published in 1833. Delacroix himself remarked that his works often had a starting point in visualizations by much weaker artists, and this is frequently true of his literary subjects. The lesser genres had an importance of their own for Delacroix: primarily illustrative, they were not bound by high-art conventions of composition, balance, and focus. They had a freedom that high art lacked, and because it was innate for Delacroix to search for the unbalanced, the incomplete, the suggestive, and the imprecisely defined, they provided for him both an excellent source material and a new range of imagery. Although artists like Smirke, Thomas Stothard, and Richard Westall were far from hacks, they worked in a tradition that was much looser than that of French illustration: their models were caricatures and genre paintings rather than *grandes machines*. It is significant that Delacroix drew less from the Boydell series of Shakespeare illustrations, which even in the small line-engraved versions retained the airs and graces of large paintings, than images actually planned as book illustrations. It was long ago pointed out that it was probably the most caricatural of illustrative sequences, the etchings made by George Cruikshank for George Clinton's *Life and Works of Byron*, which provided the most lively source for Delacroix's Byron paintings.[83] Delacroix saw that the simply, or at times ironically, illustrative could possess an inadvertent metaphoric power, a poetry of reduction – and, often, of movement – more vital than the comparative stiffness of much high art. Delacroix worked from the instant impression that he then cautiously aggrandized, allusions to high-art models entering later in the process. And this trend is displayed also in Delacroix's own willingness to treat the same subjects in similar – occasionally identical – compositions across a wide range of sizes and media: paintings, watercolors, and lithographs. He intentionally blurred boundaries among media and levels in the hierarchies of style.

Delacroix also sought the appropriate visual language for his subjects. The demonic manner of the Faust lithographs was largely reserved for his treatments of that play. It recurs obviously in the small painting *Mephistopheles Appears to Faust*, virtually identical in composition to the lithograph[84] and, somewhat softened, is found again in his two versions of the *Death of Valentin* painted in c. 1826 and 1847.[85] But it did not extend to his other treatments of subjects from Goethe:

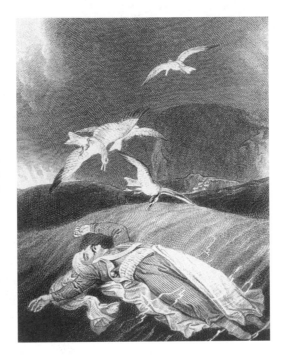

Fig. 57. Stothard, *The Body of Selim Float-ing in the Waves.* Illustration in Byron, *The Bride of Abydos* (London: John Murray, 1814). 151 × 99 mm.

there is no hint of it in the paintings or lithographs from *Goetz,* mostly worked in a style that could well serve for the Renaissance romances. However, this figure style did affect Delacroix's 1828 lithograph of *Hamlet and Horatio in the Ceme-tery*[86] and it also emerges in a Byron subject of 1826, immediately contemporary with the Faust lithographs, the *Marino Faliero* in which the executioner and the figures in the crowd at the lower right could come straight from the lithographs. It can also be seen in the sketch for the *Shipwreck of Don Juan.*[87]

Although it would be wrong to suggest that Delacroix invariably treated par-ticular writers in styles derived from particular painters, he seems to have main-tained certain broad associations. In the case of Walter Scott, for example, whose novels frequently allude to Dutch genre painting and to Wilkie – and much of whose work is strongly descriptive – Delacroix often followed the writer's lead. Teniers and Ostade have been mentioned, but more significant is Rembrandt: the *Murder of the Bishop of Liège* (Fig. 48) is inconceivable without his example. Its central expressive device, the lighting from below, issuing by reflection from the cloth spread over the table, is irresistibly reminiscent of Rembrandt's *Conspiracy of Junius Civilis.* And whether or not Delacroix could have known that painting, the Louvre's *Supper at Emmaus* or some of Rem-brandt's etchings could have provided that idea.[88] Delacroix had already tried out expressionistic lighting in his lithographs of *Macbeth and the Witches* and *Mephistopheles in the Students' Tavern,* but in a tonal medium, such experi-ments were easier to control.[89] For the *Murder of the Bishop of Liège,* greater subtlety was required, and for this Rembrandt's paint application as well as his design provided inspiration. The gradual obscuring of the setting, the way that

dramatically significant forms and gestures are picked out by light, reveal a highly intelligent understanding of Rembrandt's technique; more generally, the obliquely canted Westminster Hall allowed Delacroix to exploit the partially revealed, partially concealed settings that Rembrandt and his followers employed to so moving an effect. The dark hall and the gothic window from the Palais de Justice at Rouen, which serves in the *Interior of a Dominican Convent in Madrid* of 1831 (Fig. 13; from Mathurin's *Melmoth the Wanderer*) as an image of institutional oppression, is another acknowledgment of one of Delacroix's less studied models.[90]

For Byron subjects, especially for the scenes of action in the *Giaour* and the *Bride of Abydos,* Rubens provided the main inspiration, both in color schemes and in the execution, in which Delacroix employed sleek liquid passages to set against more heavily impasted detailing. Rubens, of course, is most obviously important for Delacroix's versions of *The Lion Hunt* (Pl. 11),[91] but knowledge of his work was vital to the registration of movement in all three versions of the *Combat of the Giaour and Pacha.* Above all, in the counter-Byronic *Sardanapalus,* Rubens is fundamental. It has often been noted that perhaps the most beautiful figure in the painting, the woman in the right foreground – and it is the destruction of beauty that gives the painting its particularly distressing edge – is taken from one of the daughters of Leucippus, in Rubens's painting of their *Abduction.* But it is not merely a question of the borrowing of a single form. It is for the richly sensual approach to flesh and materials, whose life-enhancing lavishness is so alien to destruction, that Rubens's work was the fundamental – indeed, the most potent possible – source.

In Delacroix's later work, notably the Renaissance romances and, perhaps, the final versions of the *Death of Lara* and the *Abduction of Rebecca,* it was less Rubens directly, but rather later artists influenced by Rubens who seem to have provided the main sources. In color and in the execution, composed of a multitude of flickering touches, the mature works of Watteau – receiving renewed attention precisely in the 1840s and 1850s – were surely important. And for the various versions of the *Death of Ophelia,* it may be that the lacy brush strokes of Gainsborough provided hints for the girl and her dress, dissolving into the water.

Delacroix's Influence

Compared with his significant French contemporaries who treated modern literary subjects from foreign sources – mostly in the 1820s – Delacroix's range is more extensive. Géricault and Eugène Lami collaborated on a suite of six lithographs of Byron subjects (two of which were Lami's sole responsibility) in 1823. Horace Vernet lithographed several subjects from Byron: the *Corsair* as early as 1819, *Manfred* in 1820, and *Don Juan* in 1823; he painted others: the *Corsair* in 1824,[92] *Mazeppa* in 1825 and 1826, and the *Giaour* in 1827 (private collection). He also painted a subject from Scott that showed his favorite theme of decapita-

tion, *A Legend of Montrose,* in 1824, but in the later 1820s he abandoned these writers and returned to them no more.[93] Vernet's single significant literary subject after 1830 is his *Lenore,* of 1839, from Bürger's ballad. Ary Scheffer painted and lithographed subjects from Byron and Scott until the early 1830s, but then concentrated above all on Goethe, in particular *Faust.* Delacroix's relation with these artists is complex because he was competitive but, simultaneously, relished isolation. With Géricault Delacroix is the debtor, with Scheffer the creditor; with Vernet what relation there is, is ambiguous. Among the most popular subjects with other artists in the 1820s was *Mazeppa,* treated by Géricault, Horace Vernet, Louis Boulanger, and Alexandre Colin. Vernet painted two popular and much reproduced versions of the subject in 1825 and 1826. The first, sadly destroyed,[94] was enormous: it showed *The Death of Mazeppa's Horse;* and the second, which exists in two autograph versions, showed the wild flight through the forest, pursued by wolves.[95] Delacroix did not ignore *Mazeppa* but seems to have painted from it only a single small oil and one watercolor, both, probably, in 1824, which depict different moments in Mazeppa's journey.[96] In the painting there is some overlap with Géricault, but the mood is very different from his heroic, Laocoon-like image; in the watercolor, in which the faltering horse is about to collapse, Delacroix achieved a pathos uniquely his own. Delacroix did not depict the subjects treated by Vernet, nor did he attempt to compete with the scale of the *Death of Mazeppa's Horse;* indeed, of his treatments of literature, only *The Barque of Dante* and the 1838 *Medea* are more or less life size.[97] He often avoided subjects treated by other artists, except when provoked by what he must have considered to be their imaginative failures. He did not depict the episodes from Byron's *Don Juan* treated ad nauseam by other artists, the *Finding of Juan on the Beach* or *Juan and Haidée in the Cave,*[98] whose sentiments would not have appealed to him, but attacked an episode not treated elsewhere, the drawing of lots by the shipwrecked sailors to determine which of them should be consumed by the others.

Delacroix's treatment of modern literary themes strongly influenced other painters who tackled such material. In the later 1820s Delacroix was seen by several young artists as a *chef d'école,* a position he soon lost and did not regain in his lifetime. His most besotted early follower was the twenty-one-year-old Louis Boulanger, whose *Mazeppa Tied to the Horse* of 1827, perhaps his masterpiece, is the largest painting of a Byron subject to be produced in France.[99] This was not an episode that Delacroix himself painted, although he did try it out in a drawing, of which Boulanger may have been aware – certainly he knew some of Delacroix's drawings. In any case, in the painting as finished, although stiffer and heavier than anything by Delacroix, the horse is patently derived from the *Massacres at Chios.* Boulanger soon thereafter came strongly under Victor Hugo's influence and moved out of Delacroix's orbit. Nevertheless, his great lithographs of the later 1820s and early 1830s are second in fantasmagoric elan only to those of Delacroix, whose *Faust* series was clearly their fundamental inspiration.

Another, lesser known, artist also had close relations with Delacroix. This is Alexandre Colin, who dealt with a considerable range of modern literary material during the 1820s and early 1830s. He showed a particular penchant for Byron and produced an album of line engravings after his works in 1833, based largely on earlier paintings and watercolors. Colin is particularly relevant in the context of the *Giaour*. Stothard illustrated the *Giaour Contemplating the Body of Hassan* in 1814 and Cruikshank etched another version in 1824; Colin showed a large painting of the subject at the Exposition au Profits des Grecs in 1826 and Horace Vernet a smaller one at the Salon of 1827, which clearly depends on Colin's version; Colin in turn riposted in 1833 with an engraving revising the composition of his 1826 painting. It is uncertain when Delacroix painted his small *Giaour Contemplating the Body of Hassan,* but it was first exhibited in 1830 and if it was painted in 1828 or 1829, then it must be seen as a critical response to the preceding interchange. And Delacroix's reaction was surely justified, for all the anecdotal elements in the other renderings are discarded in favor of the silent communion between the hero and his dead enemy, in which hatred is still the motivating force.[100] The alternative, if Delacroix's painting is of c. 1825, which to this writer's eye still appears plausible, is that it initiated the cycle. But whichever the case, Delacroix had certainly treated the subject before 1828, as a finished watercolor and at least one drawing indicate.[101]

Although Ary Scheffer is, among French artists, the preeminent painter of Goethe, and highly individual in his approach, some of his earlier treatments of subjects from *Faust* were closely inspired by Delacroix. Scheffer's *Faust in His Study* of 1831, for example, essentially a character study, is a patent tribute to Delacroix's characterization of Faust in the spade-like beard and the type of headgear.[102] More obviously still, his painting of *Marguerite in Church* quotes virtually verbatim Delacroix's lithograph of the same subject from his *Faust* suite. And his sketchlike treatment of another subject from German Romantic literature, Bürger's *Lenore. The Dead Ride Fast,* probably painted in 1830, is virtually a pastiche of Delacroix's *Tam o'Shanter.*[103] Although Scheffer's use of color is unlike Delacroix's, in works of this kind he too displayed a considerable debt to Rembrandt; whether this was in part due to Delacroix's example, or to that of Géricault, also a close observer of Rembrandt, or simply represents a return to his own Dutch roots, is moot. But from the mid-1930s onward, Scheffer relinquished interest in Delacroix's edgy movement and intense characterization in favor of more rounded, idealized forms; and his Rembrandtesque chiaroscuro and varied paint handling gives way to even lighting, and clearer and paler color areas, in part inspired by the *rappel à l'ordre* proposed by the followers of Ingres, then coming to prominence. In Scheffer's work of the 1840s, it is as though Delacroix had never existed. But, ironically, it was a direct pupil of Ingres, Théodore Chassériau, who, in the mid-1840s in prints, and thereafter with increasing devotion in paint, showed himself Delacroix's closest and most intelligent follower. His suite of sixteen etchings of *Othello,* published in 1844, was inspired by Delacroix's *Hamlet* series, and although Chassériau treats his

figures in a flat, proto-cloisoniste style, with firm contours that still owe much to Ingres, his fractured compositions and tense and unbalanced poses come close to those of Delacroix.[104] In the later 1840s and early 1850s Chassériau shadowed Delacroix. His *Finding of Mazeppa* of 1851, in its abrupt foreshortening of Mazeppa's body, the outstretched arm of the young Cossack princess, and the painting's sense of instantaneity might have been designed by Delacroix, and although the color range is cooler, the employment of broken contours to evoke movement actual and potential and to allow air to flow round the forms, shows he had studied closely Delacroix's paint application.[105] Chassériau was the prime mover in the Romantic revival that gathered force in the late 1840s and through the 1850s, and was the main conduit through which the influence of Delacroix passed into Gustave Moreau. For a moment Moreau set out to challenge the master. His *Hamlet Forcing Claudius to Drink the Poisoned Chalice* fills a gap left in Delacroix's lithographic sequence, and his two versions of *Tam o'Shanter* obviously respond to Delacroix's paintings.[106] And even later in Moreau's work, when modern literature was far behind him, Delacroix's presence remains palpable. The fires ignited in the early 1820s burned until the end of the century.

9 Delacroix as Essayist

Writings on Art

Michèle Hannoosh

[T]his man who excused himself for not being able to write, his business being, he used to say, with silent things.[1]

Thank you very much for the high value you so kindly place on the articles you mention; I do not feel the same affection for them, and anyway if I were to publish them, they would need considerable revision.[2]

Delacroix was one of the few painters ever to write substantially on art. The importance of the *Journal* and the projected *Dictionnaire des Beaux-Arts* in this respect cannot be overestimated: no other artist, not even Leonardo, left such extended and substantive discussions of the arts as he did of painting, sculpture, photography, engraving, architecture, in addition to music, theater, opera, and of course literature. No other artist ever reflected so extensively on the theoretical relations between the different arts, or linked this reflection to his own writing about them. I have argued elsewhere for the unparalleled importance of Delacroix's experimental writing about art, in both its content and its form, for his most pressing concern, his most consuming interest, painting, and for his conception of the crucial role of the painter writing in the modern world.[3] In these largely private meditations he elaborated his ideas with extraordinary freedom, ranging widely over the whole field of art, from his own work to all the different genres, to styles, periods, schools and movements, to individual artists past and present, to techniques and materials, to aesthetics and especially, as he said, "philosophy," the ways in which form and matter provoke and express ideas. A painter writing on art affirmed the compatibility, which he considered of special urgency in modern experience, of action and thought, material and abstract, painting and philosophy.

But in addition to the remarkable writings of the *Journal* and the *Dictionnaire*, Delacroix was the author of a significant body of published articles. From the earliest, ironic one on art critics (1829) to the final one on Charlet (1862), these essays, occupying about 250 pages of print, span the greater part of his career as a painter

and cover a wide range of subjects: mostly individual artists (Raphael, Michelangelo, Puget, Prud'hon, Gros, Poussin, and Charlet), but also works (Lawrence's *Portrait of Pius VII*, Michelangelo's *Last Judgment*, Puget's *Andromeda*), and the more general aesthetic questions of drawing and the beautiful.[4] As the letter quoted at the beginning of this chapter indicates, Delacroix was rather dismissive of them; others, however, felt differently. Baudelaire devoted a chapter of his essay on Delacroix to them[5] and conceived a project to collect them together, perhaps with an introduction on Delacroix's writing; he even requested permission to do so, as did Théophile Silvestre, but both were refused.[6]

Since then, these articles have received almost no critical attention.[7] Yet they occupy a special place in Delacroix's activity: thoughts on art which, unlike the *Journal,* were meant for a relatively wide public and, unlike the *Dictionnaire des beaux-arts,* were completed and published; studies of other artists or of broad aesthetic issues that incorporate many of his most personal aesthetic concerns and thus become a commentary on his own art and ideas. This method of indirection – probing his own ideas through a reflection on others – is one of the most striking aspects of the writing of the *Journal,* regardless of subject: from its myriad quotations from the autobiographies and memoirs of others, to its discussions of art of all types, to its observations on the behavior of his contemporaries or the dynamics of the natural world, the Montaignian self-study of the *Journal* is conducted at every stage through the mediation of others. And so the articles too: essays in the fullest sense, they provide the occasion and the means through which Delacroix explores his own ideas, positions and repositions himself, reviews and revises his assumptions, with sometimes unexpected and highly significant results.

Taken together, the articles present a certain consistency of approach: those on individual artists interweave personal biography, professional career, and critical judgment.[8] In them, Delacroix rarely describes or analyzes particular works in any detail, but tends rather to offer a summary assessment of the features of the *œuvre* as a whole, its originality in its time, and its decisive role in the history of art. He emphasizes the artist's encounter with the great masters or with the antique, consistent with his own experience – one thinks of the "Intense emotion!" which marks his sight of Rubens's *Raising of the Cross* in 1850 – and with his belief in the "exercise" of copying and imitation.[9] As his general introduction to the piece on Raphael implies, this was partly the motivation for the articles themselves: to present these artists in their difference from himself and his contemporaries, to cultivate in his audience, of another sensibility altogether, the qualities, the "perspective," the "appetite," by which to understand and appreciate their work.[10] This involved cutting through the clichés, avoiding the "blind routine" that so often constituted art history, contradicting the customary view. But behind the effort was another, more persistent one, which, given the importance of the terms in Delacroix's aesthetic vocabulary, cannot have been mere rhetoric: "The pleasure of dealing with such interesting subjects

[. . .] is enough to make one set out on that route."[11] Pleasure and interest are the purpose of all Delacroix's aesthetic activity.

That misunderstood talent with whom he felt a kind of affinity . . .[12]

Within the corpus of his criticism, the essay on Poussin occupies a unique position. Along with the one on Gros, it is the longest of the articles; unlike any of the others, it evolved over a period of more than fifteen years. He first conceived of it in 1837 when it was destined for François Buloz's *Revue des deux-mondes*.[13] He did not finish it, however, instead fulfilling his obligations with a short piece on Michelangelo's *Last Judgment*.[14] Three years later Buloz reminded him of the project, as an unpublished letter from him to Delacroix, dated 3 June 1840, attests.[15] Delacroix responded the following day: "I cannot give you the Poussin article for another two weeks yet; but I am busy working on it. It has been under way for so long that it has to be completely recast, and I cannot work quickly when it comes to writing. My only regret is that you have waited so long for something so unimportant."[16] Once again the project was dropped, until a peculiar conjunction of circumstances in the spring of 1853 led him to revive it.

"14 April 1853. Dinner at M. Fould's. The *Moniteur* would like a sample of my prose: this comes at a bad time, with all I have to do." As is so often the case in the *Journal*, behind this unelaborated and apparently insignificant remark stands a whole political situation. In 1853 the *Moniteur universel*, official voice of the newly proclaimed Second Empire, adopted a strategy of recruiting the participation of respected writers, artists, and critics. Ever since the brutally repressive decree on the press of 17 February 1852, which had reintroduced the stamp tax and the system of costly down payments by newspaper editors against eventual fines, required prior government authorization for the creation of any new periodicals or for any changes in the administration or the editorial policy of existing ones, allowed only official accounts of political proceedings, banned accounts of press trials, and authorized the total suppression of a paper after three warnings by the government, the *Moniteur* had become nearly the sole source of information.[17] Art and culture had nevertheless remained the domain of other periodicals, which survived for that reason alone. With this new initiative, however, the *Moniteur* aimed to stamp out all competition. Like so many others – Halévy in 1853, Gautier who became the chief literary reviewer in 1854, Mérimée, Sainte-Beuve, Vigny, even, by the most bizarre of ironies, Baudelaire[18] – Delacroix would be brought, one might say taken, in. Achille Fould, minister of state, here solicits his contribution; as it turns out, the favor would be returned, when later that year Fould would actively support Delacroix's (unsuccessful) candidacy for the Institute.[19]

A week after the dinner at Fould's, Delacroix began to note some possible subjects: "On the English school of thirty years ago: Lawrence, Wilkie. The *Thousand and One Nights*, Smirke; Stothard, Northcote. Reynolds, Gainsborough. On Oudry and the *Discourses* of Reynolds, eventually: his preference for draftsmen. Letters of Poussin. On the difference between the study or sketch and the finished work; on the effect in general of what is not complete, and of

the lack of proportion adding to its grandeur."[20] Of these projects, some will be recycled into the later *Dictionnaire des Beaux-Arts*;[21] the final one becomes the basis for an essay, never completed, on the sublime, of which numerous notes survive. The *Discourses* of Joshua Reynolds and the letters of Poussin, however, would have led Delacroix back to the subject of Poussin, abandoned so many years before. This time, uniquely in his criticism, it is the writings of these painters that inspired the article: both are cited abundantly in it.[22] Although the *Journal* does not specify the precise moment, he decided the topic over the next couple of weeks, perhaps around 28 April, when in a long diary entry Poussin figures prominently.

The Poussin article occupies a crucial position in the history of Delacroix's art writing, and thus makes a unique contribution to our understanding of the role of writing in the formulation and evolution of his thought. It is the first article written under the influence of the experimental writing of the *Journal*, and the sophisticated reflection on writing as a medium which he had maintained in it since taking it up again, after a twenty-three year break, in 1847. Moreover, coming between the formality of his hitherto published articles and the highly innovative form of the *Dictionnaire des Beaux-Arts*, it marks a turning point in his concept of writing, and the philosophical issues it raised for him as a painter. As I have shown elsewhere, the day-to-day record of its composition, preserved in the *Journal* for 1853, demonstrates clearly his growing awareness of the advantages, indeed the importance, of a freer, more essayistic style, a writing not subject to the "literary" constraints of rhetoric, narrative, or logical exposition, but full, diverse, and meandering, contradictory, unfinished, and thus suggestive, provocative of thought: a writing, that is, having the qualities which he attributed to painting.[23] From 8 May to 7 June, he sequestered himself at his country house in Champrosay, dreaming of an ideal writing like that of Montaigne's *Essais*, Pascal's *Pensées*, Addison's *Spectator*, Rousseau's *Rêveries*, but forcing himself to compose in a conventional form. The diary records his frustration with the limits of the genre, and his emotional, intellectual, and physical resistance to the "demands" of discursive prose. He worked now with loathing, now with exhilaration; in the fire of inspiration or with blood, sweat, and tears, in either case not daring to think about painting for fear of "distracting" himself from his task. If writing his thoughts comes easily, more so even than painting does,[24] the difficulty arises in ordering such diverse material, bending it to the required form. Unlike the notes for it, the article itself is always "cursed," "damnable," something which he must "attack," which he wants to "send packing" or "throw out of the window."[25] Through both his theoretical reflections and his intense frustration with practice, a new kind of writing is taking shape, which he will only realize a few years later in drafting the *Dictionnaire*. And as I also argued previously, a series of crucial aesthetic issues are interwoven with these remarks on the composition of the article: finish versus sketch, proportion versus disproportion, detail versus ensemble, the sublime.[26]

More important for my purposes here, however, is the highly complex relationship that exists between Delacroix's published article and his own aesthetic

preoccupations as these appear in the *Journal*. A comparison of the two works reveals that, from about February 1852, long before the article itself was even imagined, to its completion in June 1853, the article evolves in a veritable dialogue with the *Journal*. Whole passages are lifted from the diary and fitted, sometimes verbatim, into the article; others are removed from their original context and worked into the new one. In both cases, the notes had initially recorded and explored Delacroix's *own* concerns and had had nothing to do with the article, nor even, in some instances, with Poussin himself; they are manifestly not drafts of the article. Instead, conversely, the article brings together and concentrates a range of diverse issues that preoccupied him during this period.

Indeed this may account for one of the most striking and puzzling aspects of the article itself: the almost total reversal of Delacroix's earlier views on Poussin. One might reasonably wonder why he even chose an artist with whom he had formerly shown little affinity and who was hardly in the forefront of aesthetic debates in the 1850s. In what little there was written on Poussin by 1853, he was associated largely with Delacroix's nemesis, academic art.[27] His own views up to the period in question had corresponded closely to the standard ones of his time: the abstract, cerebral, linear, "correct" Poussin versus the more suave, "naïf," almost colorist Le Sueur.[28] In diary entries for 1847 and 1851, Delacroix calls him a "prose painter," rather than a "poetic" one, inspiring thought only through the gestural "pantomime" of his figures, rather than through the expressive art of form and color that strikes the imagination immediately;[29] lacking harmony, grace, effect, anything which might render the emotive force of the subject, those "lapses" (*"négligences"*) that reflect the personality of the artist or the power of the composition itself; Poussin's figures are "correct," "tense," "unconnected," "cut-out," making his paintings "extremely dry."[30]

The article, however, presents a Poussin who is almost unrecognizably different, and, as such, marks one of the first stages in the critical revival of this artist in the nineteenth century. Delacroix's sources were well-known ones – Félibien, de Piles, Reynolds – but he in no way merely repeats their arguments.[31] Under the new influence of Poussin's letters and of his own aesthetic concerns, he presents Poussin as a painter of "verve," "sincerity of expression," and simplicity of execution, a "reformer" and "innovator" who broke from the showy mannerist tradition that dominated French art, to give to each object only and all the importance it requires; whose landscapes create an impression of grandeur and melancholy and to which Delacroix applies two of the most important words in his aesthetic vocabulary, *"charme"* and *"simplicité"*; expressly not a classical or academic painter, but one of "delectation," a painter's painter.[32] Accordingly, when the article does evoke Poussin's flaws, they are attenuated: *"perhaps* an exaggerated dryness," "a *certain* isolation of figures," "that *slightly* bare look of the whole"; the "hard," "cut-out" quality of his figures and the lack of harmony among them are expressed in the interrogative.[33] Moreover Delacroix attributes these flaws to Poussin's early work, particularly well represented in the Louvre's holdings, as though to head off any potential objection by readers familiar with the national collection. So different is his position that in subsequent art histor-

ical discussion the article is cited as proof of his admiration for Poussin, the 1847 and 1851 *Journal* as equally strong proof of his dislike.[34] A comparison of the two works permits us to appreciate the process by which this extraordinary evolution takes place, and the implications it has for his later thought.

The complex relation between Delacroix and Poussin during this period may have been enhanced by a circumstance that has gone curiously unnoticed. On 21 February 1852, he notes for the first time the subject he has chosen for the Salon de la Paix at the Hôtel de Ville, commissioned a few weeks previously:[35] scenes from the life of Hercules to occupy the eleven lunettes, the very subject of Poussin's own (twelve) medallions, later destroyed, for the Long Gallery of the Louvre.[36] Delacroix was aware of these compositions, for in his article he mentions Jean Pesne's engravings of them.[37] Although his own designs differ considerably, five of the subjects coincide, and may have in part inspired Delacroix's choice for his own series.

The parallels between the *Journal* and what will become the article start up a few days later. At a dinner at the actress Rachel's, Delacroix sees Alfred de Musset, just elected to the Académie:

> I saw Musset, and I said to him that a nation has taste only in the things in which it is successful. The French are only good at what is spoken or read. They have never had any taste in music or painting. Pretty, dainty painting is the only kind that they like. The great masters like Poussin, Le Sueur, Puget never found a school. The French are impressed above all by manner; it's more or less the same for music. (26 February 1852)

This entry recurs almost verbatim in the Poussin article:

> A nation has taste only in the things in which it is successful by nature. It's a consequence of our bent toward literature that our own presents those exquisite merits which place it at the forefront of all literatures. In France one likes more than anything reasoning, discourse, in a word thought expressed by the written or spoken word; one also finds here a greater number of discerning critics on these subjects. We share this with the people of ancient Athens, where supposedly everyone, right down to the grain merchants, had an ear sensitive to fine language; but on the other hand, the Phidiases and Apelles do not flourish as spontaneously in this country *remote from the sun*. It was necessary from time to time that examples from Italy come to revive French public taste and, while they were greeted with favor, the talents which were arising right at home went unappreciated.[38]

The language is softened and generalized. The negative allusion to the French predilection for the word becomes a more positive assertion of the superiority of French literature. The French lack of taste in music and painting is expressed through a contorted comparison with the ancient Athenians, who, excelling like them in writing and speaking, nevertheless had their Phidias and Apelles. The neglect of the great French masters, and the attraction to "pretty, dainty painting" and to mannerism become toned down through lack of specificity. But conversely, Delacroix strengthens these points through quotations

from Poussin himself: he had just evoked Poussin's "disdain for *mignardises* and the fashions of the day"; the italicized *"remote from the sun"* comes from a letter of Poussin's that Delacroix had cited earlier about his "dislike of being in Paris";[39] three times in the space of as many pages he evokes Poussin's regret about "the neglect and too little love which our nation has for fine things," precisely Delacroix's own remark to Musset.[40]

Moreover the points made in the *Journal* passage become the main themes of the article, the ones around which it is structured and through which Delacroix's conception of Poussin's importance and value are developed. In presenting Poussin explicitly as not a "classical" painter, but "one of the boldest innovators in the history of painting,"[41] the article will focus, like the diary passage, on his rejection of manner, which, inherited from Italian art in its decline, had subsequently become the practice of the French school, and in Delacroix's view, still largely was: Poussin's refusal to privilege virtuosity of technique over expression, his rejection of "habit" in execution, his dual goal of simplicity of means and sincerity of expression,[42] his subordination of accessory to principal subject, his concern for interest, his reliance on an observation of nature.

All these issues run throughout the diary of this period, long before Delacroix weaves them into his article. In the entry for 29 October 1852, for example, inspired by a visit to the sculpture gallery of the Louvre,[43] he traces the French pictorial tradition to the decadence of the Italian school, notably to his *bêtes noires,* the Carracci – a tradition resisted and interrupted only by Poussin and Lesueur:

> *On the difference between the French and Italian spirit in the arts.* The former stands equal to the latter in the Renaissance for elegance and style. How is it that that detestable soft, Carracci-like style came to prevail? Fortunately, painting had not yet been born. Only the sculpture of Jean Goujon, Pilon, etc., remains from that period. There must be, at any rate, in the French spirit some more pronounced bent for sculpture: in nearly all periods there have been great sculptors, and that art has always been ahead of the other one, except for Poussin and Lesueur. When these two great painters appeared, there was no more trace of the great Italian schools; I mean those in which simplicity went along with the greatest understanding. The schools which arose sixty or a hundred years after Raphael were only academies for the teaching of formulas. Those are the models which Lesueur and Poussin saw prevail in their time: fashion, common practice drew them in, despite that very real admiration for the antique which characterizes the Poussins, the Théodons, the Legros and all the sculptors of the Apollo Gallery.
>
> [. . .] Poussin is perhaps the painter who most effaces himself behind his work.[44]

Similarly, in the article, Delacroix evokes Jean Goujon and Germain Pilon as examples of French sculptors who equaled the great Italian masters of the Renaissance: "Instead of dwelling on the last remains of that Italian art whose decline was already so manifest, we would have seen a wholly new art blossom once again, as fecund as that which very great French artists such as the Jean

Goujons, the Germain Pilons, the Philibert Delormes, had invented [. . .], by taking their cue, in an independent way from the forms of the Renaissance."[45]

Similarly, dominance of the Carracci, the decadent manner that followed them, and the rise of academic art, all suggested briefly here, are elaborated in the article into a history of painting: for Delacroix, Poussin emerged, like Lesueur, within the mannerist vogue which followed the Carracci; the pictorial tradition skipped over them, predominating even in their follower Lebrun, and thus in the French school he founded.[46] Everything Delacroix disliked in academic art came to be expressed in the terms in which he describes manner in the *Journal* entry, and repeats in the article: recipes and formulas, an excessive concern for imitation, a lack of genuine sentiment and a poverty of thought, overattention to the model, a show of technical dexterity, of pedantic local color and attention to detail, as with the Carracci relative to their predecessor, Raphael:

> They thought that by adding to the grace, to the beauty of the invention which were so brilliant in their predecessor, a further degree of material imitation, they would attain the fullest perfection possible to painting. They thought that they could avoid incorrect drawing or flaws, which are more frequent in works where feeling dominates: all that was needed, no doubt, was more attentive study of the model, and they thought that this refinement was one more quality added to all the others. In a word, they wished to be knowledgeable and to appear so: from that moment the academic style was born, and that living nature which delights us in its freedom and variety lost all its grace, constrained by the whim of the artist and lit by studio lighting.[47]

As the diary entry had noted, Poussin, in contrast, is "absent" from his work, an idea the article then takes up: unlike the Italians, he makes no concession to the desire to shine, either in his knowledge or his technical ability, instead seeking to satisfy the requirements of reason and the imagination. Thus he is the "least Italian" of all painters.[48]

Delacroix would become interested in this question in connection with the Hôtel de Ville, where he and Léon Riesener were working at the same time. An entry for 30 November 1852 notes a possible idea for an article: "On manner, with respect to the Hôtel de Ville paintings compared to Riesener's.[49] – Boucher, Vanloo admired; imitators of Michelangelo and Raphael, same bunch."[50] In the article, Delacroix suggests that Poussin may have been the only great artist *not* to have imitated Michelangelo, preferring to these terrifyingly grand, superhuman subjects the "more human" grandeur of the antique.[51] The great Italian masters became for him a kind of negative model:

> Artists endowed with a very definite sensibility, while admiring a fine work, can criticize it not only for the flaws which are in it, but also with respect to the difference that work presents vis-à-vis their own sensibility. When Correggio, standing before a painting by Raphael, uttered his famous *Anch'io son pittore,* he no doubt meant: "There is a fine work, but I would have put into it something that is not there."[52]

In the *Journal* entry from which this comes almost verbatim (20 April 1853), the passage occurs in a different context altogether: a conversation with his friend, the Polish expatriate, Albert Grzymala, about Chopin's improvisations, which Grzymala considers bolder than his finished works. This leads Delacroix to ponder the relative value of the sketch and the finished work, which he had considered a few days before: a sketch seems more satisfying because each person "finishes" it in his or her own way. The Correggio passage then illustrates the remarkable principle that, for true artists, all works, however highly finished, are "sketches" in this sense; and that a finished work will always reveal not only the extent, but also the limits, of the artist's talent.[53] Reworked into the Poussin article, the passage not only implies that he developed his own style in contradistinction to Michelangelo, but also that he is himself the kind of "finished" artist from whom a very different one, like Delacroix, can learn.

The entry for 28 April 1853, written around the time at which Delacroix was deciding on the subject of his article, presents a good example of both the process of his thought and its transformation into the essay. Engaged in his portrait of Alfred Bruyas, he comments on the importance, in his own style, of pictorial sacrifice, of subordinating all aspects of the painting to the principal object of expression, as though it were natural and necessary; at the same time, he recognizes the tremendous expressive value of exaggeration in an artist like Rembrandt:

> You need a whole host of sacrifices to enhance a painting, and I believe I do that a lot; but I can't stand for the artist to make a show of it. Yet there are some really lovely things which are conceived in an exaggerated way for effect: this is how the works of Rembrandt are and, closer to home, Decamps'. That exaggeration is natural to them and is in no way shocking. I make this observation as I look at my portrait of M. Bruyas; Rembrandt would only have shown the head; the hands would have been only just sketched in, like the clothing. Without saying that I prefer the method which shows all objects according to their importance, since I admire the Rembrandts exceedingly, I feel that I would be awkward if I tried for those effects. In that I am on the side of the Italians. Veronese is the *ne plus ultra* of execution, in every aspect; Rubens likewise, and in subjects of pathos he has perhaps an advantage over the glorious *Paolo* in that he knows how, through certain exaggerations, to draw attention to the main object and increase the power of the expression.

But in its artificiality, this latter approach, which Delacroix considers his own, is equally, perhaps even more, unsatisfactory. He would like the artifice not to be felt at all, but nevertheless for the interest to be brought out as it should. As he searches for an artist who might fulfill this ideal, he touches briefly on the *negative* example of Poussin, whose total lack of harmony he had frequently criticized:

> My memory does not present me at the moment, among the great painters, with a perfect example of the perfection which I require. Poussin never

sought it and does not desire it; his figures are planted one next to the other like statues; does that come from the habit he had, so they say, of making little models so as to get the shadows right? If he obtains this latter advantage, I am less grateful to him than if he had linked his figures together better, with less precision in the observation of effect.

In the entry of 6 June 1851 noted earlier, Delacroix, having visited the newly refurbished galleries of the Louvre, had expressed his admiration of Lesueur's *Life of Saint Bruno,* and criticized severely the *Adoration of the Magi,* then attributed to Poussin, in precisely these same terms, using the same language: Poussin's lack of unity, his refusal to concede anything to harmony, grace, or the force of the composition; his stiffness, dryness, tenseness, the disjointed quality of his figures. He had likewise evoked the same legend of Poussin's use of maquettes so as to achieve the correct distribution of light and shadow:

> Grace is a muse which he never glimpsed. Harmony of line, of the effect of color, is likewise a quality which was refused him completely. I am convinced that Lesueur did not have that same practice of Poussin's of arranging the effect of his paintings by means of little models lit by the light of the studio. That so-called conscientiousness gives to Poussin's paintings an extreme dryness. His figures all seem to be unconnected with one another and cut-out; whence those gaps and that lack of unity, harmony, effect, which are found in Lesueur and in all the colorists.

But whereas this 1851 entry is striking in its harshness, the almost exact repetition of it two years later leads Delacroix in a completely different direction. Now, in 1853, he cuts short his critique to review the painters who might fit his ideal, and fixes on Veronese: but Veronese's effects "have something banal and conventional about them," which comes from relying, like Rubens, on certain habits of execution. Thus Delacroix returns, in an abrupt *volte-face,* to Poussin:

> It is the glorious achievement of those two great French painters, Poussin and Lesueur, to have tried to break out of that banality, and been successful. In this respect, not only do they recall the simplicity of the Flemish and Italian primitives, in whom directness of expression is not spoiled by any habit of execution, but also they opened up a whole new direction for the future. Although they were followed immediately by the painters of the decadence, in whom the dominance of habit [. . .] soon arrested this drive toward the study of what was true, these two great masters prepare the way for the modern schools, which broke with convention and looked to the source itself for the effects which painting is meant to produce on the imagination. If these same schools which came after did not follow exactly in the footsteps of those great men, they at least found in them a vigorous protest against academic convention, and consequently against bad taste. David, Gros, Prud'hon, whatever difference one sees in their manner, had their eyes fixed on these two fathers of French art; in a word, they consecrated the artist's independence from tradition, by teaching him, along with a respect for the usefulness it can offer, the courage to privilege, above all, his own sensibility.

Poussin's historians, — and there are many of them — have not suffi-
ciently thought of him as an innovator of the rarest kind. The climate of
mannerism in which he was raised, and against which he protested through
his works, extended to the whole domain of the arts, and despite his long
career, its influence outlived this great man. The Italian decadence passed
the torch to the school of Lebrun and Jouvenet, and then to that of Vanloo
and after. Lesueur and Poussin did not stop this torrent. When Poussin
arrives in Italy, he finds the Carracci and their followers praised to the skies
and the arbiters of glory and reputation. An artist's education was not com-
plete without the trip to Italy, which did not mean that one was sent there to
study true models like the antique and the Renaissance masters. The Car-
racci and their students had grabbed all the renown that was possible and
[. . .] they conspired, with all the authority they had from the momentary
infatuation they inspired, against everything which seemed to go off the
beaten track. [. . .]

This independence from all convention is found to a very high degree in
Poussin, in his landscapes, etc. As a scrupulous and at the same time poetic
observer of history and the movements of the human heart, Poussin is a
unique painter.

This remarkable passage, the conclusion of a meandering meditation begun
with an observation on his own work, passing through Rembrandt, Decamps,
Veronese, and Rubens, taking a detour through the severely critical *Journal*
entry of 1851 that it quotes, formulates the main argument of the Poussin article,
defining the originality and innovation it so exceptionally attributes to him:
Poussin's refusal of convention and habit, his frankness of expression, his rejec-
tion of manner, his naturalness and simplicity, his belief in personal sentiment
place him at the very origin of modern French painting, however superficially
different in style. In freeing the artist from banal convention and turning atten-
tion from the study of pictorial formulas to an observation of nature and the
"true" masters — the antique and the sixteenth century — Poussin led directly to
what Delacroix considered the great modern French tradition, that of David,
Gros, and Prud'hon. Poussin here becomes an expressive painter, not only a
"scrupulous," but also a "poetic observer of history and the movements of the
human heart." In the article, this is extended to present an unorthodox Poussin
of "verve," of rapid, sketch-like, but deliberate and intelligent execution, of
"*seeming* negligence," whose paintings, criticized by Raphael Mengs as mere
sketches and studies, are for Delacroix "exquisite studies, where everything is
rendered for the soul and the mind," "happy and precious sketches, where every
touch of his knowing hand is a finished thought."[54] He has the art of giving to
each object only the degree of interest it requires for the ideas that the painting
expresses, and sacrificing all other elements, however much they might demon-
strate his technical virtuosity.

All these traits will later enter Delacroix's own *Dictionnaire des Beaux-Arts* in
precisely the same terms as here, defining his most fundamental criteria of art.
The emphasis on Poussin's interest becomes the entry "*Intérêt*,"[55] which should
be the "primary purpose which the artist sets for himself," and cannot be

achieved through "manner"; an expression of soul that in turn touches the soul, and the imagination, with irresistible force. The qualities attributed to Poussin will become those of the *Dictionnaire's* entry "Titian," like Poussin the least mannered of painters, *"naïf,"* displaying not habit but variety, obeying a true emotion and shunning whatever does not lead to a more vivid expression of his thought.[56] Poussin's "Sacrifices" become the *Dictionnaire* entry of that title, defined as that "great art which novices never know."[57] The entry *"Ecole, Faire Ecole,"*[58] as here, defines a stylistic school as the opposite of art, the domain of mediocre and secondary talents.

In another example of such a reversal of his earlier opinions, Delacroix's thoughts about writing itself lead him to an observation which he will take up in the article in a very different context. On 1 November 1852, reflecting on the futility of writing a treatise on the arts systematically, methodically, and from a position of authority, he envisages a personal, idiosyncratic, essayistic writing in which he would "note, observe as nature offers him interesting objects." He then proceeds to elaborate:

> Let a talented man, who wishes to set down his thoughts on the arts, pour them out as they come to him; let him not be afraid of contradicting himself; there will be more fruit to be had amid the profusion of his ideas, even if contradictory, than in the thread – combed, tightened, and cut – of a work in which he will have taken care with the form. . . . When Poussin said, in a witticism, that Raphael was an ass, he knew what he was saying: he was only thinking of comparing the draftsmanship, the knowledge of anatomy of the one with others, and he was well placed to prove that Raphael was ignorant in comparison with the ancients.
>
> In that respect, he could have also said that Raphael didn't know as much as he, Poussin, did; but from another perspective, faced with the miracles of grace and simplicity combined, of knowledge and the instinct for composition taken to the point at which no one equaled him, Raphael would have seemed to him what he in fact is, superior even to the ancients in many aspects of his art, and particularly in those which were entirely lacking in Poussin.
>
> In Raphael, the execution, and I understand by that both line and color, is as it can be; not that I mean by that that it is bad; but that as it is, if we compare it to the wonders in that domain of Titian, Correggio, the Flemish painters, it falls into second place, and it had to be so; it could have been even much more so without distracting remarkably from the merits which place Raphael not only in the first rank, but above all artists, ancient and modern, in the areas in which he excels. I would even dare to affirm that these latter qualities would be diminished by greater care with anatomical exactitude or with the handling of the brush and the effect. One could almost say as much of Poussin himself, with respect to the areas in which he is superior. His disdain of color, the rather harsh precision of his touch, especially in the paintings in his best manner, contribute to enhancing the impression of expression or character.

What begins as an example of the kind of personal, eccentric observation he envisages for his own writing – Poussin's "witticism" about Raphael –[59] evolves

into a positive statement about the art of both painters as Delacroix weighs up the rightness of Poussin's seemingly flamboyant judgment. The statement is correct from a *certain* perspective – that of Raphael's anatomical accuracy – and thus has its value, precisely the point Delacroix is making about writing; viewed from a different perspective, using different criteria – Raphael's skill and instinct for composition – the statement would have been otherwise. Delacroix then offers his own nuanced account, which mediates between the two positions: Raphael's execution is indeed inferior to that of Titian, Correggio, the Flemish school, but this is compensated for by the qualities in which he excels; moreover, Delacroix argues, these qualities would even be diminished by greater attention to anatomical correctness or to execution; thus his execution is as it should be. Similarly for Poussin: his "flaws" – his disdain for color, the "hard precision" of his touch – make the expression and character of his figures all the more striking.

Severed from its original point of departure, his reflection on writing, this entire passage reappears, almost verbatim, in the article.[60] This is important not simply as a parallel, but because it demonstrates how Delacroix's presentation of Poussin derives from the kind of "essayistic" reflection that, in drafting the article six months later, he feels obliged, with such reluctance, to suppress. If the form becomes more conventional, however, the nuanced view of the original passage is not lost: Delacroix does not "excuse" Poussin, as though the nobility and gravity of his art compensated for these faults, but rather states his inferiority to Raphael in some respects – charm, the "irresistible attraction" of Raphael's figures, a certain sensuality of the type found in Correggio and Murillo – while recognizing Poussin's superiority in the expression of historical subjects, their heroism, vigor, and grandeur, which liken him to the antique.[61] The distinction is crucial, and characteristic of Delacroix's view of criticism as encompassing diverse, apparently contradictory views, rather than finding a common, stable ground or a unified "system": that which, in the diary entry, he dismisses as "erroneous, a waste of time, a false and useless idea." It is significant that, through a cross-reference, this same entry will become the matter of the preface to the *Dictionnaire des Beaux-Arts*: "Preface to a little Dictionary of the Fine Arts. See year 52, 31 October.[62] A talented man cannot embrace the whole of art. He can only note what he knows, etc. Nothing too absolute; Poussin's saying about Raphael."[63] Varied and variable, personal and idiosyncratic, stated from a particular perspective, nuanced – "nothing too absolute" – limited and yet correct, like "Poussin's saying about Raphael," such is the writing Delacroix will cultivate in the *Dictionnaire*, theorize in its preface, and associate with its "instructive," "philosophical" objectives, namely to interest and provoke thought.

There are some subjects to which one never wearies of returning[64]

The issues discussed in the Poussin article and in the diary entries which informed it in turn become those that dominate the later *Journal*. Significantly,

they appear rarely à propos of Poussin himself, but rather metamorphose into traits of those artists on whom Delacroix never published a formal article and rather treats only in the innovative, experimental writing of the diary: Rubens, Titian, David, the Flemish masters, the antique. The Poussin article, condensing his own thoughts on art as they are worked out in the diary over the preceding year, is the catalyst in this extraordinary development. The question of manner will interest him increasingly, absorbing most of his categories of "bad" art and thus dominating the *Dictionnaire*, in such entries as *"manière," "exécution," "décadence," "modèle," "imitateur," "Ecole."* Already in November 1853, five months after the publication of the Poussin article, he addresses this question. Having viewed at the Louvre the Carracci drawings for the Farnese palace, he remarks in them the same mannered traits evoked in the article – technical virtuosity rather than sentiment, expression, or intellectual content.[65] This leads him to consider his own approach, and the evolution of his own ideal: "I still remember the time, which is not far off, when I was incessantly cross with myself for not being able to achieve that dexterity in execution which the academic tradition unfortunately inspires the best minds to consider the ideal of art. My own tendency was always to a simpler imitation, and by unaffected means, and yet I so envied the easy brush, the charming touch of Bonington and his kind." Such simplicity – naïveté – had been the defining characteristic of Poussin, which Delacroix only now comes to value in himself.

Similarly, his account of Poussin's ardor for copying and his particular kind of imitation, in which he discovers himself, and thus remains original,[66] returns in the *Dictionnaire* as a characteristic of the greatest artists. Poussin copying with relentless zeal the works of the ancients and drawing a profound knowledge from this resembles the Rubens of the entry *"Science,"* whose copying "was the source of an immense understanding."[67] Discovering himself through copying or imitating others, Poussin provides the image, once again, of Rubens, who realized his own genius through imitating Michelangelo, an imitation "so very different from that of the Carracci."[68] In the article *"Imitation"* of 3 March 1859 this is the chief means of forming one's own style. Poussin imitating the antique not in its material side, but in its "spirit," reviving its "genius" in the modern world,[69] foreshadows the *Dictionnaire*'s remarkable article on Titian, in which "Titian and the Flemish painters reflect the spirit of the antique and do not merely imitate its external forms"; the Neoclassical school of David is the opposite, a "fantasy" of the antique without penetrating its "spirit."[70] The "new" Poussin of the article engenders not only the modern French school, but also the principal positions of the *Dictionnaire*.

These letters say more than any narrative or any commentary[71]

Finally, we must ask what Delacroix's evolving self-recognition in Poussin might owe to that prominent element of the article, "that so very valuable collection" of the artist's letters.[72] For Delacroix constantly invokes these writings of a fellow painter for attitudes he has either himself already expressed in other

contexts or he will come to do. As I have argued, a reading of these letters moti-vated, in part at least, the subject of the article and contributed to the radically different attitude it articulates. "That misunderstood talent with whom he felt a kind of affinity," as he says of Poussin's admiration for Domenichino,[73] describes as much Delacroix's own relationship to a painter toward whom he had hitherto felt little warmth, even a certain antipathy, but whose letters revealed to him judgments and tastes, feelings and traits of character, most important, perhaps, a theoretical reflection on painting, with which he himself identified. One finds such affinities everywhere in the article's use of these letters: Poussin's dislike of Paris, his long-standing friendships, his disdain of flattery, his attachment to solitude and independence, his love of ancient literature and Italian Renais-sance poetry that "inflamed" his imagination – all are well-known traits of Delacroix's.[74] Poussin's reluctance to disrupt his state of well-being to return to Paris, and his restlessness and agitation once he has decided to do so,[75] remind us of Delacroix's own remark on 7 June 1853, the day he finished the Poussin article: "I think in the end that I'll leave tomorrow. Perhaps I'm a little less happy here, not because I've been here a while but because I've decided to leave. I often think, when I consider the sadness that always accompanies any pleasure: can one be truly happy in a situation which must end?" Poussin's remark about the "passing infatuation" of people who had formerly shown him no interest, even as his works had been long before their eyes, recalls Delacroix's comment at this time (3 April 1853) about the sudden demand for his own paint-ings: "Never has there been as much enthusiasm. It seems that my painting is a novelty recently discovered." Poussin's desire, the older he becomes, to "surpass himself," his belief that he could paint great works if his hand only obeyed him, his recognition of the truth of the Themistoclean adage that man declines and dies just when he is ready to do great things,[76] are echoed often in the *Journal* of this period and after. On 12 October 1852, commenting on the performance of the aging actor Beauvallet as Auguste in Corneille's *Cinna*, Delacroix makes this same point, and extends it to himself:

> How is it that at present, when I have brush in hand, I do not grow weary of it a single instant, and feel that if my strength could handle it, I would only stop painting long enough to eat and sleep? [. . .] The sorry situation in which nature places us as we grow older is a mockery. Maturity is at its height and imagination as fresh and active as ever, especially with the calming of those mad, impetuous passions which age carries off with it; but we lack strength, our senses are worn out and need rest more than movement.[77]

The many instances of this are increasingly counterbalanced by another recur-rent theme, the pleasure of painting, the rejuvenating power of work, as in the famous entry of 1 January 1861 about his work on the Saint-Sulpice chapel, which in its "horrible and incessant difficulties" nevertheless provides him with endless food for thought, the "happy compensation for what our best years have carried off with them."[78]

Two aspects of Poussin that Delacroix encountered in these letters would have been especially important for the future of his aesthetic thought. "1st January 1857. Poussin defines the beautiful as: delectation."[79] This belief in the *pleasure* – both sensual and spiritual – of the beautiful will dominate Delacroix's late thought, from his article on the beautiful of 1854[80] through the entry for the *Dictionnaire* (11 January 1857), both of which refer to Poussin's definition, to the very last remark of the extant *Journal:* "The foremost quality of a painting is to be a feast for the eye" (22 June 1863). Second, a remark at the end of the essay is suggestive: "[Poussin] takes the trouble [. . .] to trace a few words on the theory of painting [. . .] These few principles, noted with a trembling hand and on the verge of death, make us regret that he did not [. . .] leave more extensive notes on that art which he had made so illustrious."[81] In 1853, when the idea of writing his thoughts on art is not yet, but about to be, born,[82] it is perhaps this regret that moves the aging Delacroix to conceive of his own aesthetic project, and inspires the remarkably rich, abundant, and complex reflections of the *Dictionnaire des Beaux-Arts.* As with his painterly commissions, in which the dictates of the Fine Arts Ministry or a particular collector became a kind of pretext for exploring his own interests, and often led to great pictorial innovation, with the Poussin project Delacroix transformed an institutional chore into an essay in discovery and self-discovery. In this it was surely for him as it was for another painter too, who claimed that Poussin restored him to himself: "Every time I come away from Poussin I know better what I am." That painter was not only one of Poussin's, but also one of Delacroix's greatest admirers: Paul Cézanne.[83]

Painting/Literature

The Impact of Delacroix on Aesthetic Theory,
Art Criticism, and Poetics in
Mid–Nineteenth-Century France

David Scott

The aim of this chapter is threefold: first, to stress the inextricable links between painting and literature in Delacroix's thinking and creative practice; second, to show how the perception and pursuit of such links constituted a particular challenge to art criticism, in particular as practiced by mid–nineteenth-century French poets; third, to argue that Delacroix's ideas and work deeply influenced developments in aesthetic theory and poetics later in the century. An important by-product of this approach will be the exploration of the implications of such developments for an understanding of the relationship between the arts, and the role of intermedial interaction in aesthetic creativity generally. The primary method employed will be that of situating the writing and artistic practice of Delacroix in the context of representative early nineteenth-century aesthetic theory (Quatremère de Quincy, Victor Cousin) and art criticism, especially that of literary writers (Gautier, Baudelaire) and of showing the decisive role it seems to have played in transforming aesthetic thinking later in the century – whether in the poetic theory of Théodore de Banville or in the teaching of Charles Blanc. Attention throughout will be focused on concepts – usually related in pairs – such as imitation and metaphor, resemblance and imagination, line and color, content and form, which play a central role in motivating argument and structuring aesthetic theory in this period. Not least of the lessons Delacroix's work teaches us, however, is that such dichotomies are ultimately false, and it is the constant concern of artistic creativity, in whatever medium, to renegotiate or undermine them.

Imitation and Metaphor

A telling paradox that Neoclassical or academic criticism failed fully to confront was that of the commitment of history painting (the form of art judged highest in the Neoclassical canon) to the use of imitative styles for the representation of a content that was largely fictional or mythic: verisimilitude of appearance is

used to represent unrealistic events or actions.[1] Although Quatremère de
Quincy and Victor Cousin, whose theories will be discussed in this essay, argue
that art's aim is to represent the ideal, both, in their different ways, stress the
importance of imitation (through the use of recognizable human or other forms)
as part of the artistic process. Although Delacroix remained throughout his
career committed to the history painting that artists and critics continued to see
as the principal genre for the expression of the ideal, he did not interpret the
rules associated with it in a conventional way. Indeed, much of his originality as
a painter was in his conferring of the metaphorical status enjoyed by the literary
or mythological figures in history painting on the *plastic image* – paint on can-
vas, and the forms represented. In order to clarify what is meant by this, it will
be helpful briefly to compare Delacroix's theory and practice with contemporary
aesthetic ideas.

Early nineteenth-century theorists of imitation such as Quatremère de
Quincy (1755–1849) and Victor Cousin (1792–1867)[2] base their thinking on clas-
sical or Neoclassical art and aesthetic theories. Contemporary or even eigh-
teenth-century artistic practice scarcely attracts their consideration. It is in part
because of this that their texts, especially those of the former, although contem-
porary with the painting and writing of Delacroix, seem to come from a different
age. They are worth examining, however, in that they state the positions from
which Delacroix rapidly differentiated himself, and exemplify ideological posi-
tions that later nineteenth-century theory and practice will diametrically oppose.
Quatremère de Quincy's *Essai sur la nature, le but et les moyens de l'imitation
dans les beaux-arts,*[3] published soon after the time (1822) when Delacroix started
his *Journal,* is symptomatic in that, in it, potentially modern perceptions are
overruled or distorted by Neoclassical prejudices or tastes. Thus when he writes
in his first *Paragraphe* that "the pleasure produced by works of imitation derives
from the act of comparing," the action of comparing is assumed to bring
together like with like as conventionally represented, not like with unlike in an
attempt to create new connections.[4] Similarly, although Quatremère underlines
art's aim to produce "the imitative appearance" and not the "reality," both con-
cepts are taken as stable, and in a stable relation to each other.[5] Although Qua-
tremère is aware of the fundamental role of conventions in artistic (and other)
representation, he does not seem to consider that these may, with time and dif-
ferent practice, become modified; on the contrary, he sees them as fixed for all
time.[6] And his resistance to change is founded most tellingly in his insistence on
dividing up mental operations into watertight compartments, the "sensitive part"
separate from the "imaginative part of the soul"; the separation of the arts is a
natural consequence of this. Seeing the arts as essentially *limitrophes,* Qua-
tremère finds only metaphorical parallels between them – "Poetry no doubt has
its pictures, but they are only pictures metaphorically [. . .]."[7] In what sense
these "pictures" are "metaphorical" Quatremère tantalizingly does not say. Simi-
larly, when later in his essay he states that the most valuable works of art are
"conceived in that style of imitation whose model cannot be shown," by which

he means *peinture d'histoire,* he does not go on to reflect that the model cannot be shown, precisely because it is drawn from *another form of art,* namely literature.[8] In other words, in proposing the principle of imitation, Quatremère does not fully think through the implications of his position: he examines the way art imitates nature, but leaves unmentioned the way in which art (at least in the form of history painting) imitates literature; and it never occurs to him that it might be possible for literature to "imitate" the visual arts in a more than metaphorical sense.[9]

The aesthetic theories of Quatremère de Quincy's younger contemporary, Victor Cousin, first delivered as lectures between 1816 and 1821 and published in 1836 as *Du Vrai, du Beau et du Bien,*[10] although sharing a basis in eighteenth-century aesthetic ideas, open out overall more modern perspectives than did Quatremère. Like that of the latter, Cousin's thinking is heavily influenced by Gotthold Lessing's critique in the *Laocoon* (1766) of the Horation formula *ut pictura poesis* and by Lessing's stress on the radically different formal and technical methods of the arts: "Similar in their common goal, all the arts differ in the particular effects they produce, and in the methods they employ. They gain nothing by exchanging their means nor by removing the boundaries which separate them."[11] However, by supplementing his thinking with later theories of the *imagination,* Cousin is able to arrive at a more nuanced understanding of the process of imitation: "The mind in applying itself to the images furnished by memory decomposes them, chooses from among their different traits and creates new images from them. Without this new power, the imagination would remain captive in memory's circle."[12] Two vital innovations emerge here: one, the imagination, in selecting and reassembling, fulfills a *creative* as much as an imitative function; two, the mechanism described applies as well to the operations of literature as of painting. What begins to emerge from Cousin's aesthetic thinking is a unified theory of artistic production and reception, in which image and imagination play a central role, one that is comparable and equally determining across the different arts. A further feature is the stress on the value and importance of fictive or imaginary elements – "imagined or imaginary objects give greater pleasure because they are *less determined*";[13] this relative lack of determination enhances the possibility of development in terms of metaphor.

Compared to David, or even Ingres (whose mannerism has often been noticed), Delacroix was much less committed to imitation as it was understood by Quatremère de Quincy, or even Cousin. It is interesting to remember that contemporary criticism, taking drawing *(le dessin)* as the first criterion for verisimilitude, took Delacroix to task for his (apparent) inability to draw, at least in the conventional manner. Delacroix's drawing, unlike that of David or Ingres, did not delineate, but rather *suggested the presence* of objects or figures, very often using light and shade or color as an integral part of the drawing process. Any vagueness or lack of focus is a result of Delacroix's concern to present not accurate delimitations but *pictorial metaphors* of figures or objects. His confrontation of the implications of what he perceived to be the fundamentally

metaphorical nature of artistic creation naturally attracted to him poets and aesthetic theorists of the next generation, such as Théophile Gautier and Charles Baudelaire.[14] Combining a real knowledge of painting (Gautier started out as a *rapin* in the studio of the painter Louis-Edouard Rioult; Baudelaire had considerable potential as an artist) with a deep understanding of literature, these writers were best able to clarify the nature of the different arts in their increasingly complex interrelationship.[15]

Théophile Gautier (1811–72), the first significant literary writer to admire Delacroix and to praise him eloquently in both the popular press and in more specialized journals, was quick to underline the shared inspiration and parallel aims of painting and poetry in the Romantic period:

> In those times, painting and poetry fraternized. Artists read the works of poets while poets visited artists. Shakespeare, Dante, Goethe, Byron, and Walter Scott were as likely to be found in the studio as in the writer's study. There were as many splashes of color as blots of ink in the margins of these fine and incessantly perused books. Imaginations, already excited in themselves, became more impassioned still when reading these foreign works with their rich color and the free and powerful reign they gave to fantasy.[16]

Gautier was also one of the first to outline, in his art criticism, a theory that accounted for the special impact of Delacroix's painting. The following quotation, an extract from an obituary article on Delacroix of 1864, in explaining both the significance of his technique as a draftsman and the more general significance of his work as a painter, sums up Gautier's thinking about Delacroix, as expressed in his art writings over the preceding quarter century:

> In his work, Delacroix always sought the characteristic detail, the sign of passion, the significant gesture, the note that was rare and strange. His drawing, so often criticized, but which is really very scientific, despite the visible mistakes that any art student could point out, ripples and trembles like a flame around the forms which he is careful not to delineate so as not to arrest their movement; his contours crack rather than risk interrupting the thrust of a raised or extended arm. Color builds up at the point which constitutes the hub of the action; for, above all, Delacroix aims to give the sensation of the thing he is representing, – in its very essence, not in its photographic reality. [. . .] The aim of art – an aim too often forgotten in these times – is not the exact reproduction of nature, but the creation by means of the forms and colors it presents to us, of a microcosm in which the dreams, sensations, and ideas which the world inspires in us may come alive and live.[17]

Significant in this passage is Gautier's focus on the formal and expressive as opposed to the literary or historical aspect of Delacroix's work. It reflects the special challenge Delacroix's unique painterly style, with its fluid outlines and expressive use of color, presented to the nineteenth-century viewer, eliciting the development of a new understanding of the aim and function of painting. This was no longer to be the attainment of some ideal through an adroit articulation

of classical forms, but the recreation of a visual world whose plastic richness and visual ambiguity involved an intense imaginative response on the viewer's part. For an art critic like Gautier, who was also a poet, this challenge was one that was also to be taken up in literary or poetic creation.

Like Gautier, Charles Baudelaire (1821–67), Delacroix's most famous critic and admirer, stresses both the unity and the infinitive suggestiveness of the artist's work in his articles summing up the artist's career: "Delacroix is the most suggestive of all painters, the one whose works [. . .] inspire the deepest reflection, and bring to mind the greatest number of poetic thoughts and feelings."[18] In Baudelaire's essay on Delacroix in the *Salon de 1846*, Gautier's concept of the painting as microcosm finds an equivalent in the concept of the *"poëme,"* which for Baudelaire is a term that can be applied equally to painting or to literature. In the painting of the mature Delacroix, a work that is a "poem" is able both to grasp the "intimate intelligence of the subject" and to open up "profound avenues" for exploration by the imagination. Baudelaire – like Gautier – is not afraid to admit, in his *Salon de 1846*, that the primitive or "naive" conception of such works, along with their "insolent execution" sometimes implies "an occasional fault in the drawing"; this is the price to pay for a painting that is conceived of as "a machine, all of whose systems are intelligible to the practiced eye," in which everything, including the occasional incorrection, has its "raison d'être, if the picture is a good one."[19] It is important to note here that the eye of the critic, whether Gautier or Baudelaire, is assumed to be almost as practiced as that of the artist himself, and that the writer as poet/critic was as much motivated by his concern to develop the potential of his own creative writing as was the artist to perfect his skill in painting. This is revealed in the shared primary points of reference of artistic creativity – imagination, poem – and the use of terminology – suggestion, harmony – applicable equally to the different art forms.

As an example of this close interaction between visual source and critical/ poetic response, compare the reactions of Gautier and Baudelaire to one of Delacroix's finest late easel paintings, *Ovid Among the Scythians* (Fig. 58), exhibited at the Salon of 1859.[20] In his *feuilleton* devoted to Delacroix in the *Moniteur universel* of 21 May 1859, Gautier reaffirms that the painter's genius and reputation are no longer in need of justification, whether in terms of his large mural projects or easel paintings, since Delacroix's masterly sense of form and color creates drama and movement regardless of scale.[21] Already in evoking the general character of the painter's work, Gautier's art-critical style reveals its shimmering contours and luminous color, layering verbs and adjectives of movement and light in a manner analogous both to Delacroix's "ardent, feverish, disturbed" personality and to his application of paint: "Everything touched by his brush stirs, palpitates, blazes."[22] Focusing more specifically on the painting *Ovid Among the Scythians,* Gautier comments on the way the landscape background takes on as much importance as the figures themselves, its description evolving into a poetic evocation in which coordination of the various linguistic phrases imitates the seamless coalescence of landscape features:

Fig. 58. Delacroix, *Ovid Among the Scythians*, 1859. London, National Gallery. Oil on canvas, 88 × 130 cm. (Photo © The National Gallery, London).

> In a broad sky, breathing light and movement, the wind blows archipelagos of greyish clouds into strange shapes and forms, their shadows playing on the verdant hills bordering a lake whose leaden and sombre waters gleam with flecks of white. On a grassy bank, the poet, expiating in exile the crime of having loved too high, reclines in sad resignation.[23]

Gautier's response is, however, nuanced by misgivings about the mare in the right foreground, which seemed, to him, too large.

Baudelaire's account of the same painting in his *Salon de 1859,* in expressing his unreserved admiration for Delacroix in general and this painting in particular, elicits writing of exceptional poetic intensity:

> Everything delicate and fertile in Ovid has passed into Delacroix's painting; and, just as exile gave to the brilliant poet the sadness that he lacked, melancholy has clothed with its magic varnish the painter's opulent landscape [. . .]. The mind sinks into it in slow and sensual delight, as if into the sky, into the sea's horizon, into thoughtful eyes, in a movement replete and rich in reverie.[24]

We notice here the ease with which qualities of literature "pass" into painting and, conversely, the smoothness with which the terminology of painting is applied figuratively to the canvas. Next we note the analogical structure of Baudelaire's account ("just as . . .," "as if . . ."). The fact that the final analogies have only a distant connection with the painting itself (no thoughtful eyes gaze

out of Delacroix's *Ovid*) scarcely disturbs us, since by the latter stage of the passage, Baudelaire is not so much evoking Delacroix's painting as proposing a generalized concept of the poetic, subtly alluding, indeed, to fragments of his own poems, offered here as literary equivalents of the visual image. In this way, we see the almost seamless link between the painterly and the poetic that establishes itself in the minds and creative impulses of the great poet/art critics of the midcentury, a link that the example of Delacroix was fundamental in inspiring and establishing.

Resemblance and Imagination

If Delacroix was able to make a radical contribution, albeit indirectly, to aesthetic debate as well as to artistic practice in the first half of the nineteenth century, it was precisely because of his ability to draw on his experience as a painter as well as his reflections on aesthetic theory. Delacroix, unlike Quatremère de Quincy, although conscious of the necessity of the separating procedures of analysis, as an artist was aware of the value of combination and synthesis. Instead of dividing and separating, Delacroix's instinctive reaction to sensation and experience is inclusive: in discussing the achievement of Rubens in a passage of his *Journal*, he writes that "success in the arts is not a function of abbreviation but of amplification, the prolongation as far as possible of sensation, using all possible means" and confirms "man's need to experience the maximum number of emotions."[25] These sensations were as likely to come from other works of art, poetry, or painting as from observation of the natural world. As Gautier suggested in the passage cited earlier, reading or writing poetry can become, for a Romantic artist like Delacroix, a valuable and authentic inspirational exercise. So, in 1824, when meditating on his painting *Scenes from the Massacres at Chios* (Pl. 2) Delacroix writes, "I think and have always thought that it would be an excellent idea to warm up by writing in verse, rhymed or not, on a subject in order to help one get into the mood to paint it with gusto."[26]

In a similar way, poets like Gautier and Baudelaire will often find unexpected poetic inspiration while leafing through albums of engravings or other images.[27] In both cases we see the role of images from another art stimulating the work of artist or poet in his own field, in a process that opens up the scope for interaction between the arts and confirms their common basis in imaginative activity. Both literature and painting can draw on the natural world; both can draw on previous texts – intertextuality and intersemiosis are indeed governing principles of European art. Delacroix's stress, which I explore further shortly, on the importance of the plastic and physical aspect of painting in creating an impact on the viewer, will inspire poets to seek formal equivalents in language and structure and to promote them as fundamental components in the sensual impact and pleasure of the reading process.

For Delacroix, the superiority of painting lies in the *tangibility* of the emotion or pleasure to which it gives rise:

> You take the same pleasure in the representation of these objects that you would get if you really saw them, while at the same time the images' deeper meaning thrills and excites you. These figures, these objects which seem to a certain part of your being to be the very thing itself, are a solid bridge supporting the imagination's entry into the deep and mysterious feeling of which these forms are in some way the hieroglyphs [. . .][28]

European painting, at least until the beginning of the twentieth century, is generally conceived as being an *iconic* art whose signs resemble those of its object. However, when a painter, like Delacroix, places an icon in a richly sensuous environment, the observer's attention is directed not merely to the object itself but also to its imaginative or metaphorical associations ("the mysterious feeling"). This is because painting is able to tell us simultaneously about a supposed objective world and about the fictional ways in which it can be read. Although Delacroix's comparison of the lusciousness of the artist's palette with the "cold representation" of typographical characters appears to underrate language's power to create a similar sense of material presence, in fact there is no reason why poetry should not, like painting, aspire to create an impression of sensual richness. It does so of course by drawing both on the rhythmic and phonetic potential of language and on the shape and form of the poem on the page – in other words by *iconizing* the conventional symbols of words or letters. Just as Delacroix gives sensual vitality through paint to the figure drawn from literature or myth, so language is able to give a similar sense of physical presence to words and ideas. The iconizing process when applied to language has similar effects when applied to objects represented in painting: it invites a *double* reading of the sign, one immediate, in which the referential dimension of the word or image is grasped; the second dynamic, in which multiple associated feelings and ideas become activated. It is the latter action that leads readers to reread poems or to remain, like Delacroix, absorbed for long moments in front of a picture.

The necessity of subsuming details to the whole is an integral part of this process. Delacroix repeatedly stresses the importance not only of unity of composition (disposition of masses and shapes within the frame) but also of color and tone as essential factors in creating the painting's effect. Géricault's lithographs, for example, are taken to task for their lack of unity and uncoordinated detail; Delacroix compares them unfavorably with a painting of his own, *Le Christ au tombeau*, which he describes as follows:

> The details are, on the whole, mediocre and largely escape notice. On the other hand, the overall impression inspires an emotion that astonishes even me. You are left unable to detach yourself, and not one detail stands out to be admired or distract your attention. In this lies the perfection of this art, whose aim is to create an impression of simultaneity.[29]

It is thus not careful delineation and microscopic detail that recreate the illusion of, say, a leaf, but a well-judged dab of paint. In an attempt to convert the conventionally linear and temporal dynamic of writing to the spatial mode of painting, poets will draw on the lessons of Delacroix. Similarly, they will strive to suggest the object rather than describe it in detail, the very abbreviation of the expression used opening it out to richer interpretation. So, just as Baudelaire stresses in the context of Delacroix's painting the importance of not mixing *touches*,[30] the poet and prosodic theorist Théodore de Banville (1823–91) describes in his *Petit Traité de poésie française* (1872) how the poet should endeavor to create a literary equivalent of the painter's mastery of the brush stroke:

> It is not in describing objects in their different aspects or in their smallest detail that verse makes them visible; it is not in expressing ideas fully in their logical order that verse communicates them to its listeners; but verse GIVES RISE to these images or ideas in the mind, and to do so a word will suffice. Similarly, by means of a deft brush stroke, the painter gives rise in the spectator's mind to the idea of beech or oak foliage: however, you can approach the picture and scrutinize it attentively, but you will find that the painter has represented neither the contour nor the structure of oak or beech leaves; it is in your mind that this image has been painted, because the painter intended it. The poet also.[31]

This concern with heterogeneity at the micro level (*mot, touche*) is balanced at the macro level by a concern with creating an overall unity and harmony of tone. This implies a certain economy in the choice of means (colors, forms; words, stanzas), which is compensated by a maximization of resources through harmonious interaction. This implies from the start a conception of the work (picture, poem) as a totality. So, unlike contemporary painters such as Horace Vernet or Paul Delaroche, who are capable of completing a corner of a canvas on the basis of a drawing that provides the skeletal framework of the picture as a whole, Delacroix's technique is based on an *allover* process in which masses of color, light, and shade are established as the organizing principle of the canvas overall, and are subsequently brought into varying degrees of focus as successive layers of paint are applied. Gautier describes Delacroix's mastery of this principle thus:

> Everything holds together, everything is linked to form a magical totality, no single part of which could be excised or altered without the whole edifice crumbling. In art, I know of no other artist but Rembrandt able to create this deep and indissoluble unity. This is because both of these masters create from their inner vision, a vision which they make manifest according to the means at their disposal, and not from their direct study of the subject.[32]

Meanwhile Baudelaire generalizes the principle in the following memorable formulation:

> A fine painting, faithful and equal to the dream which gave it birth, should be produced like a world. Just as creation, as we see it, is the result of several creations of which the predecessors are completed by the successor, so a har-

moniously constructed picture consists of a series of paintings superimposed one above the other, each layer heightening the reality of the dream and bringing it nearer to perfection.[33]

A similarly simultaneous or overall approach will be adopted by poets from Gautier and Baudelaire onward in relation to poetic composition. The theoretical basis of their practice is once again stated by Banville, whose use of painterly terminology (vision, salient, brilliant, colored, images, etc.) betrays his sources in the visual arts:

> As soon as the poet has learned his craft and got used to recognizing his visions, he hears quickly, at the same time, in such a way that strikes him overpoweringly, not only the matching rhyme, but all the rhymes of a stanza or a passage, and after the rhymes, all the characteristic or salient words which create the effect of images, and after these words, all those that are correlative to them, long if the first are short, muffled, brilliant, mute, colored in such and such a way, just as they should be to complete the meaning and to harmonize with earlier words and to form with them a whole that is lively, graceful, vivid and complete.[34]

Line and Color

At about the same time that Banville was in his *Petit Traité* (1872) retrospectively theorizing, as it were, the *aesthetics* of French prosody as practiced by earlier nineteenth-century French poets, Charles Blanc (1813–82) was codifying the *grammar* of artistic practice in the visual arts. Because Blanc is one of the chief nineteenth-century sources of informed comment on Delacroix's artistic practice,[35] the *Grammaire des arts du dessin. Architecture, sculpture, peinture* (1876)[36] will be taken here, along with Baudelaire's comments, as the frame through which Delacroix's practice is filtered and interpreted by both aesthetics and poetics. Blanc founds his opening remarks in his *Grammaire des arts* on a major but symptomatic misconception, namely that line is the masculine principle in art and color feminine, the latter naturally subservient to the former:

> The union of drawing and color is necessary to engender painting, just as the union of man and woman is necessary to engender humanity; but drawing should retain its preponderance over color. If not, painting runs to its ruin; it will be betrayed by color just as Humanity was betrayed by Eve.[37]

But this view, a result of Blanc's awareness of the radical new developments in impressionist painting as well as of Delacroix's practice, is already dated by comparison with the much more subtle view of the French nineteenth century's obsession with the line/color relationship expressed by Baudelaire twenty years before.[38] For the great originality of Delacroix was not only to have realized in his work as an artist but also to have stated in comments, to Baudelaire and others, the *structural* role color can have in painting:

> Artists who are not colorists are illuminators not painters [. . .] Colorists
> [. . .] should mass with color just as the sculptor masses with clay, marble,
> or stone; their first outline, like that of the sculptor, should present at the
> same time proportion, perspective, color, and effect.[39]

This does not, of course, mean that lines disappeared from Delacroix's painting
or that he was not able to draw in the conventional sense, but rather that his
style of drawing changed as the demands of color as a compositional element
became clear. And because color very often expressed light or shadow, elements
that bathed objects regardless of their shape or form, it naturally tended to
efface or redefine contours. As Baudelaire confirms in the *Salon de 1859*, "a
good drawing is not a hard, cruel, despotic, static line, emprisoning a figure as
in a straitjacket," but is "like Nature, living and moving."[40] Baudelaire also says
(Salon de 1846) that lines are not necessarily forms in themselves but a function
of *the fusion of colors*.[41]

When color begins in this way, as it does in Delacroix – and as it did in Rubens
and in other, earlier, colorist painters he admired – to detach itself from a purely
representational function and to assert itself as a structural and expressive power
in its own right, its potential is massively increased. It need no longer passively
record the literal appearance of objects but may start asserting its own inherent
metaphorical possibilities, bathing objects in an expressive light and creating har-
monies that speak to the viewer over and beyond the content of the images repre-
sented in the painting. So a painting such as Delacroix's *Entry of the Crusaders
into Constantinople* (1840) "is profoundly moving, leaving aside its subject, in its
stormy and lugubrious harmony"[42]; indeed, Baudelaire repeatedly notes the
abstract potential of Delacroix's use of color.[43] Color and the plastic qualities of
paint in this way become the key formal and expressive elements in pictorial art.
On the one hand, color is able to harmonize the various parts of the picture
through a system of tonal correspondences: "Just as a dream exists in its own
atmosphere, similarly a conception, when it has become a composition, needs to
move in a colored environment peculiar to it. There is clearly a particular hue
found in a particular part of the picture that becomes the key and sets the tone for
all the rest"[44]; on the other, color can articulate feeling, mood, and tone, each hue
inspiring a certain set of associations: "Everyone knows that yellow, orange, and
red inspire and express ideas of joy, richness, glory, and love."[45] In other words,
color is itself a kind of language, a way of thinking; or, as Baudelaire memorably
puts it: "Color thinks for itself, independently of the objects it clothes."[46]

Charles Blanc's analysis of color in his *Grammaire* is strongest when based,
as much of it is, on the discoveries of Charles Bourgeois and Eugène Chevreul
(see Blanc, *Grammaire*, third book),[47] and his comments on Delacroix's practice
as a colorist are best founded when based on the new scientific approach: "This
is how colorists can entrance us using means which Science has discovered,"[48]
Blanc writes and singles out for praise in particular Delacroix's ability to predict
color harmonies and contrasts on the wall or canvas without preparing them
beforehand on his palette, as in *Women of Algiers* (1834) (Pl. 6) with its "pinkish

blouse scattered with little green flowers."[49] Blanc likewise praises, as Baudelaire had done, the harmonizing role color plays in Delacroix's painting, using the musical metaphor both to clarify and lyricize his observations:

> More poetlike, more deeply moved by his subject and by his own emotion, Eugène Delacroix never fails to tune his lyre to his thinking, and to arrange things in such a way that the first impression his picture makes is a prelude to a melody [. . .] From further away, before discerning anything, the spectator divines the strokes which will penetrate his soul.[50]

The more radical implications of Delacroix's use of color, however, were perceived as dangerous by Blanc. When he comments, for example, that "The passionate colorist [. . .] creates form through color," this is an implied criticism, for, Blanc infers, "a love of color, when it predominates absolutely, requires many sacrifices; often it diverts the mind from its planned route, alters feeling, devours thought."[51] This leads, he implies, to a skewing of painting's conventions, as in Delacroix:

> Everything with him is subordinated to hue. Not only is drawing made to bend, but also composition is controlled, obstructed, assaulted by color. To introduce a violet hue to heighten yellow drapery, it is necessary to arrange a space for this color, to introduce a perhaps unnecessary accessory. In *The Massacre at Chios*, a *sabretache* is placed in a corner simply because the painter needed a blob of orange there.[52]

It is in part for this reason that oriental subjects were so popular with Romantic artists, offering the possibility of brilliant spectacle under strong lighting with endless potential for color harmonies, maneuvered by adroit incorporation of exotic or picturesque detail, especially of costumes and weaponry. It is interesting to note that Charles Blanc clearly had literature in mind as much as painting in making these remarks, for his comments on Delacroix's technique in the *Scenes from the Massacres at Chios* and other early orientalist works could as well apply to Victor Hugo (1802–85) whose collection *Les Orientales* (1829), partly inspired by Delacroix's and Louis Boulanger's paintings, was as much constructed around rhyme schemes and exotic oriental terminology as around story or theme (Hugo had not visited the Orient before writing his poems). The text that more than any other in the century was to inspire Parnassian and even early Symbolist poetry, *Les Orientales* was an unashamed celebration of the power of the image, not only as a suggestive motif in its own right, but also as part of a tonal and suggestive *system* that became the organizing principle of the poem. So when, forty years later, in 1868, Mallarmé was obliged to invent the word *ptyx* to fit into the rich, rare rhyme scheme in *yx*, which forms the backbone to his famous "Sonnet en yx," he took the same liberties with poetry as Delacroix had taken with painting in including the *sabretache* in his *Scenes from the Massacres at Chios*. And Mallarmé's practice was to prove symptomatic of that "decadence" that Blanc predicted in his *Grammaire* when images superseded ideas as the governing components of poetic composition:

Just as literature falls into decadence when images take precedence over ideas, so art declines infallibly into materialism when the spirit's drawing is vanquished by sensation's coloring; when, in a word, the orchestra, instead of accompanying the song, becomes itself alone the poem.[53]

What Blanc did not realize was that in taking the risky road of the pure image, Symbolist poets would institute guidelines and safety barriers based on what they perceived as the aesthetic practice of Romantic and Impressionist painters: use of color imagery to provide unity and coherence; rhyme and form to provide an aesthetic framework; rhythmic and phonetic patterns to provide musical harmony. I will show how they do this in the next section.

Form and Content

The close link between Baudelaire's reflections on aesthetics and poetics is attested to by his habit of discussing the latter in the context of the former, and never more often than when he is writing about the imagination. Thus, immediately after analyzing the way romantic painting is constructed,[54] Baudelaire goes on to make the following capital comment:

[I]t is obvious that rhetoric and prosody are not arbitrarily invented tyrannies but a collection of rules sought by the mind's organizing powers; and prosody and rhetoric have never prevented originality from manifesting itself. The contrary, that is, that these rules have helped the burgeoning of originality, would be much nearer the truth.[55]

This habit of mixing reflection on painting and poetry may have been derived from Delacroix, who over a decade before, in 1847, had made the following entry in his diary:

I see painters as prose-writers and as poets. Rhyme, formal difficulties and turns, indispensable to verse and which give it such vigor, are analogous to hidden symmetry, to that scientifically calculated and yet inspired rhythmic balance that controls the meeting or separation of lines, spots, colour, etc. [. . .] But the beauty of verse does not depend on exactly obeying the rules, whose inobservance any fool will notice. It resides in a thousand hidden harmonies or proprieties which constitute poetry's strength and which appeal to the imagination; just as a happy choice of forms and their effective coordination act on the imagination in the art of painting.[56]

The equivalence established here by Delacroix between rhyme and color, in effect, already implicit in Hugo's poetry from the time of *Les Orientales,* will become consciously recognized as the basis of poetic practice from Baudelaire onward, particularly in the context of a poetry that was becoming increasingly image-centered. Since *"l'imagination de la Rime,"* as Banville had defined it,[57] is, in effect, the equivalent of *l'imagination de la couleur* in Romantic painting, poets and prosodists of the midcentury will constantly define rhyme in terms of

color or plastic form. For Baudelaire, "richly coloured rhymes are the lanterns which light the idea's highway,"[58] and for Banville, rhyme, "an effect similar to that of *color harmonies* in painting"[59] should be "at the same time rich, bright, substantial, varied, as one would expect from a sculptor or painter."[60]

Note here that these poets' conception of the image was quite different from that of Charles Blanc. In poetry, it is not, as the latter assumed, ideas that create images or rhymes, but images and rhymes that create ideas; not only that, but these images, in organizing themselves into aesthetic patterns (rhyme schemes, stanzaic structures, other patterns of homophony) establish the structural principle of the poem as a whole and thus help shape the thematic or logical framework of the text overall. This will lead poets to exercise extreme care in their choice of poetic form, differences in which, like the difference between landscape or portrait format, will have a radical impact on the way the content of the poem is shaped. Often, the rhyme scheme itself is established before the rest of the poem, leading to a vertical or spatial conception of the poetic text that will bring it closer in terms of format and aesthetic organization to the pictorial image. Like the painting, the poem is a *signifying surface* in which the words' referential function is secondary to the aesthetic patterns to which their appearance and sound give rise. For example, in the Delacroix stanza of Baudelaire's "Les Phares," the color harmonies in red and green, the muffled alliterations, and the wistful *enjambement* of lines 3–4 create formal effects that transform the words' literal meaning. And the transfer of the *visual* impact of Delacroix's painting to the *aural* sensations of Weber's music in effect allegorizes the poetic process I have just described:

> Delacroix, blood-red lake haunted by angels
> Shaded by a forest of evergreen pines
> Where, under heavy skies, fanfares strange
> Sound like Weber's music's muffled sighs.

A form that answered with particular effectiveness the demands of such a poetics was the sonnet. It is significant that in their theoretical analysis of this form, poets and prosodists stress the notion of *cadre*, or frame. For Baudelaire, for example, the sonnet's framing effect immeasurably intensifies the impact created:

> Because the form is constricting, the idea spurts forth with increased intensity [. . .]. Have you noticed how a patch of sky viewed through a skylight, between two chimneys, two rocks or from beneath an arcade, gave a sharper sense of infinity than a vast panorama viewed from a mountaintop?[61]

And in his own sonnet "Le Cadre," the *cadre* operates as a picture frame, isolating the central poetic image from the chaos of "l'immense nature" that threatens to absorb it. For Mallarmé, in the famous "Sonnet en -yx" or "Sonnet allégorique de lui-même," mentioned earlier, the frame of the sonnet becomes that of a mirror whose function is to fix the central image of the poem.

A further remarkable aspect of the sonnet is that the formal framework

established by the rhymes and stanzas also constitutes a semantic structure. The vertical patterns of the rhymes, in their different configurations (embraced, alternating, couplets), in itself initiates a kind of argument whose vertical or paradigmatic axis enters into a relationship with the lateral or syntagmatic logic of regular discourse. This dialectical relationship between vectors has the effect of *spatializing* the semantic elements involved, with the result that the sonnet can be read as a *diagramme*. This diagrammatic potential was naturally tapped by poets like Baudelaire who sought to transpose images from the visual arts into painting. So, in 1844, he uses the sonnet as a framing device to transpose Delacroix's *Tasso in the Hospital of Saint Anna* (a painting that exists in two versions, see Figs. 5 and 21) into the poem "Sur le *Tasse en prison* d'Eugène Delacroix," in which the form both structures the variety and simultaneity of effects associated with the visual image and promotes the unifying focus of the picture frame. Baudelaire produced a revised version of this sonnet in 1864, the year after Delacroix's death.[62]

Conclusion: Genius as Janus

In the light of the above, it is perhaps surprising that Delacroix so little appreciated the poetry written in French during his time. Even though he knew both Gautier and Baudelaire[63] well, as art critics and as poets, his ambivalence toward them in the first category turns either to indifference or hostility in the second. It may be that the latter poets suffered from the sins of their immediate predecessors, the first-generation Romantic poets such as Lamartine and Hugo; for even as late as 1857, the year of the publication of Baudelaire's *Les Fleurs du Mal,* Delacroix's view of contemporary literature reflects the practice of earlier writers far more than that of contemporary poets. He writes in his notes for his planned *Dictionary* under the heading *Style moderne*:

> The modern style of writing is bad. Sentimentality and the picturesque applied indiscriminately to everything [. . .] Everything is lengthened and poeticized. The writer has to appear moved, penetrated and it is mistakenly believed that this perpetual eulogizing will win the reader over and give him a high respect for the author and, above all the goodness of his heart [. . .][64]

Delacroix seems quite unaware of the cult of objectivity promoted by Parnassian poets such as Gautier, Leconte de Lisle, and José-Maria de Heredia, and totally oblivious to the fascination of evil as shown in the poetry of Baudelaire. What is more, he seems to read poetry primarily in terms of content, rather than in terms of form. The reason for this is that Delacroix's tastes in literature were formed early in his life and were based on those European classics that, as Gautier observed, were avidly read by Romantic poets and painters alike: Dante, Tasso, Shakespeare, Goethe, and, most recent, Byron. The texts by these authors that Delacroix most prized were essentially epic or dramatic in theme or

form (the *Inferno, Hamlet, Faust, Sardanapalus*) and of course inspired in him subjects for the kind of work a history painter might reasonably tackle.

The problem with contemporary poetry (that of Banville, Gautier, or Baudelaire) was perhaps precisely that it had been too influenced by Delacroix's and other artists' practice. Drawing its inspiration, its organizational practice and much of its imagery from Romantic painting, it had concentrated and transformed visual material so thoroughly that it gave little opportunity for further pictorial inspiration or development, at least to an artist such as Delacroix, still committed to a clearly defined theme or subject in his work. Delacroix's successors in the French tradition – Symbolist artists such as Gustave Moreau, Odilon Redon – would again have recourse to literature, and would manage to distill even from contemporary writers (Poe, Mallarmé, Huysmans) certain themes they would submit to further transformations in subtlety and ambiguity.

Delacroix's difficulties with mid-nineteenth-century French poetry are thrown into clearer light when we examine his response to the art criticism of his poet contemporaries, a field in which, once again, Gautier and Baudelaire are the leading figures. Although Baudelaire's aesthetic judgment is mostly admired by Delacroix (it could hardly be otherwise, given the praise the poet lavished on him), his expression or style leave him uneasy: "He is right: but the sloppiness and incomprehensibility of some of his conceptions do not suit my way of thinking."[65] Delacroix's remarks on Gautier the art critic are more developed, and proportionately more telling:

> He takes a picture, describes it in his way, makes himself a picture which is charming, but he has not really executed a true critical act; provided he is able to add sparkle and shine to the macaronic expressions which he finds with a pleasure that the reader also sometimes shares, provided that he can cite Spain and Turkey, the Alhambra and the Atmeidan in Constantinople, he is happy, he has achieved his aim as a writer, and I don't think he sees far beyond that. [. . .] In this sort of criticism, there is neither instruction nor philosophy.[66]

The first irritation for Delacroix here seems to be Gautier's choice of a language that in its very ostentation and ingeniousness supersedes as much as it describes the object it evokes; secondly, the critical text as a whole becomes in itself a picture which is in danger of replacing as much as evoking the one it purports to criticize; thirdly, the exploration of picturesque associations or metaphorical links risks diminishing or trivializing the content of the picture under discussion. Finally, and perhaps most seriously, Gautier's style of criticism seems not to see beyond the surface of the painting's signs and enter into the profound implications or hidden depths of the subject portrayed. It is this final misconception that is perhaps the most symptomatic of Delacroix's mistrust and misunderstanding of contemporary poetry and poetic art criticism. For although both the latter seem superficially geared to exploring the content or signified of the images in question, they are as likely to do so through further metaphorical or

formal development as through literal interpretation. For the aim of Baudelaire's and Gautier's poetry is to exploit language's unique analytical and logical potential while at the same time asserting that it too can work like a painting, producing images it does not itself *need* (even though it is certainly able) fully to articulate. In other words, poetry can both imitate and transcend painting: indeed in the very act of imitating, it transcends painting.

In a period in which the *fraternité des arts* was as much motivated by a rivalry as by peaceful exchange of resources, such a position as that of Gautier and Baudelaire would obviously be construed as a threat by Delacroix. In his concern fully to explore and celebrate the metaphorical and expressive potential of the visual world, the more refined strategies of poetic creation might well appear to him as sophistry. But his failure fully to understand them is not a criticism that can be leveled at him seriously. For Delacroix's greatness, as his name implies, is to be a giant at the crossroads, looking as much backward to the glories of the post-Renaissance pictorial tradition, as forward to the achievements of the Symbolists and Impressionists. "The last painter of the old school,"[67] Delacroix stands like a Janus at the gateway not only of the nineteenth century but also of modernity.

Delacroix and *La Liberté. Revue des Arts*

"Pensée des journaux. Sur la remise de l'exposition,"
***La Liberté. Revue des Arts*, no. 14 (December 1832): 126–7**

Presque tous les journaux qui nous sont tombés sous la main, ces jours-ci, s'occupent du retard apporté à l'ouverture du salon, et la plupart flétrissent avec plus ou moins d'énergie cette mesure scandaleuse; quelques-uns, même, ont eu vent des intrigues dont nous suivons la trame pour les exposer au grand jour, et en disent quelques mots. Le *Messager,* entre autres, paraît assez bien informé des résolutions prises par les meneurs.

C'est aussi les mois d'août et de septembre que le *Messager* assigne, dans son numéro du 11 janvier, à la remise définitive du salon, et il ajoute:

"Il y a un caprice (nous dirions une mauvaise foi) incroyable dans toutes ces affaires. . . . Rien n'est arrêté, rien n'est stable; rien ne se base ni sur la nature des choses, ni sur les besoins et les intérêts du temps. Tout s'arrange pour les personnes, pour *certaines personnes* qui ne sont pas prêtes et qui ont assez d'influence et de crédit pour qu'on fasse, ou qu'on ne fasse pas, selon leur volonté."

Et plus bas: "Mais ceux qui sont prêts, ceux qui, bien certains de ne pas obtenir de faveur, se sont hâtés de terminer leur travaux pour arriver à l'heure fixée. . . . que feront-ils jusque-là, jusqu'à ce qu'il plaise au Louvre d'ouvrir ses portes? Ils attendront. Leur zèle est pris pour dupe et leur ponctualité sera tournée en dérision. Il n'y a de règle que pour ceux qui n'ont pas de voix au chapitre et qui ne sont pas, apparemment, bien en cour. Mais les exceptions, les délais, les facilités, et plus tard les achats et les récompenses seront, et furent toujours, en réserve pour une classe privilégiée qu'il est bien singulier de rencontrer encore dans la république des arts."

Les hommes du dehors s'étonnent quand ils remarquent qu'il y a des privilégiés et des aristocrates dans les arts aussi bien qu'ailleurs, et par ce qu'on dit dans le monde de la république des arts, ils se sont figuré que la liberté et l'égalité leur étaient acquises. Aussi s'indignent-ils bien fort quand ils s'aperçoivent que le plus capricieux arbitraire, la plus dégoûtante partialité ont pris leur place.

De là cette grande colère de tous les journaux de l'opposition, encore que quelques-uns soient ordinairement assez indifférens à nos intérêts les plus chers. Il n'y a pas jusqu'au pâle *Constitutionnel* qui n'ait pas craint de compromettre son rôle d'opposition moutonnière en soutenant qu'un délai, même de quelques semaines, doit nuire singulièrement tant *aux intérêts matériels* qu'*aux intérêts de réputation* d'un grand nombre d'artistes.

E. DELACROIX

"Exposition. Ceux qui en veulent et ceux qui n'en veulent pas," *La Liberté. Revue des Arts*, no. 15 (January 1833): 129–31

Qu'est-ce qu'une exposition? Si tout le monde était éclairé, de bonne foi, sans préventions ni politesses, il serait aisé de s'entendre sur la signification de ce mot. Et puis, nous ouvririons tout simplement un dictionnaire français (non pas celui de l'académie), et nous dirions: Voyez! – Malheureusement il n'en est pas ainsi. Aucun mot, peut-être, dans notre langue n'a reçu de signification plus variable, plus flexible, plus malléable, plus étendue. Chacun l'entend à sa manière, non seulement suivant son intelligence, mais, de plus, suivant son intérêt ou ses petites passions.

Pour un pauvre diable qui n'a pas une *mise décente*, qui n'a que ses yeux et son cœur d'homme pour voir et sentir, exposition veut dire: Ici l'on n'entre pas . . . Sans armes, sans doute? ajoute-t-il en s'en allant. C'est presque synonime de Tuileries. – Il n'y a pas grand mal, dira-t-on peut-être, à ce que le peuple ne soit pas juge des arts qu'il ne comprend pas, faute d'instruction. A la bonne heure; et c'est pour l'instruire qu'on lui distribue, chaque dimanche, sa ration hebdomadaire des superbes discours extraits du *Moniteur?* Ainsi soit-il!

Pour un épicier (je prends un type) l'exposition est une grande galerie ornée de glaces et soutenue par des colonnes, tout justement celle du Louvre, que le roi des Français prête le dimanche pour s'y promener et regarder les *portraits* pendus à la muraille. – Passons.

Pour les jolis hommes musqués, enrubanés, pincés et bien cravatés; pour les belles dames ambrées, rouges, emplumées, brillantes; pour les jeunes filles droites, timides, qui marchent en éparpillant à droite et à gauche des coups-d'œil furtifs, l'exposition, c'est presque le boulevart Italien. – On y voit des gens à la mode, des toilettes, de jolis costumes, des fleurs et des porcelaines; on y promène les yeux sur des couleurs, on s'arrête un instant à celle qui plaît, que l'on veut demander à sa modiste, et l'on passe. Les jolis hommes tirent leur lorgnon, disent: Délicieux! – approuvent d'un signe de tête et suivent. – Passons.

Mais il est des gens qui prennent au sérieux le mot exposition, parce que, pour eux, l'exposition est le seul moyen de faire triompher l'art de la mode, en le tirant de la boutique pour l'exposer au grand jour, parce que c'est le seul moyen de renverser le monopole et d'établir la liberté et l'égalité dans les arts, parce qu'enfin l'exposition est, à leur yeux, le grand tribunal où sont jugées les réputa-

tions faites, pour savoir si elles sont toujours dignes du commandement, et les réputations nouvelles qui font là leur premier pas dans l'avenir. On conçoit aisément que ceux-ci veuillent une exposition.

Malheureusement il est d'autres hommes pour qui le mot exposition veut dire aussi tribunal, et par suite, pour eux, réputation flétrie, gloire tombée, ambition déçue, titres anéantis. Ces mots, écrits comme en traits de feu dans la grande salle noire du Louvre, sont, pour eux, un cauchemar qui les poursuit dans tous leurs rêves; c'est presque un arrêt de mort artistique dont il se voient menacés; et comme personne ne veut être mis vivant dans la tombe, ceux-là sont furieux et ne veulent pas d'exposition. Ceux-là sont les intrigans, faiseurs royaux, artistes officiels, ayant brevet pour exploiter et monopoliser les arts, le tout à leur profit et à la plus grande gloire de la monarchie française. Ceux-là sont les hommes influens, dont les avis prévalent dans les conseils, sans doute parce qu'ils donnent à entendre qu'une exposition est une institution démocratique et révolutionnaire; qu'il en est ici des artistes comme des électeurs, qui exigent, à certaine époque, un compte-rendu de la conduite de leurs représentans; comme des députés qui veulent savoir ce qu'on fait du sang et des sueurs d'un peuple. Or, on conçoit l'audace et l'absurdité de telles prétentions. Il n'y a rien à répondre à des raisons si puissantes. L'exposition n'aura donc pas lieu, ou sera retardée autant que possible, et cela en vertu de la loi du *bon plaisir*.

Tant pis pour les arts! oui, mais tant mieux, n'est-ce pas, pour certains hommes pour qui *l'exposition* serait peut-être la marque et le poteau, la flétrissure et le carcan, avec cette inscription au-dessus de leurs têtes: *Réputations tombées*.

E. DELACROIX

Notes

CHAPTER 1. BETH S. WRIGHT. PAINTING THOUGHTS: AN INTRODUCTION TO DELACROIX

1. Delacroix, supplement to *Journal* c. 1840, ed. André Joubin (1931–2), rev. ed. Régis Labourdette (Paris: Plon, 1980; reprint 1996), 829; cited by Michèle Hannoosh, *Painting and the 'Journal' of Eugène Delacroix* (Princeton, NJ: Princeton UP, 1995), 200–1.
2. Delacroix, *Journal* (6 October 1822), Pach ed., 41.
3. Delacroix, *Journal* (25 January 1857), ed. Hubert Wellington, trans. Lucy Norton [1951] (London: Phaidon, 1995), after quoting Mme Cavé: "In painting, and especially in portraiture, mind speaks to mind and not knowledge to knowledge." See also his earlier passage on the hieroglyph (20 October 1853).
4. Delacroix, *Journal* (13 January 1857), Pach ed., 546.
5. Delacroix, *Journal* (5 January 1857); Wellington/Phaidon ed., 348–9. See also Delacroix, *Journal* (13 January 1857), cited by Petra ten-Doesschate Chu in her essay, n. 84.
6. This was not necessarily a contradiction for him: "For his contemporaries, Racine was a Romantic, but for every age he is classical, that is to say, he is faultless." Delacroix, *Journal* (13 January 1857), Wellington/Phaidon ed., 360.
7. See Jean Marchand, "Delacroix fut écrivain avant d'être peintre." *Nouvelles littéraires, artistiques et scientifiques,* no. 1302 (14 August 1952), no pagination; Jean Marchand, "Eugène Delacroix, homme de lettres d'après trois oeuvres de jeunesse." *Le Livre et l'estampe* 19, no. 3 (1959): 173–84. André Joubin published several early poems in "Etudes sur Eugène Delacroix," *Gazette des Beaux-Arts* (March 1927), 159–82.
8. Delacroix, *Journal* (4 October 1855), Wellington/Phaidon ed., 323.
9. Delacroix, *Journal* (8 May 1853), Pach ed., 304.
10. See Roger Delage, "Delacroix et la musique," in *Delacroix. La naissance d'un nouveau romantisme,* exhib. cat. (Rouen: Musée des Beaux-Arts, 1998), 129–40.
11. Charles Baudelaire, "The Salon of 1846," in *Art in Paris 1845–1862. Salons and Other Exhibitions Reviewed by Charles Baudelaire,* trans. and ed. Jonathan Mayne (Ithaca, NY, 1965; reprinted 1981); sections 2 "What Is Romanticism?" (46–8), 3 "On Colour" (48–52), and 4 "Eugène Delacroix" (52–68). In his review of the Exposition Universelle in 1855, Baudelaire cited his own poem "Les Phares," which hailed Delacroix with Rubens, Leonardo, Rembrandt, and Watteau, among others, as beacons to humanity; this poem is discussed in essays by both Chu and Scott.
12. "'[T]he powerful imagination of this artist forces us to rethink the situations as per-

fectly as he has himself. And if I must admit that in these scenes M. Delacroix has surpassed my own vision, how much more strongly the readers will find all of it alive and superior to what they were imagining!'" (Barthélémy/*Delacroix* [Princeton: Princeton UP, 1998], 108, citing Eckermann, *Conversations de Goethe avec Eckermann*, trans. J. Chuzeville (Paris, 1949; rev. ed. 1988), 171–2 (conversation of 29 November 1826).

13. Delacroix discussed the "work of the reader" in regard to Montaigne on 7 May 1850 (Pach ed., 220–1; Joubin/Labourdette ed., 236), and recopied the passage on 13 January 1857 (Pach ed., 546–7; Joubin/Labourdette ed., 618).

14. I set Delacroix's *Massacres at Chios, Rebecca and the Wounded Ivanhoe,* and *Marino Faliero* into the context of contemporary political and historiographic developments, and examined his novella *Les Dangers de la Cour* as it shed light on Delacroix's response to the novels of Walter Scott and literary taste and historical conception; see Beth S. Wright, *Painting and History during the French Restoration. Abandoned by the Past* (Cambridge and New York: Cambridge University Press, 1997), 128–36; Beth S. Wright, "'The Idea in the Image': Delacroix and Modern Literature," lecture at the Philadelphia Museum of Art October 1998 as part of the symposium organized by Nina Athanassoglou-Kallmyer and Joseph Rishel in conjunction with the exhibition *Delacroix: The Late Years.*

15. "Je vois dans les peintres des prosateurs et des poètes. La rime, les entraves, le tour indispensables aux vers et qui leur donnent tant de vigueur, est l'analogue de la symétrie cachée, du balancement savant en même temps et inspiré qui règle les rencontres ou l'écartement des lignes, les taches, les rappels de couleur, etc. . . . Les *Thermopyles* de David sont de la prose mâle et vigoureuse, j'en conviens." Delacroix, *Journal* (19 September 1847); Joubin/Labourdette ed., 163–4.

16. "His feeling of confidence that he was *writing* what he really thought about a canvas was always balanced by his concern that he was not able to *paint* his thoughts upon the paper." Baudelaire in "L'Art et la Vie d'Eugène Delacroix" for *L'Opinion Nationale* (2 and 14 September, 22 November 1863) in *Charles Baudelaire. The Painter of Modern Life and Other Essays,* trans. and ed. Jonathan Mayne (Phaidon, 1964), 41–68; 53.

17. As Michèle Hannoosh has pointed out (*Painting and the 'Journal' of Eugène Delacroix,* 118), the *Dictionnaire de l'Académie des Beaux-Arts, contenant les mots qui appartiennent à l'enseignement, à la pratique, à l'histoire des beaux-arts, etc.* began publication in 1858. Delacroix was invited to contribute an article, but the second volume appeared in 1865, after his death. It ceased publication in 1896 with the sixth volume (*Gypse*). Delacroix had read Antoine Pernety, *Dictionnaire portatif de peinture, sculpture et gravure* (Paris, 1757); William Hogarth, *The Analysis of Beauty* (London, 1753); and Jonathan Richardson, *The Theory of Painting* (London, 1715); see Lee Johnson, "A Brief Chronology of Delacroix's Early Years: 1798–1831. Life and Principal Paintings, with Some Notes on His Reading," *Paintings* (1981), 1: xv–xx, "Delacroix's Reading List, c. 1816–21," xvi–xvii.

18. Delacroix, *Journal* (4 February 1857), Wellington/Phaidon ed., 381.

19. Julius Meier-Graefe, cited by Bernard Karpel, in his preface to the selected bibliography for *The Journal of Eugène Delacroix,* trans. Walter Pach [1937] (New York: Viking Press, 1972), 737. See Julius Meier-Graefe, *The Development of Modern Art* [1908], and Julius Meier-Graefe, *Eugène Delacroix. Beitrage zu einer Analyse* [1913] (Munich: Piper, 1922).

20. "It is an illustrious name, it is a great name, it is not a well-known name." Paul Jamot, on the occasion of the 1930 Louvre exhibition *Centenaire du romantisme. Exposition E. Delacroix* (Paris, 1930, 11), cited by Jobert, *Delacroix,* 7. For an assessment of the bicentennial exhibitions in Paris, Philadelphia, and elsewhere in 1998, see Nina Athanassoglou-Kallmyer, *Burlington Magazine,* 140, no. 1148 (November 1998): 772–6.

21. Delacroix's *Barque of Dante, Massacres of Chios, Death of Sardanapalus,* and *The 28th July. Liberty Leading the People* were situated in their cultural context by Hélène Toussaint, Michael Marrinan, and Nina Athanassoglou-Kallmyer, among others.

22. Delacroix, *Journal* (11 May 1824), Wellington/Phaidon ed., 40.

23. The first published version of the *Journal* was edited by Paul Flat and René Piot, 3 vols. (Paris: Plon-Nourrit, 1893).

24. Delacroix's outrage at the exploitation of artists by "messieurs de la banque et du commerce," expressed in his "Influence du commerce et du gouvernement dans les arts," *La Liberté. Journal des arts,* no. 16 (December 1832): 65–8, is discussed by Marie-Claude Chaudonneret in *L'Etat & les Artistes. De la Restauration à la monarchie de Juillet (1815–1833)* (Paris: Flammarion, 1999), 119, 150–1.

CHAPTER 2. ALAN B. SPITZER. DELACROIX IN HIS GENERATION

1. I have drawn much of the discussion of Delacroix's youth from Alan B. Spitzer, *The French Generation of 1820* (Princeton, 1987).

2. Eugène Delacroix, *The Journal of Eugène Delacroix,* trans. Walter Pach (New York, 1961), 20.

3. *Le Globe,* 4 November 1826.

4. Alfred de Musset, *La confession d'un enfant du siècle: Oeuvres complètes en prose* (Paris, 1951), 85.

5. Lycée Louis-le-Grand, *Palmarès* (Paris, s.d.); Léon Rosenthal, "Géricault et Delacroix au Lycée imperial," *Bulletin de la société de l'histoire de l'art français* (1925), 85–8.

6. Nina Maria Athanassoglou-Kallmyer, *Eugène Delacroix, Prints, Politics and Satire 1814–1822* (New Haven, 1991), 125 n. 18, effectively disposes of the myth that Delacroix was a member of the *charbonnerie.*

7. *Le Globe,* 30 November 1825.

8. *La Muse française,* 1:75–6; *Le Globe,* "Profession de foi," 18 September 1824.

9. Delacroix to F. Guillemardet, 20 October 1820, Eugène Delacroix, *Lettres intimes,* ed. Alfred Dupont (Paris, 1954), 88, 120.

10. In 1824 Delacroix characterized Stendhal as "rude, arrogant when he is right but often nonsensical." But he eventually became a fond, if critical friend. Delacroix will remind himself four times in his journal of Stendhal's aphorism, "Ne negligez rien de tout ce qui peut vous faire grand." Eugène Delacroix, *Journal. 1822–1863* (Paris, 1966) (25 January 1824; 31 January 1850; 27 May 1854; 4 October 1855), 48, 219, 428, 550.

11. Delacroix to J. B. Pierret, 6 November 1818. Eugène Delacroix, *Correspondance générale de Eugène Delacroix,* ed. Andre Joubin (Paris, 1936), 1:35.

12. Delacroix, *Journal* (4 October 1855), 498.

13. Delacroix to Charles de Verninac, 1 May 1830, Eugène Delacroix, *Eugène Delacroix. Further Correspondence,1817–1863,* Lee Johnson, ed. (Oxford, 1991), 15.

14. Delacroix to Raymond Soulier, 21 February 1821, *Correspondance générale,* 1:115.

15. Max Milner, *Le Romantisme, 1820–1843* (Paris, 1973), 1:21; Pierre Barbéris, *Balzac et le mal du siècle* (Paris, 1970), 1:88–9.

16. E. A. Piron, *Eugène Delacroix. Sa vie et ses oeuvres* (Paris, 1865), 71–3.

17. Athanassoglou-Kallmyer, *Eugène Delacroix. Prints, Politics and Satire,* xii.

18. Delacroix, *Journal* (11 May 1824), 87.

19. R. S. Alexander, *Bonapartism and the Revolutionary Tradition in France. The Fédérés of 1815* (Cambridge, 1991).

20. Agricol Perdiguier, *Memoirs d'un compagnon* (Paris, 1964),117; Benjamin Pance, "Les étudiants sous la Restauration," *Paris révolutionnaire* (Paris, 1848), 270.

21. René Huyghe, *Delacroix,* trans. Jonathan Guffin (London, 1963), 201.

22. Jules Michelet, *Introduction à l'histoire universelle* (Paris, 1834), 98.

23. David Pinkney, *The French Revolution of 1830* (Princeton, 1972), 252–73.

24. Delacroix to Théophile Thoré, 18 January 1836, *Correspondance générale*, 1:408.
25. For a survey of interpretations of the painting, see Nicos Hadjinicolau, "La Liberté guidant le peuple de Delacroix devant son premier public," *Actes de la recherche en sciences sociales*, no. 28 (juin 1979), 3–26; see also Beth S. Wright, *Painting and History during the French Restoration. Abandoned by the Past* (Cambridge, 1997), 162–6; Pierre Gaudibert, "Delacroix et le romantisme révolutionnaire, À propos de la Liberté sur les Barricades," *Europe*, 41 année – no. 408 (April 1963), 4–21.
26. Maurice Agulhon, *Marianne into Battle. Republican Imagery and Symbolism in France, 1789–1880* (Cambridge, England, 1991), 2–39; T. J. Clark, *The Absolute Bourgeois. Artist and Politics in France. 1848–1851* (Princeton, 1982), 18–19; Heinrich Heine, *De La France* (Paris, 1873), 340, first published in *Morgenblatt für gebildete Stände*, No. 260, 31 October 1831; Jörg Traeger, "L'Epiphanie de la Liberté. La Révolution vue par Eugène Delacroix," *Revue de l'Art*, 98 (1992): 9–28; Michael Marrinan, *Painting Politics for Louis-Philippe. Art and Ideology in Orleanist France. 1830–1848* (New Haven, 1988), 74–5.
27. Delacroix to Charles de Verninac, 17 April 1830, *Further Correspondence*, 11.
28. Raymond Escholier, *Delacroix. Peintre, Graveur, Ecrivain* (Paris, 1926), 1:267.
29. Delacroix to Charles de Verninac, 4 September 1830, *Further Correspondence*, 18.
30. Delacroix to F. Villot [automne 1830], *Correspondance générale*, 1:262; Delacroix to F. Guillemardet, 15 February 1831, *Lettres intimes*, 155.
31. Delacroix to Charles de Verninac, 4 September 1830, *Further Correspondence*, 18.
32. Delacroix to J.P. Pierret, 2 to 3 October 1820, *Correspondance générale*, 1:80; for similar views expressed by Delacroix's coevals, see Spitzer, *The French Generation of 1820*, 230–1.
33. Jerrold Siegel, *Bohemian Paris. Culture, Politics and the Boundaries of Bourgeois Life, 1830–1930* (New York, 1986), 14.
34. Delacroix, *Journal* (29 April 1824), 83.
35. Years later he will observe that a great painter can only be effectively supported by the state. Delacroix to the comte de Niewerkerke, 19 February 1856, *Correspondance générale*, 3:312–18.
35. *L'Artiste*, 1 May 1831; also published in *Correspondance générale*, 1:268–76.
37. On this subject, see Albert Boime, "The Quasi-Open Competitions of the Quasi-Legitimate July Monarchy," *Arts Magazine*, 59 no. 8 (April 1985): 98–102; Marrinan, *Painting Politics for Louis-Philippe*, 79–98; Marie-Claude Chaudonneret, "Le concours de 1830 pour le Chambre des Deputés: Deux Esquisses d'A.-E. Fragonard au Louvre," *Revue du Louvre* 35, no. 2 (1987): 128–35.
38. See, e.g., Delacroix to Théophile Thoré, 13 February 1848, *Correspondance générale*, 2:339–40.
39. "Minute d'une adresse envoyé au nom de la Société Libre des Beaux-Arts à M. d'Agoult, ministre de l'Intérieur, et rédigée par Delacroix," ibid., 1:286–90.
40. Albert Boime, *The Academy and French Painting in the Nineteenth Century* (New Haven, 1986), 5.
41. Stendhal, "Le Salon de 1839. À une dame de Naples" (1839), *Correspondance* (Paris, 1968), 3:277.
42. Boime, *The Academy and French Painting in the Nineteenth Century*, 19–20.
43. Quoted in Escholier, *Delacroix*, 2:244.
44. Delacroix to Paul de Musset, 9 April 1838, *Correspondance générale*, 2:9.
45. Delacroix to F. Villot, 10 July 1846, ibid., 274.
46. Delacroix to Soulier, 21 January 1857, ibid., 3:371.
47. A. J. Tudesq, *Les grands notables en France 1810–1849*, 2 vols. (Paris, 1964); A. Jardin and A. J. Tudesq, *La France des notables* (Paris, 1973).
48. Delacroix to General baron Delacroix, 31 August 1839, *Lettres intimes*, 199.
49. Delacroix, *Journal* (28 February 1847), 151.
50. Madame Ancelot, *Un salon de Paris. 1824 à 1864* (Paris, 1866), 152. Delacroix appears

in one of Ancelot's visual representations of her salon in which the silhouette of each guest is numbered and represented by a key.

51. Delacroix to Felix Feuillet (de Conches), 25 January 1832, *Correspondance générale*, 1:308–9.
52. Escholier, *Delacroix*, 2:186.
53. Delacroix to Monsieur Ch. de Mornay, 30 July 1838, *Correspondance générale*, 2:14–16.
54. There is a fragmentary note: "Mornay qui revenait aussi m'a dit que mon affaire pour Saint-Sulpice. . . ." *Journal. 1822–1863* (3 March 1849), 181.
55. Delacroix to Madame de Forget, 15 April 1848, *Correspondance générale*, 2:358–9.
56. Vincent Pomarède, "Eugène Delacroix: The State, Collectors and Dealers," *Delacroix. The Late Work* (Philadelphia, 1998), 47–61.
57. Copy of a letter dated 18 January 1850 in *Journal. 1822–1863*, 218. See also Delacroix to Monsieur Gaultron, 18 January 1850, *Correspondance générale*, 3:3–4.
58. Charles Baudelaire, "L'Oeuvre et la vie d'Eugène Delacroix," *Oeuvres complètes* (Paris, 1966), 3:740. Among many similar characterizations, see Charles Rivet quoted in Escholier, *Delacroix*, 2:245; Arsène Houssaye, *Les confessions: Souvenirs d'un demi-siècle, 1830–1880* (Paris, 1891), 4:323; Odilon Redon, *A Soi-Même. Journal (1867–1915)* (Paris, 1961), 180.
59. See, e.g., Chapter 5 of Huyghe, *Delacroix ou le combat solitaire* (London, 1964), 233–56, entitled *Le Dandysme français*.
60. J. Barbey d'Aurevilly, "Du dandysme et de George Brummell," in *Oeuvres romanesques complètes* (Paris, 1966), 2:667–733 (first published in 1845); Charles Baudelaire, "Le dandy" in *Le peintre de la vie moderne. Oeuvres complètes*, 3:482–6.
61. Baudelaire, "Le dandy," 483, 486; "L'Oeuvre et la vie d'Eugène Delacroix," 741.
62. Huyghe, *Delacroix ou le combat solitaire*, 244.
63. On a visit to Eaux-Bonnes in the Pyrenees in 1845 he observes, "Ce bien n'est pas seulement rempli de malades, mais il l'est aussi d'oisifs dont l'occupation est de faire de parties dans les environs et de changer de cravates trois au quatre fois par jour." Delacroix to Monsieur Gaultron, 5 April 1845, *Correspondance générale*, 2:227; in his *Journal* (10 February 1849), 183, he refers to a silly fop with a most scrupulous toilette and "hermetical" gloves.
64. See, e.g., Barbey d'Aurevilly on Beau Brummell, "Du dandysme et de George Brummell," 693. "Il était un grande artiste à sa manière; seulement son art n'était pas spécial ne s'excerçait pas dans un temps donné. C'était sa vie même."
65. Baudelaire, "L'Oeuvre et la vie d'Eugène Delacroix," 742.
66. Clark, *The Absolute Bourgeois*, 126–41.
67. Delacroix, *Journal* (5 February 1849), 182–3.
68. Ibid., 147, Delacroix to Lassalle-Bordes, 4 September 1848, *Correspondance générale*, 2:365.
69. Delacroix, *Journal* (23 October 1849), 208.
70. Jean Gaudon, "Hugo juge de Delacroix," *Gazette des beaux arts*, 68 (1966): 173–4.
71. Delacroix to Balzac [fin 1832], *Correspondance générale*, 1:345.
72. This was the aborted insurrection of 5–6 June 1832 on the occasion of General Lamarque's funeral.
73. Delacroix to J. P. Pierret, 5 July 1832, *Correspondance générale*, 1:334; Delacroix to F. P. Villot, 7 July 1832, ibid., 335.
74. Delacroix to George Sand [March 1848], *Correspondance générale*, 2:342–5.
75. Delacroix was glad to see the government clamp down on people of that stripe in June 1849, "Voila plus de cent signataires du manifeste des journaux qui en bonne police, sont ennemis de la chose publique et mériteraient une sévère leçon." Delacroix to Madame de Forget, Lundi [25 June 1849], *Correspondance générale*, 2:384–5.
76. Eugène Cavaignac's father was a *conventionnel* who voted the death of King Louis XVI; his brother Godefroy was a republican hero who died in 1845.

77. Baudelaire, "L'Oeuvre et la vie d'Eugène Delacroix," 751.

78. Eugène Delacroix, *Oeuvres littéraires* (Paris, 1923), 2:184. Originally published in the *Revue des deux-mondes,* 1 September 1848.

79. Delacroix to Madame de Forget, 3 October 1848, *Correspondance générale,* 2:369.

80. Delacroix to George Sand, 22 January 1852, ibid., 3:101–2.

81. Delacroix to Madame de Forget, 23 July [1858], ibid., 4:39; Delacroix to Monsieur Pierre Antoine Berryer, 2 November 1858, ibid., 51.

82. For an excellent description of the Exposition see Patricia Mainardi, *Art and Politics of the Second Empire. The Universal Expositions of 1855 and 1867* (New Haven, 1987), 33–120.

83. Delacroix, *Journal* (7 November 1855), 499.

84. Mitigating Delacroix's harsh criticisms of Ingres, we find, "The group of Ingres' things [at the Exposition of 1855] seemed to me better than it did the first time and I am thankful to him for many fine qualities that he gets." Ibid. (1 June 1855), 465.

85. He thought that Courbet's *The Studio, a Real Allegory of Seven Years of My Life as an Artist,* rejected by the Exposition, was a masterpiece, and expressed qualified admiration of *The Burial at Ornans.* Ibid. (3 August 1855), 479–80.

86. Delacroix to Mme la baronne de Maupoint, 28 March 1853, *Correspondance générale,* 3:145–6.

87. Delacroix to Pierre-Antoine Berryer, 1 August 1862, ibid., 4:320–7.

88. Delacroix, *Journal* (29 June 1854), 393.

89. Delacroix to Madame de Forget, 30 June 1862, *Correspondance générale,* 4:321.

90. Delacroix to Raymond Soulier, 27 November 1861, ibid., 284–5.

91. Clark, *The Absolute Bourgeois,* 139.

92. Delacroix to Madame Babut, 20 January 1844, *Correspondance générale,* 2:166; *Journal, 1822–1863,* 353.

93. Delacroix to la duchesse Calonna de Castiglione, 23 September 1862, *Correspondance générale,* 4:336.

94. Carl E. Schorske, "The Idea of the City in European Thought: Voltaire to Spengler," in *Thinking with History. Explorations in the Passage to Modernism* (Princeton, 1998), 37–55.

95. Delacroix, *Journal* (6 May 1852), 269–71.

96. Delacroix, *Journal* (16 May 1853), 310.

97. Ibid. (26 August 1854; 6 June 1856), 418, 512.

98. Delacroix to Madame de Forget, 23 September 1860, *Correspondance générale,* 4:199.

99. Delacroix, *Journal* (22 March 1850), 217.

100. See Timothy Wilson Smith, *Delacroix. A Life* (London, 1992), 186–99; Lucien Rudrauf, *Eugène Delacroix et le problème du romantisme artistique* (Paris, 1942), 157–82.

101. An annotation in the 1932 edition of Delacroix's *Journal,* 3:258.

102. Delacroix, *Journal* (20 May 1856), 510.

103. Delacroix, ibid. (12 August 1862), 697.

104. Delacroix to George Sand, 25 November 1860, *Correspondance générale,* 4:213.

105. Delacroix to Raymond Soulier, "Ce 14 . . . 1858," ibid., 4:62. Even work, Delacroix adds, is only an "étourdissement passager . . . où l'âme se trouve en face de ce cruel néant."

106. This is in Joubin's introduction to the year 1861 in the *Correspondance générale,* 4:225.

107. Charles Baudelaire, *Salon de 1846* (Oxford, 1975), 136, 140.

CHAPTER 3. JAMES H. RUBIN. DELACROIX AND ROMANTICISM

1. Delacroix's response to being greeted as "the Victor Hugo of painting" by the librarian of the Chamber of Deputies. André Joubin, ed., *Delacroix, Journal, 1822–1863* [1931] (Paris, 1996), 15.

2. Friedrich Wilhelm Schlegel, Fragment no. 116, *Athenaeum*, 1798. Quoted in Charles Rosen and Henri Zerner, *Romanticism and Realism: The Mythology of Nineteenth-Century Art* (New York: W. W. Norton, 1984), 16–17.

3. [Henri Beyle] Stendhal, *Racine et Shakespeare,* ed. and preface by Pierre Martino, 2 vols. (Paris: Champion, 1925), 1:1.

4. See my "*Pygmalion and Galatea:* Girodet and Rousseau," *Burlington Magazine* 127 (August 1985): 517–20.

5. Etienne-Jean Delécluze, "Lettres au rédacteur du *Lycée français* sur l'exposition des artistes vivants," *Le Lycée français* 2 (1819): 237–8.

6. See Lorenz Eitner, *Géricault's 'Raft of the Medusa'* (London and New York: Phaidon, 1972).

7. Delécluze, "Lettres au rédacteur du *Lycée français,*" 322.

8. Lee Johnson, *The Paintings of Eugène Delacroix, A Critical Catalogue, 1816–1831,* J. 100 (Oxford, 1981), 1:72–8.

9. See my *Eugène Delacroix, 'Die Dantebarke': Idealismus und Modernität* (Frankfurt: Fischer Verlag Kunststück, 1987) and "Delacroix's *Barque* as a Romantic Manifesto: Politics and Theory in the Early 1820s," *Art Journal* 52, no. 2 (Summer 1993): 48–58.

10. Johnson, op. cit., 1:83–91.

11. On the mixed racial heritage of the contemporary Greeks, see Darcy Grimaldo Grigsby, *Extremities in Paint. Embodying Empire in Post-Revolutionary France,* forthcoming.

12. Nina M. Athanassoglou-Kallmyer, *French Images from the Greek War of Independence, 1821–1830* (New Haven and London: Yale University Press, 1989), 31–7.

13. Beyle-Stendhal, "Salon de 1824," *Journal de Paris,* reprinted in *Mélanges d'art et de littérature* (Paris 1867), 150, 179–80.

14. Athanassoglou-Kallmyer, op. cit., 66–107.

15. Delécluze, "Beaux-Arts, Expositions du Louvre, 1824," *Journal des débats,* 8 September and 5 October 1824. Alexandre Dumas attributed the "massacre" remark to Gros, who had become wary of his own influence on younger artists (Johnson, op. cit., 1:87).

16. On Delacroix and "gothic" literature, see the essay by Nina Athanassoglou-Kallmyer on "Eugène Delacroix and Popular Culture" in this volume.

17. Johnson, op. cit., J. 125, 1:114–21.

18. A. Marchwinski, "The Romantic Suicide and the Artists," *Gazette des Beaux-Arts* 109, no. 1417 (1987): 62–74.

19. Théophile Gautier, *Histoire du romantisme,* in *Oeuvres,* 27 (Paris: Charpentier, 1882), 99–108.

20. Both Byron and Goethe had treated the subject of Tasso prior to Delacroix's picture, and Delacroix's friend Jean-Baptiste Pierret was collaborating on a new French translation of Tasso's work (Johnson, op. cit., J. 106, 1:91–3).

21. Timothy J. Clark, *The Absolute Bourgeois: Art and Politics in France, 1848–51* (Greenwich, CT: New York Graphic Society, 1973), 17–19.

22. Johnson, op. cit., J. 144, 1:144–51, reviews the various possible sources.

23. Elisabeth A. Fraser, "Uncivil Alliances: Delacroix, the Private Collector, and the Public," *Oxford Art Journal* 21, no. 1 (Spring 1998): 87–103.

24. Summarized by Frank Anderson Trapp, *The Attainment of Delacroix* (Baltimore: Johns Hopkins University Press, 1970), 113–15.

25. See Michèle Hannoosh, Introduction and notes to the "Voyage au Maroc" section of her new critical edition of Delacroix's *Journal* (Macula, forthcoming).

26. Charles Baudelaire, "Salon of 1846," in *Art in Paris,* trans. and ed. Jonathan Mayne (London and New York: Phaidon, 1965), 65–6.

27. See the essay by Darcy Grimaldo Grigsby, "Orients and Colonies: Delacroix's Algerian Harem," in this volume.

28. See Maurice Sérullaz, *Les Peintures murales de Delacroix* (Paris: Editions du Temps,

1963), and Johnson, *The Paintings of Eugène Delacroix: A Critical Catalogue (The Public Decorations and Their Sketches)* 5 (Oxford: Clarendon Press, 1989), 3–77, 87–114.

29. See Anne Larue, "Delacroix and his critics: the stakes and strategies," in Michael Orwicz, ed., *Art criticism and its institutions in nineteenth-century France* (Manchester and New York: Manchester University Press, 1994), 63–87.

30. See George Mras, *Delacroix's Theory of Art* (Princeton: Princeton UP, 1966), 33–46.

31. See the essay by Dorothy Johnson, "Delacroix's Dialogue with the French Classical Tradition," in this volume.

32. *Journal* (13 January 1857).

33. Lecture by Nina Athanassoglou-Kallmyer, "Blemished Physiognomies: Delacroix and Paganini," at the Delacroix Symposium, Philadelphia Museum of Art, October 1998.

34. Johann Wolfgang von Goethe, *Sämtliche Werke* (Munich: C. Hanser, 1985), 19, *Johann Peter Eckermanns Gespräche mit Goethe,* ed. Heinz Schlaffer, 300 (2 April 1829).

35. Donald D. Egbert, *Social Radicalism and the Arts, Western Europe: A Cultural History from the French Revolution to 1968* (New York: Knopf, 1970), and Neil McWilliam, *Dreams of Happiness: Social Art and the French Left, 1830–1850* (Princeton: Princeton UP, 1993).

36. See Jerome Peignot, *Pierre Leroux: inventeur du socialisme* (Paris: Klincksieck, 1988); Jean-Pierre Lacassagne, ed., *Histoire d'une amitié (d'après une correspondance inédite, 1836–1866); Pierre Leroux et George Sand* (Paris: Klincksieck, 1973); and Jean-Jacques Goblot, *La jeune France libérale: Le Globe et son groupe littéraire, 1824–1830* (Paris: Plon, 1995).

37. Michèle Hannoosh, *Painting and the 'Journal' of Eugène Delacroix* (Princeton: Princeton UP, 1995), chap. 5 "The Ambiguities of History: The Apollo Gallery," 161–80.

38. *Journal* (5 February 1849). "[Baudelaire jumped to the topic of] Proudhon, qu'il admire et qu'il dit l'idole du peuple. Ses vues me paraissent des plus modernes et tout à fait dans le progrès." I differ with T. J. Clark's interpretation of Delacroix's attitude toward Baudelaire's interest in Proudhon, which I view as particular and focused, whereas Clark lumps it with Delacroix's overall disdain for political theorizing. See Clark, op. cit., 124–6. On Baudelaire and Proudhon, see my *Realism and Social Vision in Courbet and Proudhon* (Princeton: Princeton UP, 1980), 48–57.

39. Baudelaire, "Salon of 1846," op. cit., 46–7.

40. Ibid., 41–3.

41. Baudelaire, "Salon of 1859," in *Art in Paris,* op. cit., 152–5.

42. Between 1821 and 1850, the number of art dealers nearly doubled, from 37 to 67. See Nicholas Green, "Dealing in Temperaments: Economic Transformation of the Artistic Field in France During the Second Half of the Nineteenth Century," *Art History* 10, no. 1 (March 1987): 59–78.

43. Johnson, op. cit., 5:115–31, esp. 122–6.

44. Ibid., 115.

45. Letter of 5 October 1850 to Constant Dutilleux, in *Correspondance,* 3:36.

46. For opposing views, see Clark, op. cit., 140, and M. Hesse, "Eugène Delacroix, 1798–1863. Deckenbild in der Galerie d'Apollon des Louvre: Realitätsstruktur und Bildaussage," *Zeitschrift für Äesthetik und allgemeine Kunstwissenschaft,* 25 (1980): 88–107.

47. Letter to George Sand, 9 September 1850, *Correspondance,* 3:81. Andrieux quoted by Johnson, op. cit., 5:118.

48. Delacroix exclaimed that Courbet had "hatched suddenly, [and] without precedent," and, as if acknowledging the political connection, he termed him "a revolutionary."

These remarks on Courbet's *After Dinner at Ornans* of 1847 are cited by Georges Riat, *Gustave Courbet, peintre* (Paris: H. Floury, 1906), 67.

49. *Journal* (12 April 1853).

50. This was the underlying principle of Delacroix's art according to Baudelaire: "Nature, for Eugène Delacroix, is a vast dictionary whose leaves he turns and consults with a sure and searching eye . . ." Baudelaire, "Salon of 1846," 58–9.

51. Baudelaire, "Salon of 1859," in *Art in Paris*, op. cit., 162.

52. Especially the letters to Madame de Forget of 1848–9, in *Correspondence*, vol. 2, esp. 29 August 1848.

53. Baudelaire, "Salon of 1846," 118.

54. See Paul de Man, "The Rhetoric of Temporality," in *Blindness and Insight: Essays in the Rhetoric of Contemporary Criticism*, 2nd ed. (Minneapolis: University of Minnesota Press, 1983), 187–228.

CHAPTER 4. NINA ATHANASSOGLOU-KALLMYER. EUGÈNE DELACROIX AND POPULAR CULTURE

1. "Mon âme est un tombeau que, mauvais cénobite,/ Depuis l'éternité je parcours et j'habite;/ Rien n'embellit les murs de ce cloître odieux." Charles Baudelaire, "Le Mauvais Moine," from "Spleen et Idéal," *Oeuvres complètes* (Paris: Gallimard, 1961), 15. This essay is an expanded version of my presentation "Satan en soutane: Delacroix, Melmoth, and the Ideology of Terror" for the College Art Association, New York, 1994, in the session entitled *The Commercialization of Culture in Paris, 1750–1850*. All translations are mine except where otherwise noted.

2. *Le Diable boiteux*, 3 and 7 September 1824. Cited in Pontus Grate, *Deux critiques d'art de l'époque romantique. Gustave Planche et Théophile Thoré* (Stockholm: Almquist and Wiksell, 1959), 22.

3. L. Vitet, *Etudes sur les beaux-arts, essais d'archéologie et fragments littéraires*, 2 vols. (Paris: Charpentier, 1847), 2:189–90. First published as "Exposition des tableaux au bénéfice des Grecs (II^e article). M. Delacroix," *Le Globe*, 3 June 1826.

4. A. Jal, *Esquisses, croquis, pochades ou tout ce qu'on voudra sur le Salon de 1827* (Paris, 1828), 102–15 and passim.

5. 26 April 1824. Joubin, *Journal de Eugène Delacroix*, 3 vols. (Paris: Plon, 1932), 1:68.

6. Jean Marchand, "Eugène Delacroix. Homme de lettres d'après trois oeuvres de jeunesse, inédites," *Le Livre et l'estampe* 19 (1959): 173–84. Marchand dates these works c. 1816. For a discussion of these novels in the context of Delacroix's early liberal politics, see my *Eugène Delacroix. Prints, Politics and Satire 1814–1822* (New Haven and London: Yale UP, 1991), 15–16; and Beth S. Wright, *Painting and History during the French Restoration: Abandoned by the Past* (Cambridge: Cambridge University Press, 1997), 128–31.

7. Joubin, *Journal*, 3:437.

8. Annie Conan, "Delacroix à l'abbaye de Valmont," *Art de France* 3 (1963): 271–6; Arlette Sérullaz, *Delacroix et la Normandie*, exhib. cat., Paris: Réunion des Musées Nationaux, 1994.

9. 10 January 1814. Jean Stewart, ed., *Eugène Delacroix. Selected Letters 1813–1863* (London: Eyre and Spottiswoode, 1971), 31–2.

10. 28 September 1813. Stewart, *Delacroix. Selected Letters*, 31.

11. James Smith Allen, *Popular French Romanticism. Authors, Readers and Books in the 19th Century* (Syracuse: Syracuse UP, 1981), 8. The fusion of social classes in public spectacles began in the eighteenth century (if not earlier); see Michele Root-Bernstein, *Boulevard Theater and Revolution in Eighteenth-Century Paris* (Ann Arbor, MI: UMI Research Press, 1984); and Robert Isherwood, *Farce and Fantasy. Popular Entertainment in Eighteenth-Century Paris* (New York: Oxford UP, 1986), passim and 32–4.

12. Other examples include Mély and Janin's *Louis XI à Péronne* adapted from Scott's *Quentin Durward* (Théâtre Français, 1827); Victor Ducange and Méré's 1821 *La Sorcière ou L'orphelin écossais*, from Scott's *Guy Mannering* (Gaîté); Boirie and Lemaire's *Le château de Kenilworth* (Porte-Saint-Martin, 1822). Shakespeare's *Othello* provided the source for Ducis (1829), Cuvelier (*Le More de Venise ou Otello*, 1818), Henri Blaze (*Desdemona*, 1836), and Royer and Vaez (*Othello*, 1844), among others. In 1828 the Porte-Saint-Martin staged Merle, Béraud, and Nodier's melodrama after Goethe's *Faust*. On such theatrical "high"–"low" exchanges, see Maurice Albert, *Les théâtres des boulevards 1789–1848* [1902] (Geneva: Slatkine Reprints, 1978); and Peter Brooks, *The Melodramatic Imagination. Balzac, Henry James, Melodrama and the Mode of Excess* (New Haven and London: Yale UP, 1976), 17 ff.

13. Victor Fleury, "Beaux Arts. Décorations de la *Tentation*. Premier article," *L'Artiste* 3 (1832): 249.

14. P. L. Jacob (Bibliophile), "Lettre au voyageur Taylor sur la danse macabre," *L'Artiste* 3 (1832): 98.

15. See Maurice Levy, "English Gothic and the French Imagination: A Calendar of Translations 1767–1828," in G. R. Thompson, ed., *The Gothic Imagination: Essays in Dark Romanticism* (Seattle: Washington State UP, 1974), 150–76; Alice Killen, *Le Roman terrifiant ou roman noir de Walpole à Anne Radcliffe et son influence sur la littérature française jusqu'en 1840* (Paris: Crès, 1915).

16. Cited in Marc Angenot, *Le Roman populaire. Recherches en paralittérature* (Montréal: Presses de l'Université de Quebec, 1975), 18.

17. On Gothic novel illustrations, see M. Lévy, *Images du roman noir* (Paris: E. Losfeld, 1973); Robert J. Bezucha, "The Renaissance of Book Illustration," in *The Art of the July Monarchy. France 1830 to 1848*, exhib. cat. (Columbia and London: University of Missouri Press, 1990), 192–213.

18. Anicet Bourgeois and J. Mallian, *La Nonne sanglante* [drame en cinq actes et six tableaux, musique par A. Piccini . . . représenté pour la première fois sur le théâtre de la Porte-Saint-Martin, 17 février 1835] (Paris: Marchant, 1835).

19. Cited in Angenot, *Roman populaire*, 18. The article "De l'horrible dans la littérature moderne" in *Le Protestant* 33 (20 June 1832) condemned "cette littérature pêtrie de boue et de sang. . . . A chaque nouveauté, il semble que la limite extrême soit atteinte, qu'on ne puisse aller plus loin, que la mine des abominations, des impuretés, des infamies est épuisée, que la satiété de l'affreux va ramener le goût de l'aimable, et que les émotions de place de Grève, de taverne, de bagne, de maisons de jeux et lieux attenants vont céder à des pensées . . . qui ne feront plus rougir, que le bon goût et les bonnes moeurs avoueront de concert. Mais non!"

20. "Ballade treizième. La legende de la nonne," in "Odes et ballades," *Victor Hugo. Poésie* (Paris: Le Seuil, 1972), 192 ff.

21. See Reginald Hartland, *Walter Scott et le "roman frénétique." Contribution à l'étude de leur fortune en France* [1928] (Geneva: Slatkine Reprints, 1975); Eric Partridge, *The French Romantics' Knowledge of English Literature (1820–1848)* [1924] (New York: B. Franklin, 1968).

22. Although not all Gothic novels contained a radical message, the majority did, especially English novels that indicted Roman Catholicism. The collaboration between the genre's formal and ideological radicalism was noted as early as the 1790s by the marquis de Sade – a social rebel and an expert in illicit horror himself – who linked the iconoclastic nature of the Gothic genre to its violent sociopolitical context, the revolutionary 1790s. The marquis de Sade, "Idées sur les romans," preface to "Des crimes d'amour," in *Oeuvres complètes* (Paris: Pauvert, 1988), 10:73. For modern views on the Gothic novel's aesthetic and ideological radicalism, Killen, *Roman terrifiant*, 80 ff.; Lucian Minor, *The Militant Hackwriter. French Popular Literature 1800–1848. Its Influence, Artistic and Political* (Bowling Green, OH: University Popu-

lar Press, 1975); and Lévy, "English Gothic and the French Imagination," in Thompson, ed., *The Gothic Imagination*, 150–76.

23. On the anticlerical content of Gothic novels and plays, see Sister Mary Muriel Tarr, *Catholicism in Gothic Fiction* (New York and London: Garland, 1979), chap. 3 "Monastic Gloom"; Irene Bostrom, "The Novel and Catholic Emancipation," *Studies in Romanticism* 2, no. 3 (Spring 1963): 155–76; Henri Welschinger, *Le Théâtre de la Révolution 1789–1799 avec documents inédits* (Paris: Charavay frères, 1880), 3 and passim.

24. Boutet de Monvel, *Les Victimes cloîtrées* [drame joué pour la première fois en 1791] (Lyon: Chambert fils, 1830).

25. Olympe de Gouges, *Le Couvent ou Les Voeux forcés* [Drame en trois actes . . . , Théâtre Français 1790] (Paris: Veuve Duchesne, 1792).

26. Fiévée, *Les Rigueurs du cloître* [comédie en deux actes en prose, mélée d'ariettes, . . . le 23 août 1790] (Paris: Lepetit, n.d.), 9.

27. 4 April 1824. Joubin, *Journal*, 1:68.

28. 6 March 1824. Joubin, *Journal*, 1:67.

29. On 7 April 1824, three days after he first mentioned *Melmoth*, Delacroix expressed his wish to make lithographic caricatures "in Goya's manner." Joubin, *Journal*, 1:69. For the anticlerical underpinnings of Delacroix drawings from Goya, see my *Delacroix. Prints, Politics and Satire*, chap. 2.

30. In their accounts of the riots (15–17 February 1831), *Le Constitutionnel* described the episcopal residence as being "d'un luxe asiatique."

31. *Journal des débats* (20 October 1830), 4.

32. It premiered in 19 August 1830. *Bibliographie de la France*, no. 4847 (1830), 594. A new edition circulated in 1833. *Bibliographie de la France*, no. 6266 (1833), 733.

33. *Le Constitutionnel* (14 March 1831), 3.

34. L. M. Fontan, *Le Moine* [drame fantastique en cinq actes . . . représenté pour la première fois sur le théâtre royal de l'Odéon, le samedi 28 mai 1831, repris à la Porte-Saint-Martin, le vendredi 13 juillet 1832] (Paris: Marchant, 1835).

35. "Spectacles. Ambigu Comique. *Le Dominicain*, mélodrame en trois actes," *Le Constitutionnel* (19 March 1832).

36. *L'Avenir* (10 November 1830); for the improvisation, *L'Artiste* 3 (1832): 208.

37. Edouard Cassagnaux, *Le Penitent*, 2 vols. (Amiens: J. Boudon-Caron, 1833); Charles-Henri d'Ambel (H. Flour de Saint-Genies), *Le Trappiste d'Aiguebelle* (Paris: H. Souverain, 1832).

38. Auguste Jal contrasted Couder's mock altarpiece with Victor Orsel's insipid neo-Nazarene moral allegory, *Le Bien et le Mal* (1832) at the same Salon, and mocked religious conservatives for their resistance to Hugo's anticlerical novel. *Salon de 1833. Les Causeries du Louvre* (Paris, 1833), 153–5. At the Salon of 1833, Boulanger exhibited *L'Amende honorable*, also from *Notre-Dame de Paris*, representing Esmeralda doing penance in the presence of the bishop. This scene's similarity to Delacroix's *Interior of a Dominican Convent* may explain why the title *L' Amende honorable* has at times, erroneously, been applied to Delacroix's work. Delacroix refuted that title in a letter to Gautier, 11 May 1860. Stewart, ed., *Delacroix. Selected Letters*, 361.

39. Martine Kahane, *Robert le Diable*, exhib. cat., Théâtre national de l'Opéra de Paris, Paris, 1985. Delacroix's comments after attending a performance of *Robert le Diable* in 1853 suggest that he had seen earlier stagings: "J'y ai trouvé encore des mérites nouveaux. Les costumes, renouvelés naturellement après tant de représentations, m'ont beaucoup intéressé." He made some costume sketches from the performance, 20 December 1853. Joubin, *Journal*, 3:134. By that time, Delacroix knew Meyerbeer personally.

40. *La Caricature*, no. 56 (24 November 1831), 449–50.

41. *Courrier des théâtres* (27 October 1831).

42. A. Sérullaz, *Delacroix et la Normandie*, reproduces several of these drawings. For a systematic listing, Maurice Sérullaz, *Dessins de Eugène Delacroix*, vol. 2 (Paris: Réunion des Musées Nationaux, 1984).

43. Album RF 9148, folio 31 verso (Paris, Musée du Louvre, Cabinet des dessins). M. Sérullaz, *Dessins de Eugène Delacroix*, 2:358 ff.

44. Dale Kramer, *Charles Robert Maturin* (New York: Twayne, 1973); Willem Scholten, *Charles Robert Maturin. The Terror Novelist* (Amsterdam, 1933); Edith Birkhead, *The Tale of Terror. A Study of the Gothic Romance* [1921] (New York: E. P. Dutton, 1963), 86 ff; Claude Fiérobe, *Charles-Robert Maturin 1780–1824: l'homme et l'oeuvre* (Lille: Université de Lille III, 1974).

45. Although the monks are Jesuits in the novel, in Delacroix's painting they wear the white and black habit of the Dominicans, an order associated with the Inquisition.

46. On the melodrama's manichean structure, see Brooks, *Melodramatic Imagination*, 29 ff.

47. Salon of 1834, no. 495: "Intérieur d'un couvent de Dominicains à Madrid. – Un jeune homme d'une grande famille, forcé de faire des voeux, est conduit devant l'évêque, qui visite le couvent, et accablé de mauvais traitement en sa présence. (Sujet tiré de *Melmoth*, roman anglais)." Lee Johnson, *The Paintings of Eugène Delacroix. A Critical Catalogue*, 6 vols. (Oxford: Clarendon Press, 1981–9), J. 148, 1:157 ff.

48. Hilaire-Léon Sazerac, *Lettres sur le Salon de 1834* (Paris: Delaunay, 1834), 140–1. The 1834 Salon featured an abundance of monastic subjects, including *Jugement d'Urbain Grandier* by Brocas (no. 226); *Tentation de Saint Antoine* by Brune (no. 232); *Sujet tiré du Moine de Lewis* by Diaz (no. 546); *Réfectoire des pères Chartreux* by Perlet (no. 1494); and *Lélia, Sténio et Magnus* by J. Laure (no. 1140), from George Sand's Gothic-like novel *Lélia*. Critics underscored the topical religious commentary embedded in such works. For J. Etex's *Les deux moines* (no. 677), Laviron noted the opposition of "un moine croyant . . . absorbé dans la méditation religieuse" and "un moine voltairien qui rit et qui persifle." He also thought that the vicious expressions on the faces of the monks in Robert Fleury's *Procession de la Ligue* (no. 724) reflected their religious fanaticism: "Chez les uns le dévouement et le fanatisme; chez d'autres l'égoisme et l'ambition . . ." Gabriel Laviron, *Le Salon de 1834* (Paris: L. Janet, 1834), 121 and 123.

49. Salon of 1834, no. 498. Johnson, *Paintings of Delacroix*, J. 221, 3:39–41.

50. On the Romantics' adoption of Rabelais as symbol of canonical inversion, especially of the classical aesthetic, see Mikhail Bakhtin, *Rabelais and His World* (Bloomington: Indiana UP, 1984). Balzac's *Contes drolatiques* (1832), tales of cavorting nuns and monks written in a medievalizing argotlike language, was reminiscent of the Rabelaisian vernacular. *L'Artiste* championed Rabelais throughout the 1830s and 1840s. See P. L. Jacob, Bibliophile [Paul Lacroix], "Facéties de Rabelais à Rome," *L'Artiste* 4 (1832): 260–5. Also, Elizabeth Childs, "Big Trouble. Daumier, Gargantua and the Censorship of Political Caricature," *Art Journal* 51, no. 1 (Spring 1992): 26 ff.

51. Lee Johnson, ed., *Eugène Delacroix. Further Correspondence 1817–1863* (Oxford: Clarendon Press, 1991), 90.

52. "[C]ar enfin des mains, fussent-elles celles de Rabelais ou du diable doivent être des mains, et non pas des griffes tordues et rabougries, comme celles du portrait de M. Delacroix." Laviron, *Salon de 1834*, 227 ff.

53. Thomas Roscoe, "Poètes et romanciers de la Grande-Bretagne. II. Maturin," *Revue des deux-mondes* 1 (1833): 35–49, 41; Allan Cunningham, "Histoire biographique et critique de la littérature anglaise depuis cinquante ans. 3e partie. Les romanciers et les conteurs," *Revue des deux-mondes* 4 (1833): 481–505. The critic Gustave Planche, a defender of Romanticism, declared that Maturin's works "will engrave the name of Maturin in the history of English poetry." Gustave Planche, "Poètes et romanciers

anglais: Maturin," *Revue des deux-mondes* 1 (1833): 35–49, reprinted in *Portraits littéraires* (Paris: Charpentier, 1853), vol. 1, chap. 2. *Melmoth* was much admired by Victor Hugo, Baudelaire, and Balzac who wrote a sequel to it, *Melmoth réconcilié* (1835); see Rosemary Lloyd, "Melmoth the Wanderer: The Code of Romanticism," in M. Bowie, A. Fairlie, and A. Finch, *Baudelaire, Mallarmé, Valéry. New Essays in Honour of Lloyd Austin* (Cambridge: Cambridge University Press, 1982), 80–94; and G. T. Clapton, "Balzac, Baudelaire et Maturin," *The French Quarterly* 12 (1930): 66–84.

54. Cunningham, "Histoire biographique," 504 and 504 n. 2.

55. Roscoe, "Poètes et romanciers," 48. See also George Haggerty, *Gothic Fiction/Gothic Form* (University Park: Pennsylvania State UP, 1989), 15 ff.

56. "Maturin est proposé au pinceau des peintres comme le type de la frénésie; il faut le représenter l'écume à la bouche." Cited in Roscoe, "Poètes et romanciers," 42 and 48. Also, Amédée Pichot, *Voyage historique et littéraire en Angleterre et en Ecosse*, 3 vols. (Paris: Gosselin, 1825), 2:25.

57. Cunningham, "Histoire biographique," 503–4.

58. G. Planche, "Histoire et philosophie de l'art. IV. De l'école française au Salon de 1834," *Revue des deux-mondes* 2 (1 April 1834): 47–84, 57. Some critics attributed these defects to the artist's "extrême négligeance née probablement d'un excès de facilité." W., "Beaux-Arts. Salon de 1834. 6e article," *Le Constitutionnel* (11 April 1834).

59. Ibid.

60. "Beaux-Arts. Salon de 1834. 8e article," *Le Temps* (11 April 1834).

61. Anonymous, "Beaux-Arts. Salon de 1834," *L'Artiste* 7 (1834): 86.

62. "Beaux Arts. Salon de 1834," *L'Artiste* 7 (1834): 101.

63. "Beaux-Arts. Salon de 1834. 8e article," *Le Temps* (11 April 1834).

64. With obvious irony, Hugo wrote, "Enfin! . . . Vous voilà pris sur le fait! Donc vous faites du laid un type d'imitation, du grotesque un élément de l'art! Mais les grâces . . . mais le bon goût . . . Les Anciens ont-ils jamais mis en oeuvre le laid et le grotesque?" Victor Hugo, *Cromwell*, preface (Paris: Garnier, 1968), 63, cited in Elisheva Rosen, *Sur le grotesque. L'ancien et le nouveau dans la réflexion esthétique* (Saint Denis: Presses Universitaires de Vincennes, 1991), 55.

65. Théophile Gautier, *Mademoiselle de Maupin*, preface (Paris: Gallimard, 1973). Gautier, like Hugo, defended the horrific as an aesthetic category: "La préface de *Cromwell* rayonnait à nos yeux comme les Tables de la Loi sur le Sinaï." Gautier, *Histoire du romantisme* in *Oeuvres complètes* 11 (Geneva: Slatkine Reprints, 1978), 5. Gautier's *Les Grotesques* (1844) paid homage to Hugo.

66. V. Hugo, "Ballade quatorzième. Ronde du sabbat," in "Odes et ballades," *Poésies* (Paris: Le Seuil, 1972), 194 ff. The ballad was dedicated to Charles Nodier, a Petit Cénacle member. Monique Geiger, "Victor Hugo et Louis Boulanger," M. Blondel and P. Georgel eds. *Colloque de Dijon. Victor Hugo et les Images* (Dijon: Aux amateurs de livres, 1989), 29–41. Critics described Boulanger as the apostle of the "ugly." Regarding Boulanger's scenes from Hugo's *Notre-Dame de Paris* at the Salon of 1833, Ch. L. wrote, "M. Boulanger sacrifie encore à l'abominable religion du laid." Ch. L, "Salon de 1833 – Troisième article," *Le Temps* (16 March 1833).

67. T. Gautier, "Salon de 1834," *La France industrielle*, no. 1 (April 1834): 17–22, 19.

68. "Eugène Delacroix," in *Théophile Gautier, critique d'art. Extraits des Salons* (Paris, 1994), 163. On the affinities between Delacroix and Gautier, see Robert Snell, *Théophile Gautier. A Romantic Critic of the Visual Arts* (Oxford: Clarendon Press, 1982), 70 ff.

69. Delacroix's presence among the Petit Cénacle's habitués is mentioned by Albert Cassagne, *La Théorie de l'art pour l'art en France chez les derniers romantiques et les premiers réalistes* [1905] (Seyssel: Champvallon, 1997), 352, and Aristide Marie, *Pétrus Borel. Le Lycanthrope* [1907] (Geneva: Slatkine Reprints, 1967), 76.

70. See the announcement of *Champavert* in *L'Artiste* 5 (1833): 56. Baudelaire's comment is cited in Lloyd, "Melmoth the Wanderer," 81.

71. A vignette designed by Joseph Bouchardy, painter and fellow member of the Petit Cénacle, showed Borel in this guise. Paul Bénichou described Borel as a "Diogène à poignard et à bonnet phrygien" in *Le Sacre de l'écrivain 1750–1830. Essai sur l'avène-ment d'un pouvoir spirituel laïque dans la France moderne* (Paris: J. Corti, 1985), 437.

72. Borel wrote: "On ne sera pas fâché d'apprendre où l'on a déposé *La liberté* de M. Delacroix. Vous pourriez peut-être croire à ce sujet que le soleil est trop chaud dans les musées, et qu'il y avait là une émeute sur une toile, une révolution en peinture, une anarchie couronnée d'un beau cadre d'or comme une éblouissante auréole . . . nos grands génies de l'Institut n'ont pas trop peur de la liberté, mais le talent qui illumine les jeunes figures assombrit les vieilles faces." Didron (Pétrus Borel), Prospectus, *La Liberté. Revue des arts* (1832), 12.

73. Eugène Delacroix, "Pensée des journaux. Sur la remise de l'exposition," *La Liberté. Revue des arts*, no. 14 (December 1832): 126–7; and Eugène Delacroix, "Exposition. Ceux qui en veulent et ceux qui n'en veulent pas," *La Liberté. Revue des arts*, no. 15 (January 1833): 129–31. Both are signed by the artist. The essays are not included in Delacroix's collected literary and critical articles edited by Elie Faure, *Eugène Delacroix. Oeuvres littéraires*, 2 vols. (Paris: Crès, 1923). Neither the *Journal*, retroac-tively, nor the *Correspondance* make any reference to them or to Borel and his news-paper. On Delacroix's "Influence du commerce et du gouvernement dans les arts," *La Liberté. Journal des arts*, no. 16 (December 1832): 65–8, see Marie-Claude Chaudonneret, *L'État & les Artistes. De la Restauration à la monarchie de Juillet (1815–1833)* (Paris: Flammarion, 1999), 119, 150–1.

74. "[I]ntrigans, faiseurs royaux, artistes officiels, ayant brevet pour exploiter et monopo-liser les arts, le tout à leur profit et à la plus grande gloire de la monarchie française." Delacroix, "Exposition. Ceux qui en veulent et ceux qui n'en veulent pas," 131. In his first essay Delacroix wrote, "Les hommes du dehors s'étonnent quand ils remarquent qu'il y a des privilégiés et des aristocrates dans les arts aussi bien qu'ailleurs, et par ce qu'on dit dans le monde de la république des arts, ils se sont figuré que la liberté et l'égalité leur étaient acquises. Aussi s'indignent-ils bien fort quand ils s' aperçoivent que le plus capricieux arbitraire, la plus dégoûtante partialité ont pris leur place. De là cette grande colère de tous les journaux de l'opposition." Delacroix, "Pensée des journaux. Sur la remise de l'exposition," 127. See Appendix.

75. Despite its radicalism in content and style, Hugo's novel became one of the nine-teenth-century's greatest publishing successes. From the 1830s to the 1850s, it went through thirteen editions. P. Devars, E. Petitier, G. Rosa, A. Vaillant, "Si Victor Hugo était compté. Essai de bibliométrie hugolienne comparée," in *La Gloire de Victor Hugo*, exhib. cat. (Paris: Réunion des Musées Nationaux, 1985), 328–91. On illustrated editions of Hugo's novels including *Notre-Dame de Paris*, see Ségolène Le Men, "Les frontispices des éditions illustrées," in M. Blondel and P. Georgel eds., *Colloque de Dijon. Hugo et les images*, 232–47. On Hugo's publishing success in the 1830s, Allen, *Popular French Romanticism*, 97. But Allen notes repeatedly the dire poverty of the Petit Cénacle poets.

76. In the 1850s, at the peak of his reputation in both official and private spheres, Delacroix bragged about his success with private patrons and the lucrative benefits he hoped to derive from his "petite vogue auprès des amateurs; ils vont m'enrichir après m'avoir méprisé." *Journal* (4 April 1853), cited in V. Pomarède, "Eugène Delacroix, l'état, les collectionneurs et les marchands," *Delacroix. Les dernières années*, exhib. cat. (Paris: Réunion des Musées Nationaux, 1998), 46–59, 50. Based on the recently discovered archives of Achille Piron, Pomarède concluded that from the 1850s onward Delacroix relied almost exclusively on private collectors and deal-ers. See also Elisabeth Fraser, "Uncivil Alliances: Delacroix, the Private Collector, and the Public," *Oxford Art Journal* 21, no. 1 (1998): 87–103; and her *Interpreting Delacroix in the 1820s: Readings in the Art Criticism and Politics of Restoration France*, Ph.D. diss., Yale University, 1993. On the commercial nature of Delacroix's

small paintings inspired by Scott, B. S. Wright and P. Joannides, "Les romans his-
toriques de Sir Walter Scott et la peinture française, 1822–1863," *Bulletin de la
Société de l'histoire de l'art français* 1ère partie, 1982 [1984]: 119–32; and 2ème partie,
1983 [1985]: 95–115.

77. For the literary sources, ownership, and sales information of these paintings, see the
relevant entries in Johnson, *Paintings of Delacroix*.

78. Eugène Briffault, *Le Duc d'Orléans. Prince royal. Le duc d'Orléans seconde partie:
Les funerailles* (Paris: Rousset, 1842), 50. Cited in Hervé Robert, "Le destin d'une
grande collection princière au XIXᵉ siècle: L'exemple de la galerie des tableaux du
duc d'Orléans, prince royal," *Gazette des Beaux-Arts* 118 (juillet-août 1991): 37–60.
Other paintings in the "Gothic" taste in the duc d'Orléans's collection included Ary
Scheffer's *Le Giaour,* Granet's *Intérieur d'un couvent. Abelard recevant une lettre
d'Héloise,* and Delacroix's *Le Prisonnier de Chillon* (1834) [Johnson, *Paintings of
Delacroix,* J. 254, 3:68–9] and *Hamlet et Horatio au cimetière* (1839) [J. 267, 3:87–8].

79. Lee Johnson, *Eugène Delacroix,* exhib. cat., Toronto-Ottawa (London: Weidenfeld
and Nicolson, 1963), 18 ff. In his catalogue raisonné (J. 148), however, Johnson sug-
gests the Krannert's work might be a copy, possibly by Pierre Andrieu.

80. 11 May 1860. Stewart ed., *Delacroix. Selected Letters,* 361.

CHAPTER 5. DARCY GRIMALDO GRIGSBY. ORIENTS AND COLONIES: DELACROIX'S ALGERIAN HAREM

This essay is indebted to UC Berkeley graduate research assistants Linda Kim, John
Tain, Marnin Young, and John Zarobell, who conducted research at various stages in
its development. Unless otherwise noted, translations from the French are my own.

1. 20 April 1824, *Eugène Delacroix. Journal 1822–1863,* eds. André Joubin, Hubert
Damisch, and Régis Labourdette (Paris: Plon, 1996), 68–9.

2. See Thomas Crow, *Emulation. Making Artists for Revolutionary France* (New Haven:
Yale UP, 1995), and Abigail Solomon-Godeau, *Male Trouble. A Crisis in Representa-
tion* (London: Thames and Hudson, 1997), as well as my "Rumor, Contagion and
Colonization in Gros's *Plague-Stricken of Jaffa* (1804)," *Representations* 51 (Summer
1995): 1–61; and forthcoming book *Extremities in Paint. Embodying Empire in Post-
Revolutionary France.*

3. Delacroix to Félix Guillemardet, 1 December 1823, *Eugène Delacroix. Lettres intimes,*
ed. Alfred Dupont (Paris: Gallimard, 1954), 148. See for example, *Journal* (24 January
1824), 47.

4. See my "*Whose colour was not black nor white nor grey,/ But an extraneous mixture,
which no pen/ Can trace, although perhaps the pencil may*': Aspasie and Delacroix's
Massacres of Chios," *Art History* 22, no. 5 (December 1999): 676–704, and *Extremities
in Paint*; Francis Haskell, "Chios, the Massacres and Delacroix," in *Chios: A Confer-
ence at the Homereion in Chios,* 1984, eds. John Boardman and C. E. Vaphopoulou-
Richardson (Oxford: Clarendon, 1986), 335–58; Nina Athanassoglou-Kallmyer,
French Images from the Greek War of Independence, 1821–1830 (New Haven: Yale
UP, 1989); Elisabeth Fraser, "Uncivil Alliances: Delacroix, the Private Collector and
the Public," *Oxford Art Journal* 21, no. 1 (1998): 87–103; and her *Interpreting
Delacroix in the 1820s: Readings in the Art Criticism and Politics of Restoration
France* (Ph.D. diss., Yale University, 1993), 65–89.

5. Fraser, "Interpreting Delacroix," 65–89.

6. For a comparison of Delacroix's *Chios* and Scheffer's painting, see Beth S. Wright,
Painting and History during the French Restoration. Abandoned by the Past (Cam-
bridge: Cambridge UP, 1997), 149–54.

7. Jack Spector, *Delacroix: The Death of Sardanapalus* (New York: Viking, 1974); John-
son, *Paintings* J 125, I (1986): 114–21; Fraser, "Interpreting Delacroix," 90–128.

8. Although Delacroix's *Sardanapalus* does not match the complexity of Byron's 1821 play on which it is loosely based, it is notable that his painted despot, despite what I would take to be Delacroix's intentions, shares the gender ambiguity of Byron's "effeminate" voluptuary. See Susan J. Wolfson, "'A Problem Few Dare to Imitate': Sardanapalus and the 'Effeminate Character,'" *ELH* 58, no. 4 (Winter 1991): 867–902. See also Balzac's wonderful 1835 story, *The Girl with the Golden Eyes*, inspired by Delacroix's *Sardanapalus*.

9. 25 January 1832 to Jean-Baptiste Pierret, *Correspondance générale de Eugène Delacroix*, ed. André Joubin, 5 vols. (Paris: Plon, 1935–8), 1:307.

10. Louvre Album RF 1712 bis, 23 verso and 24 recto. For facsimiles of the four extant notebooks, see Maurice Arama, *Le Voyage au Maroc*, 6 vols. (Paris: Editions du Sagitaire, 1992). See also Paris, Institut du Monde Arabe. *Delacroix in Morocco*, exhib. cat. (Paris: Flammarion, 1994); Barthélémy Jobert, *Delacroix* (Princeton: Princeton UP, 1998), 140–75.

11. Louvre Album RF 39050, 24 verso.

12. Ibid., 20 recto.

13. 8 February 1832 to Pierret, *Correspondance*, 1:310–11.

14. 16 March 1832 to Pierret, ibid., 1:320–2.

15. Louvre Album RF 1712 bis, 9 verso; 2 April 1832, to Pierret, *Correspondance*, 1:325–6.

16. Alternately Delacroix represented Moroccan men whose horses engage in combat so the riders appear to fight one another; see Lee Johnson, "Delacroix's 'Rencontre de Cavaliers Maures,'" *Burlington Magazine* 103 (October 1961): 417–23.

17. 2 April 1832 to Armand Bertin, *Correspondance*, 1:327–8.

18. Louvre Album RF 1712 bis, 33 recto.

19. See, for example, Cissy Grossman, "The Real Meaning of Eugène Delacroix's *Noce Juive au Maroc*," *Jewish Art* 14 (1988): 64–73.

20. Louvre Album RF 39050, 17 verso, 18 verso, and 14 recto.

21. Charles Lenormant, *Le Temps*, 3 March 1834, 2.

22. See Elie Lambert, *Delacroix et "Les Femmes d'Alger"* (Paris: Librairie Renouard, 1937); Todd Porterfield, *The Allure of Empire. Art in the Service of French Imperialism 1798–1836* (Princeton: Princeton UP, 1998), 117–41; and his "Western Views of Oriental Women in Modern Painting and Photography," in *Forces of Change: Artists of the Arab World*, ed. Salwa Mikdadi Nashashibi, exhib. cat., The National Museum of Women in the Arts, Washington D.C., 1994, 58–71; Mary J. Harper, "The Poetics and the Politics of Delacroix's Representation of the Harem in *Women of Algiers in Their Apartment*," in *Picturing the Middle East. A Hundred Years of European Orientalism. A Symposium* (New York: Dahesh Museum, 1996), 52–65; Johnson, *Paintings* J 356, 1 (1986): 165–70.

23. See prints at Bibliothèque Nationale, Cabinet des Estampes, Qb1 1830. Significantly, twentieth-century black radical Frantz Fanon would champion Algerian women's use of the veil as a form of opposition to French colonialism; see Edy Souffrant, "To Conquer the Veil: Woman as Critique of Liberalism," in *Fanon: A Critical Reader*, ed. Lewis Gordon (Oxford: Blackwell, 1996), 170–8.

24. *The Allure of Empire*, 138–40.

25. Our questionable evidence concerning Delacroix's visit to an Algerian harem is Philippe Burty's compilation of retrospective accounts, "Eugène Delacroix à Alger," *L'Art* 32, no. 1 (1883): 94–8.

26. Images also mocked the naive French soldier pretending to be a sultan. The joke lay in the sheer impossibility of a Frenchman, at least an ordinary soldier, assuming the Oriental despot's phallic authority.

27. Only one print I have seen thus far attempts to imagine an indigenous Arab rather than a black or white woman.

28. I thank anthropologist Mia Fuller for interpreting the Arabic.

29. Louvre Album RF 39050, 15 recto.

30. Louvre Album RF 1712 bis, 33 recto.

31. For example, 4 June 1832 to Auguste Jal, *Correspondance*, 1:329–30.

32. Anonymous, *Journal des jeunes dessinateurs*, no. 5, 17.

33. Gustave Planche, *Etudes sur l'Ecole française (1831–1852)* (Paris: Michel Lévy, 1855), 1:248; and Alexandre Decamps, *Le Musée. Revue du Salon de 1834* (Paris, n.d.), 58.

34. Etienne-Jean Delécluze, *Journal des Débats*, 8 March 1834.

35. *L'Artiste*, 1834, vol. 7 no. 8, 86.

36. *Orientalism* (New York: Vintage, 1979).

37. Thereby qualifying recent arguments that European colonizers insist on the representation of the Orient as unchanging and untouched by Western presence; see ibid. and Linda Nochlin, "The Imaginary Orient," *Art in America* (May 1983): 119–31, 187–91.

38. *L'Impartial*, 29 April 1834, 2.

39. W., *Le Constitutionnel*, 11 April 1834, 1; Général D'Almivar, *Salon de 1834. Analyse de ses productions les plus remarquables* (Paris, 1834), 21.

40. Cited in *La Guerre d'Algérie*, eds. Henri Alleg et al. (Paris: Temps Actuels, 1981), 1:63–4. The French word *Barbare* can signify both the inhabitants of the Barbary regencies and "barbarians."

41. Concerning the French controversial conduct including the massacre of 12,000 persons of Al' Ouffia; see ibid., 64, and Charles-André Julien, *Histoire de l'Algérie Contemporaine* (Paris: Presses Universitaires de France, 1964), 64–105.

42. To have traversed Algeria rather than Morocco may, we can hope, have deprived Delacroix of the capacity imaginatively to excise his and France's bodily presence. Not that French atrocities stopped artists like Horace Vernet, who visited Algeria in 1833, opportunistically joined other speculators seizing property, and painted Algerian subjects.

43. Cited in Jobert, *Delacroix*, 172.

44. Michèle Hannoosh, lecture, "Memories of Morocco. A New Text by Delacroix," Delacroix Symposium, Philadelphia Museum of Art, 10 October 1998.

CHAPTER 6. PETRA TEN-DOESSCHATE CHU. "A SCIENCE AND AN ART AT ONCE": DELACROIX'S PICTORIAL THEORY AND PRACTICE

I thank Beth Wright for her efforts to put this volume together. Thanks go out as well to Hsiao-Yun Chu, who has edited my text and given me many valuable suggestions. In this chapter, all citations from French sources, except for Baudelaire's poems, are given in English. Where English translations were not available, I have furnished my own.

1. Delacroix himself was often bemused about the way his name was invariably linked to color. As early as 1847, he wrote in his diary, "Yesterday Clésinger spoke to me about a statue of his which, he had no doubt, I should greatly like, on account of the *color*. Color, as it appears, being my only domain, I've got to find it in sculpture before I can be pleased with the work or before I can even understand the work!" *Journal* (13 March 1847); Eugène Delacroix, *The Journal of Eugène Delacroix*, trans. Walter Pach (New York: Viking Press, 1972), 158 (hereafter Delacroix 1972).

2. Vincent van Gogh, *The Complete Letters of Vincent van Gogh*, ed. and trans. J. van Gogh Bonger and C. de Dood, 3 vols. (Boston/Toronto/London: Little, Brown, 1958), 2:424 (hereafter van Gogh 1958). He ranked Delacroix as a colorist among Hals, Veronese, Rubens, and Velazquez.

3. Ibid., 3:164.

4. Ibid., 2:6.

5. Paul Signac, *D'Eugène Delacroix au néo-impressionisme* [1899], intr. and ann. Françoise Cachin (Paris: Hermann, 1964), 35 ff.

6. Cf. n. 10.

7. Signac 1964, 38.
8. Most importantly, the large Salon paintings that had been bought by the state and had been sent to public museums, including *The Barque of Dante*, *The Massacre at Chios*, *Liberty Guiding the People*, and *Women of Algiers in Their Apartment* in the Louvre and *The Battle of Taillebourg* and *The Capture of Constantinople by the Crusaders* in the Historical Museum in Versailles. Some works could be seen in private collections accessible to the public. Van Gogh, during his Arles period, saw several paintings in the collection of Alfred Bruyas.
9. "One must note, however, that the paintings by Delacroix, despite his efforts and his science, are less luminous and less colored than the pictures of the painters who have followed in his footsteps. The *Entry of the Crusaders* would seem dark if placed between the *Boating Party* by Renoir and the *Circus* by Seurat." Signac 1964, 75.
10. Baudelaire, "L'oeuvre et la vie de Delacroix," first published in *L'Opinion nationale* in 1863; reprinted, with other critical articles about the artist, in *L'Art romantique* in 1869. An English translation is found in Charles Baudelaire, *A Mirror of Art*, ed. Jonathan Mayne (New York: Doubleday, 1956); Charles Blanc, "Eugène Delacroix," first published in *Gazette des Beaux-Arts* in 1864; reprinted in *Les Artistes de mon temps* (Paris: Firmin Didot, 1876); Silvestre's essay was part of his *Histoire des artistes vivants: Etudes d'après nature* (1855).
11. Neither van Gogh nor Seurat ever read Delacroix's diaries, having died before they were published by Paul Flat and René Piot (Paris: Plon, 1893–5).
12. Charles Blanc was working on his *Grammaire des arts du dessin* when he wrote the article on Delacroix in the *Gazette des Beaux-Arts*. In a footnote to the article, Blanc explicitly stated, "The digressions that we have allowed ourselves in what we are going to say about color are perhaps not quite à propos here. The reader of the *Gazette* will find them later in the *Grammaire des arts du dessin*." Charles Blanc, "Eugène Delacroix," *Gazette des Beaux-Arts* 16 (1864): 5–27 and 97–129; 108. Blanc had read Bourgeois's *Mémoire sur les couleurs de l'iris produites par la réflexion de la lumière . . . et examen des bases des doctrines de M. Henri Brougham, de Newton, de Gauthier et de M. Marat sur la lumière et les couleurs par Ch. Bourgeois, Peintre* (Paris: Testu, 1813) and Chevreul's *De la loi du contraste simultanée des couleurs et de l'assortiment des objets colorés* (Paris, 1839).
13. "Those principles [of color theory], developed by modern scholars like Charles Bourgeois and M. Chevreul, have led to . . . a luminous theory of colors, a theory that Eugène Delacroix knew scientifically and thoroughly, after having known it by instinct." Blanc 1864, 108.
14. On the importance of Blanc's article on Delacroix for Seurat, see William Innes Homer, *Seurat and the Science of Painting* (Cambridge: MIT Press, 1964), 34–5; for van Gogh, see van Gogh 1958, 2:364–6.
15. *Journal* (1 March 1859); Delacroix 1972, 638. In the *Larousse du XIXe siècle*, the word *art* is defined as "pratique spontanée," as opposed to "science théorique" (s.v. "art").
16. Ibid.
17. Baudelaire 1956, 311.
18. Delacroix put down his ideas about art in 1857 in the format of a dictionary, as he felt more inclined to write a series of detached articles than a coherent thesis. See Delacroix 1996, xv–xix. His dictionary never went beyond a draft, the pieces of which are scattered in the artist's diary. Recently, an attempt was made to reconstruct the dictionary by publishing the entries together in alphabetical order.
19. Delacroix's artistic ideas were fertilized by a broad range of art theoretical and philosophical writings by such authors as Denis Diderot, Johann Wolfgang von Goethe, Immanuel Kant, Roger de Piles, Sir Joshua Reynolds, Jean-Jacques Rousseau, Germaine de Staël, and Stendhal. See George P. Mras, *Eugène Delacroix's Theory of Art* (Princeton: Princeton UP, 1966). On Delacroix and music, see René Jullian,

"Delacroix et la musique du tableau, " *Gazette des Beaux-Arts* 87 (March 1976): 81–8; n. 1 lists bibliography.

20. *Journal* (23 February 1852); Delacroix 1972, 263.

21. *Journal* (15 July 1849); Delacroix 1972, 199. Peisse had reviewed Delacroix's paintings at the Salon that year.

22. As n. 20.

23. *Journal* (11 January 1857); Delacroix 1972, 531.

24. The debate between line and color dated from antiquity. Comparing rhetoric and painting, Aristotle had associated the plot of a story with a black and white drawing and the sketching of the characters with dabs of color. See Michèle Hannoosh, *Painting and the* Journal *of Eugène Delacroix* (Princeton: Princeton UP, 1995), 14. In the Renaissance, the debate was between the linear style of Florentine painting and the coloristic style of the Venetians. See Rudolf Arnheim, "Osservazioni sul colore in Delacroix," *Eidos* (December 1988): 36–9. On the seventeenth-century debate in France between *Rubénistes* and *Poussinistes,* see André Fontaine, *Les Doctrines d'art en France* (Paris: Renouard/Laurens, 1909).

25. Immanuel Kant stated that *"delineation* is the essential thing; [. . .] The colors which light up the sketch belong to the charm [. . . .] but they cannot make it [. . .] beautiful." Quoted in Albert Hofstadter and Richard Kuhns, eds., *Philosophies of Art and Beauty from Plato to Heidegger* (New York: Random House: The Modern Library, 1964), 297. See also *Journal* (15 July 1849); Delacroix 1972, 199 (letter to Peisse): "The famous element, the beautiful, which some see in the serpentine line, others see in the straight line, but they are all resolved that it is to be seen only in line."

26. On Delacroix's rejection of absolute beauty, see *Journal* (9 February 1847); Delacroix 1972, 144; also *Journal* (1 August 1860); Delacroix 1972, 686.

27. Johann Wolfgang von Goethe, *Goethe's Color Theory,* ed. Rupprecht Matthaei, trans. Herb Aach (New York: Van Nostrand Reinhold, 1971), 168.

28. See Neil McWilliam, *Dreams of Happiness: Social Art and the French Left, 1830–1850* (Princeton: Princeton UP, 1993), 222–31.

29. Ibid., 224.

30. Ibid.

31. Ibid., 223.

32. For Ingres, color was subservient to line: "Color adds ornament to painting; but it is never more than its dressing lady, because it does nothing more than render the true perfections of art [i.e., line and form] more lovely." Jean-Dominique Ingres, *Ecrits sur l'art,* intr. R. Cogniat (Paris: La Jeune Parque, 1947), 8.

33. Adolphe Thiers (1797–1877) was a conservative politician who played an important role in July Monarchy politics. Pierre-Joseph Proudhon (1809–1865) was a journalist and economic theorist who shocked France in 1840 with his book, *Qu'est-ce que la propriété?* The politicization of their artistic conflict is further emphasized by an inscription on the skirt of Ingres's horse, which reads, "Rubens [commonly seen as Delacroix's artistic forebear] is a red."

34. Delacroix studied with the Neoclassical painter Pierre-Narcisse Guérin, who must have emphasized the study of these masters.

35. For Delacroix's opinion of Poussin, especially his essay in the *Moniteur universel* between 26 and 30 June 1853 (reprinted in Delacroix 1923), see the essay by Michèle Hannoosh in this volume.

36. *Journal* (6 June 1851); Delacroix 1972, 252.

37. In his treatise on painting of 1829, Paillot de Montabert wrote, "It is chiefly to combinations of light and dark that the effect owes its energy, sweetness and charm. . . . Color of course produces an effect of its own, but it is optically subordinate to that obtained by masses of light and dark half-lights and half-darks." Quoted in Albert

Boime, *The Academy and French Painting in the Nineteenth Century* (New York: Phaidon, 1971), 29 (hereafter Boime 1971). See also Joyce Bernstein Howell, "Eugène Delacroix and Color: Practice, Theory, and Legend," *Athanor* II (1982): 37–43, 38 (hereafter Howell 1982).

38. *Journal* (29 September 1850); Delacroix 1972, 248.

39. *Journal* (5 May 1852); Delacroix 1972, 268.

40. *Journal* (11 January 1857); Delacroix 1972, 532. The word *ombre*, which can mean both shading and shadow, is generally translated as "shadow" by Delacroix.

41. *Journal* (13 January 1857); Delacroix 1972, 535.

42. A primary color complements the secondary color resulting from a mixture of the other two primaries; thus red is the complement to green (mixture of yellow and blue). "Of the three primary colors one can form the three secondaries. If to the binary tone you add the opposite primary, you annihilate it, that is to say, you create the necessary half-tone . . . therefore, adding black is not adding a half-tone, it is to dirty the tone, the true half-tone of which can be found in the opposite tone. Hence the green shading in the red. The head of the two little chicks. The one who was yellow had violet shading. The one who was more sanguine and more red, green shading." Delacroix, *Album de voyage de 1834.*

43. Baudelaire 1956, 5.

44. *Journal* (11 October 1852); Delacroix 1972, 278.

45. Howell 1982, 37–8.

46. On Chevreul's two main principles of color harmony (harmony of analogous colors and harmony of contrasting colors), see Homer 1964, 20–4.

47. Homer 1964, 28.

48. Fifty-three pages of notes and diagrams, apparently taken from Chevreul's work, may be found in a notebook in the Cabinet des dessins of the Louvre. Six of the pages are dated 1848, which is an indication that Delacroix may have become acquainted with Chevreul's ideas through his lectures. See Homer 1964, 272, n. 59.

49. Blanc 1864, 110–11.

50. Delacroix 1923, 1:63–4.

51. Charles Baudelaire, *Oeuvres complètes,* ed. Y.-G. Le Dantec and Claude Pichois (Paris: Gallimard, 1961), 1. Note, in particular, the line: "Les parfums, les couleurs et les sons se répondent."

52. Beside Delacroix, they include Rubens, Leonardo da Vinci, Rembrandt, Michelangelo, Puget, Watteau, and Goya.

53. "Delacroix, lac de sang hanté des mauvais anges,/Ombragé par un bois de sapins toujours vert,/Où, sous un ciel chagrin, des fanfares étranges/Passent, comme un soupir étouffé de Weber." Baudelaire 1961, 13. For a complete English translation, see the essay by David Scott in this volume. The German Romantic composer Carl Maria von Weber (1786–1826) was much admired in nineteenth-century France.

54. Baudelaire 1956, 216–17.

55. For Romantic views on the relative values of the arts, see Hugh Honour, *Romanticism* (New York: Harper & Row Icon Editions, 1979), 119 ff.

56. *Journal* (6 June 1851); Delacroix 1972, 251.

57. Baudelaire 1956, 319.

58. *Journal* (25 January 1857); Delacroix 1972, 568.

59. *Journal* (25 January 1857); Delacroix 1972, 562–3.

60. *Journal* undated (c. 1840); Delacroix 1972, 711.

61. On this subject, see especially Mras 1966, passim.

62. *Journal* (5 October 1847); Delacroix 1972, 175; and *Journal* (1 June 1849); Delacroix 1972, 199.

63. "I have recaptured my youth . . . it's Rubens who has worked this miracle." See Lee Johnson, *Eugène Delacroix: Further Correspondence, 1817–1863* (Oxford: Clarendon Press, 1991), 114.

64. *Journal* 1847 (loose note); Delacroix 1972, 179.

65. *Journal* (9 October 1862); Delacroix 1972, 696. On Delacroix's contempt for Rococo painting (what he called the "Van Loo school"), see also *Journal* (13 September 1857); Delacroix 1972, 600: "Everything that followed Lebrun, and especially the whole eighteenth century, is mere banality and professional skill."

66. *Journal* (22 November 1853); Delacroix 1972, 348. Delacroix speaks here primarily about drawing, but it is clear that his opinion can be extended to painting as well.

67. *Journal* (9 October 1862); Delacroix 1972, 696.

68. *Journal* (10 October 1853); Delacroix 1972, 329.

69. See, for example, *Journal* (1 July 1847); Delacroix 1972, 170–1. Delacroix assiduously studied Veronese's most important paintings in the Louvre, *The Marriage at Cana, Susannah and the Elders,* and *The Supper at Emmaus.* In his youth he made three copies after details of Veronese's *Marriage of Cana,* no simple matter as it required that he rent a scaffolding in order to be able to see the painting close up. See Lee Johnson, *The Paintings of Eugène Delacroix: A Critical Catalogue* (Oxford: Clarendon Press, 1981–9), 1:13.

70. *Journal* (10 July 1847); Delacroix 1972, 171. Delacroix attributed these qualities of Veronese's art to his generally working on mural-size, "decorative" paintings and in the medium of tempera. Ibid.

71. *Journal* (22 March 1854); Delacroix 1972, 366–7.

72. *Journal* (12 October 1853); Delacroix 1972, 328–9.

73. *Journal* (28 April 1853); Delacroix 1972, 299.

74. *Journal* (28 April 1853); Delacroix 1972, 300.

75. On Delacroix's attempts to study paintings close up, see *Journal* (30 March 1824); Delacroix 1972, 68: ". . . admired . . . Paolo Veronese, standing on a stool."

76. *Journal* (18 March 1853); Delacroix 1972, 287.

77. *Journal* (3 November 1850); Delacroix 1972, 249.

78. Ibid.

79. *Journal* (5 October 1847); Delacroix 1972, 175. On Rubens's white grounds, see also *Journal* n.d. 1852; Delacroix 1972, 284.

80. See *Journal* (5 October 1847); Delacroix 1972, 175: "What give so much finesse and brilliance to painting on white paper is doubtless that transparence which is a matter of the essentially white nature of the paper. The brilliance of pictures by Van Eyck and those by Rubens later on doubtless comes from the white of their panels."

81. Delacroix subsequently received a number of other decorative commissions, but none were as extensive as the ones in the Palais Bourbon and the Luxembourg Palace. Later commissions included the Apollo Gallery in the Louvre (1850–1), the Salon de la Paix in the Hôtel de Ville (1852–4), and the Chapelle des Saints-Anges in Saint-Sulpice. The latter project, not completed until 1861, was more closely linked to Delacroix's late easel paintings than to the decorative projects of the 1830s and 1840s. Cf. *Delacroix: The Late Work,* exhib. cat. Paris, Galeries Nationales du Grand Palais, and Philadelphia Museum of Art, 1998–9; Philadelphia Museum of Art (1998–9), 13.

82. Delacroix's admiration for simplicity of effect explains his respect for stage sets as well as Veronese's large decorative paintings. See *Journal* (3 March 1847 and 1 July 1847); Delacroix 1972, 154 and 170.

83. Cf. Delacroix's remark in his diary 30 November 1853: "I am in that phase of my life when . . . I go to my work as others hasten to their mistress, and when I leave it, I carry away into my solitude, or amidst the distraction which I go to seek, a charming memory . . ." Delacroix 1972, 353.

84. In his dictionary notes on "touch" (Delacroix 1972, 537), written as late as 13 January 1857, Delacroix still found it necessary to defend a paint surface that shows the "work" of the brush, against those who prefer smooth paint surfaces and "invisible" brush strokes: "Many masters have taken care not to permit the spectator to feel it

[the touch], doubtless thinking that they thereby became closer to nature which, to be sure, does not show it. Touch is one of the many means which contribute the thought in painting. A painting can doubtless be very fine without showing the touch, but to think that one gets close to the effect of nature by such avoidance is puerile: one might just as well put real colored reliefs onto one's picture, on the theory that bodies have projection! In all the arts there are means of execution which are accepted and agreed upon, and one is but an imperfect connoisseur if one cannot read the language that expresses these indications of the thought; the proof is that the vulgar prefer to all other pictures those which are smoothest and show the touch to the smallest extent, and that such people prefer them for that very reason."

85. On the critical reception of the *Barque of Dante,* see Johnson 100, 1 (1981): 72–8, 75. According to the *Larousse du XIX^e siècle,* a *"tartouillade"* was a "tableau confusément et lâchement dessiné, où l'on a tout sacrifié à l'éclat."

86. The painter Jean-Antoine Gros is said to have called the painting a "chastened Rubens" (*du Rubens châtié*); Thiers, in contrast, wrote that Delacroix put down his figures with Rubens's "fecundity." Johnson 1:75.

87. Baudelaire informs us, in his review of the International Exhibition of 1855, that one of the nudes (the upturned body) was for years falsely attributed to Géricault. Baudelaire 1956, 212.

88. "The study of the gradations of the rainbow, that palette of creation, caused him to find the lively effect of those water drops." See Alfred Bruyas et al., *Musée de Montpellier. La Galerie Bruyas* (Paris: Quantin, 1876), 361–2.

89. *Journal* (10 April 1824); Delacroix 1972, 73.

90. The genesis of the *Massacre of Chios* is extensively documented in Delacroix's diary, in the entries between 12 January and 19 July 1824, which also list his numerous visits to the Louvre and the Musée du Luxembourg. The works of Veronese, Velazquez, Murillo, Gros, and Géricault have all been mentioned as models for the execution of individual figures or passages of the painting.

91. The sight of these works, which included the famous *Haywain,* did him "much good." *Journal* (19 June 1824); Delacroix 1972, 97. John Arrowsmith was a British art dealer who had opened a shop in Paris.

92. Paul-Henri Michel, *The Massacre of Chios* (Paris: Vendôme, 1947), n.p.

93. This entire paragraph is much indebted to Howell 1982, 39.

94. This process turned out to be unstable; already during Delacroix's lifetime the painting needed major restoration. See Johnson 1981–9, 1:121.

95. According to Pierre Andrieu (Bruyas 1876, 366), Delacroix expressed the desire to achieve, in *Sardanapalus,* the "blondeur et fraîcheur" of pastel and distemper.

96. The studies are now in the Louvre. For some excellent color reproductions, see Jean Clay, *Romanticism* (Paris: Hachette-*Vendôme,* 1981), 158–60.

97. Hatching (*hachures*): closely placed, parallel lines used in areas of shading. Sometimes two sets of parallels lines are used at an angle to each other ("cross-hatching").

98. Louis de Planet, *Souvenirs de travaux de peinture avec M. Eugène Delacroix* (Paris: Armand Colin, 1929), 23–7 (hereafter Planet 1929). The *grisaille* lay-in (*ébauche*) marks the composition's contours and its lit and shaded areas. Delacroix himself frequently discussed the *grisaille* as a stage in the process of his own paintings, and his student Piot referred to the practice of preparing *grisailles* for Delacroix's decorative paintings. See René Piot, *Les Palettes de Delacroix* (Paris: Librarie de France, 1931), 86–7.

99. For a detailed description of the *ébauche* in academic painting, see Boime 1971, 36–41.

100. Boime (1971, 38) has shown that students in the Academy were taught to use at least six middle tones to link the lights and the darks.

101. Cf. Howell 1982, 38. The academic palette for a *grisaille ébauche* was silver white,

Naples yellow, yellow ochre, *ochre de ru,* red ochre, cinnabar, ivory or color black, and Prussian blue. Planet's palette for the *grisaille ébauche* of the copy of the *Jewish Wedding* was lead white for the highlights, a mixture of lead white and *noir de pêche* for the demi-teintes, *noir de pêche* and *terre d'ombre* for the cast shadows, and *terre d'ombre* and white for the reflections. See Boime 1971, 37, and Planet 1929, 25.

102. See Boime 1971, 37.

103. Delacroix claimed that the term *lit de la couleur,* which he liked to use, originated with Titian. See Piot 1931, 88.

104. On the importance of relief, both real and illusionary, for Delacroix, see David Liot, "The Technique of Eugène Delacroix: A Historical Approach," in *Delacroix. The Late Work* (as in n. 81), 384–94, 385–6.

105. Planet 1929, 25.

106. On the importance of the palette's preparation in the generative process of Delacroix's paintings, see especially Piot, 1931. In the forthcoming new edition of Delacroix's *Journal,* edited by Michèle Hannoosh, readers will be able to see the interminable color notations the artist made in anticipation of preparing his palettes. Most of these were left out in previous editions. To Delacroix, the palette was both a major determining factor in the outcome of a painting and a source of inspiration. He wrote in his diary, "My palette, newly set and brilliant with the contrast of colors, suffices to inflame my enthusiasm." See *Journal* (21 July 1850); Delacroix 1972, 235.

107. Planet 1929, 26.

108. Seeing a painting by Rubens after the removal of its varnish coating, he wrote to Constant Dutilleux on 8 August 1858: "It would be desirable never to use varnish." *Correspondance générale de Eugène Delacroix,* ed. André Joubin, 5 vols. (Paris: Plon, 1935–8), 4:42–3.

109. On 7 February 1849, for example, he wrote in his notebook, "Looking at the picture of the *Women of Algiers,* I feel how agreeable and even how necessary it is to paint on the varnish." Delacroix 1972, 183.

110. In 1844 he moved to a new studio on the rue Notre-Dame-de Lorette, where he remained until December 1857. On 2 January 1846, he buried the last of his siblings, his brother Charles-Henry. By December 1846 he had completed the decorative paintings for the Luxembourg Palace, and by December 1847, those in the Palais Bourbon.

111. *Journal* (19 January 1847); Delacroix 1972, 130.

112. It is interesting that he embarked on it in midcareer, because for many nineteenth-century artists still life was a genre that they practiced in their youth, for the purpose of experimenting with form and color. This subject is discussed by Laura Coyle in her doctoral dissertation, currently in progress (Princeton University).

113. See *Delacroix. The Late Work,* 298–303.

114. On the genesis of the painting, see *Journal* (3, 6, 15 February and 1, 2, 3 March 1847); Delacroix 1972, 141, 143, 145–6, 151, 152, 153.

115. *Journal* (1 March 1847); Delacroix 1972, 151.

116. On this tension, see especially Boime 1971, passim.

117. *Journal* (3 March 1847); Delacroix 1972, 153.

118. The main charm of the sketch, according to Delacroix, was that it allowed viewers to finish it to their liking. *Journal* (20 April 1853); Delacroix 1972, 295.

119. Ibid.

120. The work was to be included in Delacroix's retrospective exhibition at the 1855 International Exposition.

121. Contemporary critics compared Delacroix's *The Lion Hunt* to Rubens's large hunting scenes. Théophile Gautier felt that Delacroix had painted a "chaos of claws, teeth, cutlasses, lances, torsos, croups, the way Rubens liked them." Quoted in *Delacroix. The Late Work,* 101.

122. Albert Boime, *Thomas Couture and the Eclectic Vision* (New Haven and London: Yale UP, 1980), 29–30.
123. Boime, *Couture*, 11.
124. *Journal* (22 June 1863); Delacroix 1972, 700.

CHAPTER 7. DOROTHY JOHNSON. DELACROIX'S DIALOGUE WITH THE FRENCH CLASSICAL TRADITION

1. Eugène Delacroix, *Journal, 1822–1863*, ed. André Joubin (Paris: Plon, 1996), 13 January 1857, 615. The translations are the author's unless otherwise noted.
2. Jon L. Whitely discusses the evolution of the word *classique* in eighteenth and early nineteenth-century France in his seminal article, "The Origin and Concept of 'Classique' in French Art Criticism," *Journal of the Warburg and Courtauld Institutes*, 39 (1976): 268–75.
3. Eugène Delacroix, *Ecrits sur l'art*, ed. D.-M. Deyrolle and C. Denissel (Paris: Librairie Séguier, 1988), 19–50.
4. Charles Baudelaire, "Salon de 1846," *Oeuvres complètes*, ed. C. Pichois (Paris: Gallimard, 1976), 2:441.
5. Albert Boime, *The Academy and French Painting in the Nineteenth Century* (New Haven and London: Yale UP, 1971); Nikolaus Pevsner, *Academies of Art, Past and Present* (London: Cambridge UP, 1940); L. Vitet, *L'Académie Royale de peinture et de sculpture. Etude historique* (Paris: Calmann Lévy, 1861); André Fontaine, *Les Doctrines d'art en France* (Paris: Laurens, 1909); J. Locquin, *La peinture d'histoire en France de 1747 à 1785* (Paris: Laurens, 1912, reprinted Paris: Arthena, 1978).
6. M. Bonnaire, *Procès-verbaux de l'Académie des Beaux-arts* (Paris: 1940), I–III. See, most recently, A. Mérot's introduction to *Les Conférences de l'Académie Royale de peinture et de sculpture au XVIIᵉ siècle*, ed. A. Mérot (Paris: Ecole nationale supérieure des beaux-arts, 1996), 11–31.
7. Lee Johnson, *The Paintings of Eugène Delacroix*, 6 vols. (Oxford: Clarendon Press, 1981–9), 1: xv–xvii. See also Nina Athanassoglou-Kallmyer, *Eugène Delacroix. Prints, Politics and Satire 1814–1822* (New Haven and London: Yale UP, 1991).
8. See R. Schneider, *Quatremère de Quincy et son intervention dans les arts* (Paris: Hachette, 1910), and Johnson, *Paintings*, "Delacroix's Reading List c. 1816–21," xvii.
9. Delacroix, "Le Poussin," *Ecrits sur l'art*, 209–55. See Michèle Hannoosh's essay in this volume.
10. Delacroix, "Raphaël," *Ecrits sur l'art*, 79–88.
11. *Les Conférences de l'Académie Royale*, ed. A. Mérot.
12. Johnson, *Paintings*, 1: xv–xvii.
13. Ibid., J. 100, 1:72–8. See also Frank Anderson Trapp, *The Attainment of Delacroix* (Baltimore: Johns Hopkins Press, 1971), 18–28, and Barthélémy Jobert, *Delacroix* (Princeton: Princeton UP, 1998), 66–70.
14. Fontaine, *Les doctrines d'art en France*, and Locquin, *La Peinture d'histoire en France*. See also *Conférences*, ed. Mérot, 50–1.
15. Ibid., 51.
16. On the Salon criticism, see Johnson, *Paintings*, J. 100, 1:75–6, and Jobert, *Delacroix*, 69.
17. For a study of the French representations of the Greek War of Independence, see Nina Athanassouglou-Kallmyer, *French Images from the Greek War of Independence 1821–1830: Art and Politics under the Restoration* (New Haven and London: Yale UP, 1989).
18. Johnson discusses the negative criticism; see *Paintings*, J. 105, 1:87–8. See also Trapp, *Attainment of Delacroix*, 40–2.
19. A. Thiers, *Le Globe*, 28 September 1824 and Johnson, ibid., 1:88–9.
20. Johnson, ibid., 1:86–7.

21. Delacroix, *Journal*, 372.
22. Johnson, *Paintings*, J. 105, 1:86–8 and Jobert, *Delacroix*, 78.
23. L. Vitet in *Le Globe*, 8 March 1828, cited in Johnson, ibid., 1:120.
24. See Johnson, ibid., 1:114–21, Trapp, *Attainment*, 92; and Jack Spector, *Delacroix. The Death of Sardanapalus* (London: Viking Press, 1974), chap. 5.
25. Beatrice Farwell, "Sources for Delacroix's *Death of Sardanapalus*," *Art Bulletin*, 40 (March 1958): 66–71, and Spector, ibid.
26. Robert Rosenblum, *Transformations in Late Eighteenth Century Art* (Princeton: Princeton UP, 1967), 50–106.
27. See Johnson, *Paintings*, J. 281, 3:106–8. In his catalogue description for the Salon, Delacroix made explicit the meaning of the painting (reproduced in full in Johnson, 3:106). Baudelaire, "Salon de 1845" in *Oeuvres complètes*, 2:354–6.
28. Erwin Panofsky, *Perspective as Symbolic Form*, trans. C. Wood (New York: Zone Books, 1991), and Hubert Damisch, *The Origin of Perspective* (Cambridge, MA: MIT Press, 1994).
29. Johnson, *Paintings*, J. 125, 1:120; Spector, *Death of Sardanapalus*, chap. 5.
30. Johnson, ibid., J. 112, 1:98–102.
31. Ibid., 1:100–1. For pictorial precedents for the *Death of Sardanapalus*, see ibid., 119. For Delacroix's use of the void in the *Execution of Marino Faliero*, see most recently Beth S. Wright, *Painting and History During the French Restoration. Abandoned by the Past* (New York and Cambridge, UK: Cambridge UP, 1997), 154–60.
32. See Johnson, ibid., J. 144, 1:144–51; Trapp, *Attainment*, 93–104, and Jobert, *Delacroix*, 128–33.
33. Théophile Thoré in *Le Siècle*, 25 February 1837, cited in Johnson, ibid., 1:149.
34. See Wright's seminal study, *Painting and History*.
35. Johnson, *Paintings*, vols. 5 and 6; Trapp, *Attainment*, 245–88; Jobert, *Delacroix*, 177–234; Michèle Hannoosh, *Painting and the 'Journal' of Eugène Delacroix* (Princeton: Princeton UP, 1995), 128–98; *Eugène Delacroix à l'Assemblée nationale*, exhib. cat., A. Sérullaz and N. Moulonguet (Paris: Assemblée Nationale, 1995).
36. Baudelaire, *Oeuvres complètes*, 2:773. Delacroix, *Journal*, 20 October 1853, 371.
37. For an analysis of the primary sources, see most recently, Jacqueline Lichtenstein, *The Eloquence of Color. Rhetoric and Painting in the French Classical Age* (Berkeley, Los Angeles, Oxford: University of California Press, 1993).
38. See most recently *Conférences*, ed. A. Mérot and J. Lichtenstein, ibid., "The Clash Between Color and Drawing," 138–68.
39. E. Delécluze, *Le Journal des Débats*, 5 October 1824, cited in Johnson, *Paintings*, 1:88.
40. See especially Baudelaire, "Salon de 1845," in *Oeuvres complètes*, 2:355–6, and "Exposition Universelle (1855)," *Oeuvres complètes*, 2:595–6.
41. Delacroix, *Journal*, 6 June 1851, 279–80, and "Questions sur le beau" in *Ecrits sur l'art*, 25–6. See also G. Mras, *Eugène Delacroix's Theory of Art* (Princeton: Princeton UP, 1966).
42. *Conférences*, ed. Mérot, 98–144.
43. Delacroix, *Journal* (1 June 1857), 602–3.
44. Joyce Bernstein Howell, "Delacroix's Lithographs of Antique Coins," *Gazette des Beaux-Arts* 124 (July/August 1994): 15–24, and D. Gerin, "Les sources des lithographies de 'médailles' d'Eugène Delacroix," *Nouvelles de l'Estampe*, no. 157 (March 1998): 12–21.
45. Johnson, *Paintings*, J. 152, 1:161–2, and Delacroix, "Raphaël," *Ecrits sur l'art*, 79–88.
46. *Conférences*, ed. Mérot, 60–7. Martin Rosenberg, *Raphael and France: The Artist as Paradigm and Symbol* (University Park: Pennsylvania State UP, 1995).
47. Johnson, *Paintings*, 5:159–92.
48. Baudelaire, "Salon de 1846," *Oeuvres complètes*, 2:435–6, and Jack Spector's "The Commission: A Skeptic Paints a Religious Mural," in *The Murals of Eugène Delacroix*

at Saint-Sulpice (New York, 1967), 13–22. See also Vincent Pomarède, "Religious Aspiration," in *Delacroix. The Late Work,* exhib. cat. Paris, Galeries Nationales du Grand Palais, and Philadelphia Museum of Art, 1998–9, 265–9 and catalogue entries by Pomarède and Arlette Sérullaz, 266–311. For Delacroix's thoughts on the loss of "types sacrées" see "Sur le 'Jugement dernier,'" in *Ecrits sur l'art,* 279, and the *Journal* (2 November 1854), 491; (29 August 1857), 676; (12 October 1862), 804–5.

49. Johnson, *Paintings,* J. 421, 3:212–13.

50. Ibid., 3:214, 216, 219–21, 238, 240, 241–2 and *Delacroix. Late Work,* 288–96.

51. T. Thoré, "Salon de 1847," *Le Constitutionnel,* 17 March, 14 April 1847, cited in Johnson, *Paintings,* 3:220–1.

52. Cited in Trapp, *Attainment,* 26.

53. See Delacroix, "Questions sur le beau," *Ecrits sur l'art,* 20–1.

54. Hannoosh, in her excellent book *Painting and the 'Journal,'* looks at this theme from a variety of perspectives.

55. Ibid., 14–16.

56. Ibid. See, in particular, her chapter "On the Boundaries of the Arts and the True Power of Painting," 23–54.

57. Discussed cogently by Lichtenstein, *Eloquence of Color,* 142 ff.

58. See Rensselaer W. Lee, *'Ut Pictura Poesis': The Humanistic Theory of Painting* (New York: W.W. Norton, 1967).

59. *Conférences,* ed. Mérot, 20, and Hannoosh, *Painting and the 'Journal,'* 14–16.

60. "Des variations du beau," *Ecrits sur l'art,* 47.

61. See, especially, Hannoosh, *Painting and the 'Journal,'* 23, 39.

62. Delacroix, *Journal,* 372–3.

63. Johnson, *Paintings,* J. 271, 3:90–95.

64. Johnson discusses several critical responses, both positive and negative, ibid., 3:92–3. See A. Tardieu, "Salon de 1840," *Le Courrier français,* 10 March 1840; T. Gautier, "Salon de 1840," *La Presse,* 13 March 1840; E. Delécluze, "Salon de 1840," *Journal des Débats,* 7 March 1840; Baudelaire, "Exposition Universelle (1855), in *Oeuvres complètes,* 2:592. G. Planche, "Salon de 1840," *Revue des Deux Mondes,* 4th ser. 22, 1 April 1840.

65. See L. Johnson, *Paintings,* J. 271, 3:92–3.

66. Antoni Deschamps, *La Divine Comédie de Dante Alighieri* (Paris, 1829).

67. Dante, *Purgatorio,* Canto X, trans. Charles S. Singleton (Princeton: Princeton UP, 1973), 102–5.

CHAPTER 8. PAUL JOANNIDES. DELACROIX AND MODERN LITERATURE

1. My Ph.D. thesis, *English Literary Subjects in French Painting, 1800–1863* (University of Cambridge, 1974), was supervised by the dedicatee, who also kindly read the present piece and corrected a number of errors and omissions. On Delacroix and literature, see the Selected Bibliography and Suggestions for Further Reading, and these significant recent contributions: Barthélémy Jobert, "Delacroix et la littérature: une nouvelle dimension du romantisme," in *Delacroix, La naissance d'un nouveau romantisme,* exhib. cat. (Rouen, 1998), 39–60; and Arlette Sérullaz and Vincent Pomarède, "Literary Inspiration," in *Delacroix, the Late Work,* exhib. cat. (Paris and Philadelphia, 1998–9), 197–244. Attention should be drawn to the pioneering work of the late Maurice Sérullaz, especially in the *Mémorial de l'Exposition Delacroix* (Paris, 1963), and to numerous studies by Lee Johnson, summarized and developed in *The Paintings of Delacroix: A Critical Catalogue,* 6 vols. (Oxford, 1981–9) (hereafter abbreviated as J.), the *oeuvre de base* for any study of Delacroix's paintings and much else besides.

2. J. 64 (1:40–2), Paris, Musée du Louvre.

3. Loys Delteil [1908], trans. and rev. by Susan Stauber, *Eugène Delacroix. The Graphic Work* (San Francisco 1997) (hereafter D.), D. 83.

4. Suggested by George Heard Hamilton, "Hamlet or Childe Harold?" *Gazette des Beaux-Arts*, n.s., 26 (1944): 365–86.

5. Louvre RF 9998; Maurice Sérullaz et al., *Dessins d'Eugène Delacroix*, 2 vols. (Paris, 1984), no. 533, 1:255 (hereafter *Dessins*).

6. As David Price-Hughes reminds me, he had earlier adopted a more light-hearted persona, that of Sterne's Yorick, in a letter to Pierret of December 1817 (André Joubin, ed., *Eugène Delacroix. Correspondance Générale*, 5 vols. [Paris, 1936–8], 1:13–15) written in mimicry of the English writer's style.

7. Toronto, Art Gallery of Ontario.

8. For Eckermann's report of Goethe's comments, see John Gage, *Goethe on Art* (London, 1980), 239.

9. *The Journal of Eugène Delacroix*, trans. Lucy Norton (London, 1951), 394.

10. From Ariosto: J. 303 (3:124–5), *Marfisa and Pinabello's Lady*, sd. 1852, Baltimore, Walters Art Gallery; J. 324 (3:142–3), *Ruggiero Rescues Angelica*, c. 1856, Grenoble, Musée des Beaux-Arts; J. 338 (3:154–5), *Angelico and the Wounded Medoro* (unfinished), c. 1860, Sydney, Art Gallery of New South Wales; J. 339 (3:155), *Ruggiero Rescues Angelica*, c. 1860, Paris, Musée du Louvre; J. 340 (3:155–6), *Ruggiero Flies Away with Angelica*, c. 1860, private collection. From Tasso: J. 321 (3:141), *Clorinda Rescues Olindo and Sofronia*, c. 1853–6, Munich, Neue Pinakothek (a sketch for this is J. 320); J. 331 (3:147–8), *Erminia and the Shepherds*, sd. 1859, Stockholm, Nationalmuseum.

11. J. 106 (1:91–2), private collection; J. 268 (3:88–9), sd. 1839, Winterthur, Oskar Reinhardt Collection; Johnson discounts Byron's influence on these paintings.

12. J. 308 (3:129–30), sd. 1852, Paris, Musée du Louvre.

13. J. 279 (3:105–6), c. 1844, private collection.

14. J. 289 (3:115), 1847, private collection; J. 310 (3:130–1), c. 1852, location unknown.

15. J. 101 (1:78–80), 1823–35, New York, Metropolitan Museum of Art.

16. J. 285 (3:112–13), sd. 1846, location unknown; J. 335 (3:152), 1850s?, Basel, Kunstmuseum.

17. J. 116a. (3:314–15), c. 1826, Munich, Neue Pinakothek; J. 288 (3:114–15), sd. 1847, Bremen, Kunsthalle.

18. J. 295 (3:119–20), *Goetz of Berlichingen Writes His Memoirs*, 1849, private collection; J. 315 (3:134–5), *Weislingen Captured by Goetz's Men*, sd. 1853, St. Louis, City Art Museum; L156 (3:280), *The Wounded Goetz Taken in by the Gipsies* (unfinished) 1863, location unknown.

19. J. 103 (1:81), 1824, private collection; D. 76.

20. See n. 90.

21. J. 109 (1:94–5), c. 1825, Nottingham, Castle Museum; J. 139 (1:136–7), c. 1829, private collection; J. 296a (6:204), 1849, Basel, Kunstmuseum.

22. J. 128 (1:123–6), 1827–8, Zurich, Kunsthaus.

23. J. 135 (1:131–4), 1829, Paris, Musée du Louvre; J. 133 (1:129–30), 1827, Lyon, Musée des Beaux-Arts; J. 134 (1:130–1), 1827–9, Paris, Musée du Louvre; J. 136 (1:134), c. 1827–c. 1844, location unknown.

24. J. 137 (1:135), c. 1828–9, Paris, Musée du Louvre, on deposit at Caen, Musée des Beaux-Arts.

25. J. L94 (supplement 1, 3:316), private collection; J. 329 (3:146–7), 1858?, private collection.

26. J. 284 (3:111–12), sd. 1846, New York, Metropolitan Museum of Art; J. 326 (3:144–5), sd. 1858, Paris, Musée du Louvre.

27. J. L141 (3:274–5), location unknown. Francis Haskell commented on the similarity to Ostade.

28. J. L.100 (1:206), location unknown; a drawing perhaps connected is reproduced by

Véronique Moreau, "Delacroix lecteur de Walter Scott," 145–84 in *Delacroix en Touraine*, exhib. cat., Musée de Tours, 1998, 161.

29. See ns. 50 and 69.

30. J. 256 (3:69–70), *The Giaour's Confession*, 1834–35?, Melbourne, National Gallery of Victoria.

31. J. 297 (3:121–2), c. 1849, Cambridge, King's College; J. 300 (3:123), 1849–51?, Lyon, Musée des Beaux-Arts; J. 311 (3:131–2), 1852–3, Paris, Musée du Louvre; J. 325 (3:143–4), sd. 1857, Fort Worth, the Kimbell Art Museum.

32. J. 290 (3:115–16), sd. 1857 (?1847), private collection; J. 328 (3:145–6), 1858, Zurich, Bührle Foundation.

33. J. 275 (see n. 45); J. 276 (3:101–3), sd. 1840, Paris, Musée du Louvre; J. 277 (3:103–4), 1840–47?, Moscow, Pushkin Museum; J. L157 (3:280–1) records a further sketch in oil on paper. Delacroix did not identify the source of J. 276 when he exhibited it at the Salon of 1841 nor that of J. 277 when he showed that at the Salon of 1847.

34. 24.2 × 19.2 cm., Los Angeles, J. Paul Getty Museum, 97.GC.30.

35. J. 112 (1:98–102), 1826, London, the Wallace Collection.

36. J. 317 (3:136–8), sd. 1855, Chantilly, Musée Condé.

37. J. 254 (3:68–9), sd. 1834, Paris, Musée du Louvre.

38. Arlette Sérullaz and Yves Bonnefoy, *Delacroix et Hamlet*, exhib. cat., Paris, 1993.

39. J. 258 (3:71–3), sd. 1835, private collection; J. 267 (3:87–8), sd. 1839, Paris, Musée du Louvre; J. L148 (3:277), 1844, private collection; for J. 332, see n. 51; D. 75, 116.

40. J. L98 (1:204), *Desdemona and Emilia*, c. 1824, location unknown; J. 304 (3:126), *Desdemona and Emilia*, 1849–53, location unknown; J. 327 (3:145), *The Death of Desdemona*, 1858 (unfinished), private collection. See also ns. 63, 64.

41. For these, see n. 52; for J. 299, see n. 62.

42. J. 117 (1:107–8), *The Capulet Ball*, c. 1826–8, private collection; J. 283, see n. 48; J. L150 (3:277–8), *Romeo Lifts Juliet from the Tomb*, 1851–5, location unknown.

43. See n. 61.

44. See Moreau, op. cit., in n. 28.

45. J. 275 (3:100–1), London, Victoria and Albert Museum; for the drawings see Sérullaz et al., *Dessins*, nos. 338–9, 1:176–7. I suggested an early date for both drawings and oil sketch in my thesis, and in 1986 Johnson was also inclined to place J. 275 in the 1820s; subsequently (Johnson, Lee, *Delacroix Pastels*, London, 1995, no. 43, 150–1) he reverted to the traditional date of the later 1830s, with a ?.

46. 17.9 × 25.7 cm., Los Angeles, J. Paul Getty Museum, 94.GC.51; L. Delteil, *Le Peintre-Graveur Illustré, XVII, Théodore Géricault*, Paris, 1924, no. 97. On their treatments of Byron, see Lee Johnson, "Delacroix et Géricault: liens et divergences" in exhib. cat. Rouen, 1998, op. cit., 18–37.

47. Cogniet's painting is in the Wallace Collection. The watercolor, Louvre RF 10573, was rejected in Sérullaz et al., *Dessins* 2:403. Arlette Sérullaz kindly informs me that she would not now exclude the possibility of Delacroix's authorship, c. 1822–3.

48. J. 283 (3:109–10), *Romeo Bids Juliet Farewell*, 1845, private collection; the drawing is RF 23357, fol. 5 recto; Sérullaz et al., *Dessins* no. 1744, 2:288.

49. D. 55 and Delteil, *Géricault*, 95.

50. J. 114 (1:103–5), *The Combat of the Giaour and Hassan*, 1826, Chicago, Art Institute; J. 257 (3:70–1), *The Combat of the Giaour and Hassan*, 1835, Paris, Musée du Petit Palais; J. 296 (3:120–1), *The Giaour Pursuing the Ravishers of his Mistress*, sd. 1849, Algiers, Musée Nationale des Beaux-Arts, which is closely allied to the *Combat*; for J. 323, see n. 71. For the drawings see Sérullaz et al., *Dessins* nos. 229–31, 1:138–9.

51. J. 332 (3:149), sd. 1859, Paris, Musée du Louvre; the lithograph is D. 75.

52. J. 107 (1:93–4), *Macbeth and the Witches*, c. 1825, private collection; J. 108 (1:94), *Macbeth and the Witches*, c. 1825, private collection.

53. J. L99 (1:204–5), sd. 1825, Cracow, Jagiellonian University; for J. 264, see n. 66.

54. D. 84, 85, 86, 88.

55. Ink wash on paper, 27 × 21 cm., Stockholm, Nationalmuseum Inv.60/1920; Maurice Sérullaz,"Unpublished Drawings by Eugène Delacroix at the Nationalmuseum, Stockholm," *Master Drawings,* 5, no. 4 (1967): 404–6. For the Scott suite, see Beth S. Wright, "Henri Gaugain et le Musée Colbert: l'entreprise d'un directeur de galerie et d'un éditeur d'art à l'époque romantique," *Nouvelles de l'Estampe* 114 (December 1990): 24–30.

56. D. 99.

57. J. 141 (1:138–9), sd. 1830, Paris, Musée du Louvre; J. 143 (1:140–4), sd. 1831, Nancy, Musée des Beaux-Arts; J. 260 (3:73–8), sd. 1837, Versailles, Musée national.

58. D. 58–74.

59. D. 103–18.

60. D. 119–25.

61. J. 262 (3:81–2), sd.1838, Chapel Hill, Ackland Memorial Art Center; the second version is J. 292 (3:118–19), Art Market.

62. J. 299 (3:122–3), *Lady Macbeth Sleepwalking,* 1849–50, Fredericton, New Brunswick, Beaverbrook Art Gallery.

63. J. 309 (3:130), *Desdemona Cursed by Her Father,* Reims, Musée Saint-Dénis; J. L152 (3:278–9), *Desdemona Cursed by her Father* 1852–3, location unknown; two other variants of this subject are rejected by Johnson, J.R. 46, 47 (3:302).

64. J. 291 (3:116–18), *Othello About to Kill Desdemona,* 1847–9, Ottawa, National Gallery of Canada.

65. Elizabeth G. Dotson, "English Shakespeare Illustrations and Eugène Delacroix," *Essays in Honor of Walter Friedländer* (New York, 1965), 40–61.

66. J. 264 (3:84), 1838, Neue Pinakothek, Munich; J. 282 (3:108–9), 1844, Winterthur, Oskar Reinhart Collection; J. 313 (3:133), 1853, Paris, Musée du Louvre.

67. J. 129 (1:126–7), private collection, reproduced beside the watercolor, 28 × 21 cm., private collection, by Moreau, op. cit., n. 28, 166.

68. D. 110, J. 294 (3:119), *Hamlet and the King at His Prayers,* 1848–9, location unknown.

69. J. 138 (1:135–6), *The Giaour Contemplating the Dead Hassan,* 1824–25?/1828–30?, private collection.

70. J. 115 (1:105–6), *Scenes from the War between the Greeks and the Turks,* Winterthur, Oskar Reinhart Collection; for the *Combat,* J. 114, see n. 50.

71. J. 322 (3:141–2), sd.1856, Athens, National Pinacothek; J. 323 (3:142), *A Turk Surrenders to a Greek Horseman* or *The Combat of the Giaour and Hassan,* sd. 1856, Cambridge, MA, Fogg Art Museum.

72. J. 98 (1:69–71), 1826, *Greece on the Ruins of Missolonghi,* Bordeaux, Musée des Beaux-Arts; George Heard Hamilton, "Delacroix's Byron Memorial," *Burlington Magazine,* 94, no. 594 (September 1952): 257–61.

73. J. 162 (1:171–3), *A Mortally Wounded Brigand Quenches his Thirst,* c. 1825, Basel, Kunstmuseum. This relation, suggested in my thesis of 1974, was independently noted by John Bandiera, "Byron's 'Lara' as a source for an early work by Delacroix," *Marsyas* 20 (1979–80): 57–60, to which Lee Johnson kindly drew my attention.

74. J. 105 (1:83–91), *Scenes from the Chios Massacres,* 1824, Paris, Musée du Louvre.

75. J. 355 (3:164–5), 1833–4, private collection; for J. 257, see n. 50.

76. For J. 328, see n. 32; J. 419 (3:211), sd.1863, *Arabs Skirmishing in the Mountains* or *The Collection of the Arab Taxes,* Washington D.C., National Gallery of Art.

77. See J. 135 (1:131–4) for analysis.

78. For J. 284, see n. 26.

79. J. 125 (1:114–21), 1827–8, Paris, Musée du Louvre.

80. J. 261 (3:78–81), sd. 1838, Lille, Musée des Beaux-Arts; J. 333 (3:149–50), sd.1859, Lost; J. 343 (3:157–8), sd. 1862, Paris, Musée du Louvre; J. 344 (3:158), sd. 1862, private collection.

81. René Huyghe, *Delacroix* (English ed.) London, 1964, 333–4; Delacroix noted his admiration for Andrea's painting in his *Journal* on 15 April 1823.

82. *Journal* (11 May 1824).

83. George Heard Hamilton, "Delacroix, Byron and the English Illustrators," *Gazette des Beaux-Arts*, n.s., 36 (1949): 261–78.

84. J. 116 (1:106–7), London, Wallace Collection.

85. See n. 17.

86. D. 75.

87. See n. 45.

88. Lee Johnson, "Review of the Revised Edition of Delteil," *Burlington Magazine* 115, no. 1140 (March 1998): 213–14.

89. D. 40, D. 64.

90. J. 148 (1:157–9), sd. 1831, Philadelphia Museum of Art. One can only speculate whether Delacroix was aware that Maturin plaigiarized this episode from Diderot's *La Religieuse*.

91. J. 198, J. 199, J. 204, etc.

92. London, Wallace Collection.

93. London, Wallace Collection.

94. Formerly Paris, Assemblée Nationale.

95. Both Avignon, Musée des Beaux-Arts.

96. J. L104 (1:207–8 + supp. 3:317), 1824, Cairo, Mahmoud Khalil Museum.

97. J. 100 (1:72–8), sd. 1822, Paris, Musée du Louvre.

98. J. L154 (3:279) does not seem to be identifiable with the unfinished panel reproduced in H. Szeeman et al., *Delacroix*, exhib. cat. Zurich-Frankfurt, 1987–8, 335.

99. Rouen, Musée des Beaux-Arts.

100. See n. 69. See my "Delacroix, Colin, Byron and the Greek War of Independence," *Burlington Magazine* 125, no. 965 (August 1983): 495–500.

101. Margret Stuffmann, *Eugène Delacroix*, exhib. cat., Frankfurt am Main, Kunstmuseum, 1987–8, H.9, private collection; Sérullaz et al., *Dessins*, no. 516, 1:249.

102. Leo Ewals, *Ary Scheffer, sa vie et son oeuvre*, Nijmegen, 1987, 259 and pl. 51.

103. Musée des Beaux-Arts, Lille; Ewals, ibid., 251.

104. See Jay Fisher, exhib. cat., *Théodore Chasseriau Illustrations for 'Othello,'* Baltimore Museum of Art, 1979–80.

105. Strasbourg, Musée des Beaux-Arts; Marc Sandoz, *Théodore Chassériau, 1819–1856. Catalogue raisonné des peintures et estampes*, Paris, 1974, no. 131.

106. Pierre Mathieu, *Gustave Moreau*, London, 1977, 35, 38.

CHAPTER 9. MICHÈLE HANNOOSH. DELACROIX AS ESSAYIST: WRITINGS ON ART

1. "Le Poussin," *Œuvres littéraires*, ed. Elie Faure (Paris, G. Crès, 1923), 2 vols. (henceforth *O.L.*), 2:57–104, here 100 (from Poussin's letter to de Noyers, 20 February 1639). Cf. the *Journal* of 23 September 1854: "J'avoue ma prédilection pour les arts silencieux, pour ces choses muettes dont Poussin disait qu'il faisait profession." All references to the *Journal* are to my edition (Paris: Macula, forthcoming); my readings and supplements thus often differ from those of previous editions.

2. Letter to Baudelaire, 17 February 1858, in Delacroix, *Correspondance*, ed. A. Joubin, 5 vols. (Paris, Plon, 1935–8) (henceforth *Corr.*), 4:14.

3. See my *Painting and the Journal of Eugène Delacroix* (Princeton: Princeton UP, 1995).

4. First published, lacking the *Andromeda* article, in A. Piron's *Eugène Delacroix, sa vie et ses œuvres* (Paris: Claye, 1865); reprinted in *O.L.*; a recent reprint (*Ecrits sur l'art*, ed. F.M. Deyrolle and C. Denissel, Paris, Séguier, 1988) adds the *Andromeda*.

5. *L'Œuvre et la vie d'Eugène Delacroix*, chap. 4 (Baudelaire, *Œuvres complètes*, ed. C. Pichois, 2 vols., Paris, Gallimard, 1975–6), 2:753–6.

6. See *Corr.* 4:14, and Baudelaire's letter to Poulet-Malassis, 19 February 1858 (*Correspondance*, ed. C. Pichois, 2 vols., Paris, Gallimard, 1973), 2:453.

7. They are occasionally cited for their views on particular artists: e.g., C. Prendergast,

Napoleon and History Painting: Antoine-Jean Gros' "La Bataille d'Eylau" (Oxford: Clarendon Press, 1998); A. Chastel, "Poussin et la postérité," in *Nicolas Poussin, ouvrage publié sous la direction d'André Chastel* (Paris, CNRS, 1958), 303–4.

8. The article on Charlet, however, does not deal with biography, since a recent work had done so.

9. *Journal,* 10 August 1850; 20 January 1857 (*Dictionnaire* entries *"Science"* and *"Copies, Copier"*); 3 March 1859 (*"Imitation"*).

10. "Raphaël," *O.L.* 2:3–18, here 6–7.

11. Ibid., 7; cf. *Journal,* 16 January 1860.

12. *O.L.* 2:74.

13. "Oui, mon cher monsieur, je vous donnerai l'article sur le Poussin; mais, puisque vous voulez que je vous parle franchement, je vous dirai que, soit la multiplicité de mes occupations, soit l'habitude d'écrire entièrement perdue, jamais je n'ai éprouvé plus de peine à mettre quelque chose en train et à plus forte raison à achever." (letter to Buloz, *Corr.* 1:430–1, n.d., but an allusion to Auguste Barbier's *Salon,* published in the *Revue* of 15 April 1837, would place it just after. Cf. R. Escholier, *Delacroix. Peintre, graveur, écrivain,* 3 vols. (Paris, H. Floury, 1926–9), 2:322, and Joubin in *Corr.*

14. *Revue des deux-mondes,* 1 August 1837.

15. "Je vous rappelle que vous avez promis quelque chose sur Poussin." This letter was part of the archive I discovered in 1996 still in the hands of Piron's heirs, and which my edition of the *Journal* incorporates; the archive was subsequently dispersed at auction in December 1997.

16. The letter, dated only "ce jeudi," was misdated to 1837 by Escholier (*Delacroix. Peintre, graveur, écrivain,* 2:323) and Joubin (*Corr.* 1:431). The letter from Buloz of 3 June 1840, a Wednesday, confirms the date of 4 June 1840.

17. *Moniteur universel,* 18 February 1852.

18. Baudelaire's letters for November and December 1853 indicate that he was to publish his translations of Poe's *Tales* in the *Moniteur* at that period (*Correspondance* 1:234 and passim), which never came about; his translation of Poe's *Narrative of Arthur Gordon Pym,* however, came out in serial form in the *Moniteur* starting on 25 February 1857, its final installment appearing just before the seizure of the *Fleurs du mal* by the police. The *Moniteur* of 1 January 1854 announces on its front page that it has procured the collaboration of Emile Augier, Chassériau, Delacroix, Gautier, Halévy, Mérimée, Musset, Jules Sandeau, Sainte-Beuve, and others; Delacroix did not contribute after the 1853 Poussin article, however.

19. See Mérimée, *Correspondance générale,* ed. M. Parturier (Toulouse: Edouard Privat, 1941–64), no. 2019: "Le pauvre E. Delacroix canevasse aidé par M. Fould et l'Empereur. Cependant il n'a guères d'espoir et c'est Flandrin qui passera sans difficulté." To Delacroix he writes: "Mr. F[ould] [. . .] me dit qu'il a vu selon notre désir tous les membres de la section, et qu'il a de tous la presque promesse qu'ils vous porteront sur la liste de présentation. Il pense même qu'avec un peu d'intrigue il ne serait pas impossible de réussir pour la grande bataille." (*Correspondance générale* no. 2021, which misreads "votre" for "notre"; ms. Pierpont Morgan Library, New York).

20. 17 April 1853.

21. An entry on the English school for the *Dictionnaire* is noted under 18 January 1857; loose notes on the subject survive (see the supplement to my edition), as well as Delacroix's letters to Silvestre (*Correspondance* 4:57–62, and postscriptum in *Further Correspondence,* 153–4) and to Thoré (*Correspondance* 4:285–9). Reynolds appears in the *Dictionnaire* entry on *"Pinceau"* and Oudry in the one on *"Technique"* (11 and 12 January 1857).

22. In the sale catalogue of a portion of Delacroix's library I have found (Paris, 30 March 1868), there figures a copy of the *Collection de lettres de Nicolas Poussin* prepared by Quatremère de Quincy (Paris, 1824), no. 488.

23. See my *Painting and the Journal of Eugène Delacroix,* chap. 3.

24. 8 May 1853.

25. See, for example, 6, 10, 12, 14, 29 May 1853.

26. *Painting and the Journal of Eugène Delacroix*, 109–11.

27. Recent work included Charles Blanc's *Histoire des peintres français au XIXᵉ siècle. I* (Paris, 1845), reworked in 1851 into his *Nicolas Poussin*. The most prominent and favorable depiction of the artist was that of Balzac's *Le Chef d'œuvre inconnu* (1831), so influential for Cézanne and Picasso. See A. Chastel, "Poussin et la postérité," 297–310; R. Verdi, "Situation de Poussin dans la France et l'Angleterre des XVIIIᵉ et XXᵉ siècles," in cat. *Nicolas Poussin 1594–1665* (Paris: Réunion des musées nationaux, 1994), 98–105; R. Shiff, "Cézanne and Poussin: How the Modern Claims the Classic," and John House, "Cézanne and Poussin: Myth and History," both in Richard Kendall, ed., *Cézanne and Poussin: A Symposium* (Sheffield Academic Press, 1993).

28. See Chastel ("Poussin et la peinture, 303), who cites Thiers's *Salon de 1822*, and Gault de Saint-Germain's *Les Trois Siècles de la peinture en France* of 1808; cf. *Journal*, 19 September 1847 and 6 June 1851.

29. 19 September 1847.

30. 6 June 1851.

31. A jotting on the inside cover of his Louvre notebook (1741) from 1821 or 1822 notes the French translation of Maria Graham's *Memoirs of the Life of Nicolas Poussin* (London, 1820).

32. *O.L.* 2:69, 93, 91, 92. In my view he does not, however, make Poussin a "romantic" painter, as R. Verdi suggests ("Situation de Poussin," 103). See John House, "Cézanne and Poussin: Myth and History," 137. Against House, nevertheless, I do not see this as Delacroix's effort to prepare his election to the Institute. The article was finished before Blondel's seat even became vacant on 11 June; the *Journal* shows that the issues raised in it go back at least a year; and Delacroix presents Poussin as a *non*academic painter (*O.L.* 2:71–2), an argument hardly likely to appeal to the *ingristes* of the Academy.

33. *O.L.* 2:68.

34. Cf. Chastel ("Poussin et la postérité") for the article and S. Schütze for the *Journal* ("Aristide de Thèbes, Raphaël et Poussin. La représentation des *affetti* dans les grands tableaux d'histoire de Poussin des années 1620–1630," in *Nicolas Poussin 1594–1665*, Actes du colloque du Musée du Louvre, ed. A. Mérot, Paris, La Documentation française, 592, n. 78).

35. Delacroix first mentions the project on 2 February 1852. If Henri Lehmann's experience is a guide, the commission must date from the latter half of January: summoned on the 11th, Lehmann accepted on the 13th and received the official notification on the 29th. For Delacroix's efforts to obtain a commission, see the note to my edition of the *Journal* under 2 February 1852.

36. On these compositions, see Anthony Blunt, "Poussin Studies VI: Poussin's Decoration of the Long Gallery in the Louvre," *Burlington Magazine* 93 (1951): 369–75; and W. Friedlaender and A. Blunt, *The Drawings of Nicolas Poussin* (London, 1963), vol. 4. Poussin worked on the designs from 1640 to 1642, when he returned to Rome and the Gallery was abandoned; what had been executed was subsequently damaged by fire, and then destroyed between 1770 and 1787 when the Gallery became the museum.

37. *O.L.* 2:81. Pesne's engravings were printed by Gerard Audran (1678) and copied by C.P. Landon in his *Vies et œuvres des peintres les plus célèbres de toutes les écoles*, vols. XIII–XVI, Paris, 1824, nos. 176–84 and 239; Delacroix sketched from other volumes of this work (Musée du Louvre, Cabinet des Dessins, *Inventaire général des dessins. Ecole française. Dessins d'Eugène Delacroix* (Paris: Réunion des musées nationaux, 1984, nos. 1244, 1251, 1413, 1738 f. 21v, 1746 f. 21, 1750 f. 21, 30v, 31r).

38. *O.L.* 2:86–7.

39. Ibid., 80.

40. Ibid., 84, 86, 87.

41. Ibid., 58.

42. Ibid., 69.

43. In his diary for this period that I have discovered (see my supplement to the *Journal*), Delacroix's assistant Pierre Andrieu notes under Sunday, 7 November, that they left work at noon so as to go to the Louvre to see the Renaissance sculptures, notably those of Jean Goujon.

44. Jean-Baptiste Théodon (1646–1733), Pierre Legros (1666–1719), sculptors who worked in Italy; the sculptors of the decoration for the Apollo Gallery in the Louvre were Girardon, Régnaudin, and the Marsy brothers.

45. In 1857 these artists will return in the entries "Sculpture française/Ecole de peinture française" and "Style français" of the *Dictionnaire des Beaux-Arts* (11 January and 14 February 1857).

46. Ibid., 58–9.

47. Ibid., 71–2.

48. Ibid., 92. On efforts to reclaim Poussin as a French painter, see R. Verdi, "Poussin's Life in Nineteenth-Century Pictures," *Burlington Magazine* 111 (December 1969): 741–50; D. Carrier, *Poussin's Paintings: A Study in Art-Historical Method* (Penn State, 1993, 71–6; R. Shiff, "Cézanne and Poussin: How the Modern Claims the Classic," in *Cézanne and Poussin: A Symposium*, ed. Richard Kendall, 57 ff.; J. House, "Cézanne and Poussin: Myth and History," in ibid., 138–9.

49. Riesener's painting for the first Salon des Prévôts represented "The city of Paris seizing the scepter of civilization and the arts on the 2nd of December" (A. Ferrier des Tourettes, *Notice sur l'Hôtel de Ville de Paris* [Paris, 1855], 64–5).

50. The mannerism of Boucher and Vanloo will in turn become an entry for the *Dictionnaire* (12 January 1857).

51. *O.L.* 2:94.

52. Ibid., 95.

53. On the importance of the diary passage for Delacroix's evolving aesthetic of the sublime, see *Painting and the Journal of Eugène Delacroix*, 71–4.

54. *O.L.* 2:69.

55. 19 January, 6 February 1857.

56. 5 January, 19 February 1857.

57. 19 January 1857.

58. 9 February 1857. There the Poussin-like example who renewed the tradition is David; the one who, like Poussin, could not found a school is Puget.

59. Delacroix would have known this at least from Roger de Piles's *Abrégé de la vie des peintres* (1699).

60. *O.L.* 2:97–8. The final two sentences on Poussin himself are not repeated, but elaborated over two further paragraphs.

61. Accordingly, Delacroix will never wholly abandon this "weakness" of Poussin's, which will define a note "on the importance of color" for the *Dictionnaire* (5 January 1857).

62. This refers to the entry of 1 November 1852, which would have overflowed onto the preceding page (31 October), in accordance with Delacroix's habit. In cross-referencing he always notes the date of the page rather than the date of composition. This principle accounts for many an error in the Joubin edition of the *Journal* and the Larue edition of the *Dictionnaire,* both of whom fail to find many of the passages to which Delacroix refers.

63. 14 January 1857. The notes for the preface found in the Piron archive (published in my supplement) also cross-reference the 1852 diary entry.

64. *O.L.* 2:57.
65. 22 November 1853; cf. *O.L.* 2:58.
66. *O.L.* 2:95–6.
67. Ibid., 95; 20 January 1857.
68. Entry *"Michel-Ange,"* 31 January 1857.
69. *O.L.* 2:95.
70. *"Antique/Titien,"* 18 February 1857; *"Classique,"* 19 January 1857.
71. *O.L.* 2:85.
72. Ibid., 58.
73. Ibid., 74.
74. Ibid., 65, 85, 66.
75. Ibid., 78–9.
76. Ibid., 91, 101.
77. Cf. 4 February 1847, 9 October 1849, 18 January 1856; 5 July 1860.
78. Cf. 10 January, 28 March and 30 November 1853, and 19 August 1858.
79. Letter to Fréart de Chambray, 1 March 1665 (*Lettres*, 1824 ed., 347).
80. *Questions sur le beau, O.L.* 1:30.
81. *O.L.* 2:102.
82. Delacroix first notes the idea of writing short essayistic pieces, "pensées détachées," on 20 May; a "dictionary" per se on 10 October.
83. *Conversations with Cézanne*, ed. P.M. Doran (Paris, Macula, 1978), 150.

CHAPTER 10. DAVID SCOTT. PAINTING/LITERATURE: THE IMPACT OF DELACROIX ON AESTHETIC THEORY, ART CRITICISM, AND POETICS IN MID–NINETEENTH CENTURY FRANCE

(Note: All translations from the French cited in the text are mine.)

1. See Michel Thévoz, *L'Académisme et ses fantasmes* (Paris: Editions de Minuit, 1980).
2. Both writers known to Delacroix, and both mentioned, the latter frequently, in the *Journal*, ed. André Joubin, 3 vols. (Paris: Plon, 1931 [1980]).
3. Quatremère de Quincy, *Essai sur la nature, le but et les moyens de l'imitation dans les beaux-arts* (Paris: Didot, 1823); hereafter Quatremère, *Essai*.
4. Quatremère, *Essai*, 5.
5. Quatremère, *Essai*, 19.
6. Quatremère, *Essai*, 120, 263.
7. Quatremère, *Essai*, 33, 82–3.
8. Quatremère, *Essai*, 175.
9. Quatremère, *Essai*, 120, 125.
10. *Du Vrai, du Beau et du Bien* [1836] (Paris: Perrin, 1917); hereafter Cousin, *Du Vrai*.
11. Cousin, *Du Vrai*, 196, 195.
12. Cousin, *Du Vrai*, 147.
13. Cousin, *Du Vrai*, 150; italics mine.
14. "L'œuvre de Delacroix [. . .] une espèce de mnémotechnie [. . .] a toujours rallié autour de lui les sympathies des poètes," in *L'Oeuvre et la vie d'Eugène Delacroix*; originally published in *L'Opinion Nationale* September 2, November 14, and November 22, 1863; hereafter *VOD*; in *Oeuvres complètes*, ed. Cl. Pichois, 2 vols., Bibliothèque de la Pléiade (Paris: Gallimard, 1975–6), II:742–70, 745; hereafter *BOC* I or II.
15. See David Scott, *Pictorialist Poetics: poetry & the visual arts in 19th-century France* (Cambridge UP, 1988).
16. Théophile Gautier, "Eugène Delacroix," published in *Le Moniteur*, 18 November 1864, cited in *Critique artistique et littéraire*, ed. F. Gohin & R. Tisserand (Paris: Larousse, 1929), 64 (hereafter "Eugène Delacroix").
17. Gautier, "Eugène Delacroix," 70.

18. *OVD; BOC* II:745.

19. *BOC* II, 432; *BOC* II, 432.

20. Lee Johnson, *The Paintings of Eugène Delacroix: A Critical Catalogue*, 6 vols. (Oxford: Clarendon Press, 1981–9), J. 334 (3:150–2).

21. Théophile Gautier, *Exposition de 1859*, ed. Wolfgang Drost & Ulrike Henninges (Heidelberg: Carl Winter Universitätsverlag, 1992) (hereafter *Exposition de 1859*).

22. Gautier, *Exposition de 1859*, 31.

23. Gautier, *Exposition de 1859*, 34.

24. *BOC* II, 635–6; II, 636.

25. Delacroix, *Journal* (21 October 1853), 373.

26. *Journal* (25 April 1824), 71.

27. For an account of this process, see *Pictorialist Poetics*, chap. 3.

28. *Journal* (21 October 1853), 372.

29. *Journal* (11 December 1855), 560.

30. *OVD; BOC* II, 749.

31. Théodore de Banville, *Petit Traité de poésie française* (Paris: Librairie de l'Echo de la Sorbonne, 1872), 43–4 (hereafter, Banville, *Petit Traité*).

32. Gautier, "Eugène Delacroix," 69.

33. *OVD; BOC* II,749.

34. Banville, *Petit Traité*, 66.

35. Cf. Anne Larue in the introduction to her reconstitution of Delacroix's *Dictionnaire des Beaux-Arts* (Paris: Hermann [Coll. Savoir: sur l'art]), 1996, xl.

36. Charles Blanc, *Grammaire des arts du dessin. Architecture, sculpture, peinture* (Paris: Renouard, 1876) (hereafter, Blanc, *Grammaire*).

37. Blanc, *Grammaire*, 21–3, 22.

38. Baudelaire, *Salon de 1846, BOC* II, 418.

39. *Journal* (23 February 1852), 292–3.

40. *BOC* II, 595.

41. *BOC* II, 434.

42. Baudelaire, *Salon de 1859, BOC* II, 592.

43. Baudelaire, *Salon de 1846; BOC* II, 425; *Salon de 1859; BOC* II, 594–5, etc.

44. Baudelaire, *Salon de 1859; BOC* II, 625.

45. *Salon de 1859; BOC* II, 625.

46. *Salon de 1859; BOC* II, 595.

47. For scientific theories of color in this period, see Bernard Howells, "The problem with colour. Three theorists: Goethe, Schopenhauer, Chevreul," in *Artistic Relations. Literature and the Visual Arts in 19th-Century France*, ed. Peter Collier & Robert Lethbridge (Yale UP, 1994), 76–93.

48. Blanc, *Grammaire*, 572.

49. Blanc, *Grammaire*, 569.

50. Blanc, *Grammaire*, 572.

51. Blanc, *Grammaire*, 572.

52. Blanc, *Grammaire*, 573.

53. Blanc, *Grammaire*, 573.

54. Baudelaire, cited above, *OVD; BOC* II, 749.

55. *OVD; BOC* II, 749–50.

56. *Journal* (13 September 1847), 163.

57. Banville, *Petit Traité*, 42.

58. Baudelaire, "Prométhée délivrée par de Senneville," in *Le Corsaire-Satan*, 3 February 1846 (*BOC* II, 11).

59. Banville, *Petit Traité*, 63.

60. Banville, *Petit Traité*, 78.

61. Baudelaire, letter to Armand Fraisse 18 February 1860; *Correspondance*, ed. Cl. Pichois, 2 vols., Bibliothèque de la Pléiade (Paris: Gallimard, 1973), I, 676.

62. For a full analysis of this poem, see *Pictorialist Poetics,* chap. 4.
63. Cf. Armand Moss, *Baudelaire et Delacroix* (Paris: Nizet, 1973).
64. *Journal* (25 January 1857), 633–4.
65. *Journal* (6 June 1856), 582.
66. *Journal* (17 June 1855), 516.
67. Larue, *Dictionnaire des Beaux-Arts,* xlii.

Selected Bibliography and Suggestions for Further Reading

CATALOGUES OF WORKS

Delteil, Loys. *Le Peintre-graveur illustré, III. Ingres-Delacroix.* Paris, 1908; 1969. Revised and trans. by Susan Strauber as *Eugène Delacroix. The Graphic Work: A Catalogue Raisonné.* San Francisco: Alan Wofsy Fine Arts, 1997.

Johnson, Lee. *The Paintings of Eugène Delacroix: A Critical Catalogue.* 6 vols. Oxford: Clarendon Press, 1981–9. *1816–1831* vol. 1, *Text*; vol. 2, *Plates*. Oxford, 1981. *1832–1863* vol. 3, *Text*; vol. 4, *Plates*. Oxford, 1986; rev. ed., 1993. *The Public Decorations and Their Sketches*, vol. 5, *Text*; vol. 6, *Plates*. Oxford, 1989.

Delacroix Pastels. New York, 1995.

Robaut, Alfred, Ernest Chesneau, and Fernand Calmettes. *L'Oeuvre complet de Eugène Delacroix. Peintures, dessins, gravures, lithographies.* Paris, 1885. The annotated copy (Bibliothèque nationale de France, Cabinet des Estampes) published New York, 1969.

Sérullaz, Maurice, et al. Musée du Louvre, Cabinet des Dessins. *Inventaire général des dessins. Ecole française. Dessins d'Eugène Delacroix.* Ed. Maurice Sérullaz, Arlette Sérullaz, Louis-Antoine Prat, and Claudine Ganeval. 2 vols. Paris: Réunion des Musées Nationaux, 1984.

DELACROIX'S WRITINGS

Delacroix, Eugène. *Oeuvres littéraires.* Ed. Elie Faure. 2 vols. I. *Etudes esthétiques.* II. *Essais sur les artistes célèbres.* Paris: G. Crès & Cie, 1923. Reprinted in rev. ed. by François-Marie Deyrolle and Christophe Denissel as *Eugène Delacroix. Ecrits sur l'art.* Paris: Séguier, 1988.

Dictionnaire des Beaux-Arts d'Eugène Delacroix. Ed. Anne Larue. Paris: Hermann (Coll. Savoir: sur l'art), 1996.

Journal, 1822–1863. Ed. André Joubin. 3 vols. Paris: Plon, 1931–2. Rev. ed. Régis Labourdette. Paris: Plon, 1980. Reprint, Paris, 1996.

The Journal of Eugène Delacroix. Trans. Walter Pach. [1937] New York: Viking Press, 1972.

The Journal of Eugène Delacroix. Ed. Hubert Wellington, trans. Lucy Norton. [1951] London: Phaidon, 1995.

Journal, 1822–1863. Ed. Michèle Hannoosh. 3 vols. Paris: Macula, forthcoming.

Correspondance générale. Ed. André Joubin. 5 vols. Paris: Plon, 1935–8.

Correspondance. Ed. Claude Pichois. 2 vols. Paris: Gallimard, 1975–6.

Lettres intimes. Correspondance inédite. Ed. A. Dupont. Paris: Gallimard, 1954. Reprint, Paris, 1995.

Further Correspondence. Ed. Lee Johnson. Oxford: Clarendon Press, 1991.

Selected Letters, 1813–1863. Selected and trans. by Jean Stewart. New York: St. Martin's, 1970.

Les Dangers de la Cour. Ed. Jean Marchand. Avignon: Aubanel, 1960.

MONOGRAPHIC STUDIES: BOOKS AND ARTICLES ON DELACROIX

Arama, Maurice. *Eugène Delacroix. Le voyage au Maroc.* Facsimile of the sketchbooks in the Musée du Louvre and the Musée Condé in Chantilly, supplemented with notes and documents. 6 vols. Paris: Institut du monde arabe; Flammarion, 1992.

Athanassoglou-Kallmyer, Nina. *Eugène Delacroix: Prints, Politics and Satire, 1814–1822.* New Haven: Yale UP, 1991.

Bessis, Henriette. "L'Inventaire après décès d'Eugène Delacroix." *Bulletin de la Société de l'Histoire de l'Art français* 1969 (1971): 199–222.

Escholier, Raymond. *Delacroix, peintre, graveur, écrivain.* 3 vols. Paris: Floury, 1926–9.

Fraser, Elisabeth A. "Uncivil Alliances: Delacroix, the Private Collector, and the Public." *Oxford Art Journal* 21, no. 1 (1998): 87–103.

Hannoosh, Michèle. *Painting and the 'Journal' of Eugène Delacroix.* Princeton: Princeton UP, 1995.

Huyghe, René. *Delacroix, ou, Le Combat solitaire.* Paris, 1964.

Jobert, Barthélémy. *Delacroix.* Paris: Gallimard, 1997; Princeton: Princeton UP, 1998.

Johnson, Lee. *Delacroix.* London: Weidenfeld and Nicolson, 1963.

 "Eugène Delacroix et les Salons. Documents inédits au Louvre." *Revue du Louvre* 4–5 (1966): 217–30.

Lambert, Elie. *Histoire d'un tableau: "L'Abd Er Rahman Sultan du Maroc" de Delacroix.* Paris, 1953.

Meier-Grafe, Julius. *Eugène Delacroix. Beiträge zu einer Analyse.* [1913] Munich: Piper, 1922.

Moreau, Adolphe. *Eugène Delacroix et son oeuvre.* Paris: Librarie des Bibliophiles, 1873.

Moreau-Nélaton, Etienne. *Delacroix raconté par lui-même.* 2 vols. Paris: Henri Laurens, 1916.

Mras, George P. *Eugène Delacroix's Theory of Art.* Princeton: Princeton UP, 1966.

Piron, Achille. *Eugène Delacroix. Sa vie et ses oeuvres.* Paris: Jules Claye, 1865.

Pomarède, Vincent. *Eugène Delacroix. "La Mort de Sardanapale."* Paris: Service culturel du musée du Louvre. Collection *solo* 9, 1998.

Rubin, James Henry. *Eugène Delacroix. Die Dantebarke. Idealismus und Modernität.* Frankfurt, 1987.

Sérullaz, Maurice. *Les Peintures murales de Delacroix.* Paris: Editions du Temps, 1963.

Spector, Jack. *The Murals of Eugène Delacroix at Saint-Sulpice.* College Art Association Monograph 16. New York: College Art Association of America, 1967.

 Delacroix. The Death of Sardanapalus. Art in Context Series. London: Allen Lane; New York: Viking Press, 1974.

Tourneux, Maurice. *Eugène Delacroix devant ses contemporains: ses écrits, ses biographes, ses critiques.* Paris: Jules Rouam, 1886.

Trapp, Frank Anderson. *The Attainment of Delacroix.* Baltimore: Johns Hopkins UP, 1970.

Véron, Eugène. *Les Artistes célèbres: Eugène Delacroix.* Paris: Librairies de l'art, 1887.

EXHIBITION CATALOGUES

Exposition des oeuvres d'Eugène Delacroix. Paris: Société Nationale des Beaux-Arts, 1864.

Exposition Eugène Delacroix au profit de la Souscription destinée à élever à Paris un monument à sa mémoire. Paris: Ecole des Beaux-Arts, 1885.

Centenaire du Romantisme. Exposition Eugène Delacroix: peintures, aquarelles, pastels,

dessins, gravures, documents. Exhib. cat., Paris: Musée du Louvre. Paris: Editions des Musées Nationaux, 1930.

Johnson, Lee. *Delacroix*. Exhib. cat., Art Gallery of Toronto and Ottawa: National Gallery of Canada, 1962–3.

Delacroix, ses maîtres, ses amis, ses élèves. Exhib. cat., Bordeaux: Musée des Beaux-Arts, 1963.

Eugène Delacroix 1798–1863. Mémorial de l'exposition organisée à l'occasion du centenaire de l'artiste. Exhib. cat., Ed. Maurice Sérullaz. Paris: Musée du Louvre. Paris: Editions des Musées Nationaux, 1963.

Delacroix. Edinburgh: Royal Scottish Academy and London: Royal Academy, 1963–4.

Eugène Delacroix (1798–1863). Bremen: Kunsthalle, 1964.

"La Liberté Guidant le Peuple" de Delacroix. Exhib. cat. by Hélène Toussaint, Paris: Musée du Louvre 1982–3. Paris: Réunion des Musées Nationaux, 1982.

Eugène Delacroix. Zurich: Kunsthaus and Frankfurt: Städelsches Kunstinstitut, 1987–8.

Eugène Delacroix. Themen und Variationen. Arbeiten auf Papier. Exhib. cat. by Margret Stuffmann. Frankfurt: Städelsches Kunstinstitut, 1987–8.

Eugène Delacroix (1798–1863). Paintings, Drawings and Prints from the North American Collections. New York: The Metropolitan Museum of Art, 1991.

Delacroix. Le voyage au Maroc. Exhib. cat. by Brahim Alaoui, Maurice Sérullaz, Arlette Sérullaz, Lee Johnson, Maurice Arama, et al. Paris: Institut du Monde Arabe, 1994–5. Paris and New York: Flammarion, 1994.

Eugène Delacroix à l'Assemblée Nationale, peintures murales, esquisses, dessins. Exhib. cat. by Arlette Sérullaz and N. Moulonguet. Paris: Assemblée Nationale, 1995.

La Grèce en révolte. Delacroix et les peintres français 1815–1848. Exhib. cat. by Claire Constans, Arlette Sérullaz, Dominique Cante, Marina Lambraki-Plaka, Francis Ribemont, and Fani-Maria Tsigakou, with essays by Nina Athanassoglou-Kallmyer, et al. Bordeaux: Musée des Beaux-Arts, Paris: Musée national Eugène-Delacroix, and Athens: Alexandre-Soutzos Museum, 1996–7. Paris: Réunion des Musées nationaux, 1996.

Delacroix. La naissance d'un nouveau romantisme. Exhib. cat. by Claude Pétry with essays by Lee Johnson, Barthélémy Jobert, Arlette Sérullaz and Vincent Pomarède, Stéphane Guégan, Diederik Dakhüys, and Roger Delage. Rouen: Musée des Beaux-Arts, 1998. Paris: Réunion des Musées nationaux, 1998.

Delacroix. The Late Work. Exhib. cat. by Arlette Sérullaz, Vincent Pomarède, and Joseph J. Rishel, with essays by Lee Johnson, Louis-Antoine Prat, David Liot. Paris: Galeries Nationales du Grand Palais, and Philadelphia Museum of Art, 1998–9. Philadelphia Museum of Art, 1998.

Suggestions for Further Reading

DELACROIX'S GENERATION AND FRENCH POLITICAL EVENTS

Agulhon, Maurice. *The Republican Experiment, 1848–1852*. Cambridge and New York: Cambridge UP; Paris: Editions de la maison des sciences de l'homme, 1983.

Bluche, Fréderic. *Le Bonapartisme*. Paris: Nouvelles Editions Latines, 1980.

Chimot, J.-P. "Delacroix et la politique." *Cahiers d'histoire* (1965): 249–74.

Dumas, Alexandre. *Causerie sur Eugène Delacroix et ses oeuvres faite par Alexandre Dumas le 10 décembre 1864 dans la salle d'exposition des oeuvres d'Eugène Delacroix*. Paris, 1865. Rev. ed. by A. Thibaudeaux as Alexandre Dumas, *Delacroix*. Paris, 1996.

Furet, François. *Revolutionary France 1770–1880*. Oxford: Blackwell, 1992.

Hannoosh, Michèle. "A painter's impressions of modernity: Delacroix, citizen of the nineteenth century." In Richard Hobbs, ed., *Impressions of French Modernity*, 9–29. Manchester and New York: Manchester UP, 1998.

Jardin, André, and André-Jean Tudesq. *Restoration and Reaction, 1815–1848*. Trans. Elborg Forster. Cambridge: Cambridge UP, 1984.

Lüdecke, H. *Eugène Delacroix und die Pariser Julirevolution*. Berlin: Deutsche Akademie der Künste zu Berlin, 1965.

Marrinan, Michael. *Painting Politics for Louis-Philippe: Art and Ideology in Orléanist France, 1830–1848*. New Haven: Yale UP, 1988.

Pinkney, David. *The Revolution of 1830*. Princeton, NJ: Princeton UP, 1972.

Plessis, Alain. *The Rise and Fall of the Second Empire, 1852–1871*. Cambridge and New York: Cambridge UP; Paris: Editions de la maison des sciences de l'homme, 1985.

Spitzer, Alan B. *The French Generation of 1820*. Princeton, NJ: Princeton UP, 1987.

Tocqueville, Alexis de. *Souvenirs*. In *Oeuvres Complètes*, Paris: Gallimard, 1951–, vol. 12 (Paris, 1964). Trans. by A. T. de Mattos, *The Recollections of A. de Tocqueville*. New York: Meridian Books, 1959.

NINETEENTH-CENTURY PICTORIAL PRACTICE

Boime, Albert. *The Academy and French Painting in the Nineteenth Century*. New York: Phaidon, 1971.

Chaudonneret, Marie-Claude. *L'État & les artistes. De la Restauration à la monarchie de Juillet (1815–1833)*. Paris: Flammarion, 1999.

Fontaine, André. *Les Doctrines d'art en France*. Paris: Renouard/Laurens, 1909. Geneva: Slatkine reprint, 1970.

Howell, Joyce Bernstein. "Eugène Delacroix and Color: Practice, Theory, and Legend." *Athanor* 2 (1982): 37–43.

Liot, David. "The Technique of Eugène Delacroix: A Historical Approach." In *Delacroix. The Late Work*, 384–94. Exhib. cat. Paris, Galeries Nationales du Grand Palais, and Philadelphia Museum of Art, 1998–9 (see earlier).

Piot, René. *Les Palettes de Delacroix*. Paris: Librairie de France, 1931.

Planet, Louis de. *Souvenirs de travaux des peintures avec M. Eugène Delacroix*. Ed. André Joubin. *Bulletin de la Société de l'Histoire de l'Art français* 2 (1928): 368–473. Paris: Librarie Armand Colin, 1929.

Signac, Paul. "La Technique de Delacroix." *La Revue blanche* (1 May 1898): 13–35.

D'Eugène Delacroix au néo-impressionisme. Paris, 1899. Rev. ed. with intro. and notes by Françoise Cachin. Paris: Hermann, 1964, 1978.

FRENCH COLONIALISM IN ALGERIA AND ORIENTALISM IN ART

Alloula, Malek. *The Colonial Harem*. Trans. Myrna and Wlad Goldzich. Minnesota Theory and History of Literature Series 21. Minneapolis: University of Minnesota Press, 1986.

Apter, Emily. "Female Trouble in the Colonial Harem." *difference: A Journal of Feminist Cultural Studies* 4, no. 1 (1992): 205–24.

Betts, Gregory K. "Wanted Women, Woman's Wants: *The Colonial Harem* and Post-colonial Discourse." *Canadian Review of Comparative Literature* 22, no. 3 (September 1995): 527–55.

Brown, Marilyn. "The Harem Dehistoricized: Ingres's *Turkish Bath*." *Arts Magazine* 61, no. 10 (Summer 1987): 58–68.

Djebar, Assia. *Women of Algiers in their Apartment*. Trans. Marjolijn de Jager. Charlottesville: UP of Virginia, 1992.

Ferrer, Daniel. "The Interaction of Verbal and Pictorial Elements in the Genesis of Eugène Delacroix's *Sultan of Morocco*." *Word & Image* 13, no. 2 (April–June 1997): 183–92.

Harper, Mary J. "The Poetics and the Politics of Delacroix's Representation of the Harem in

Women of Algiers in Their Apartment." In *Picturing the Middle East. A Hundred Years of European Orientalism. A Symposium,* 52–65. New York: Dahesh Museum, 1996.

Lowe, Lisa. *Critical Terrains. French and British Orientalisms.* Ithaca: Cornell UP, 1991.

MacKenzie, John M. *Orientalism: History, Theory and the Arts.* Manchester: Manchester UP, 1995.

Montagnon, Pierre. *La Conquête de l'Algérie.* Paris, 1986.

Porterfield, Todd. *The Allure of Empire. Art in the Service of French Imperialism 1798–1836.* Princeton: Princeton UP, 1998.

Said, Edward. *Orientalism.* New York: Vintage, 1979.

Wein, Jo Ann. "Delacroix's *Street in Meknès* and the Ideology of Orientalism." *Arts Magazine* 83 (June 1983): 106–9.

ROMANTICISM AND THE TRANSFORMATION OF LITERATURE INTO ART

Charlton, D. G., ed. *The French Romantics.* 2 vols. Cambridge UP, 1984. Essays by D. G. Charlton, Frank Paul Bowman, J. C. Ireson, W. D. Howarth, Roger Fayolle, Douglas Johnson, William Vaughan, Hugh Macdonald, Max Milner.

Doy, Guinevere. "Delacroix et Faust." *Nouvelles de l'Estampe* 21 (May–June 1975): 18–23.

Estève, E. *Byron et le romantisme français. Essai sur la fortune et l'influence de l'oeuvre de Byron en France de 1812 à 1850.* [2nd ed. 1929]. Paris: Hachette, 1987.

Johnson, Lee. "Delacroix and *The Bride of Abydos.*" *Burlington Magazine* 114, no. 834 (September 1972): 579–85.

Jullian, René. "Delacroix et la scène d'*Hamlet au cimetière.*" *Bulletin de la Société de l'Histoire de l'Art français* 1975 [1976]: 245–59.

Kemp, Martin. "Scott and Delacroix, with some Assistance from Hugo and Bonington." In *Scott Bicentenary Essays,* ed. Alan Bell, 213–27. Edinburgh: Scottish Academic Press, 1973.

Larue, Anne. "Byron et le crépuscule du 'sujet' en peinture. Une Folie littéraire du jeune Delacroix." *Romantisme* 19, no. 66 (1989): 23–40.

Moreau, Véronique. "Delacroix lecteur de Walter Scott," 145–84. In *Delacroix en Touraine.* Exhib cat. by Philippe Le Leyzour, with essays by Philippe Le Leyzour, Arlette Sérullaz, Lee Johnson, Jacques Olivier Boufier, Michèle Prévost, Véronique Moreau, Sophie Join-Lambert. Musée des Beaux-Arts de Tours, 1998.

Partridge, Eric. *The French Romantics' Knowledge of English Literature (1820–1848).* Paris: E. Champion (Bibliothèque de la revue de littérature comparée, 1924). New York: B. Franklin, 1968.

Sinnreich, U. "Delacroix, Faust-Illustrationen," 56–99. In *Eugène Delacroix. Themen und Variationen. Arbeiten auf Papier.* Exhib. cat. by Margret Stuffmann. Frankfurt: Städelsches Kunstinstitut, 1987–8.

Wright, Beth S. *Painting and History during the French Restoration: Abandoned by the Past.* New York: Cambridge UP, 1997.

Wright, Beth S., and Joannides, Paul. "Les Romans historiques de Sir Walter Scott et la peinture française, 1822–1863," pts. 1 and 2. *Bulletin de la Société de l'Histoire de l'Art français,* année 1982 (1984): 119–32; année 1983 (1985): 95–115.

ROMANTICISM AND POPULAR CULTURE

Allen, James Smith. *Popular French Romanticism. Authors, Readers and Books in the 19th Century.* Syracuse: Syracuse UP, 1981.

Eggli, Edmond, and Pierre Martino. *Le Débat romantique en France (1813–1830). Pamphlets. Manifestes. Polemiques de presse.* Vol. 1 (1813–1816). Paris: Belles Lettres, 1933.

Le Hir, Marie-Pierre. *Le Romantisme aux enchères. Ducange, Pixérécourt, Hugo.* Philadelphia: Benjamin, 1992.

Minor, Lucian. *The Militant Hackwriter. French Popular Literature 1800–1848. Its Influence, Artistic and Political.* Bowling Green, OH: University Popular Press, 1975.

Steinmetz, Jean-Luc. *La France frénétique de 1830. Choix de textes.* Paris: Phébus, 1978.

ART CRITICISM AND AESTHETICS DURING DELACROIX'S LIFETIME

Abel, Elizabeth. "Redefining the Sister Arts: Baudelaire's Response to the Art of Delacroix." *Critical Inquiry,* 6, no. 3 (1979–80): 363–84.

Baudelaire, Charles. "L'Oeuvre et la vie d'Eugène Delacroix," 2: 742–70. In *Oeuvres complètes,* ed. Cl. Pichois. 2 vols. Bibliothèque de la Pléiade, Paris: Gallimard, 1975–6.

Gautier, Théophile. "Eugène Delacroix." In *Le Moniteur* (18 November 1864); reprinted in *Critique artistique et littéraire,* ed. F. Gohin and R. Tisserand. Paris: Larousse, 1929.

Guégan, Stéphane, ed. *Charles Baudelaire. Théophile Gautier. Correspondances esthétiques sur Delacroix.* Paris: Olbia, 1998.

Hannoosh, Michèle. *Painting and the 'Journal' of Eugène Delacroix.* Princeton: Princeton UP, 1995.

Iknayan, Marguerite. *The Concave Mirror: From Imitation to Expression in French Esthetic Theory, 1800–1830.* Stanford French and Italian Studies, no. 30. Palo Alto, CA: ANMA Libri, 1983.

McWilliam, Neil, ed. *A Bibliography of Salon Criticism in Paris from the July Monarchy to the Second Republic, 1831–1851.* Cambridge: Cambridge UP, 1991.

McWilliam, Neil, Vera Schuster, and Richard Wrigley, eds. *A Bibliography of Salon Criticism in Paris from the Ancien Régime to the Restoration 1699–1827.* Cambridge: Cambridge UP, 1991.

Moss, Armand. *Baudelaire et Delacroix.* Paris: A. G. Nizet, 1973.

Scott, David. *Pictorialist Poetics: poetry & the visual arts in 19th-century France.* Cambridge UP, 1988.

Snell, Robert. *Théophile Gautier. A Romantic Critic of the Visual Arts.* Oxford: Clarendon Press, 1982.

Wrigley, Richard. *The Origins of French Art Criticism from the Ancien Régime to the Restoration.* Oxford: Clarendon Press, 1993.

Index

Page or plate numbers for illustrations are in *italics*